BUCKINGHAM PALACE

Is photography an art or a science? At the outset, every
photographer had to have a fairly thorough knowledge of the
complicated chemical processes involved in order to produce any
successful pictures. By 1857, Prince Albert showed by lending
photographs to the Manchester Exhibition of Art Treasures that he
felt that photography had become an art form. Today, photographers,
assisted as they are by the electronic and optical gadgetry which
anyone can buy, no longer need the depth of scientific knowledge
that was required in the last Century. However, it is the knowledge
of optical and printing techniques which enables the photographer of
today to place his own individual interpretation on a picture. In
this respect, it is the very science of photography which enables
it to be an art form.

Within the Royal collection there are a great many photographs
from which to choose, taken by many different photographers. A number
of those shown in this exhibition have been taken by members of the
Royal Family, in particular Queen Alexandra, who was a keen photographer
and always travelled with a camera. Queen Victoria's second son,
Prince Alfred,Duke of Edinburgh, took photographs during his visit
to South Africa in 1860 just like any tourist today. Many of the
photographs in the Royal Collection are of great historical interest,
such as the one of Balmoral Castle being built.

Some of them have a personal involvement or a poignancy of their
own. I was particularly impressed by the photographs of the Crimea,
especially the Guards' Hill Church Parade, which is an example of how
difficult it is to draw the line between art and the simple recording
of history. My personal favourite is Midshipmen's Physical Drill on
H.M.S. CRESCENT in 1898 - not least because the Captain was another
Duke of York.

From my own limited experience as a photographer I know that
choosing pictures for an exhibition is a complex and sometimes
disheartening task. I think that the selection which has been made
for this exhibition is a particularly successful one and shows very
well that the original question as to whether photography is art or
science can only be answered by saying that each photograph is one
person's view at one instant in time. It is the eye of the individual
which makes art out of a simple record.

Frances Dimond and Roger Taylor

CROWN & CAMERA

The Royal Family and Photography 1842–1910

VIKING

VIKING

Penguin Books Ltd, Harmondsworth, Middlesex, England
Viking Penguin Inc., 40 West 23rd Street, New York, New York 10010, U.S.A.
Penguin Books Australia Ltd, Ringwood, Victoria, Australia
Penguin Books Canada Limited, 2801 John Street, Markham, Ontario, Canada L3R 1B4
Penguin Books (N.Z.) Ltd, 182–190 Wairau Road, Auckland 10, New Zealand

First published 1987
Published simultaneously in paperback by Penguin Books

Printed in Great Britain by
Butler & Tanner Ltd,
Frome and London

Typeset in Imprint and Helvetica

Designed by Paul McAlinden

British Library Cataloguing in Publication Data
Dimond, Frances
 Crown and camera: the Royal Family
 and photography 1842–1910.
 1. Photography—Great Britain—History
 2. Great Britain—Kings and rulers—
 Art patronage
 I. Title II. Taylor, Roger
 770'.79 TR57

 ISBN 0–670–80762–1

Contents

Foreword

The Royal Photograph Collection is a unique archive dating from the early years following the invention of photography. Queen Victoria and Prince Albert bought their first photograph in 1840. In succeeding years they collected very many more. These form a major part of the existing Royal Photographic Archive which contains over 50,000 images and is housed at Windsor Castle, which, appropriately, is where Queen Victoria and Prince Albert started it.

The exhibition in the Queen's Gallery, Buckingham Palace, with which this book is associated is drawn from that part of the collection which dates from 1842 to 1910. 1842 was the year when the first known photograph of a member of the Royal Family was taken; it was of Prince Albert [17]. 1910 was the end of the reign of King Edward VII, whose consort, Queen Alexandra, was herself a prolific photographer. This is the first time that an exhibition devoted to photographs from the Royal Collection has been mounted.

The collection is important in a number of ways. From it one can follow the development of photography from its early stages, both in terms of the technical processes and as a form of art. In contrast to many other collections, the provenance of the photographs at Windsor is largely contained amongst the papers in the Royal Archives, which are also housed at Windsor Castle. It is frequently possible therefore to tell who took the photographs and who bought, ordered or commissioned them and what for.

The collection also shows how the Royal Family, and particularly Queen Victoria and Prince Albert, gave very important encouragement to photography in its early days. Their support and patronage undoubtedly helped this new invention to receive greater scientific, artistic and public attention. Queen Victoria and Prince Albert became Patrons of the Royal Photographic Society soon after it was founded in 1853 and took much interest in the invention and development of new photographic techniques.

The Royal Photograph Collection gives a comprehensive view of the lives and interests of members of the Royal Family, and in so doing illustrates many aspects of the Victorian and Edwardian periods. In particular it provides a detailed and continuous portrait gallery of the Royal Family themselves. At the present time, when the camera is ubiquitous and sometimes intrusive, it is difficult to realize that it was only in 1860 that Queen Victoria first gave permission for photographs of herself to be on sale to the general public. Never before had the likeness of the Sovereign been available in this way to so many of her subjects. It opened an entirely new era in the public's perception of the monarchy.

The photographic archive is the least known and most recently formed of the Royal Collections. During the 1960s it was decided, in view of growing public interest in early photography, that historical photographs in royal possession should be amalgamated and catalogued. A subject index of some eighty volumes of Victorian portraits, then housed in the Royal Library at Windsor Castle, was made by the late Mr Ernest Hetherington. In 1970 Miss Frances Dimond took over the work of cataloguing, which expanded rapidly with the addition of further material. The Photograph Collection thus created became in 1974 a distinct section of the Royal Archives. Miss Dimond has been its Curator since 1977. She is responsible for part of this book and for selecting the images for the exhibition.

Miss Dimond's co-author is Mr Roger Taylor, the photographic historian. He is Curator of the Kodak Museum at the National Museum of Photography, Film and Television at Bradford, and has undertaken extensive research in the Photograph Collection and the Royal Archives.

Oliver Everett
Librarian and Assistant Keeper, Royal Archives, Windsor Castle

Frances Dimond

Preface

The collection of historical photographs at Windsor Castle has existed as a separate archive within the main Royal Archives since 1974, and this catalogue, with the associated exhibition, will provide the first major opportunity for a selection from its contents to be shown to the public. The subjects have been chosen from the earlier part of the collection, which contains about 25,000 photographs, and the resulting group of images, dating from 1842 to 1910, is intended to represent the many different aspects of the collection.

The Photograph Collection has a dual purpose: it acts as a picture gallery and is at the same time a record office, as the majority of the photographs are present for historical reasons for which documentary evidence can be found within the Royal Archives or elsewhere. Thus a book of views taken in Germany proves to have been commissioned as a birthday present for the Prince Consort, and a portrait of a musician is enlivened by Queen Victoria's description of her meeting with him. Its main significance, however, is that it is a microcosm of the experiences and interests of one family, being not merely a record of their public life but a repository of many photographs presented to, collected or taken by them. It has come into being because successive generations of the Royal Family have shown an interest in photography, and it has taken its present rich and diverse form not only because, by virtue of their position, the best work being produced has been available to them, but also because the images which they have chosen and preserved reflect the different characters and tastes of each member.

Queen Victoria and Prince Albert encouraged and supported photography from the 1840s: the earliest surviving albums compiled by them show evidence of the Prince's orderly and systematic arrangement, and his choice of images indicates that he regarded the new medium both as an art form and as a means of keeping records. His death in 1861 coincided with the beginning of the development of new techniques, greater popular interest in photography and consequently a growth in the number of photographers. The collection began to change direction: Queen Victoria was less interested in fine art than in people and places. She continued her collection of family portraits and was soon able to obtain photographs of many more distinguished and remarkable people than had previously been possible. At the same time she allowed increasing numbers of portraits of herself and her family to be sold. She also used photography to perpetuate the memory of Prince Albert: she would be photographed holding his portrait, or seated beside his bust, and would wear jewellery containing his photographic likeness. Albums of pictures of the royal residences were also compiled, many showing the rooms used by the Prince, which remained as he had left them. Military campaigns were recorded, and the Queen's sons and grandsons brought back albums from foreign tours.

By the 1880s further progress in photographic methods put simplified cameras at the disposal of amateurs: many, including members of the Royal Family, began taking their own snapshots. This heralds the second change in the collection: during the years between 1890 and 1910 the Royal Family's own photographs rival in number those by professionals. The best-known royal photographer of this period is Queen Alexandra; the collection includes several of her albums, commemorating her life in this country and visits abroad. Another is her daughter, Princess Victoria, who compiled many albums of her own work. The third change which the collection demonstrates, as though to balance the greater informality made possible by snapshots, is the development of the 'state portrait' photograph, closely related to the traditional painted portraits of kings and queens. This is particularly evident in the photographs of Queen Victoria: in her earlier portraits she is shown almost exclusively as a woman, whose social position is not emphasized, but from the 1880s onwards, she emerges increasingly as Queen and Empress.

Acknowledgements

Frances Dimond and Roger Taylor would like to record their appreciation of the kind and generous help of many people during the preparation of this catalogue.

They gratefully acknowledge the gracious permission of Her Majesty The Queen to reproduce photographs from the Photograph Collection and to publish extracts from papers in the Royal Archives.

Frances Dimond's colleagues, past and present, in the Royal Household have given help and encouragement which is deeply valued. In thanking them all, she and Roger Taylor would particularly like to mention Sir Robin Mackworth-Young, Librarian Emeritus, Miss Jane Langton, former Registrar, Royal Archives, Mr Stanley Finbow, former Senior Photographer, and Mrs Finbow.

Of the many others who have generously spent time and energy on their behalf, the authors are especially grateful to the following:

J. A. Allen
Herbert Appeltshauser
Mark Haworth Booth, Victoria and Albert Museum
Roy Brinton
Gail Buckland
Brian Coe, Royal Photographic Society
Helen Cordell, School of Oriental, African and
 Asian Studies, London University
Mrs Ulla Corkill
Manuel Corte-Real
Alan Davies
Stephen Davies, Penguin Books Ltd
Frances Dunkels, Department of Prints and Draw-
 ings, British Museum
J. C. Everest
Dr A. Fielding
Philippe Garner, Sothebys
Arthur Gill
Anne Harrison, Manx Museum Library
Andrew Hewson
Bill Jay
Paul McAlinden
J. V. G. Mallet, Victoria and Albert Museum
Constance Messenger
Delia Millar
Ann Monaghan
Geoffrey Munn, Wartski
Newcastle upon Tyne Central Library
Terence Pepper, National Portrait Gallery
Gaby Porter, National Museum of Photography,
 Film and Television
Howard Ricketts
Chris Roberts, Kodak Ltd
Pamela Roberts, Royal Photographic Society
Thomas Ryder
South Yorkshire Microsystems Centre, Sheffield
Sara Stevenson, Scottish National Portrait Gallery
Baroness Strange
William Straughan, Kodak Ltd
Sir Peter and Lady Tennant
Dr D. B. Thomas, Science Museum
Nicholas Turner, Department of Prints and Draw-
 ings, British Museum

John Ward, Science Museum
Judith Wardman
C. J. Ware, National Maritime Museum
Mrs Sanders Watney
Avril Williams
The Reverend T. A. McLean Wilson
Stephen Wood, Scottish United Services Museum
A. E. Woodbridge, Household Cavalry Museum
Clare Wright, National Army Museum

Permission to publish extracts from the Hall Caine Papers in the Manx Museum Library is gratefully acknowledged. The photographs on pages 16 and 75 are reproduced by courtesy of the Royal Photographic Society and Kodak Ltd respectively.

Frances Dimond is indebted to all who have given her assistance and advice during the mounting of the exhibition with which this catalogue is associated, especially the following:

Richard Day, Roderick Lane, Megan Gent, David
 Westwood, Michael Warnes and Julian Clare,
 Royal Bindery and Conservation Department
Eva Zielinska-Millar, Senior Photographer, Royal
 Library

Graham Johnson
Paul Williams

She would also like to thank Kodak Ltd for the loan of George Eastman's Warrant of Appointment, and the Kodak Museum at the National Museum of Photography, Film and Television for the loan of Queen Alexandra's camera and exposure meter.

Finally, this work would not have been possible without encouragement at home. Roger Taylor thanks his family for their support and understanding, and Frances Dimond is extremely grateful to her mother for cheerful assistance with mundane but essential aspects of the job.

October 1986

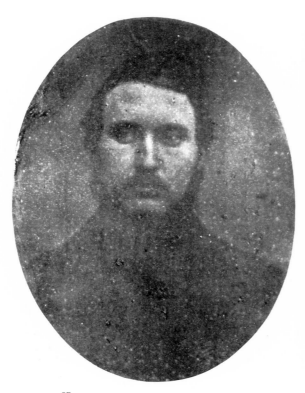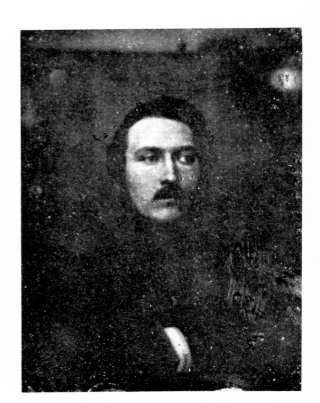

17.
Two portraits of Prince Albert, 1842
Attributed to William Constable

Royal patronage and photography 1839–1901

The early years, 1839–51

The first public announcement of photography in Britain appeared on 26 January 1839 in the Foreign Correspondence column of *The Athenaeum*, which published a vague and somewhat ambiguous description of the new process invented in France by Louis Daguerre. In September of that year an entrepreneurial Frenchman, M. de St Croix, brought examples of the daguerreotype process, along with the necessary apparatus, chemicals and plates, to London, and from early October he regularly demonstrated the process and exhibited his results at the Royal Adelaide Gallery of Practical Science, West Strand.[1]

We do not know when the young Queen Victoria first heard of this novelty, but during these months she was preparing for the visit of a prospective husband, Prince Albert, from Germany. They became engaged on 15 October 1839 (custom required that it was Victoria who should propose to the Prince); they were to marry in the following February.

The Queen felt that she had won the heart of the most handsome of young men, whose eyes were 'those of an angel'[2]; but the adulation with which she regarded Prince Albert was not shared either by her ministers or by her subjects. The general public, being naturally distrustful of foreigners and largely ignorant of Albert's personal qualities, felt that he had won a prize far above his station, a belief supported by his apparent lack of wealth.

The resentment and ill-feeling generated by the proposed marriage became publicly evident when the annuity normally given by the nation to royal consorts was bitterly contested in Parliament and reduced from £50,000 to £30,000. The matter of his title raised other problems, and despite several proposals from the Queen to call her husband King Consort, he was known officially as The Prince Albert until 1857, when she gave him the title of Prince Consort. By then his sense of duty, hard work, and the good examples he set in all walks of life had endeared him to the people.

It had been the Prince's ambition to become a patron of 'artists . . . men of learning and science'. That had been curtailed by the reduction of his annuity, but his influence upon the cultural life of Britain did not rest solely on his munificence.[3] In 1841 he was invited by the Prime Minister, Sir Robert Peel, to lead a Royal Commission selecting works of art to decorate the new Palace of Westminster. The Prince later recalled the debt of gratitude he owed Peel for this initiation into public life, where he was able to become 'intimately acquainted with some of the most distinguished men of the day without reference to politics'.[4]

Following this public demonstration of his interest in the arts, the Prince was invited in 1843 to become President of the Society of Arts. By encouraging it to consider the relationship of science and the arts within an industrial context, he restored the moribund society to its former importance.

Under his guidance it played an important role in the commercial growth of Britain by bringing together aesthetic taste and technological developments in the creation of new consumer goods for the rapidly expanding world market. This ideal was to have profound implications for the future of photography. The first large-scale exhibition of photographs to be seen in Britain, with nearly 800 prints, was mounted at the society's rooms in The Adelphi, London, during December 1852.

There is little tangible evidence to suggest that the Queen and Prince Albert had more than a passing interest in photography before that date. Certainly if one compares their patronage of photography with that of the more traditional arts throughout the 1840s, it is clear that their regard for it was still unformed. The first recorded instance of their purchasing photographs was in the spring of 1840, when they examined samples of the daguerreotype process that had been imported from the continent by Claudet & Houghton. The royal couple were 'graciously pleased to purchase some specimens . . . and to express their highest admiration for such a wonderful discovery.'[5]

It was almost exactly a year later, on 23 March 1841, that the world's first photographic portrait studio was opened in London by Richard Beard, who had paid Daguerre the appropriate patent fee to operate the process. The studio was so successful that Beard opened eight others, operated under licence, later that year.

William Constable had one such studio in Brighton, and on 7 March 1842, when the Court was in residence at the Pavilion, Prince Albert sat to him. These small and emotive daguerreotype portraits are the first photographs of British royalty and have an iconic quality that transcends their diminutive scale [**17**].

Perhaps encouraged by this experience, Prince Albert visited Richard Beard's principal studio in Parliament Street when he returned to London later that month. On that occasion six portraits were made and in spite of the cloudy weather, which prolonged the exposures, the results were pronounced successful.[6]

Events on the other side of the world soon led to the Queen making practical use of photography. On 29 August 1842 the signing of the Treaty of Nanking between the British and the Chinese brought to an end the hostilities known as the 'Opium Wars' and opened up formal trade relations with the Orient. Under the terms of the treaty the island of Hong Kong was ceded to Britain. As one historian described it, 'the document was a graphic symbol of the might of the British Empire, and its arrival in England in late 1842 was met with great enthusiasm and public attention.'[7]

The Queen's painter of miniatures, Henry Collen, who had recently begun to photograph using the calotype process, was called upon to make a photographic copy of the Chinese portion of the treaty. As it was written entirely in unfamiliar orien-

1. H. and A. Gernsheim, **L. J. M. Daguerre** (Dover reprint, New York, 1968, pp. 144–5).

2. C. Woodham-Smith, **Queen Victoria,** Vol. 1 (1972), p. 137.

3. Sir Theodore Martin, **The Life of His Royal Highness The Prince Consort** (1875–80), Vol. I, p. 60.

4. Prince Albert to Sir Robert Peel, 4 April 1844; Martin, op. cit., Vol. I, p. 122.

5. Advertisement for Claudet & Houghton, **The Athenaeum,** frontis., 18 April 1840.

6. 'Prince Albert's visit to the Photographic Institution', **The Times,** 22 March 1842, p. 5.

7. L. Schaaf, 'Henry Collen and the Treaty of Nanking', **History of Photography,** Vol. 6, No. 4, p. 353.

tal characters, a copy made by hand would have taken days of patient labour; but photography could produce an accurate result in a matter of hours. As well as the official copy, prepared to receive the Queen's signature and the Great Seal of England, Collen was asked to prepare a further print for display at Buckingham Palace.

These three examples, all taken from the first years of photography, show Queen Victoria and Prince Albert forming attitudes towards the potential and application of photography which were to be typical of their future associations with it.

Their purchase of daguerreotypes from Claudet & Houghton reflected their growing interest in new ideas in technology and the arts. In later years this type of patronage was developed more fully by Prince Albert, who regularly made purchases from the leading photographers who exhibited their work in London.

When he made his first visits to photographic studios in both Brighton and London within a month, he not only established the respectability of the new medium but also began to learn at first hand how technology and art had come together to create a new form of visual representation.

The recognition that photography was also a technical tool, capable of accurately reproducing the minutest details of engravings, drawings and text, was to be enthusiastically taken up by Prince Albert when he began to form a study collection of Raphael's work (see pages 46–9). Without photography this collection could not have been created so readily.

It is tempting to speculate how these attitudes came to be formed. William Henry Fox Talbot in his published announcement of *The Art of Photogenic Drawing* (1839) carefully detailed many specific uses for photography. These included portraiture, microscopy, the copying of engravings and the delineation of 'architecture, landscape, and external nature'.[8] Talbot's prophecies about the application of photography laid down the rationale for its future acceptance by the artistic, scientific and commercial world.

His half-sister, Caroline, Lady Mount Edgcumbe, was Lady of the Bedchamber to Queen Victoria, and in this capacity she may well have taken the opportunity to promote Talbot's work. It is known that during 1840 she showed an album of his calotypes to the Queen and Prince Albert, who 'admired the great progress' made. [9] Nothing more tangible appears to have come from this presentation. With such a connection Talbot could perhaps have made greater efforts to promote his work with royalty for the publicity and prestige it would have brought him; but, apart from *Sun Pictures in Scotland*, published in 1845 with twenty-three calotype views pasted in, no examples of his work appear to have been preserved in the Royal Collection.

Equally surprising is the apparent absence of any work by the noted Scottish calotypists Hill and Adamson, whose photography was universally

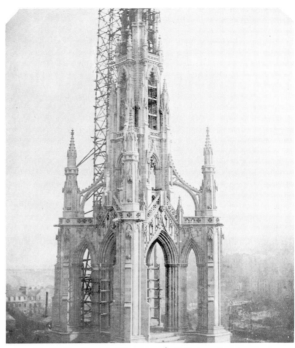

Sir Walter Scott's Monument, Edinburgh, when nearly finished, October 1844. From *Sun Pictures in Scotland* by W. H. Fox Talbot

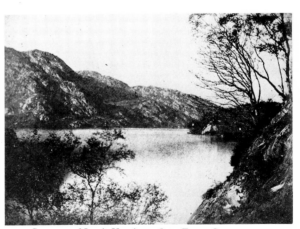

Scenery of Loch Katrine, 1845. From *Sun Pictures in Scotland* by W. H. Fox Talbot

8. **The Athenaeum,** 9 February 1839, pp. 114–17.

9. H. J. P. Arnold, **William Henry Fox Talbot** (1977), p. 126.

10. C. Ford and R. Strong, **An Early Victorian Album** (New York, 1976), p. 33.

admired and readily available – particularly as W. Leighton Leitch, the Queen's Drawing Master from 1839 to 1861, had been photographed by them in Edinburgh. It is hardly credible that in his capacity within the Royal Household he would have failed to refer to their outstanding work and speak of its contribution to art.[10]

The absence of work by these photographers confirms the circumstantial evidence of the archives at Windsor, which suggest that the Queen and Prince Albert had little contact with photography during the 1840s. This early period is uncharacteristically devoid of images by comparison with their extensive use of photography in later decades.

The golden years for photography, 1851–62

Like so much else, the spectacular rise of Britain as the leading industrial nation of the world can be directly traced to the influence of the Great Exhibition of 1851. This was partly due to Prince Albert, who played a significant role in the promotion of the Exhibition. He had urged that it should be international in its scope, arguing that it would be an error to limit it to articles of home manufacture, since a 'peculiar advantage to British Industry might be derived from placing it in fair competition with that of other nations'.[11]

The Royal Commissioners decided to allow photography to be displayed under two of the thirty classes into which the Exhibition was subdivided. This was an important factor because 'never before was so rich a collection of photographic pictures brought together.'[12] The spirit of competition fostered by the Prince did not, on this occasion, show off British photography in a favourable light. In choosing the medal winners, the Jurors noted somewhat ruefully that 'for daguerreotype portraits, America stands prominently forward', and France was 'first in order of merit for calotypes, or sun-pictures'. All they could find to say about British photography was that it possessed 'a distinct character'.[13]

This judgement was not altogether reflected in the distribution of prize medals: eight were awarded to Britain, seven to France, three to America, two to Austria, and one to Germany. But the outstanding excellence of the foreign photographs had caught everyone's attention and dominated the Exhibition.

One reason for this state of affairs was that Britain alone had patent laws governing the commercial use of the daguerreotype and calotype; elsewhere in the world these processes were freely available.[14] It was generally agreed that the patent restrictions had held back the development of both processes in Britain, and it was suggested that, as an alternative to the commercial stimulus found abroad, a photographic society should be formed to promote the free interchange of ideas and technical innovations.

With encouragement and assistance from the Society of Arts, work began on constituting the new photographic society. One major obstacle to its aims was Talbot's restrictive patent, and two members of the Society of Arts sympathetic to the future of photography volunteered to try to persuade him to relinquish his patent. Lord Rosse, representing the interests of science, and Sir Charles Eastlake, representing art, put forward the argument that it was 'desirable that we should not be left behind by the nations of the continent in the improvement and development of a purely British invention.'[15]

Talbot relented, saying that 'ever since the Great Exhibition I have felt that a new era has commenced for photography'. He went on to agree to give up his patent and 'present [his] ... invention to the country, and trust that it may realise our hopes of its future utility'.[16]

The way was now clear, and the Photographic Society of London was formally constituted on 20 January 1853 at a meeting in the rooms of the Society of Arts. Sir Charles Eastlake was elected its first president,[17] and at its June meeting he was able to announce that the Queen and Prince Albert had consented to become Patrons of the Society.

No doubt it was Eastlake's influence that had helped to win such important patrons so early in the Society's life. He had been known to the Queen and the Prince since 1841, when he acted as secretary to the Royal Commission on Fine Arts, and more recently they had supported his election as President of the Royal Academy in 1851.

A founder member of the Photographic Society, and a member of its council, was Dr Ernst Becker, librarian to Prince Albert and an assistant tutor to the young Princes. He had been recommended by Baron Stockmar, the Prince's mentor, and brought over from Germany to Edinburgh to learn English and continue with his scientific studies. He joined the Royal Household in May 1851.[18] His presence on the Photographic Society council ensured that there was an informal, but direct, channel of communication between the Society and Prince Albert. As an enthusiastic amateur, Becker introduced photography to the Royal Family and acted on their behalf to purchase cameras, lenses, chemicals and all the necessary paraphernalia. Under his tutorship the young Prince Alfred became a proficient and talented photographer.

Another influence within the complex pattern of changes taking place at the opening of the decade was the introduction of the collodion process in March 1851 (see pages 57–8). Significantly for the future development of photography, the new process was given freely to the world, unfettered by any patent restrictions. The introduction of collodion transformed the potential of photography because it combined the advantages of both the daguerreotype and calotype, sharpness, detail, tonality and multiple copies, while overcoming all of their disadvantages. It was this new technology which helped to move photography on from its experimental and tentative stages into the period of expansion and proliferation of the later 1850s.

During the early years of the 1850s, a number of factors were combining in a somewhat arbitrary way to bring about changes fundamental to the future of photography. The effect of some of these factors is discernible only with hindsight; very few people involved with photography at the time would have predicted the long-term effects which the introduction of collodion would bring.

But there were photographers who had recognized the pulse of change that had quickened at the Great Exhibition. They knew that, unless prompt and positive action were taken, Britain was in danger of losing her place in the world of photography and would become the recipient, rather than the promoter, of new ideas.

Such a decline was unthinkable, and the foun-

11. H. Hobhouse, **Prince Albert, His Life and Work** (1983), p. 96.

12. **Reports by the Juries** (1852), Class X, p. 243.

13. ibid., p. 244.

14. For full details of why and how Britain came to be singled out in this way, see Gernsheim, **Daguerre,** and Arnold, **Talbot.**

15. 'Registration of the Photographic Patents', **The Art Journal**, 1 August 1852, p. 270.

16. ibid., pp. 270–71.

17. J. Dudley Johnston, F.R.P.S., **The Story of the R.P.S.** (privately printed, 1946), pp. 1–6.

18. For biographical details and a discussion of his photographic work, see H. C. Adam, 'Dr Ernst Becker (1826–1888), Amateurfotograf bei Hof', **Fotogeschichte** (Frankfurt, 1982), Heft 6, p. 3.

ders of the Photographic Society were determined to avert it. By disseminating details of new processes as they became available, they sought to demystify the alchemical secrets of photography. They resolved to find a wider audience through exhibitions and soirées, and through the publication of articles and critical reviews in their journal. They did this in the belief that it would accelerate change and consolidate the status of photography within Britain.

In these aims they modelled themselves closely on the Society of Arts, with which they shared many ideals, particularly about the relationship between art, science and industry. At one point during its inauguration it was even proposed that the Photographic Society became an integral part of the Society of Arts,[19] but this idea was dropped, and the Photographic Society kept its own identity and autonomy.

In the 1850s both the Queen and Prince Albert began to show a far more active enthusiasm for photography. On her visit to the Great Exhibition, the Queen was enchanted by a new optical device, a stereoscope, displayed by the Parisian instrument makers Dubosq-Soleil. The device relied upon having a pair of photographs mounted side by side, which it optically merged into a single, three-dimensional, spatially correct image. The perspectival illusion so created was thought to be magical, and the Queen asked that one be sent to her. Her purchase of this single stereoscope and its accompanying photographs is credited for having established a fashionable following. More importantly it marks the start of a commercial revolution for photography. From that date it can be argued that photographers first began to capitalize upon the full potential of the collodion process to mass-produce millions upon millions of stereo-cards.

Meanwhile Prince Albert was taking his responsibility as Patron of the Photographic Society seriously. It was his belief that

persons in our position of life can never be distinguished artists. It takes the study of a whole life to become that ... our business is not so much to create, as to learn to appreciate and understand the work of others, and we can never do this till we have realised the difficulties to be overcome. Acting upon this principle myself, I have always tried to learn the rudiments of art ... not, of course, with a view of doing anything worth looking at ... but simply to enable me to judge and appreciate the works of others.[20]

Accordingly, the Prince began to collect photographs and to practise photography himself. Initially his print collection appears to have been tentative and limited in its scope. The earliest known album is entitled 'Calotypes Vol II 1850–1854', and its contents, chronologically ordered, illustrate the changing pattern of the Prince's collecting over this period.

The images from 1850 and 1851 are chiefly representations of paintings, engravings, drawings, statuary, medallions and architecture. There are very few photographs 'taken from life'. The latter part of the album, which covers the years 1853–4, is much more lively. It contains portraits by Roger Fenton, ethnographic studies of 'Zulu Kaffirs' by Nicolaas Henneman, panoramas of Florence by E. Kater, and studies of prize livestock by Joseph Cundall.

The Privy Purse accounts, which record the private expenditure of the Queen and Prince Albert, reveal that whereas before 1853 there were virtually no photographic purchases, from that year on there was systematic expenditure, increasing annually.[21]

It was during this period that the Queen and the Prince began to learn about the mysteries of photography and practise what was popularly known as the 'black art', because of the chemical stains that it left behind on the hands and clothing of all its practitioners. They were probably taught by Dr Becker, though it has also been claimed that it was Roger Fenton who had that honour.

Whoever their teacher was, he would have found the first camera owned by the Queen and the Prince something of a curiosity, as it was mounted on the superstructure of the Royal Yacht *Victoria and Albert*, which served as a floating platform for the camera. It had been made in 1853 by W. C. Cox of Devonport to designs by Sir William Snow Harris, who was at pains to point out that the camera was demountable and could be used at 'any place on land which Her Majesty may occupy'.[22]

A more conventional photographic outfit was purchased in 1854 from the instrument makers Ottewill & Morgan of London, who provided their 'Registered double body folding camera with rack adjustment' and sundry accessories.[23] The lens was supplied separately by the optician Andrew Ross. The total cost was the considerable sum of £71 1s. 6d. (£71.08).[24]

At that time a photographer manipulating the collodion process must have a darkroom close at hand in which to sensitize and develop the plates. Mobile darkrooms became the order of the day, as they could be erected wherever the photographer wanted to work (see page 57). In 1854 William Duguid of Westminster was asked to provide the Queen and Prince with 'a portable darkened room for photographic purposes, the exterior covered with green and white Spanish stripe ... and fitted up with Cistern, plug and Basin etc.' It was delivered to Buckingham Palace on 8 April and was followed on 5 May by a 'large folding and portable photographic portrait room fitted with a patent felt carpet'.[25] A further darkroom was made for Windsor Castle and erected in the conservatory on 26 December 1854.[26]

The steady increase in the amount of money expended by the Queen and Prince Albert on purchasing prints, commissioning photographers and using the camera to serve a wide range of needs continued unchecked until about 1860, when the influence of commercial practice began to make itself felt, not just upon photography itself but in the way in which it was now perceived by the Queen

19. J. Dudley Johnston, op. cit., p. 4.

20. Martin, op. cit., Vol. IV, pp. 15–16.

21. During the five months from November 1853 to March 1854, Robertson's views of Constantinople and Baldus's large French studies were bought from the Photographic Institution (R A P P2/4/4035), Clifford's Spanish photographs from G. Hamilton (printseller?; R A P P2/5/4163, R A P P2/5/4242). Fenton's views of the Fleet were bought direct (R A P P2/5/4638), and various unidentified French photographs were bought from the printseller William Spooner (R A P P2/5/4130, R A P P2/5/4304).

22. R A P P2/5/4212, W. C. Cox, bill for making camera and fixing to the top of Round House of the Royal Yacht *Victoria and Albert*, July 1853. Accompanied by a letter from Sir William Snow Harris to Col. Phipps, 16 March 1854.

23. R A P P2/8/5089, Ottewill & Morgan, bill for camera & etc., 22 December 1854.

24. R A P P2/8/5066, Andrew Ross, bill for No. 6 Landscape lens, 9 December 1854.

25. R A P P2/6/4633, William Duguid, bill for portable darkroom and portrait room, June 1854. By implication these were for use at Buckingham Palace.

26. R A P P2/11/5354, William Duguid, bill for portable darkroom, delivered to Windsor Castle, 26 December 1854.

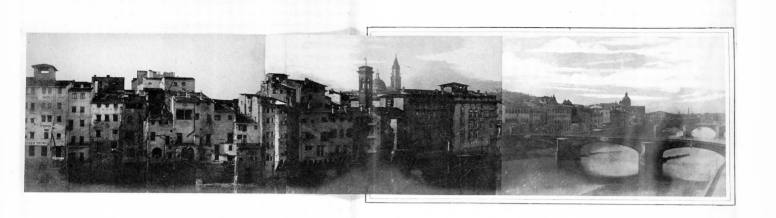

Panoramic view of Florence, 2 September 1850.
By E. Kater

and Prince. By the late 1850s it can be said that photography was entering the third phase of its development, which was to take it from the idealized domains of the Photographic Society firmly into the arena of commercial profit.

Lady Eastlake, writing in 1857, described how the public's attitudes to photography had changed since it was first introduced in 1839. As a member of that public herself she recognized that the early examples she had seen were full of faults and distortions, but she recalled that they were so novel and exciting for her that she had 'examined them with the keenest admiration, and felt that the spirit of Rembrandt had revived'.[27] The photography to which Lady Eastlake had had access during the 1840s was very much the province of her own social class. To practise photography at that time one must be literate, numerate, familiar with the precepts of art and conversant with chemistry and optics. These attributes came only through education and wealth, and the costs of the equipment, chemicals and paraphernalia also put photography beyond the reach of all but the upper classes.

For example, when Fox Talbot, a man of wealth and leisure, ordered for himself a number of cameras of several shapes and sizes from Andrew Ross, the price he paid for just one of the cameras, with its lenses, was equivalent to a year's wages for a domestic servant.[28] And if the cost of making a photograph was daunting, so was the cost of buying one. A visit to a leading London daguerreotype studio in the early 1840s cost the sitter £1 13s. 6d. (£1.68) for a portrait. This was considerably cheaper than the conventional painted miniature portrait, but too expensive for most people.[29]

The changes that began the process of democratizing photography, making it more widely available, were already at work during the late 1840s, and developed rapidly throughout the early 1850s. By 1857, the shift of social emphasis was such that Lady Eastlake could confidently state that

photography has become a household word and household want; is used alike by art and science, by love, business and justice; is found in the most sumptuous saloon, and in the dingiest attic – in the solitude of the Highland cottage, and in the glare of the London gin-palace, in the pocket of the detective, in the cell of the convict, in the folio of the painter and architect, among the papers and patterns of the mill-owner and manufacturer, and on the cold brave breast on the battlefield.[30]

Not surprisingly, this proliferation of the photographic image was matched by an equally dramatic rise in the number of professional photographers. Hardly a city or town was without its 'Photographic Studio'. As competition increased and techniques improved, mass-production methods were introduced to increase efficiency. These factors combined to reduce the costs of photography, which fell in inverse proportion to its rise in popularity.

In 1857 it was just possible for a working-class person to have a portrait made for as little as a shilling (5p). Despite the often dubious quality of these portraits, they were treasured because for most people the experience of having a likeness of oneself was utterly new. Lady Eastlake calculated that, whereas formerly there had been no 'vocation' in photography, there were now 'tens of thousands ... following a new business, practising a new pleasure, speaking a new language, and bound together by a new sympathy.'[30]

An analysis of the Privy Purse accounts for the years 1857 and 1858 reveals much about the place of photography within the Royal Household. These were the years when photographic spending by the Queen and the Prince was at its peak, and the commercial influences had yet to take their full effect.

The announcement that photographs were to be included in the Manchester Art Treasures Exhibition of 1857 (see pages 41–3), on an equal footing with the more traditional fine arts, was greeted with enthusiasm by photographers, who recognized the significance of the gesture: they had expected their work to be displayed with the 'mechanical arts' or as the productions of machines.

Oscar G. Rejlander, an artist turned pho-

27. Elizabeth, Lady Eastlake, writing anonymously, **Quarterly Review**, April 1857, Vol. 101, No. 202, p. 442.

28. Arnold, **Talbot**, p. 123.

29. R. Derek Wood, 'The Daguerreotype in England', **History of Photography**, Vol. 3, No. 4, October 1979, pp. 305–6.

30. Eastlake, op. cit., p. 443.

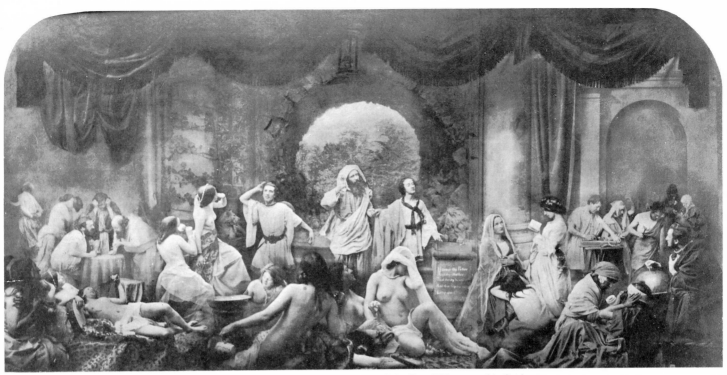

The Two Ways of Life, 1857. By O. G. Rejlander. Reproduced by courtesy of the Royal Photographic Society

tographer, originally from Sweden, but living in Wolverhampton, saw the opportunity to create a work worthy of the event. No doubt he was also encouraged by his earlier successes at the Paris Exposition of 1855 and the Photographic Society exhibition in 1856. For Manchester he conceived an elaborate allegorical study inspired by Raphael's *The School of Athens*.[31] The theme of Raphael's fresco is the contrast between philosophy and science. Rejlander chose a subject much closer to Victorian sentiments, illustrating the contrasts between 'Industry' and 'Dissipation' to show that there are *Two Ways of Life* between which one must choose.

To construct the image (for that is just what Rejlander had in mind), he made some thirty separate negatives of the figure groups and backgrounds according to sketches he had prepared. To create a single image, Rejlander then printed these negatives, one after the other, all marked and arranged so as to fit together like a jigsaw, on to two sheets of photographic paper; unfortunately no manufacturer was able to supply him with paper large enough to contain the $31 \times 16''$ image on a single sheet.[32] Creating such an elaborate and complex photographic montage required a prodigious effort and the skill of an artist to harmonize the several elements during printing. It was a truly innovative feat.

When Prince Albert heard of this undertaking (perhaps through Becker and his contact with the Photographic Society, to which Rejlander had been elected in 1856), he invited Rejlander to come to Buckingham Palace in April 1857 to show him *The Two Ways of Life* before it was sent off to Manchester.[33] The dramatic force of the allegorical tableau with its references to Raphael was not lost on the Prince. Three copies were ordered and sub-

sequently delivered during August 1857, reputedly to be sent to different royal residences to be hung in the Prince's dressing rooms.[34] Unfortunately none of these prints has yet been found.

The aesthetic achievement of *The Two Ways of Life* no doubt confirmed the Prince's earlier opinion that Rejlander fully understood the relationship between art and photography. The previous year he had been sufficiently impressed by the studies exhibited by Rejlander at the Photographic Society to order several copies,[35] and in the course of 1858 he bought further examples of Rejlander's genre studies, composite landscape views and architectural studies taken in the village of Tong, Shropshire.[36] Some of these photographs the Prince sent to his eldest daughter, Victoria, Princess Frederick William of Prussia, then living in Berlin. She was delighted with them, and in her letter thanking her father wrote that she thought Rejlander was 'the best photographer now'.[37]

The Prince, perhaps knowing of Rejlander's close affinity with Raphael, commissioned him, not as a photographer, but as an artist, to copy Raphael's study entitled *Mantua* and then provide photographic copies of the result. This work was intended for the Raphael Collection (see pages 46–9).[38]

In 1869, long after the Prince's death in 1861, the Queen took the unprecedented step of ordering additional and duplicate copies of Rejlander's works. One can only assume that these prints were added to the collection so as to preserve continuity, and at the same time to serve as a memorial to the Prince's admiration for Rejlander.[39]

The annual exhibitions of the Photographic Society provided a regular source of material for the Prince to select works for his collection, and his visit to the Manchester Art Treasures Exhibition, which

31. H. and A. Gernsheim, **The History of Photography** (1969), p. 246.

32. In his article 'On Photographic Composition; with a Description of "Two Ways of Life"', **Journal of the Photographic Society**, 21 April 1858, pp. 191–7, Rejlander discusses his method of printing.

33. **Wolverhampton Chronicle,** 15 April 1857.

34. R A P P2/24/8012, O. G. Rejlander, bill for three '*original* "Two Ways of Life"', 13 August 1857. The emphasis on the word 'original' refers to the several versions that were available through his publisher, Beckingham & Co., Birmingham. Many of these versions were made from copy photographs. See advertisement in **The Athenaeum,** 13 June 1857, p. 742.

35. A. Fielding, 'Rejlander in Wolverhampton', **The Photographic Journal,** May 1985, pp. 226–30. This article gives much new and helpful information.

36. R A P P2/28/8786, P P2/29/9084, P P2/31/9379, O. G. Rejlander, various bills for photographs throughout 1858.

Tong Church, Shropshire, 1858. By O. G. Rejlander

Corridor in Windsor Castle, 1860. By William Lake Price

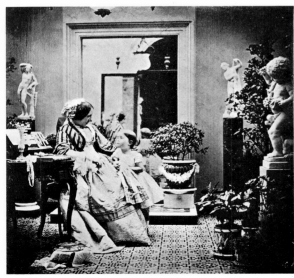

Study from life, *c.* 1854. By William Lake Price

he formally opened in May 1857 and to which he and the Queen had generously lent photographs and other works of art, seems to have been another opportunity for him to make purchases.

The Parisian photographer Gustave Le Gray exhibited at both these venues. His study of *Sea and Sky*, advertised as being 'the finest photograph yet produced', was widely praised by the public and critics. Le Gray's achievement was to have combined in a single photograph a faithful transcription of both sky and foreground, which was normally precluded because the correct exposure for the main subject overexposed the sky, leaving it pure white (see page 35). Le Gray created his effect by artifice, printing from two separate negatives, one for the foreground and one for the sky, to produce a photographic montage that seemed to have been made from a single exposure.[40]

William Lake Price, yet another artist who had turned to photography, chose to exhibit at Manchester several examples of the genre and still-life studies for which he was justly well-known, and a series of portraits of eminent people, including one of Prince Albert, which had been specially taken for the exhibition.[41] Examples of work by both these photographers were subsequently bought by the Prince and added to his collection.[42]

Photographs were occasionally submitted on a speculative basis in the hope that they would receive royal approbation. In cases where the prints were retained, a bill was invariably asked for so that there should be no obligation in the transaction.[43]

A more reliable way of acquiring photographs, and one that gave the collection a sense of direction, was to commission new work from leading photographers. For example, Francis Bedford was sent to Coburg in 1857 to make a series of views to be given by the Queen to her husband (see pages 50–55).

The complete set of sixty photographs no doubt served to remind the Prince of the architecture, landscapes and peasant folk of his homeland and gave him nostalgic pleasure, but the series does not show Bedford at his best. He appears to have been working under difficult conditions. It was widely recognized that the harsh and angular light of June produced poor results in comparison with other seasons when the light was softer and more descriptive. The timing of his visit to Coburg was arranged so that the photographs could be printed and bound for presentation to the Prince on his birthday, 26 August.[44]

The years 1857 and 1858 were domestically eventful for the Queen and the Prince, as they marked the birth of their youngest child, Princess Beatrice, on 14 April 1857, and the marriage of their eldest daughter, the Princess Royal, to Prince Frederick William of Prussia on 25 January 1858.

Following the birth, the Queen and her family went to Osborne, where she could recuperate in the tranquillity of the Isle of Wight. On 23 May Signor Caldesi, of Caldesi & Montecchi, was summoned from London to make a series of photographs of the

37. R A Z1/14, Princess Victoria to the Prince Consort, letter dated 3 April 1858.

38. R A P P2/32/9545, O. G. Rejlander, bill for copying Raphael's *Mantua* at Charlecote Park, December 1858. Rejlander exhibited a photographic copy of his sketch at the Photographic Society 1859, catalogue No. 529.

39. R A P P2/139/15415, O. G. Rejlander, bill for twenty-two prints selected by H.M. The Queen, 19 February 1869.

40. For further details of Le Gray's career and photographic achievements, see **After Daguerre: Masterworks of French Photography, 1848–1900, from the Bibliothèque Nationale** (Metropolitan Museum of Art, New York, 1980–81), catalogue entries 79–84.

41. **Catalogue of the Art Treasures of the United Kingdom** (Manchester, 1857) lists the works exhibited by Lake Price. A review mentioning his portrait of Prince Albert is to be found in **The Liverpool and Manchester Photographic Journal**, 1 July 1857, p. 186.

42. R A P P2/28/8776, Murray & Heath, bill listing purchases of various photographs, including Le Gray, 14 July 1857. Later the same year Lake Price was commissioned to make a series of architectural studies of the interiors at Osborne (R A P P2/32/9491).

43. R A P P2/21/7388, Edwin D. Smith, bill for stereoscopic views previously submitted to the Queen for her approval, 20 February 1857.

44. R A P P2/25/8124, Francis Bedford, bill for photographing and travelling expenses and etc., in Coburg and neighbourhood, 10 October 1857.

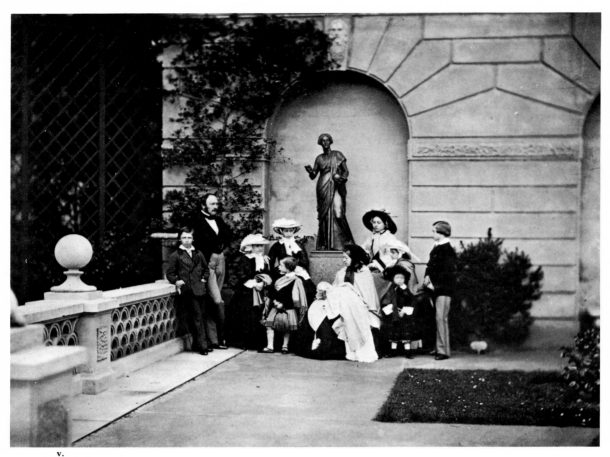

v.
The Royal Family at Osborne, 26 May 1857
By Caldesi

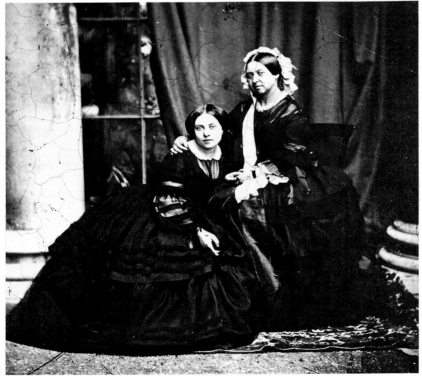

Queen Victoria and the Princess Royal, 25 June
1857. By Caldesi

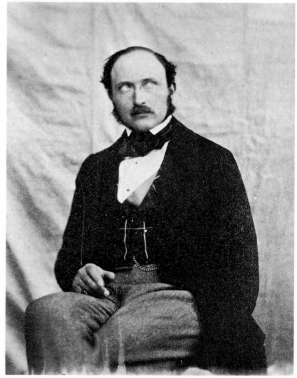

Prince Albert, 1854, with a crumpled sheet as
background. By Roger Fenton

children [v], including one of the infant Beatrice in
the splendid cradle that had originally been made
for the Princess Royal in 1840. Caldesi's account
for these photographs also reveals that in the fol-
lowing month he was several times called to Buck-
ingham Palace to make a further series of portraits.
Some of these were part of the flurry of photo-
graphic activity that preceded the wedding of the
Princess Royal; others were intended as birthday
presents for Prince Albert.[45]

One of these portraits would have held a special
significance for the Prince as it was made in response
to the impending marriage of his eldest daughter,
and shows the Princess Royal at the feet of her
mother, looking directly at the camera with an open
and innocent expression. The Queen has an arm
around her daughter's shoulder and holds her hand
in a comforting gesture. The expression on the
Queen's face, though no less direct, seems to reflect
the sadness and apprehension of losing a daughter.

The portraits that were finally given to the
Prince as a present did not closely resemble photo-
graphs. Both had been worked upon by skilled artists
and transformed into highly coloured images that
were neither a photograph nor a painting, but a
hybrid belonging somewhere between the two
media.

This 'elaborating upon photographic foun-
dations', as it was called by one artist, was extremely
popular with the Queen.[46] It was photography more
in keeping with conventional portraiture, and
allowed for a degree of flattery and idealization.
Perhaps this after-treatment of the image explains
why so many of the studio portraits of members of
the Royal Family taken during the Queen's lifetime
have creased backgrounds, crumpled carpets and a
general air of disorder that is strangely at odds with
the careful composition of the figures.[47] They were
probably intended to be worked upon by an artist.

At first sight, the choice of the daguerreotype
process to record the wedding of the Princess Royal
in 1858 may seem anachronistic, particularly as it
required that all duplicates be re-photographed
from the original rather than printed from negatives.
Its major advantage, however, was the permanence
of its image, which, unlike other processes, did not
fade. The problems of fading prints had been
brought to the Prince's attention in 1855 by the
Photographic Society, which was anxious to dis-
cover the causes. The Prince contributed £50
towards the costs of the research proposed by the
Society.[48] The choice of the daguerreotype for such
an important occasion thus ensured that there would
be a permanent photographic record. T. R. Williams
was chosen, not just for his ability as a portraitist
but for his notable skill in copying daguerreotypes
without any appreciable loss of quality.[49]

The photographs were taken on the wedding
day, 25 January 1858 [20]. In addition to the usual
portrait of the bride and parents, Williams made
studies of the wedding dress and veil, described as
being of 'white moire antique, trimmed with three

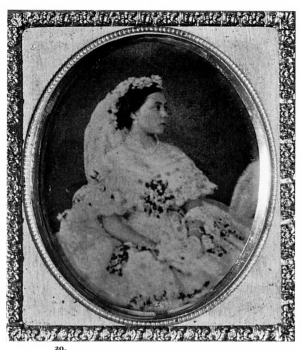

20.
**Victoria, Princess Royal, in her wedding dress,
Buckingham Palace,** 25 January 1858
By T. R. Williams

flounces of Honiton lace and wreaths, and sprays of
orange flowers and myrtle, with veil and wreath to
match'.[50] Of the wedding itself there are, of course,
no photographs: it was impossible to make adequate
exposures in the dimly lit confines of the Chapel
Royal, St James's Palace. But there is a charming
portrait of the bride and groom pausing for a
moment as they walk through the grounds of
Windsor Castle while on their honeymoon there. It
was taken by William Bambridge of Windsor who,
by 1858, was acting in the important capacity of
photographic factotum to the Royal Family at
Windsor.

Bambridge had been working regularly for the
Queen and Prince since 1854, photographing their
pictures, their pets and farm animals, and occasion-
ally taking portraits. Living close to the castle he
was an ideal person to have on hand to undertake
the numerous photographic tasks that arose every
month.

As confidence in his work grew, he gradually
assumed responsibility for the organization, num-
bering and printing of the Queen's negatives. Many
of these Bambridge would have taken himself, but
others were by leading photographers, who, as part
of the arrangements of their commissions, sur-
rendered the negatives they had taken for the Queen
so that she might have total control over their use.[51]

Even though the majority of these private nega-
tives were family portraits, there was the occasional
series on royal residences. Roger Fenton, working
in Scotland during September 1856, made eight
large views of Balmoral Castle and its surround-

45. R A P P2/25/8111,
Caldesi & Montecchi, bill
for travelling expenses to
Osborne, prints and por-
traits made between March
and July 1857.

46. R A P P2/17/6670, E. H.
Corbould, bill for 'elab-
orating upon photographic
foundations', June 1856.

47. Apart from those pho-
tographers who employed
their own artists to work
upon and colour images,
there were independent
artists who coloured photo-
graphs and 'miniaturized'
portraits for the Queen.
Among the names that
appear in the accounts are
Miss Bond, W. Corden,
Faija, Henry C. Heath,
J. Horrock, Moira & Haigh,
J. Roberts and W. Roberts.

48. **The Art Journal,** 1 June
1855, p. 194.

49. R A P P2/33/9772, T. R.
Williams, bill for
daguerreotype photo-
graphs, copy negatives,
prints & etc., Xmas 1858.

50. Woodham-Smith, op.
cit., p. 388.

51. The ninety-six bills for
W. Bambridge cover the
period from 1854 to 1869
and reflect the pattern of
photographic usage for
that period. They are the
most complete record for
any one photographer.

ings.[52] Having made an initial set of prints for the Queen, Fenton sent the negatives to Windsor, where they were printed by Bambridge the following year and on subsequent occasions.[53]

Bambridge's work as a photographer and printer reached its peak in 1857; his accounts for the year reveal that the Queen paid the unprecedented sum of £643 3s. 6d. for his services.[54] The bills show in great detail how the majority of these costs arose from the regular print orders that Bambridge executed from the Queen's private negatives. His busiest period was between July and September 1857, when he made nearly 2000 prints.[55]

Thereafter the orders slowly declined and the pattern of Bambridge's work at the Castle gradually altered as others undertook photography that would normally have been his prerogative. It was not that Bambridge's work had declined in quality. Rather, new fashions and ideas in the commercial world of photography meant that his role in the production and dissemination of photographs was no longer central to the Royal Family. In particular it was the introduction of the carte-de-visite portrait to Britain in 1857 that ultimately led to this shift in emphasis.

The carte de visite had been introduced by A. Marion & Co., a French firm of photographic dealers and publishers based in London. The new format was not popular at first and it did not find widespread favour until 1860. Its cheapness made photography available to a larger cross-section of the public than ever before and the comparative ease with which one could buy multiple prints encouraged families to exchange photographs and assemble the visual history of their generation within the pages of a family album. As well as exchanging cartes with each other many families started to collect portraits of royalty, statesmen, clergy, authors, scientists and artists. These began to be published around 1860, and so lucrative was this form of commercial portraiture that photographers found themselves in direct competition to 'capture' eminent people for their carte-de-visite publications.

It was J. E. Mayall who was sanctioned by the Queen to publish the carte portraits he had taken on 10 May 1860.[56] The release of his *Royal Album* in August of the same year helped to establish the fashion for collecting cartes de visite. Being entrusted with such an important commission assured Mayall's pre-eminence as a portraitist and secured his fortune.

Another photographer who found favour with members of the Royal Family was Camille Silvy, whose elegant settings were far superior to Mayall's plaster columns and drapery. Strangely, though, his studio was never visited by the Queen, and as a result his status within fashionable circles was never as high as Mayall's.[57]

The importance of the Queen's decision to allow the carte portraits of herself and Prince Albert to be published cannot be underestimated. The significance of the gesture was not lost upon the public, who immediately understood the importance of being able to own a photograph of the Royal Family, something that was previously denied to them. The experience of owning a photograph of the Queen was distinctly different from owning an engraving or lithograph. A photograph was known to be 'real'; it was not an idealized portrait, but something actual, made in Mayall's studio on 10 May 1860. In one sense the publication of the portraits was a tacit acknowledgement on the part of the Queen that the public could invade her privacy through the agency of photography. The widespread dissemination of the portraits allowed innumerable people to 'see' the Queen and her family for the first time, and thus helped to draw the populace closer to the monarchy.[58]

The Queen herself became an avid collector of carte portraits, which enabled her to satisfy her deep interest in other people. With the aid of her Ladies in Waiting she soon assembled a vast dynastic collection of European royalty, English aristocracy, statesmen, church leaders, and those eminent personalities who accorded with her views and tastes.[59]

To the Queen, photography, by its very nature, commemorated events, people and places. This conception defined her attitude when commissioning or collecting photographs. To her, personalities were invariably associated with events, especially in the theatre, where the persona of the actor and that of the character were fused by the dynamic action of the play to create a powerful impression. In early February 1857, Charles Kean gave a great command performance of *Richard II* in St George's Hall at Windsor Castle. Even though Kean was suffering from a cold and gout and so did not give of his best, the Queen still enjoyed the performance[60] – so much so that she saw the play a further five times at the Princess's Theatre in London during March and June 1857,[61] and she bought six sets of photographs from M. Laroche showing the players in costume adopting poses from *Richard II.*[62] John Mitchell of Bond Street was fortunate in being able to combine his theatrical interests as an impresario and ticket agent to Her Majesty with his publishing activities. This allowed him to provide the Queen not only with her theatrical entertainment but with the photographs of the performers as well.[63]

When Prince Albert visited the seventh Annual Exhibition of the Photographic Society in January 1859, it was widely understood that he regarded 'the productions of photographers with an eye of affection'. His 'intimate knowledge of the various minute details of nearly all the processes' won him the respect of photographers, who felt that he could appreciate the difficulties they had overcome and share in the excitement of their new discoveries. Perhaps more significantly, the Prince's tastes were so well known that it was possible to 'predict where a longer pause than normal would occur as he approached the neighbourhood of any work'.[64]

By consistently demonstrating these qualities to the members of the Photographic Society and

52. R A P P2/22/7526, Roger Fenton, bill for eight negatives taken at Balmoral, September 1856.

53. R A P P2/24/7932, W. Bambridge, bill for printing etc., including four prints from large views of Balmoral, 16 April 1857.

54. R A P P2/22/7515, PP2/24/7932, P P2/25/8110, P P2/26/8457, and P P2/28/8823 (December portion only), W. Bambridge, bills for photography, printing & etc., for 1857.

55. R A P P2/25/8110, W. Bambridge, bill for photography and printing. This gives detailed information for the prints ordered between July and September 1857; these number 1909 in total.

56. R A P P2/71/5146, J. E. Mayall, bill for various cartes 'sanctioned for publication' between 10 May 1860 and 27 March 1863, March 1863. See also **The Athenaeum,** 18 August 1860, p. 260, for a review of the **Royal Album.**

57. R A P P2/55/2598, Camille Silvy, bill for cartes de visite, August 1861.

58. A parallel to this would be the showing on British television of **The Royal Family** in 1969. This was the first time that informal documentary techniques were allowed to be used for the filming of the British monarchy. Its success was largely due to the appeal of seeing the Royal Family in a new light.

59. The Hon. Eleanor Stanley, Lady in Waiting to Queen Victoria, wrote 'I have been writing to all the fine ladies in London for their husband's photographs, for the Queen. I believe the Queen could be bought and sold for a photograph' (24 November 1860; quoted in H. and A. Gernsheim, **The History of Photography,** p. 295).

60. G. Rowell, **Queen Victoria goes to the Theatre** (1978), pp. 49–50.

61. ibid., p. 136.

62. R A P P2/25/8128, P P2/26/8428/7, M. Laroche, bills for photographs of Richard II, October and November 1857.

63. R A P P2/8/5068, P P2/12/5584, J. Mitchell, bills for theatre boxes and large daguerreotypes of Zulu Kaffirs and Bushmen. Xmas 1854. The Kaffirs were then appearing at the

41

St George s Gallery, London: **Illustrated London News,** 28 May 1853, p. 410. It was Mitchell who subsequently sold the photographs by Julia Margaret Cameron to the Queen in 1865 (R A P P2/104/10370).

64. **The Photographic Journal,** 15 January 1859, p. 13. (**The Photographic Journal** became the **British Journal of Photography** in 1860 following complaints from the Photographic Society of London about the plagiarization of their journal's name.)

The Countess of Erroll. 1872

The Earl of Erroll. 1872

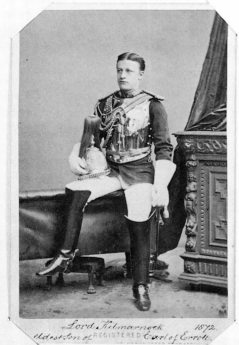

Lord Kilmarnock. 1872.
eldest Son of REGISTERED *Earl of Erroll.*

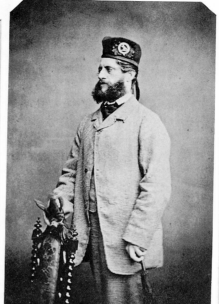

*Lady Cecilia Hay.
Daughter of the Earl of Erroll*

A page from one of Queen Victoria's carte-de-visite albums, 1872, showing the Countess of Erroll, the Earl of Erroll, Lord Kilmarnock, the eldest son of the Earl of Erroll, and Lady Cecilia Hay, daughter of the Earl of Erroll

through his regular purchases of prints the Prince had effectively encouraged a whole body of individuals to achieve greater excellence in their work and greater ingenuity in their chemical manipulations. For them, the incentive to improve arose from the hope that their work might be bought by the Prince for his collection, the highest accolade that any photographer could wish for.

As it transpired, the Prince's role as an energetic force within photography, where his example and patronage had created powerful incentives for photographers, was coming to an end as the decade drew to its close. During his years as Patron of the Photographic Society the medium had matured beyond most people's expectations and had now settled down into being an accepted way of life rather than a cause for which one struggled. This tendency must have been evident for some time, as one critic, reviewing the Photographic Society exhibition for 1861, remarked that all he saw was a repetition of the 'dull level of excellence which has marked the exhibition for several years'. This caused him to speculate as to whether photography had 'arrived at its maximum power'.[65]

When Sir Charles Eastlake had been elected President of the Photographic Society in 1853, he was chosen, according to his wife, 'to give the newly instituted body the support and recognition which art was supposed to owe it'.[66]

But whatever emphasis Eastlake's presidency gave to the society was lost when he resigned two years later. The new President was Sir Frederick Pollock, a lawyer, the Chief Baron of the Court of Exchequer, and, at seventy, set in his ways. Lady Eastlake saw him as representing the very opposite values to those of her husband. During the years of Sir Frederick's presidency the society battled, with growing weariness and lack of success, against the unremitting forces of commercialism that were threatening to undermine its artistic integrity. The 'dull excellence' noted in 1861 was the first warning that something was seriously wrong and was a portent that the annual exhibitions would ultimately be dominated by commercially perfect photographs. In response to this shift in emphasis some members felt obliged to give up photography altogether as a protest at what was happening to the society; others preferred to acquiesce to the new order.

What Prince Albert thought of these changes, as commercial photography became increasingly dominant within the society, is not recorded. With his usual perceptive understanding he had probably recognized already that within photography as a whole a process of transition was under way and that the society would have to reformulate its policies if it were to remain an active force.

Ever since he had first become involved with photography, the Prince had consistently shown that he believed in the pluralistic nature of the medium. On the one hand it was an agency of self-expression by which artists could communicate their ideas, and as such was equal to the more traditional media. On the other, it was a process of mechanical reproduction capable of disseminating information to a large audience. Between these two extremes lay a rich variety of uses and applications, all of which held an interest for the Prince.

What began to emerge, as the 1850s progressed, was a divergence between the interests of the Photographic Society, where men of the arts and sciences believed they could advance the medium for the greater good of the medium, and the interests of the business world, where the laws of capital, manufacture, supply and demand were harnessed to encourage the widespread circulation of photographs to all classes of society. It was a conflict of interests that set art against commerce, idealism against profit.

These divergent interests were perfectly demonstrated at the death of Prince Albert in December 1861. The Photographic Society lost a patron to whom they owed a great debt for his encouragement and example. They also lost that sense of purpose and direction that had characterized their early years. Their influence within the world of photography began a serious decline, and the impact of their annual exhibitions upon the public consciousness started to dwindle.[67]

In contrast, the photographic trade found that the Prince's death created a demand for carte portraits of the Royal Family that was without precedent. It was reported that within one week of his death 'no less than 70,000 of his cartes-de-visite were ordered from . . . Marion & Co.'[68] Nor was this demand limited to Britain; in Paris, one printseller claimed to have sold over 30,000 cartes of the Prince in one day.[69] Public sympathy for the Queen meant that Mayall's portraits of her were being ordered 'by the 100,000'.[70] Because photography was able to respond so rapidly to such demands it enabled the public to share in the Queen's grief. The purchase of a memorial portrait of Prince Albert was, in effect, a small act of public mourning.

The years of widowhood, 1862–1901

It is not hard to imagine the devastating effect that Prince Albert's death had upon the Queen. Her love for her husband and her dependence on him had left her unprepared for this loss. During his illness she had steadfastly refused to believe that he could possibly die, but during the afternoon of 14 December 1861 he relapsed into a critical state, and by early evening the Queen and her elder children knelt in the darkened sick-room waiting for the end to come. The Prince died at 10.50 p.m.

Sir Charles Phipps, Keeper of the Privy Purse, who had been at the Queen's side throughout her ordeal, noted that

The Queen, though in an agony of grief, is perfectly collected, and shows self control that is quite extraordinary. Alas! She has not realised her loss – and, when the full consciousness comes upon her – I tremble – but only for the depth of her grief. What will happen – where can she look for that support and assistance upon which she leaned in the greatest and least questions of her life.

65. **The Art Journal,** 1 February 1861, pp. 46–7.

66. Eastlake, op. cit., p. 444.

67. Evidence for this comes from the Annual Exhibition catalogues for the period and from the critical reviews published in the photographic press. After 1861 there was an increasing tendency for commercial landscapes and portraits to be shown at the exhibitions. See particularly the **Catalogue for the 10th Annual Exhibition,** 1864.

68. M. D. Wynter, M.D., 'Cartes de Visite', **The Photographic News,** 28 February 1862, p. 104.

69. **The Photographic News,** 28 February 1862, p. 108.

70. Wynter, op. cit.

In another note Phipps confirmed this view and added 'she is determined to do Her duty to the Country.'[71]

These sensitive observations draw attention to the dilemma facing the Queen as she approached the most desolate period of her life. She had to choose between giving way to her grief, as was her nature, and the affairs of state which demanded self-control and objectivity. This conflict gives the key to her behaviour in the years following her loss.

There has been constant and harsh criticism of Queen Victoria's apparent morbidity and fascination with death. Evidence for this comes from her obsessive desire to memorialize her husband and from the prolonged period of mourning into which she plunged. But instead of viewing this behaviour as extreme or unnatural it is more helpful to regard her actions as an attempt to reconcile the emotional struggle she was experiencing and to distance herself from the death of her husband.

Photography played a crucial role in her desire to do justice to his memory; as a medium it was perfectly adapted to documenting, recollecting and memorializing. On 16 December Bambridge was summoned to the Castle where he was 'engaged' on unspecified work on behalf of the Queen.[72] It is likely that he had been commissioned to photograph the Prince upon his death bed in the Blue Room.

To the Victorians, this kind of portraiture was not macabre, as it may seem to us today. The casting of death masks and photographing of the deceased was socially acceptable and was practised at all levels of society. Queen Victoria hung a likeness of the Prince, surmounted by a wreath, above the unoccupied portion of her bed. At the foot of her bed at Balmoral Castle stood a small table on which lay a marble sculpture of the Prince's hands modelled directly from casts taken after his death.

Bambridge was kept busy throughout the remaining days of 1861 executing the numerous orders that came to him for photographs of the Prince. It must have been a particularly difficult time for him as the lack of daylight inhibited speedy printing, and as soon as he completed one order another came to hand.[72] This pattern of ordering continued well into 1862 as the demand for memorial portraits increased as time went on.[73]

Interspersed with his work as a printer Bambridge was also commissioned to make studies of those rooms most closely associated with the Prince. His results were forwarded to the Queen, in mourning at Osborne, where no doubt the sight of these quiet interiors served as poignant reminders of her recent ordeal.

These photographs were to serve another purpose. The Queen ordered that the Prince's rooms be kept exactly as they had been during his lifetime. Each day his clothes were to be laid out and fresh water provided in his dressing room. The photographs fixed in perpetuity the precise configuration of each room and served as evidence for future generations.

In keeping with the Queen's wish to pay full tribute to her husband many of the photographs that were delivered from Bambridge and other photographers were then sent on to craftsmen to be elaborately framed, mounted into albums or set into pieces of jewellery.[74]

Garrard & Co., Goldsmiths to the Crown, supplied on New Year's Day 1862 'nine gold lockets for photograph Miniatures with Crown loops and black pearl drops'. These lockets were probably intended for each of the Queen's children.[75]

Another jeweller, Harry Emanuel, used his ingenuity to make four onyx stick pins with fine gold settings. Each was surmounted with the Prince Consort's crown and initial in diamonds, and was designed so that it would open to reveal the Prince's portrait.[76]

The reduction of photographs to such miniature proportions had been introduced a few years earlier by J. B. Dancer of Manchester, who had devised a method of reducing images to the size of a pinhead without any loss of detail when examined under a microscope. It was a small step to adapt this method to producing portraits of an appropriate scale for jewellery. Many such pieces were made for the Queen, including a ring with the linked initials 'V' and 'A' and set with a profile portrait of the Prince attributed to Mayall [**180**].

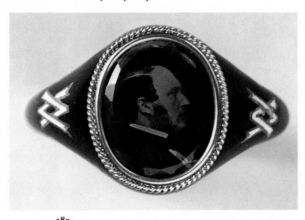

180.
Memorial ring containing a microphotograph of the Prince Consort in 1861, attributed to J. J. E. Mayall, with the cypher linking the initials 'V' and 'A'

In March 1862 the Queen returned to Windsor Castle for the first time since her departure to Osborne. It was a sense of duty to the Prince that drew her back. Within one week of his death she had chosen the site for a mausoleum and by the end of January 1862 had approved the architect's scheme. On 15 March she laid the foundation stone.[77] The Queen used the occasion of her presence at Windsor to commission Bambridge to make a series of memorial portraits in which she and her eldest children pay homage to the Prince. His presence is implied by a photograph which provides a focus for their contemplation. The principal focus

71. Sir Charles Phipps to Lord Palmerston, n.d. (14 December 1861), quoted in Woodham-Smith, op. cit., p. 430.

72. R A P P2/57/2998, W. Bambridge, bill for photographic work, Xmas 1861.

73. R A P P2/60/3477, W. Bambridge, bill for photographic work, including recording the Prince Consort's Rooms, executing print orders etc., March 1862.

74. See Privy Purse accounts of the period for evidence of this work.

75. R A P P2/59/3379, R. & S. Garrard, bill for jewellery etc., April 1862.

76. R A P P2/60/3430, H. Emanuel, bill for jewellery etc., April 1862.

77. See Hobhouse, op. cit., Chapter 10.

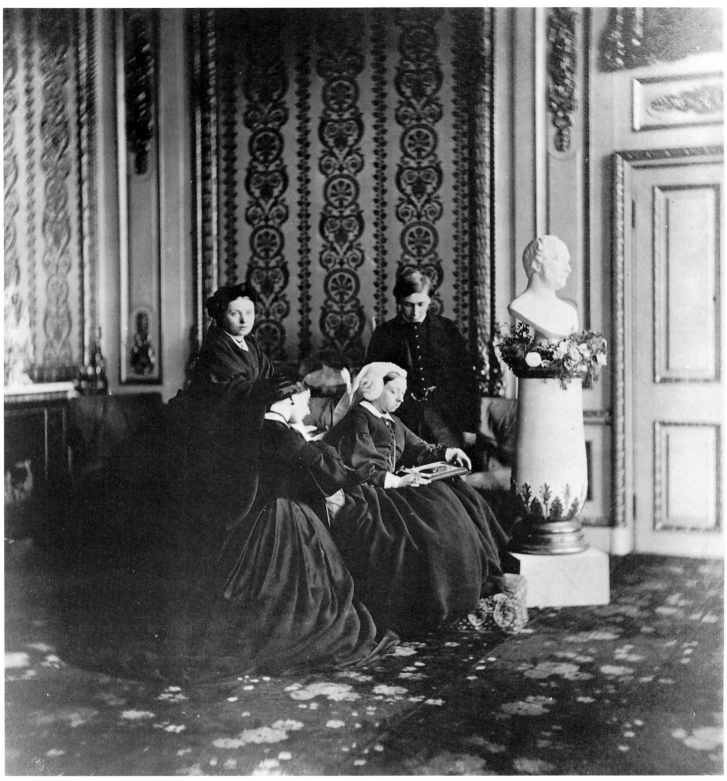

Mourning group, Windsor Castle, March 1862,
with a bust of the Prince Consort. Left to right:
Victoria, Princess Frederick William of Prussia;
Princess Alice; Queen Victoria; Prince Alfred.
By William Bambridge

for the viewer's attention is not the photograph being held by the Queen, but the marble bust of the Prince set to the right of the group, where it gazes serenely towards the light. Beneath this photograph the Queen wrote 'Day turned into night'.

But perhaps the most poignant of these memorial photographs, and there were to be a great many, was taken by Prince Alfred, then barely eighteen years old. His photograph shows the familiar bust of his father. Instead of placing it to one side he chose to keep it central to the composition where it dominates the image. Flanking the statue are the Queen and Princess Alice, both dressed in mourning clothes which contrast sharply with the whiteness of the marble bust. The Queen's gaze is directed towards her husband and has a longing, resigned quality that is in keeping with her view that it would be only a matter of months before she would be at her husband's side. The Princess Alice sits with her arms folded, as if to keep out the chill, and gazes at the camera with a direct expression that immediately captures one's sympathy.

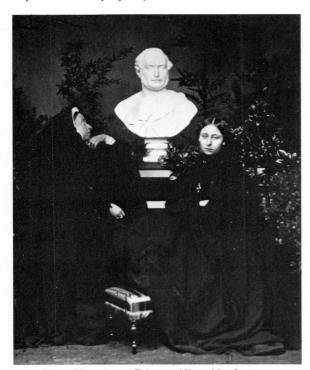

Queen Victoria and Princess Alice with a bust of the Prince Consort, 1862. By Prince Alfred

For a brief period, notably the early months of 1862, photographs continued to be delivered to the Queen from printsellers and photographic dealers. For the most part these were orders that had been put in hand by the Prince before his death and represent the last group of photographs to be purchased as examples of the art. From 1862 onwards, the Queen's use of photography concentrated on her family and on matters of state.[78] The decade of patronage headed by Prince Albert which saw photography gain its place among the fine arts effectively drew to a close in December 1861. The first golden age of British photography had come to an end.

Confirmation of this can be found in the Privy Purse accounts. Instead of the rich variety of photographic activity that characterized 1857, for example, 1867 has an austere look, as most of the photographic accounts are solely concerned with portraiture. Looking through the records, one gets the feeling that members of the Royal Family spent a good percentage of their time either being photographed or exchanging portraits, so numerous are the orders for cartes de visite and cabinet prints. In 1857 the portraits of the Royal Family would have been taken either by Bambridge or another photographer known to the Queen or Prince through their contact with the Photographic Society; in 1867 this work was exclusively in the hands of the leading commercial studios. The precedent established when the Queen and the Prince visited Mayall's studio in 1860 had become standard practice by 1867.[79]

This shift to commercialism meant that photographers were no longer allowed the privilege of informality that formerly had been accorded to them as artists. Photographers were now regarded as tradesmen and as such were subject to the full etiquette of court procedure. This imposed such restrictions on them that it was often impossible to establish the proper rapport so crucial to a successful portrait. It was reported that 'The Queen merely takes her seat, and intimates through her secretary that she wishes to be taken in a certain attitude and the [photographer] has nothing to do but comply with the order.'[80] It is thus hardly surprising that photographs of the Royal Family from this period are so stiff and formal, each sitter adopting a pose appropriate to his or her rank and precedence.

This state of affairs continued well into the 1880s, when the fundamental changes in photographic technology combined with advances in camera design to make it possible for George Eastman to introduce his revolutionary Kodak camera. This handy piece of apparatus liberated photographers from the burden of carrying heavy apparatus and plates, and from the need for messy darkroom work. Instead, a hundred exposures on one roll of film were loaded into the camera by the manufacturer; once exposed, the whole camera was mailed back to the factory, where it was unloaded and the film processed and printed. This attractive invention soon persuaded members of the Royal Family to take up photography again, and before long they were 'snapping' each other with an abandon quite unlike the formality of the studio portraits made for public distribution.

The dichotomy was now complete. The gradual evolution of photography had eventually produced two distinct forms of the art, one private, the other public, each fulfilling its own function. This is a situation of great stability, and it has survived, virtually unchanged, for almost a century.

78. RA PP2/69/4834, PP2/63/4019, G. W. Wilson; RA PP2/65/4387, Murray & Heath; RA PP2/66/4464, W. Lake Price.

79. For evidence of the extent of this, see RA PP2/119/12630 and PP2/125/13461, J. J. Mayall; RA PP2/121/12807, Disderi; RA PP2/116/12153, PP2/123/13104 and PP2/125/13492, Hills & Saunders; RA PP2/123/13113, W. & D. Downey. All date from 1867.

80. A. Wynter, 'Cartes de Visite', **British Journal of Photography,** 12 March 1869, p. 125.

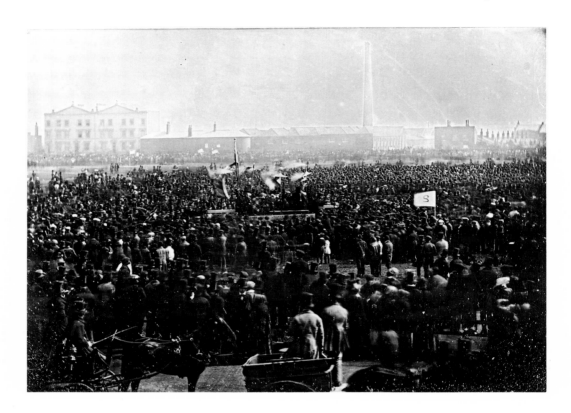

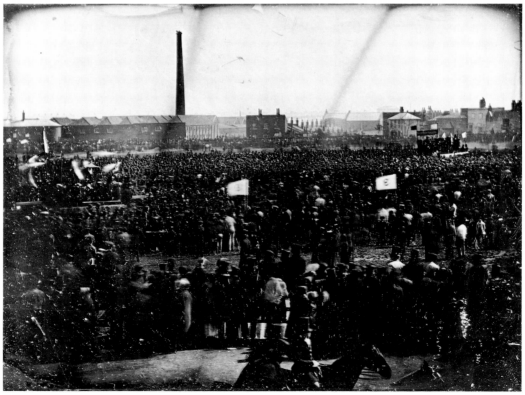

11, 12.
**Two views of the Great Chartist Meeting on Ken-
nington Common,** 10 April 1848
By W. E. Kilburn

The Chartist meeting, 10 April 1848

In the spring of 1848, the news that the Chartists were preparing a huge meeting on Kennington Common in London spread fear throughout the nation. The French monarchy had fallen only weeks before, and it was seriously believed that Chartist agitation would bring revolution and overthrow the monarchy in Britain too.

The movement that caused so much alarm had been born of the failure of the 1832 Reform Act to improve the representation of the working classes in Parliament. It was always something of a paradox, able to agree on the very precise political demands of its People's Charter, but otherwise diffuse, unco-ordinated, plagued by regional differences and weak leadership. An observer noted in 1848 that there were 'steady old Chartists, mere suckling Chartists, physical and moral force Chartists, simple Chartists and Chartists who would join anyone in making a row, whatever the cause. There were Union Chartists, Land Company Chartists, zealous Chartists, democratic Chartists and loyal Chartists.'[1]

But for all its diversity Chartism moved in phase with economic conditions, a barometer of depression and unemployment, and of the sufferings and frustration of the working classes. The final outburst of Chartist activity in 1848 can be traced to 1846, a good year, when the trade surplus encouraged investors to overspeculate, creating an artificially buoyant market. The trade depression of 1847 brought the inevitable collapse of the commercial and money markets, and this wrought havoc in the labour market, casting thousands out of work.

Then the dramatic turn of events in Europe gave the Chartists not only hope and impetus but a model for their struggle to impress a largely unsympathetic and uncaring government. The balance of power established by the peace treaties of 1815 was under severe strain as it became clear that the undemocratic rule of several European monarchs could no longer be tolerated by the mass of their subjects. In September 1847 Prince Albert noted that 'the political horizon grows darker and darker, Italy, Greece, Spain and Portugal are in a state of ferment'.[2] But it was France which saw the first of the revolutionary upheavals that were to change the political structure of Europe: in February 1848 King Louis-Philippe was forced to abdicate and fled the country for the sanctuary of Britain.

The suddenness of his downfall shocked the British government to its foundation; 'no one imagined that the [French] King, defended by an Army of 100,000 men ... was exposed to any personal risk and danger'.[3] It was seen as a portent of what could happen in London. Then news came of unrest in Berlin, Vienna, Rome, Palermo and Naples as the powder-trail of revolution ran through Europe. Monarchies and governments were brought down, to be replaced with republics or constitutional monarchies.

To the Chartists the news that France was free of a government which had cared little for its people and had refused all reforms seemed the dawn of a new era that would bring their own victory. The middle and upper levels of society felt themselves in the gravest danger as Chartism gathered its forces for a confrontation with the government.

Anxieties about the possibility of revolution in Britain were fed by the continental news regularly transmitted by *The Times*, which increased its daily print-run to an unprecedented 54,000 copies.[4] Queen Victoria and Prince Albert received their news about the state of Europe through private government intelligence and from their own numerous relatives directly affected by the upheavals in Europe. The Queen must have felt especially vulnerable, for on 15 March she gave birth to her sixth child, Princess Louise. Two weeks later the growing sense of foreboding overwhelmed her and she confessed in her Journal that 'all this and the uncertainty everywhere, as well as for the future of our children, unarmed me. I quite gave way to my grief; I feel grown 20 years older ... I tremble at the thought of what may possibly await us here'.[5]

In spite of these very human fears, she placed great faith in the loyalty of 'the people at large' and calmly prepared herself for what God might send, fervently hoping that she and Albert would at least be together throughout.

The Chartists, now confident of their strength, announced their intention of holding a meeting on 10 April at Kennington Common in South London. It was to be a national gathering, bringing together Chartists from all over Britain. There would be speeches by their leader, Fergus O'Connor, and others, and then the assembled company, firmly expected to number 200,000, was to march upon Parliament to deliver its 'Monster Petition' with over five million signatures in support of the principles of the Charter.

The government's reaction was to draft an estimated 120,000 special constables and equip them with truncheons and staves. The Duke of Wellington was called upon to organize his last military campaign, the defence of London. In an attempt to defuse the situation, the government banned the march, an action which *The Times* supported as the only way to deal with agitators who 'were openly and ostentatiously arranging the most efficacious and summary means of cutting our throats, blowing our brains out, impaling us on pikes, and establishing themselves on the overthrow of the constitution.'[6] Such was the confidence and determination of the Chartists that they resolved to continue with the meeting as planned.

The Queen took the advice of her Prime Minister, Lord John Russell, to leave London, and on 8 April, unannounced, she went to Osborne in the Isle of Wight. Prince Albert, drawn by his sense of duty to the nation, seriously contemplated coming up from Windsor to London, but his private secretary, Colonel Phipps, at last persuaded him to join the Queen and the Royal Family at Osborne, so as to be on hand should any emergency arise.[7]

Contrary to the belief of some, the Prince felt a

Note on the title: 'Sharpen the sickle' is a quotation from the poem 'Chartism's Last Offensive' by Ernest Jones (1819–69).

1. R A C56/62, cutting from **The Times**, n.d.

2. R A Y148/2, Prince Albert to Baron Stockmar, 11 September 1847, quoted in C. Woodham-Smith, **Queen Victoria** (1972), p. 21.

3. ibid., p. 286.

4. R. Postgate, **Story of a Year, 1848** (1955), p. 100.

5. R A Queen Victoria's Journal: 3 April 1848.
Note on references to Queen Victoria's Journal: Before her death, realizing that her private Journal contained much of historical importance, Queen Victoria instructed her youngest daughter, Princess Beatrice, to edit the volumes and to destroy the originals. The Journal which is now kept in the Royal Archives, and which is extensively quoted in this catalogue, is Princess Beatrice's abbreviated transcript.

6. R A C56/2, cutting from **The Times**, 7 April 1848.

7. R A C56/11, Col. Phipps to Prince Albert, 9 April 1848.

deep sympathy for the plight of the working classes and was frustrated by the political barriers which inhibited him from making these feelings more widely known. There were already instances of his practical philanthropic help. When the grounds of Osborne were being laid out during 1846 he instructed his bailiff to release the men so that they could work on the local harvest and earn extra wages before returning to his employment. One observer felt that this was 'doing good very wisely'.[8] In 1844 the Prince had accepted the presidency of 'The Society for the Improvement of the Condition of the Labouring Classes', and, working with Lord Ashley (later the Earl of Shaftesbury), he took a close and enduring interest in its work.

Despite the government ban on the march, preparations for the defence of London continued. The Duke of Wellington distributed an estimated 10,000 troops throughout the capital and positioned artillery at the most sensitive points; so as not to incite trouble, he decided to keep them all discreetly hidden. It was planned to let the procession pass through central London and over the Thames on its way to Kennington Common. The bridges would then be closed by the police to confine any disturbances south of the river. In case this plan failed, every government building was closed, barricaded and garrisoned by its staff. Palmerston was in command at the Foreign Office. It was also decided to take control of the Electric Telegraph Company 'in order to prevent unfounded reports being sent into the country which might have . . . a mischievous effect in places where the chartist proceedings have been looked to with much expectation.'[9]

On the day of the meeting, Prince Albert, now at Osborne, felt he had to express himself clearly to the Prime Minister and sent him a strongly worded letter condemning the government's attitude towards unemployment and criticizing the way in which men had been laid off from public works. 'Surely this is not the moment for the Tax payers to economise upon the working classes . . . I think the government is bound to do what it can to help . . . [them] over the present moment of distress'. He went on to warn that he would 'be exceedingly mortified if anything like a commotion was to take place.'[10]

At Kennington Common on the morning of the 10th there was an air of anticipation and suppressed excitement as the crowds, not all of them of the Chartist persuasion, began to assemble. At 10.15 the first detachments of Chartists began to converge on Kennington to take up their positions by the numbered flags. Successive bands of men carrying trade banners or Chartist flags gradually began to fill the common and await the main procession, which was making its way down through the city.

The column was headed by a wagon containing the petition, followed by an impressive vehicle, drawn by six horses, carrying O'Connor, his colleagues, and delegates from the regions. Both wagons were boldly decorated with the red, green and white colours of Chartism, flags, tricolours and banners. The sides of the wagons were painted with the slogans 'We are the millions, and claim to live by the fruits of our own industry; Liberty is worth living for, and worth dying for; The voice of the people is the voice of God'.[11]

The procession was greeted at Kennington with great enthusiasm, applause, and much hat waving. Once the wagons had drawn up, a man approached O'Connor and asked him if he would come to the Horn's Tavern to meet Mr Mayne, a Police Commissioner, and discuss the day's procedure. A rumour spread through the crowd that O'Connor had been arrested, but before things turned ugly he reappeared, having been told of the government's determination to hold the bridges and prevent a mass procession to Parliament. Instead it was agreed that O'Connor and a few of his party could deliver the petition themselves by cab.

It has never been clearly understood why O'Connor so readily accepted these proposals. There were suggestions that he was a sick and tired man, already defeated before the meeting; some thought he was frightened by the knowledge that he would be shot if there was any trouble. One factor could well have been the poor turn-out, probably only about one tenth of the expected 200,000. In that case, the thorough preparations of the government, the sheer weight of force they had assembled with the Army and special constables, and the strategic skill shown in keeping the Chartists south of the river, would have been sufficient to convince O'Connor that confrontation would be futile. His speech, though stirring, was not phrased so as to rouse anger and resentment but, instead, was conciliatory in tone and stressed the need for peace and order, emphasizing that, through a respect for authority, the movement would gain for itself a respect that would give strength to its claims.

The government, sufficiently confident of success, felt able to send a telegram to the Queen at two o'clock in the afternoon announcing that 'the meeting at Kennington Common has dispersed quietly – the procession has been given up – the petition will be brought to the House of Commons without any display. No disturbance of any kind has taken place and not a soldier has been seen'.[12] Four hours later another telegram confirmed that all in 'London [was] perfectly quiet . . .'[13]

Within the House of Commons, however, the scene was one of concentrated activity as thirteen law-stationers' clerks toiled for seventeen hours to count the signatures on the petition and check O'Connor's claim that they totalled 5,706,000. This careful scrutiny was designed to test the credibility of the Chartists, and when it was discovered that there were only 1,975,496 signatures (amongst them those of Victoria Rex, The Duke of Wellington, Pug Nose and No Cheese), the government felt able to discredit the whole movement by casting doubt on all its assertions.

As a Member of Parliament for Nottingham,

8. Sir Theodore Martin, **The Life of His Royal Highness The Prince Consort** (1875–80), Vol. I, p. 249n.

9. R A C56/22, Sir George Grey to Prince Albert, 10 April 1848.

10. R A C56/12, Prince Albert to Lord John Russell, 10 April 1848.

11. R A C56/25, cutting from unattributed newspaper, 11 April 1848.

12. R A C56/18, telegram from Sir C. Ogle to Queen Victoria, 10 April 1848.

13. R A C56/20, telegram from Sir C. Ogle to Queen Victoria, 10 April 1848.

O'Connor was present in the House during the debate that followed the government's revelation about the signatures. His inadequate explanation of the discrepancy reveals that he was unprepared for this challenge, and his unconvincing performance brought ridicule and scorn from his fellow members. One of them, Colonel Sibthorpe, an able but eccentric speaker whose name had been falsely added to the petition, was incensed by the outrage to his family name, and pronounced himself sad that everything had gone off so peacefully: otherwise he would have had the opportunity to give O'Connor 'the damnedest hiding mortal man ever received'.[14]

This suggestion was greeted with loud cheers and laughter. Such mocking and jeering at the defeated – a common reaction after a thorough fright – did nothing to remove the source of the threat, the distress, frustration and anger created by continuing poor trade and high unemployment. No matter how successful the government had been in containing the Chartist movement – which indeed never recovered from this disastrous setback – the appalling conditions of the working classes had still to be acted upon.

Prince Albert was anxious that an example should be set by the Royal Family. As President of the Society for the Improvement of the Condition of the Labouring Classes, he indicated that he would like to speak at the society's fourth annual meeting, to be held on 18 May. The suggestion was strongly opposed by the Prime Minister and the Home Secretary, on the grounds that it would provoke trouble, invite abuse, and place the Prince in personal danger from those malcontents among the Chartists who felt that their cause had been subverted by O'Connor and who now wanted retribution.[15]

The Prince was not to be deterred. He felt that it was the appropriate moment for the Royal Family to demonstrate their sympathy and concern for the working classes, and in a reply to the Prime Minister he pointed out that 'we may possess these feelings and still the mass of the people may be ignorant of it because they have never heard it expressed to them or seen any tangible proof of it.'[16]

The Prime Minister reluctantly agreed to the Prince's attendance at the meeting and suggested that he should accompany him. Sensing that Russell's motives were political, the Prince tactfully suggested that he should go alone, 'as it would be more valuable if it preserved the character of a personal step than if it appeared in any way connected with the Government.'[17]

Once it was publicly known that the Prince was to address the meeting, there was an unprecedented rush for tickets, and on the day the hall was besieged by people hoping to find a place. In his speech the Prince alluded to the personal sympathies of the Royal Family and called upon those who 'under the blessing of Divine Providence enjoy station, wealth, and education' to use these advantages to assist the working classes. This was not to be achieved by 'dictatorial interference with labour and employ-

ment, which frightens away capital, which destroys that liberty of thought and independence of action which must be left to every man if he is to work out his own happiness.'[18]

The Prince's views were readily acknowledged to be 'a true exposition of the Condition of England'. That a member of the Royal Family should express so clear an opinion on the state of the working classes was 'of itself . . . an admission that their condition requires improvement'.[19] By taking this public stand, the Prince confounded the commonly held belief that 'the intellect and affections of Royalty are apt to be straitened and chilled by the narrow sphere of its employments, its friendships and its experience'.[20]

Thus the great Chartist meeting may be said to have inspired the British monarchy to come out from behind the cloak of court procedure and make an open commitment to philanthropy. When Prince Albert acquired Kilburn's daguerreotypes of the meeting [11–12], he was recording within the Royal Collection not just a time of personal danger for his family but a critical moment in constitutional history.

14. R A C56/20, unattributed newspaper report on debate in the House of Commons, 13 April 1848.

15. R A C56/48–69, correspondence relating to Prince Albert's wish to address the Society and the government's opposition to it.

16. R A C56/56, Prince Albert to Lord John Russell, 29 April 1848.

17. R A C56/65, Prince Albert to Lord John Russell, 17 May 1848.

18. R A C56/67, unattributed newspaper report on the meeting of the Society for the Improvement of the Condition of the Labouring Classes, 18 May 1848.

19. R A C56/70, cutting from **Morning Chronicle**, n.d. (19 May 1848).

20. R A C56/69, cutting from **The Times**, n.d. (19 May 1848).

iv.
**The Queen, the Prince and eight Royal Children
in Buckingham Palace Garden,** 22 May 1854
By Roger Fenton

Photography and truth

The British public, hearing that a wonderful new discovery had been announced in Paris, scanned their newspapers and journals for confirmation that M. Daguerre's invention was not just a 'marvel of a fairy tale or delusion of necromancy' but was in fact 'nothing less than making light produce permanent pictures and engrave them at the same time, in the course of a few minutes.'[1]

Confirmation came from the respected Scottish scientist Sir John Robison, who had inspected the daguerreotypes in Paris in May 1839 and reported his observations in a letter published by *The Athenaeum*:

> It was manifest at once, that Mr Daguerre's method of producing pictures was altogether different from anything I had seen or heard of in England – *The pictures were as perfect as it is possible to be without colour* . . . its absence was scarcely felt, as the truth, distinctness, and fidelity of the minutest details were so exquisite, that colour could have added little to the charm felt in contemplating them . . . (on examination by the microscope) the pictures are found to contain – the smallest crack, a withered leaf, or a little dust, which a telescope will only detect on a distant building.[2]

This astonishment at the resolving power of the daguerreotype was a common reponse, leading typically to an expression of wonder at the way in which science had surpassed the ability of man to convey visual information about the world. Such detail, correctness of perspective and accuracy of delineation suggested the notion that what the daguerreotype offered was 'truth': a reflection of the world, smaller, but perfect in every sense.

In fact, this 'truth' was tempered by the technical limitations of the process to create results that were purely photographic in their interpretation – something that Sir John was quick to note:

> There is one point in which these pictures have a striking dissemblance from nature, viz., the deserted appearance they give to the busiest thoroughfares – nothing which moves onwards leaves a sensible trace behind . . . waving objects make confused images; but . . . living objects, if they remain motionless during the short periods of exposure are given with perfect fidelity.[2]

The relatively insensitive daguerreotype plates of 1839 needed exposures of 15–30 minutes, and the imposition of this time-frame upon the reality of a scene effectively hurried the pedestrians and the traffic to invisibility. Only absolutely static objects were recorded with the detail that the process was capable of.

Here, right at the very moment of its announcement, is the paradox that has bedevilled photography and caused it to be viewed with mistrust and a lack of understanding. On the evidence of its detail the photograph appears to be totally faithful and accurate – which in this sense it is. At the same time, there are characteristics of the process which impose themselves upon the image and undermine its apparent truthfulness. This 'photographicness' is what Sir John Robison was referring to when he wrote of the disappearance of moving objects. We simply do not see the world as a camera does, and one of the constant preoccupations of photographic technology has been to make the camera and film approximate more closely to human vision.

The first priority for daguerreotypists was to reduce the lengthy exposure times to a more practical level, so that the process could be transferred from the world of scientific novelty into the arena of commercial application. Daguerre was sensitive to the criticisms and attempted to shorten his exposure times. In June 1840 he felt sufficiently confident to announce that he was 'on the eve of completing an important improvement in photographic delineation; [and] . . . expects to be able to produce instantaneously . . . accurate pictures of moving objects'.[3]

Unfortunately he was not successful, and exposure times remained inordinately long. But the search for the elusive instantaneous exposure was under way. The term 'instantaneous' was used with a variety of meanings, and until the introduction of camera shutters its interpretation could be entirely subjective.

The major preoccupation of the portraitist was to make the exposure as pleasant as possible for the sitter without jeopardizing the quality of the result. This was not easily achieved, as one sitter remembered: 'I was seated one sultry summer afternoon at about three o'clock, in the full blazing sunshine and after an exposure of about a minute the plate was developed and fixed with hypo. My eyes were made to stare steadily at the light until the tears streamed from them . . .'[4] It was therefore good commercial practice to be able to claim, for example, that your exposures were 'as near as may be termed instantaneous; . . . the time they require generally is only a few seconds'.[5]

For portrait photographers the word 'instantaneous' was equated with spontaneity, and those who wanted to move away from formal poses and severe facial expressions saw short exposures as one way of catching fleeting looks and natural gestures. Sir David Brewster went so far as to envisage a studio where the camera could be entirely hidden, so that informal portraits could be taken surreptitiously and instantaneously. Only in this way could one 'have *absolute truth* in the portrait'.[6]

Roger Fenton made a group portrait of the Royal Family in the grounds of Buckingham Palace on 22 May 1854 [iv], and, with so many small, unrestrained children to photograph, he wisely decided to make the exposure instantaneously. The result approaches a snapshot both in scale and in style, but it really does not succeed as an informal portrait, because the Queen's pose and the gaze of the children suggest a carefully prearranged moment.

The portrait of *A Polish Lady*, 1855, by Dolamore & Bullock [83], conforms more closely to the conventions of the period; what sets it apart is the woman's facial expression, which has a frankness and openness that would have been lost with a prolonged exposure.

The landscape and topographic photographer had problems similar to those of the portraitist. The major difficulty sprang from the annoying breezes and winds which disturbed the foliage and grass. If

Note on the title: 'Pictures of unquestionable fidelity' is a quotation from **The Athenaeum**, 8 June 1839, p. 435.

1. Quoted in R. Rudisill, **Mirror Image** (Albuquerque, New Mexico, 1971), p. 38.

2. **The Athenaeum**, 8 June 1839, p. 435.

3. **The Athenaeum**, 27 June 1840, p. 518.

4. Thomas Sutton, 'Reminiscences of an old Photographer'. **British Journal of Photography**, 30 April 1867, p. 413.

5. 'Photography', **Aberdeen Herald**, 20 August 1842.

6. Sir David Brewster, 'Recent Progress of Photographic Art', **North British Review**, Vol. XXXVI, May 1862, pp. 189–90.

83.
A Polish Lady, 1855
By Dolamore & Bullock

vi.
Thames Street, Windsor, 1856
By Arthur J. Melhuish

trees were to be included as a significant part of the composition, the photographer had to wait until the air was absolutely still before he could make a successful exposure. Blurred areas in a picture were anathema to artistic taste, as well as being a distraction to the eye, which sought stillness and repose in images of landscape. Flowing or moving water created another kind of problem, but here the long exposures smoothed the surface into satin textures which were considered harmonious and were therefore acceptable. The landscape photographer had to be careful to avoid including any distracting elements that might upset the widely held view that nature offered society the opportunity for reflection, meditation, and spiritual regeneration.

The plight of the topographic photographer remained what it was for Daguerre; the long exposures removed all trace of moving traffic and pedestrians from the scene, leaving streets funereally empty. This was the problem faced by Arthur Melhuish in 1856 when he used a large 15 × 12″ camera with the relatively insensitive waxed paper process. This combination produced lengthy exposure times. Thames Street, one of the busiest

thoroughfares of Windsor, must have been alive with traffic and pedestrians, yet Melhuish's photograph [**vi**] presents us with an unnaturally empty scene. Only one cart is recorded for posterity; the rest have exposed themselves into photographic oblivion.

The collodion process was more light-sensitive than waxed paper, though the quality of its results depended very much on the individual photographer, who could modify the chemistry and his manipulations to 'accelerate' the exposure times. The study of *Fleet Street and Ludgate Hill* [**77**] must have required a considerable knowledge and understanding of the collodion process to achieve such a fine result. Evidence suggests that it was taken by William Lake Price,[7] a leading photographer best-known for his portraiture and genre studies. On the publication of his *Manual of Photographic Manipulation* in 1858, a reviewer acknowledged that Price 'not only studies photography as an art, but he has rendered himself familiar with all the physical conditions which are involved in the production of sun pictures, and with the delicate chemical phenomena upon which . . . success depends'.[8] The exposure of the *Fleet Street* view (about an eighth of a second)

7. See R A P P2/33/9664 for the invoice from Lake Price for his photograph *Ludgate Hill*.

8. **The Athenaeum**, 26 June 1858, p. 825.

Fleet Street and Ludgate Hill
Attributed to W. Lake Price

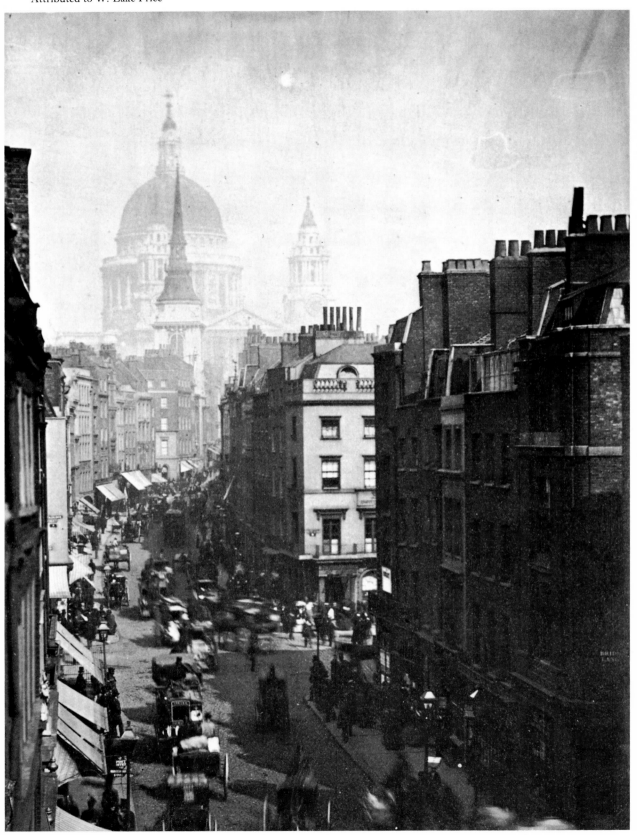

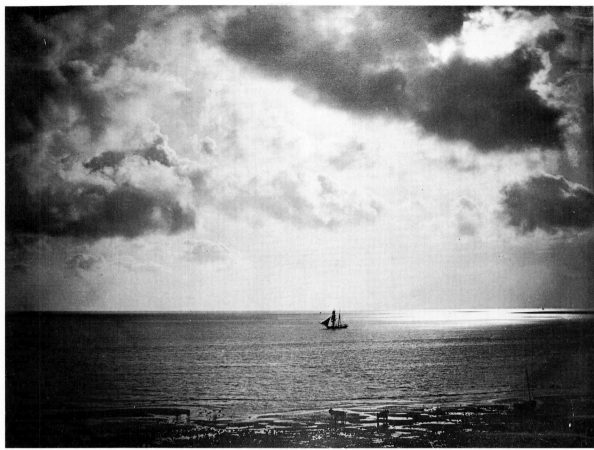

A View of Sea and Sky, 1857. By Gustave Le
Gray. See page 17

was brief enough to arrest the movement of all but
the most active cabs and pedestrians, and here a
little blur adds to the image, suggesting life and
animation. To have achieved this instantaneous
exposure would by itself have been a considerable
achievement for 1858; but Lake Price compounds
the effect by retaining shadow details and a range of
tones through to the silvery highlight of the dome
of St Paul's, which acts as a subtle focal point within
the overall structure of the picture.

Another difficulty that photographers hoped
would be resolved by instantaneous exposures was
the rendering of skies, particularly cloud formations.
The problem lay with the emulsions then in use,
which were sensitive only to the blue end of the
spectrum. This meant that the correct exposure for
the main part of the subject would dramatically over-
expose the sky, burning it out into a blaze of white
in the print.

Aesthetically, these large white patches of sky
offended the viewer by undermining the har-
monious structure of the composition, since the eye
was naturally drawn to the brightest point in the
scene. Gustave Le Gray tried one remedy (see
above); another, less happy, was to paint in the
clouds and introduce tone into the sky areas by a

mixture of artifice and manipulation during print-
ing. The results looked faked, and this method never
really found favour. A better solution lay with the
manipulation of the photographic chemistry to
introduce an instantaneous exposure which, given
the right conditions, would render the desired tonal-
ity and clouds within the sky. The chances of success
were further increased if the foreground included an
expanse of water, to balance out the inequalities of
the exposure through reflection, and if the exposure
could be made just before sunset, when the clouds
begin to gather and the dying rays of the sun add a
tinge of compensating redness to the actinic blue of
the sky.

This search for photographic truth is bound up
with the Victorian belief that through the applica-
tion of science and technology mankind would reach
a higher level of knowledge and understanding.
This ideal was coupled with an ardent faith in truth
itself and its particular value in photography:

> Truth is a divine quality, at the very foundation of every-
> thing that is lovely in earth and heaven; and it is . . . quite
> impossible that this quality can so obviously and largely
> pervade a popular art, without exercising the happiest and
> most important influence, both upon the tastes and the morals
> of the people.[9]

9. Francis Frith, 'The Art of
Photography', **The Art
Journal**, 1 March 1859,
p. 51.

'These noble, brave, patient men':

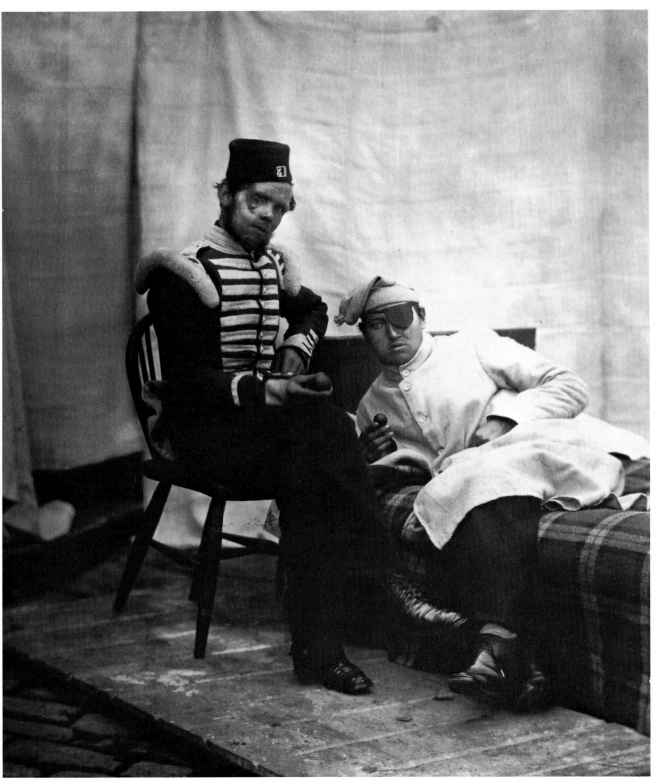

104.
Private Jesse Lockhurst, 31st Regiment, and
Thomas O'Brien, 1st Royals, seen by the Queen
at Chatham
By Cundall & Howlett

Queen Victoria and the Crimean heroes

The Crimean War arose from a dispute in 1853 between the already hostile governments of Turkey and Russia over the control of the rights of access to the holy places in Palestine. The Russian government took advantage of a disturbance in Turkey, in which Russian monks were killed, to justify their invasion of Turkish provinces on both banks of the Lower Danube.

The French government took the side of the Turks, ostensibly in defence of the rights of its own pilgrims to the Holy Land, but in fact for more complex political reasons. The British, who had long been suspicious of Tsar Nicholas's ambitions, joined forces with the French and Turks in defence of their own interests within the Mediterranean. War between Russia and the British and French followed in March 1854.

After forty years of peace the British Army was ill prepared to engage with a numerically superior enemy in a hostile territory three thousand miles from home. The scale of the unreadiness and the prevailing incompetence were summarized in a memorandum by Prince Albert:

No generals trained and practised in the duties of that rank ..., no general staff or staff corps ..., no field commissariat, no field army department, no ambulance corps, no baggage train, no corps of drivers, no corps of artisans, no practice, or possibility of acquiring it, in the use of the three arms, cavalry, infantry, and artillery, no general qualified to handle more than one of these arms, and the artillery kept as distinct from the army as if it were a separate profession.[1]

Little wonder then that the greatest danger to the Army came not from the enemy but from its own lack of structure and organization. An army of 28,000 men under Lord Raglan landed at Varna on 29 May 1854. Immediately the practical difficulties of maintaining that number without adequate preparation and co-ordination became evident. Apart from the hardships caused by poor provisions and lack of equipment, the men suffered from diarrhoea, which was at first put down to the unripe cherries and plums they foraged as a supplement to their rations. The true cause was infected water and insanitary conditions. Within two months, 5677 men had been admitted to hospital with diarrhoea. This was twenty per cent of the Army's strength but probably represented only a fraction of those affected, since many must have remained on duty.[2] Cholera made its first appearance in June; by mid-July an epidemic was raging and at the General Hospital, Varna, the death rate reached eighty-six per cent.

The effect on the morale of the Army was devastating. Throughout the long voyage the men had been building themselves up for battle, and now, without a shot being fired, at least 900 lives had been lost and many more were laid low.

The Battle of the Alma, fought on 20 September, gave the brigade and regimental surgeons their first experience of working under wartime conditions. Everything was in short supply: they used rough planks or doors torn from buildings as operating tables. Fresh casualties were constantly arriving from the front. In all they treated 1600 men in forty-eight hours. Post-operative care was more or less non-existent; there were no beds, only 125 blankets to go round, and no shelter. The only comfort came from the few straw-filled palliasses that were available. On 23 September the whole contingent was put on board 'hospital' ships to be sent to Scutari. But the conditions for receiving them were only marginally better than they had been in the field.[3]

At home the conscience of the nation was stirred by the thundering criticisms of W. H. Russell, correspondent for *The Times*, who described in graphic detail the inhumane conditions which the sick and wounded were having to endure.

Not only are there not sufficient surgeons ... not only are there no dressers and nurses ... there is not even enough linen to make bandages .. there is no preparation for the commonest surgical operations. Not only are the men kept, in some cases for a week, without the hand of a medical man coming near their wounds ... it is found that the commonest appliances of a sick ward are wanting, and that men must die through the medical staff ... having forgotten that old rags are necessary for the dressing of wounds.[4]

It did not take long for the public to realize that the British nation, with the most advanced technology in the world, was allowing its Army to ignore the fundamental well-being of its men. Many of the attitudes prevalent in the Crimean campaign could be traced back to Waterloo. For forty years the Army had remained closed to public scrutiny, and it had failed to adjust itself to the modern sensibility of 1854. The result of these revelations was an outcry against the government, which ultimately brought down Lord Aberdeen's administration in January 1855.

Queen Victoria's attitude, as Head of State and of the Army, in whose name this war was being fought, was characteristically humane. One popular perception of her today is of a cold, unapproachable and formal woman, widowed in mid-life and saddened for ever by that loss. This is the image fostered by the regal photographs and engravings of the Queen in her later years, dressed in black and with an imperious expression that seems to lack compassion.

But this was 1854, and the Queen was a maturing woman of thirty-five, a mother of eight, and intensely interested in people and affairs of the moment. To her, human beings mattered a great deal. The Journal she kept throughout her life reveals that the focus of her attention was invariably upon other people, and her observations show her to have been a fair judge of character and possessed of immense humanity towards others.

By mid-October the Queen knew that 'the sickness amongst the troops, [was] alas! very great, [with] 6000 in Hospital,' but she took comfort from the news that the Duke of Newcastle, Secretary for War, had arranged 'to send out 30 nurses for the Hospitals at Scutari & Varna, under a Miss Nightingale'.[5] In early December she received first-hand reports of conditions at Scutari from Florence Night-

1. Sir Theodore Martin, **The Life of His Royal Highness The Prince Consort** (1875–80), Vol. III, p. 188n.

2. Lt Gen. Sir Neil Cantlie, **A History of the Army Medical Department**, Vol. II (1974), p. 29.

3. ibid., pp. 51–5.

4. ibid., p. 55.

5. R A Queen Victoria's Journal: 18 October 1854.

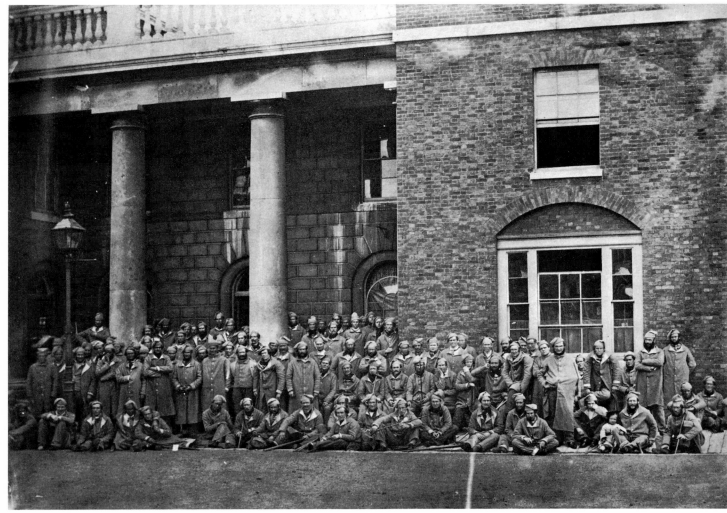

xiii.
Wounded soldiers seen by the Queen at Brompton Barracks, Chatham
Photographer unknown

ingale, whose letters described in unflinching detail the horrors facing her and the nursing staff:

> We have now four miles of beds of not 18 inches apart ... the dysentery cases have died at the rate of one in two ... These poor fellows bear pain of mutilation with an unshrinking heroism that is really superhuman or die or are cut up without a complaint ... I think we have not an average of 3 limbs to a man ... One poor fellow, exhausted with haemorrhage had his leg amputated as a last hope and dies ten minutes after the surgeon has left him. Almost before the breath has left his body it is sewn up in its blanket and carried away and buried the same day – we have no room for corpses in the ward.[6]

The Queen's sympathy for the wounded men was bound up with her admiration for Miss Nightingale, with whom she felt a strong affinity. In her Journal she noted: 'I envy her being able to do so much good and look after the noble heroes whose behaviour is admirable'.[7] As a monarch it was impossible for her to nurse the sick and wounded herself, as it seems she would have wished, but instead she gave moral and practical support to Miss Nightingale by sending her cases of provisions, medical supplies and reading matter, things not normally provided by the Army. In addition, she made money available for the purchase of fresh provisions locally, and she instructed her secretary, Colonel Phipps, to pay immediate attention to any suggestions that Miss Nightingale might propose for the increased comfort of the men.[8]

At a more formal level she wrote to Lord Raglan, Commander of the Army in the Crimea, expressing her distress and concern and laying the responsibility for ensuring better conditions squarely on him:

> The sad privations of the army, the bad weather, and the constant sickness are causes of the deepest concern and anxiety ... The braver her whole troops are, the more patiently and heroically they bear all their trials and sufferings, the more miserable we feel at their long continuance. The Queen trusts that Lord Raglan will be *very* strict in seeing that no

6. R A F1/47, extracts of letter from Miss Nightingale, n.d.

7. R A Queen Victoria's Journal: 8 December 1854.

8. R A F1/66/70/76/77.

unnecessary privations are incurred by any negligence of those whose duty it is to watch over their wants.[9]

When the first batch of wounded men returned from the Crimea in February 1855, a small group of the less disabled were invited by the Queen to Buckingham Palace. The sight of these 'mutilated' men so affected her that the speech of welcome she had prepared 'all stuck in my throat' and she had to excuse herself from giving it for fear of breaking down.[10]

But though such encounters were distressing she set out to meet as many of the wounded as possible, show a personal interest in their recovery, and fight for their better welfare. This brought her thoughts and actions into harmony with Miss Nightingale, whom she admired for her courage and Christian attitudes. If the Queen could not herself be a nurse in the sick wards, she could hope that her concern and support would bring psychological benefits for the morale of the wounded.

After her first visit to the military hospital at Chatham on 3 March 1855, she wrote in her Journal of her desire to 'pay constant visits of this kind to the Hospitals and tend and cheer these noble, brave, patient men!'[11] But visits were not enough; there remained a tension that could be resolved only in terms, and under conditions, that were permissible to a monarch.

Thus, when the contents of a private letter giving her support to Miss Nightingale were published in the British press, the Queen, instead of being alarmed by the breach of confidence, felt 'it may be the means of my *real* sentiments getting known by the Army'.[12] The effect of the Queen's letter upon the men was immediate: 'It has been received with the greatest enthusiasm, many beg for a copy to keep as their greatest treasure, some saying they will learn it by heart'.[12]

This response encouraged the Queen to become more involved with the welfare of the Army, and through 1855 and 1856 she and Prince Albert were closely engaged with the problems that continually arose as the war progressed.

Their frequent visits to Chatham were immediately followed up by detailed reports from the medical staff on the health of the men they had seen. Photographers were commissioned to take portraits of individuals or groups that had been of particular interest. Various new ideas and schemes for helping the men began to form themselves in the Queen's mind.

In a memorandum about one group of men she had visited on 19 June 1855, she told Colonel Phipps that if 'amongst those who *were* or *are* at *Chatham* there are any who from their poverty or suffering she could help by the gift of a wooden leg, or arm, or any such sort of thing, or by getting them into any sort of situation, or in the way of business or employment, she need *not* say how truly happy she should be – the Queen feels she can never do enough for these poor men'.[13] She paid for a significant number of artificial limbs and supports,[14] found

employment for some of the men, and equalized the rate of pay for all, whereas formerly there had been a distinction between those who were sick and those who were wounded.[15] Through acts of this kind, and deliberately seeking to give assistance to all ranks, the Queen overthrew the traditional attitude of the monarch, which had treated the Army as if it were composed only of the officers and gentlemen.

Meanwhile, by assembling volumes of photographs, correspondence, medical reports, statistical evidence and eye-witness accounts embracing all aspects of the war, the Queen had gathered about her the greatest amount of detail and information possible. The most revealing request in her correspondence is for a collection of wild flowers to be picked in the Crimea and sent to her in England. The possession of these flowers linked her directly to the place; they were something tangible from the seat of the war.[16]

The image of Jesse Lockhurst and Thomas O'Brien [**104**] records a similar experience for the Queen. She commissioned it after her visit to Chatham on 16 April 1856, when she met these two gravely injured men and held in her hand the shot extracted from their wounds.[17] The smaller shot weighed $6\frac{3}{4}$ ounces, the larger $18\frac{1}{2}$ ounces (about 190 and 525 grammes respectively), and the shock of their weight must have brought home to the Queen the physical realities of war. If the photograph had been commissioned out of mere curiosity, it might seem an intrusion into privacy. Given the Queen's sensibilities and her conduct throughout the Crimean campaign, the image resounds with her humanity.

9. Martin, op. cit., Vol. III, p. 180.

10. R A Queen Victoria's Journal: 20 and 22 February 1855.

11. R A Queen Victoria's Journal: 3 March 1855.

12. R A Queen Victoria's Journal: 6 January 1855.

13. R A F2/135, Queen Victoria to Col. Phipps, 24 June 1855.

14. R A F3/119/120/131.

15. C. Woodham-Smith, **Florence Nightingale** (1950), p. 196.

16. R A F2/130. The flowers were picked and sent by Lord Rokeby on 20 July 1855.

17. R A Queen Victoria's Journal: 16 April 1856.

The Manchester Exhibition of Art Treasures provided one of the earliest opportunities for photographs to be displayed on equal terms with paintings and other works of art. The suggestion that such an exhibition should be held in Manchester came in 1856 from several influential local merchants and manufacturers. They had been impressed by the Dublin Exhibition of 1853 and the Paris Exposition of 1855, but, believing that England's own art treasures were more numerous and of even greater interest than those of other countries, they proposed a grand scheme of borrowing a selection of these from their owners and bringing them together in an exhibition for the general education and improvement of the public, notably the working classes. Mr J. C. Deane, the Commissioner of the Dublin Exhibition, and Mr Peter Cunningham issued a paper, which they circulated among influential parties, suggesting that Manchester, being densely populated, situated in the middle of the country and possessing railway facilities, would be a suitable place for such an exhibition. The considerable interest this caused resulted in a meeting in the Mayor's parlour on 26 March 1856, where the decision to embark on the project was taken. An appeal for support brought in a guarantee fund of £62,000. One of the subscribers, Mr Thomas Fairbairn, collected estimates from several large contractors for building an exhibition hall. The promoters now felt confident enough to inform Prince Albert (who, with the Queen, had given his patronage to the Dublin Exhibition) of their intention and to seek his support: of this they were assured when he gave them an interview at Buckingham Palace on 7 May.

A General Council was formed to put the plan into execution, and the Lord Lieutenant of Lancashire, Lord Ellesmere, who was also the owner of a number of works of art, was chosen as President. Mr Fairbairn was appointed Chairman of the Executive Committee. One of his duties was to act as liaison officer with the Prince through members of the Royal Household, and by this means he kept the Queen and Prince Albert informed of progress. After a meeting of the Executive Committee in June 1856, during which the treatment and conditions of display of the various works of art were considered, it was decided that he should write to Colonel Phipps suggesting that a promise of contributions from the Royal Collection would have a very beneficial effect in persuading others to lend their property to the exhibition.[1]

Prince Albert, who saw the full possibilities of the exhibition, gave another interview to the committee on 2 July 1856. He showed his warm interest in the project in a long letter written the following day to Lord Ellesmere:

I was very sorry not to see you with the Deputation from Manchester that came to me yesterday upon the subject of the Exhibition of Art Treasures which it is proposed to open in that city in May 1857 – Lord Overstone, however, as well as the other members of the Deputation left nothing to desire in explaining the objects which they had in view. I could not fail to admire the public spirit which has prompted the People

of Manchester to enter upon so large & magnificent an Undertaking.

We had a good deal of discussion upon its general principles, upon the soundness & fitness of which much of its future success must necessarily depend.

Manchester enters upon this undertaking at a certain disadvantage. It has been preceded by the Exhibition of 1851 – that of Dublin in 1853 – & that at Paris during the last year. That a mere repetition of what has thus gone before would fail to attract sufficient notice & public support appears to have been felt by the Committee, & they most wisely gave a distinctive character to their scheme by making it an Exhibition of what may emphatically be called Art-Treasures of this country. How to succeed in collecting such treasures, fondly cherished as they are by their owners, who are justly jealous of their safety, is the problem to be solved.

In my opinion the solution will be found in the satisfactory proof of the *usefulness* of the undertaking. The mere gratification of public curiosity, & the giving an intellectual entertainment to the dense population of a particular locality, would be praiseworthy in itself, but hardly sufficient to convince the owners of works of art that it is their duty, at a certain risk & inconvenience, to send their choicest treasures to Manchester for exhibition. That national usefulness might however be found in the *educational direction* which may be given to the whole scheme. No country invests a larger amount of capital in works of art of all kinds, than England, & in none, almost, is so little done for art education. If the Collection you propose to form were made to illustrate the history of art in a chronological & systematic arrangement, it would speak powerfully to the public mind, & enable, in a practical way, the most uneducated eye to gather the lessons which ages of thought & scientific research have attempted to abstract, & would present to the world, for the first time, a gallery such as no other country could produce, but for which, I feel convinced, the materials exist abundantly in private hands amongst us.

As far as painting is concerned, I enclose a catalogue, exhibiting all the different schools, with the masters who illustrate them, which able hands have compiled for me, & which was communicated to the National Gallery Committee of 1853, & printed by them with the evidence.

If such a catalogue, for instance, were to be filled up with the specimens of the best paintings by the different masters enumerated in it, which exist in this country, I feel certain that the committee would come with very different powers of persuasion, & a very different claim to attention to their owners, than when the demand for the loan of certain of their pictures were apparently dependent upon mere accident or caprice. A person who would not otherwise be inclined to part with a picture would probably shrink from refusing it, if he knew that his doing so tended to mar the realisation of a great national object.

Whatever may be the decision of the committee, I assure you that it will give me the greatest pleasure to give you any feeble assistance or support which I may be enabled to render – and I may at the same time repeat to you the assurance of the Queen's best wishes for the success of your labours.[1]

This encouraging response, which Lord Ellesmere passed on to the committee, was received with delight, and shortly afterwards, on 18 July, some photographs by Delamotte of the exhibition building were sent to the Prince.[1]

Following the Prince's advice, prospective lenders were canvassed for their support. Several had already volunteered loans, showing, as Fairbairn wrote on 12 August to General Grey, Private Secretary to Prince Albert, 'how widespread is the sympathy in the success of this attempted illustration of the notorious art-wealth of our country'.[1] Next, the

1. RA PP Vic. 10026.

Frances Dimond

The Exhibition of Art Treasures of the United Kingdom, 1857

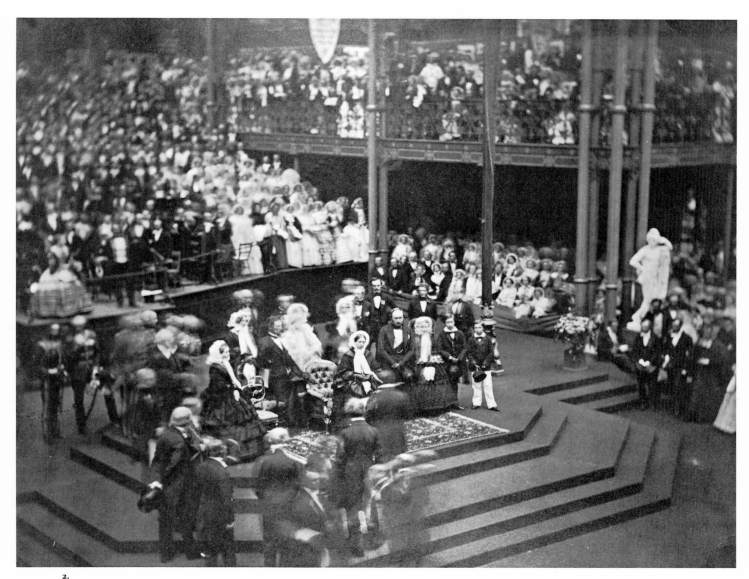

2.
The Queen at the Manchester Exhibition of Art Treasures, June 1857. **The Address**
By Alfred Brothers

Queen and Prince themselves were asked to lend works from their own collections. At the committee's instigation Dr Waagen, Director of the Royal Gallery of Pictures in Berlin, an art historian with an intimate knowledge of the paintings in the Royal Collection, drew up a list of paintings belonging to Prince Albert, from the Byzantine and early Italian and German schools, which it was hoped could be lent. The Prince agreed unreservedly, and when a similar list of works belonging to the Queen was submitted she allowed thirty-eight paintings to be loaned for exhibition, including works by Rubens, Rembrandt and van Dyck. In addition to this, other works of art and many photographs were also lent. This royal support undoubtedly encouraged other owners to lend their property.

Prince Albert was kept informed of progress, and promised to open the exhibition on 5 May in the following year. The royal contributions arrived in Manchester by special train on 4 April 1857. Fairbairn asked Colonel Phipps on 5 April for instructions as to the ceremonial and celebrations to be observed on the opening day. In another letter to General Grey, of 11 April, he mentioned the publication by Messrs Agnew and Colnaghi of a book commemorating the exhibition. The Queen and the Prince had given permission for their contributions to be photographed for this purpose, and it was hoped that the work would be 'one of very rare excellence'. The committee had stipulated that it should be published at a modest price and with a considerable reduction to those who subscribed to

the whole work. Two copies were to be presented by the committee to the Queen and Prince Albert.

However, when Caldesi, one of the photographers employed on the project, started work, it was reported to Colonel Phipps on 21 April that his progress was very slow 'in consequence of the extreme difficulty of taking some of the pictures in the position in which they are placed. The Committee have naturally a nervous dread of moving the pictures into the open air – without the permission of the owners – tho' everybody feels that if that were done – one good negative would at once be obtained – where now there are 4 or 5 indifferent. I therefore venture respectfully to ask whether His Royal Highness the Prince would permit the pictures to be removed to the private space outside the door – by which means Mr Caldesi would then execute negatives which would not require touching.' Phipps replied the same day that 'The Q[ueen] & Prince have no objection with regard to their pictures, if the Committee do not object, care being taken with respect to weather & dust. The Q[ueen] has no power of course to give any permission with respect to other people's pictures.'[1]

Further evidence of the Prince's enthusiasm and commitment to the exhibition was soon forthcoming. All seemed set for the opening on 5 May when a cloud appeared on the horizon. The Queen's aunt, Princess Mary, Duchess of Gloucester, the last surviving child of King George III, became seriously ill and was not expected to survive. The period of mourning that must follow her death would inhibit members of the Royal Family in carrying out engagements, and it was feared that, should she die before 5 May, it would prevent Prince Albert's appearance in Manchester. However, Phipps told Fairbairn on 23 April that the Prince 'would consider his presence at Manchester to be a public duty, to which private considerations must give way'; and on 25 April he wrote that 'The Prince will be very sorry if anything should prevent his keeping his engagement at Manchester of which HRH fully appreciates the importance, & you may depend upon it that he would *stretch a point* to be present'. Phipps added that, in the event of the Duchess's death, it would be as well to have an address of condolence ready, as 'HRH thinks that the presentation of such an address, before the ceremony begins, might give him an opportunity of stating, in his answer, the reasons, suggested by the great importance of the occasion, which might induce him under all circumstances to consider this as a public duty, to which private feelings must give way ... In the event of the poor Duchess's death ... the Prince would of course not attend the concert, but would remain quietly in the evening at the Mayor's house and would merely go through the public ceremonies. The Prince thinks that he should himself declare the exhibition open.'

The Prince was as good as his word. The Duchess of Gloucester died on 30 April, and at Manchester on 5 May her nephew-in-law paid her

a tribute in his address replying to the message of condolence, assuring his hearers that 'If I have thought it my duty to attend here today ... my decision has been rendered easy by the conviction, that could her own opinions and wishes have been known, she would, with that sense of duty and patriotic feeling which so much distinguished her, and the generation to which she belonged, have been anxious that I should not, on her account, or from private feelings, disturb an arrangement intended for the public good.'

With the exhibition open, and proving a success, arrangements for a further royal visit were soon under way: the Queen, with Prince Albert (shortly to be given the title of Prince Consort), their four eldest children and suite, would visit the Exhibition in state on 30 June. Enthusiasm in Manchester was great, but the Town Council was inclined to limit the expenditure on street decorations, feeling that 'the erection of triumphal arches – which were usually anything but triumphs of art ... by a corporate body, afforded no real evidence of popular attachment to Her Majesty.' Many people disagreed with this and decorated the streets at their own expense, providing 'lofty coloured poles' supporting 'garlands of flowers and evergreens which had a really beautiful effect'. Some banners, put up by tradesmen, combined loyalty with business, and after 'V.A.' and 'Welcome' they 'went on to inform the public that the old established concern, &c. was still there, or had moved to over the way, as the case might be.'[2]

2. Press reports.

On 30 June 1857, the Queen and Prince Albert, with their four eldest children, Prince Frederick William of Prussia (who was engaged to the Princess Royal), and their suite, drove to Manchester from Worsley, where they were staying with Lord and Lady Ellesmere. It was a dull, showery day, but as the royal party, escorted by the 4th Dragoons, drove in open carriages through the streets they were greeted, as the Queen later noted in her Journal, by 'most enormous crowds, more than I ever saw before, enthusiastic beyond belief, with such kind & friendly faces ... There must have been $\frac{1}{2}$ a million of people out.' She was delighted to see that the streets were beautifully decorated with 'flowers, flags & draperies, Triumphal Arches & endless kind & appropriate inscriptions', one of which, addressed to 'Albert, the Patron of Art, & Promoter of Peace', especially pleased her.

When the royal party arrived at the exhibition at 11.15 the rain was pouring down, and the open carriages gave no protection. According to a press report, 'As several carriages preceded that containing Her Majesty, the occupants – no matter how distinguished – had to descend with all speed, for the Royal party were waiting in the rain for their turn to draw up. Her Majesty seemed considerably amused at the hurry with which each alighted and hurried on; and the Prince Consort, in a great coat, was doing his utmost to manage a large carriage umbrella and assist Her Majesty to descend.'

Once inside, the royal party proceeded to the platform, and the Queen received three addresses (the first from Mr Fairbairn, the second from the Recorder, and the third from the Mayor and Corporation of Salford), read her answers, and knighted the Mayor of Manchester, Sir James Watts, with 'Sir H. Smith's sword, which had been in 4 general actions.' Unfortunately, as the rain continued to fall heavily on the roof, none of the speeches could be heard. However, the exhibition itself gave the Queen a great deal of pleasure as she inspected 'glorious works of art, beautifully classified & arranged, from the very earliest schools. There were Fiesoles, Francias, Philippe Lippis, Raphaels, Guidos, Albert Dürers, Memlings, Van Eyks, Holbeins, & *such* Rubenses, Van Dycks, Correggios, Velasquezes, Murillos &c.' After luncheon the royal party saw the modern school, 'Sir J. Reynolds, Copley, Gainsborough, Lawrence, Landseer, Leslie, Maclise, Cope, Herbert &c.' When they left, to return to Worsley, it was still raining, but 'all the people [were] out, just the same.'[3]

On the following day, 1 July, the Royal Family returned for a private visit, during which they examined 'all the splendid works of art, in cases, in the nave: specimens of ivory & wood carving, china, glass, enamels, ornaments, & relics of all sorts & kinds, then, the most interesting portraits . . . & upstairs saw the splendid collection of engravings, & drawings, by the Old Masters. Many of our things, & pictures, are in the Exhibition.'[4] The young Prince of Wales noted in his diary for the same day that he had seen 'all the different curiosities & the photographs.' He had a particular reason just then for wanting to see the latter: after an early attempt with a camera on 7 June 1856, when he took a picture of Maharajah Duleep Singh (who took two of him), he had determined to 'learn to photo.', and on 18 June 1857 he ordered himself a 'Photo. Apparatus' from Messrs Horne & Thornthwaite. He had used it on several occasions since 23 June, and some of the portraits taken by him at this time still survive.

During the visit on 1 July the Executive Committee presented the Queen with some of the photographs of the principal art treasures on display, taken by Caldesi and Montecchi for Messrs Agnew and Colnaghi's work. The Queen and the Prince Consort also acquired copies of several photographs on exhibition, including some by Francis Bedford (see page 132). Three copies of Rejlander's *The Two Ways of Life* (see page 16) had been ordered before the exhibition opened.

By 13 September 1857 many thousands of tickets for the exhibition had been issued, but Fairbairn, who was anxious that it should prove to have been self-supporting, knew that greater attendances were still needed to justify it. His hopes were realized, and on 4 October he wrote to Colonel Phipps, with a mixture of triumph and relief, that there had been a remarkable increase since his last letter, 26,000 people having come on one day alone. The undertaking would close 'a self-supporting

work' after all, and he confessed that 'I cannot well explain the mortification I should have felt, if the scheme to which I had devoted all my time and at least an earnest however inefficient attention, [had] been referred to by carping critics as a mistake, as a work which was ill-chosen in time, locality and arrangement. The ground for detraction is now removed, and I sincerely hope as you have said that the seed of much future good has been sown by the Exhibition of Art Treasures and that its memory will awaken many a pleasant thought of it . . . as an undertaking of which a local community may fairly feel a pride.'[5] Fairbairn wrote once more to Phipps on 18 October, the day after the exhibition closed, to acknowledge the great debt owed to the patronage of the Queen and Prince Consort: 'encouraged by their example we have been enabled to bring a novel and perhaps a daring experiment to a triumphant conclusion'.

The exhibition was open for ninety days and had over one and a quarter million visitors, most of them working people from Manchester and neighbouring towns. It was highly successful both financially and aesthetically. More importantly in the present context, it provided one of the earliest opportunities in this country for photographs to be exhibited as 'art treasures' on an equal footing with paintings and other works. Of the 597 prints shown, about a sixth had been lent by the Queen and Prince Albert. Photography's claim to be regarded as art had received royal approval and its status was thereby enhanced. Another result of the exhibition was to bring the new art form to the notice of a great many of Queen Victoria's subjects. Some of the best examples of photography could be seen at Manchester by people who would otherwise have had no chance to do so. The wider interest thus stimulated would encourage the expansion of the photographic market which began in the 1860s and has continued ever since.

3. R A Queen Victoria's Journal: 30 June 1857.

4. ibid.: 1 July 1857.

5. R A P P Vic. 14010.

Work consulted
The Art Treasures Examiner: A Pictorial, Critical and Historical Record of the Art-Treasures Exhibition, at Manchester, in 1857. Published by the Proprietors of the **Manchester Examiner and Times**.

ix.
The Sailor Boy, 1855
By O. G. Rejlander

Prince Albert and the application of photography

Defining his role as a member of the Royal Family to Lady Bloomfield in 1860, Prince Albert stated his belief in the value of learning the rudiments of the various art forms in order to appreciate the masterpieces of others rather than to produce his own. Not only did the Prince seek to learn from the works of masters, but he was also active in promoting the instruction of other people through art. In his opinion the Manchester Exhibition of 1857 was not merely for enjoyment: it would also teach people about their history by showing them works of art which had been produced throughout the ages.

However, although the Prince recognized the importance of history, he was primarily a man of his own time, which, as he was aware, was a 'period of wonderful transition'. In his speech at the Mansion House on 21 March, 1850, heralding the Great Exhibition of 1851, he spoke of his belief that modern inventions were leading to the unity of mankind. Science and art were the guiding factors: science discovered laws which were then applied by industry, and art gave form, according to the laws of beauty and symmetry, to what was produced. In this context, the Prince believed that it was 'the duty of every educated person, closely to watch and study the time in which he lives, and, as far as in him lies, to add his humble mite of individual exertion to further the accomplishment of what he believes Providence to have ordained'. His own time saw a revolution in the development of machinery, and mass employment in factories, and he held that the working people should not regard themselves as slaves, but should be encouraged to take a pride in their work by being taught to understand the principles and ingenuity of the machines among which their lives were spent. Once this understanding had been gained, they should be given the chance of broadening their knowledge still further. This was the principle behind the Prince's plans for the Museums of Science and Art at South Kensington, where the working classes would have an equal chance with the rich to see for themselves what Science and Art had achieved.

It was inevitable that photography, a nineteenth-century development which combined techniques of both science and art, should claim Prince Albert's attention. His attitude to it was broadly twofold: he saw it as an art form (and therefore a potential method of instruction) and also as a recording system which could be used as a means to an end. Given his beliefs and eager intellectual curiosity, it would be surprising if he had not learned to take photographs himself, and indeed photographic materials and equipment were soon to be supplied to Windsor Castle – whether for use by the Prince or by his German librarian, Dr Ernst Becker, who was a keen photographer, is not clear. It is curious, however, that no photographs by Prince Albert or by Queen Victoria appear to have survived, while many by Becker have done so. Whatever the case, the Prince would certainly have learnt the rudiments of photography, and he soon gave further evidence of his support for the new medium when he and the Queen became Patrons of the newly formed Photographic Society (see page 13).

When Prince Albert lent over sixty photographs to the Exhibition of Art Treasures in Manchester in 1857, he showed that he regarded photography in one sense as a branch of art. The prints he loaned were views, photographs of works of art and one portrait, but he was also interested in genre pictures, of which a number, chosen and arranged by him, survive in his 'Calotype' albums.* A photographer he particularly admired was O. G. Rejlander, at least fifteen of whose prints, including fourteen genre studies, were placed in the albums. One, *The Sailor Boy* [**ix**], dated 1855, is the first print he obtained from Rejlander; another is *Longing for Home*, taken in 1857, a study of a sad-looking young man, which may have struck a chord in the Prince's heart. There is evidence that other works by Rejlander were purchased, including his famous picture *The Two Ways of Life* (see pages 15–16), exhibited at Manchester in 1857, which, contrasting a life of dissipation with a life of industry, cannot have failed to appeal to the Prince as offering direct moral instruction.

While appreciating the artistic qualities of photography, Prince Albert fully realized its potential in other directions. The photographs collected by himself and the Queen covered most aspects of their lives, including relatives, Household, acquaintances, journeys and special occasions, as well as current events, such as the Crimean War. Their experiences could be recorded in a tangible form within the covers of photograph albums. In her *Reminiscences*, written soon after her husband's death in December 1861, Queen Victoria remembered the happy times she and Prince Albert had spent with such volumes. They usually dined alone on two days a week, generally including Sundays, and after dinner they would arrange or look at albums of prints, drawings or photographs.

I always kept for those evegs. the placing [of] any new drawings & photographs into the various albums – wh. my beloved Angel always did himself – There were the so called View Albums, 9 in number – filled since the year 40 with views of all the places we visited . . . Then there were the 'Journey Albums', – 6 in number, begun in 42 – into which we placed *all* the prints, woodcuts & photographs we cd. get, of the places we visited, went thro', & events wh. took place – & it was *such* an amusement to collect all these on our journies. I sent for *all* that cd. be got, wherever we went to – & when they arrived *he* selected them, & they were then kept to be sorted – when we got home again, & he (as in everything) showed such wonderful method in sorting & arranging them, 1st putting together each particular subject in a sheet of paper – with the name written outside, cutting them, & then when we had got everything – placing them on *each* sheet with such taste for the man (we employed to paste in) & he wd. often stop my impatience to paste them in – saying 'Hast

*It should be explained that very few of the prints in these albums are genuine calotypes. The majority are albumen prints, or copies made with the carbon process. However, as 'calotype' was apparently used by Queen Victoria in this instance as a generic term for early photographs, the original title of the albums has been retained.

Du denn auch alles? – Wharte bis wir alles haben, – sonst ist alles umsonst'* – for frequently this had happened & was a gt. annoyance for it had either to be inserted or left out. And often my maids mislaid some of the things & they were not put in – It was *such* an amusement – such an interest ... Then there were many other albums ... but the principal ones ... were the small albums of the photographic 'Cartes de Visite' wh. for the last 2 years has been a great amusement; he delighted in them & went on buying constantly fresh ones – & always placed them himself – how he wished they shd. be fixed. There are 14 Vols: *all* differently classed – according to Rank – Nation etc. These he still arranged [in November 1861].[1]

At some time in the 1850s the Prince decided to make further use of photography's potential as a recording instrument. He initiated a survey of the entire collection of pictures in Queen Victoria's possession, which eventually covered works at Windsor Castle, Buckingham Palace, Hampton Court, St James's Palace, Kew, Stud Lodge, Holyroodhouse and Cumberland Lodge. The survey, which was carried out by two Surveyors of the Queen's Pictures, Richard Redgrave and (after 1882) Sir John Charles Robinson, was composed of individual sheets giving a description and a photograph of each picture, with notes on its history and condition. The photographs were taken by Charles Thurston Thompson, William Bambridge, William Johnson and E. Kemp. This work has been described by the present Surveyor, Sir Oliver Millar, as 'a landmark in the history of the collection and Surveyorship'.[2]

During the same decade which saw the beginning of the survey, Prince Albert embarked on another project which was to have even more far-reaching consequences, and which again would make use of photography. One of his greatest pleasures was to visit the Print Room in Windsor Castle, where a magnificent collection of some 15,000 Old Master drawings, as well as engravings and other material, was housed. They had been neglected, and the Prince decided to take action. He began sorting and arranging them, then classified them according to artist and subject. He and the Queen added the work of modern artists, and the Prince began a collection of miniatures to supplement those already in royal possession, including some of his own from Coburg. As Queen Victoria later recalled:

In *this* as in everything else his gt. unselfish mind showed itself – He wd. have nothing kept for himself – but placed *all* in the Royal Collection saying 'I see them here just as often, & I know they are safe & cannot be lost' – whereas if they were carried about in boxes or left in drawers – they were forgotten & might be lost & injured. How true, how wise! *All* for futurity & for the general good – nothing for himself, & he enjoyed it much more if it was for others![3]

The Prince had shown a similar generosity with his possessions in his attitude to the museum at Coburg which he and his brother had started when they were children; for this he was still collecting items, 'with such zeal and delight!'[3] The same wish to work for the benefit of others now suggested to

*Translation: 'Have you really got them all, then? Wait until we have everything, otherwise it will all be no use.'

the Prince a far-sighted and imaginative plan, destined as an aid to future scholars. The material in the Print Room was to be used in providing a systematic history of painting, showing the succession of the schools and periods of art and illustrating the work of each of the great artists. This would be achieved by showing, not only reproductions of the finished works of each Old Master, but also the preparatory drawings, so that a student could see the development from the first inspiration all the way through to the final stage.

One artist who was particularly well represented in the Print Room was Raphael. As he was also indisputably a great and influential painter, he was chosen as the first (and, as it turned out, the only) artist to receive this treatment. An additional advantage was that a biography of Raphael by J. D. Passavant had been published in 1839. This work, the first example of a scientific art historical monograph, included a *catalogue raisonné*.

The Prince was not alone in his wish to make the works of masters accessible to a wider public. The Society for Promoting the Knowledge of Art (also known as the Arundel Society), which had been founded in 1848, was aiming to make available a collection of reproductions of medieval frescoes, exhibiting and publishing them by various modern processes, which were from 1856 onwards to include chromolithography. The methods by which the frescoes were initially reproduced included photography, although this at first proved unsatisfactory, not least because of its obvious disadvantage in providing only monochrome prints. In August 1853, the same year that he embarked on his Raphael project, Prince Albert, with Queen Victoria, paid a subscription to the Arundel Society.[4]

The Prince decided that the collection of engravings after Raphael's works which already existed in the Print Room was to be completed as far as possible. He wanted to obtain the best copies available of every painting correctly ascribed to Raphael. Passavant's book listed all the engravings that had been made, but there were so many of them that it was necessary to make a selection. The first to be chosen were some sixteenth-century engravings, many made during Raphael's lifetime and probably under his own direction. The best of the

1. RA Z491.

2. See *The Later Georgian Pictures in the Collection of Her Majesty The Queen* by Oliver Millar (1969), p. lii.

3. RA Z491.

4. RA PP2/3/3626.

A page from Portfolio 3 of the Raphael Collection, showing (top left) a photograph by Caldesi and Montecchi of *The Agony in the Garden*, painted on wood. This was in the collection of W. Fuller Maitland. The photograph was published by P. & D. Colnaghi & Co. and T. Agnew & Sons in September 1857. The small narrow photograph is of a painting on wood, in the possession of H. Farrer, showing Christ and the Angel alone in a similar position. The large photograph is of a drawing in the Uffizi at Florence, showing the four principal figures in the composition. Both paintings are now in the National Gallery, London, with an ascription to Lo Spagna, a contemporary of Raphael at Perugia

THE AGONY IN THE GARDEN, BY FRANCIA.

more modern copies were added, thus completing the series of all authentic works. But this was only the beginning. When the Prince compared the original Raphael drawings in the Print Room with his series of engravings of the finished works, for which the drawings were studies, he was intrigued by the many discrepancies between the first sketch and the final work. He found it deeply interesting to try to trace the motives for the changes, and thus gain an insight into the artist's mind. The projected collection would be of enormous value if it could show the development of the paintings and explain how the final result had been achieved.

Prince Albert was fascinated by the prospect of such a systematic plan, and gave it his closest attention. It was decided that the best copies after the paintings should be obtained, and that any existing drawings should be placed with the pictures for which they could be identified as studies. This raised a difficulty, as, although many of Raphael's drawings had already been published, the number which had never been reproduced in any form was

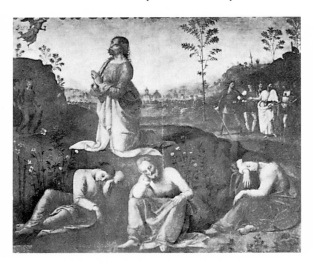

Details from the illustration on page 47

far greater; moreover, the majority of these were in private hands.

This was where photography stepped into the breach. Recognizing the value of the new tool waiting at his disposal, Prince Albert took the lead by having all the Raphael drawings in the Royal Collection photographed. Other owners were then 'induced to follow his example, and frequently the impulse given by His Royal Highness's request for photographic copies, led to the publication of such copies, which thus became a boon to amateurs in general.' When the owner did not give this assistance, the photographs had to be taken at the Prince's own expense and for his collection only. Only one owner refused to allow reproductions of the drawings in his possession to be 'deposited in the Prince's portfolios'. The task of collecting the reproductions was made more difficult because many of the private collections in which Passavant had found Raphael drawings during his travels had been dispersed since the publication of his book, and the fate of each drawing had to be carefully traced through sale catalogues.

The Raphael Collection was not completed until 1876, having been continued by Queen Victoria's wish after Prince Albert's death. Only one copy of the work was produced. This took the form of forty-nine portfolios, in which the reproductions were mounted, either singly or in groups, with triple-line borders on loose sheets of paper. The Collection is now on loan in the Department of Prints and Drawings at the British Museum. A catalogue of the Collection was written by Carl Ruland, who was responsible for the care of the material in the Print Room at Windsor. This was published privately in a limited edition. Ruland, who was perhaps not an impartial judge, described the Raphael Collection as 'a beautiful illustrative memorial of how an artist can be, and ought to be, studied.' This opinion has been endorsed by a more recent authority, which also considers that the scope of Ruland's catalogue 'is so wide and its arrangement so well thought out that it still constitutes the most complete skeleton catalogue of Raphael's entire work – comprising as it does paintings, all the related engravings, and a very high proportion of the surviving drawings.'[5]

It is fair to say that the Raphael Collection would have been far more difficult to achieve had photography not been invented, or had the Prince lacked the foresight to use the best available means of monochrome reproduction (which also included lithography). He was assisted in assembling the photographs first by his German librarian, Dr Becker, and later by Ruland. Three volumes of 'Raphael Correspondence' (now on loan with the Raphael Collection in the British Museum) survive to tell how owners of the artist's works in this country, France, Italy, Spain, Germany, Holland, Belgium, Denmark, Sweden and Russia were persuaded to allow their treasures to be copied. Most were only too delighted to comply.

5. Exhibition catalogue, **Drawings by Raphael**, by J. A. Gere and N. Turner (British Museum, 1983).

The Raphael Collection was arranged according to the Prince's directions by two successive Royal librarians, Bernard Woodward and Sir Richard Holmes. In the earlier stages of preparation, some of C. Thurston Thompson's photographs of Raphael drawings from the Print Room were shown at the Photographic Society's exhibition in 1855. A review of the exhibition in *The Art Journal* noted that 'the application of photographs in this direction is of great importance. In these productions every peculiarity of the artist is preserved with far greater fidelity than could possibly be done by the most skilful engraver; hence, as studies, these photographs are invaluable.'[6] The volume *Drawings by Raffaelle in the Royal Collection* was published in 1857, containing sixty-one photographic illustrations made, 'by command of His Royal Highness Prince Albert', by C. Thurston Thompson. Some of this photographer's Raphael prints were also displayed at the Manchester Art Treasures Exhibition in 1857.

Of the quantities of reproductions in the completed Raphael Collection about two thousand are photographs. Surviving Privy Purse accounts show that, in addition to the work done by Thurston Thompson, numbers of prints were obtained from other photographers. Several in England, including Bambridge (from 1860 to at least 1869), Caldesi (between 1859 and 1867), Cundall (1861), Delamotte (in the late 1850s), Howlett (1858), Frederick Molini (1860), the Photographic Institution (between 1858 and 1867), Rejlander (1858) and the Science and Art Department at South Kensington (1859), as well as a number of photographers abroad, were employed on the project.

Prince Albert took an active interest in the proceedings, and was shown all the photographs. It is clear from the 'Raphael Correspondence' that the photographers' task was far from easy. Among the chief problems were unfavourable weather (they were obliged to rely on daylight), lenses and printing apparatuses which were too small, and the frustrations of trying to get good negatives from ageing and delicate works of art. Joseph Cundall wrote to Becker on 4 August 1858 that 'Mr Howlett wishes me to write you a line to say that he finds it quite impossible to procure a photograph of the Raffaelle in Kensington Palace – He has given four days exposure with a dry plate (portrait lens $2\frac{1}{2}$ inch aperture) with bright sun – but without effect. The painting is so yellow that in a weak light no intensity can possibly be obtained. Mr Howlett has found the best results with wet collodion but they are too bad to be shown.' Further problems abroad included the lack of suitable apparatus for the work, the 'feebleness of the light during the winter months' (in Russia), the unstable political situation (in Italy), and a certain unwillingness to cooperate (in Spain). Not surprisingly, some photographers, probably feeling that they were surrounded by obstacles, refused to be hurried. Robert Bingham, working in Paris, wrote defensively on 11 November 1859 that 'the reason you have not had the Louvre drawings

already, is, that I am taking very great care in the printing and fixing'. The fact that so many photographs are included in the final work appears to be a triumph over many odds.

Among his other sources the Prince obtained about ten reproductions from the Arundel Society and a number of chromolithographs, lithographs and engravings by Ludwig Grüner. This gentleman was Keeper of the Royal Print Room at Dresden, an engraver and art publisher who directed the production of chromolithography by the Berlin firm of Storch & Kramer. He also acted as adviser to the Prince on matters relating to art.

The Raphael project shows Prince Albert, aided by photography, working with the zeal of a pioneer in the service of art history. His attitude towards photography in this instance gives an example of his belief in the virtue of usefulness. As a child he had written to his father that he and his brother were 'striving to become good and useful men',[7] and he followed this precept throughout his life. Photography could be exceptionally useful: not only was it aesthetically pleasing, but even more impressive was its accuracy in recording and its value as an aid to education. By such examples as *The Two Ways of Life* it could even give moral guidance. The Prince may initially have been attracted to photography as a new scientific curiosity, but it was such attributes as these which led him to become its dedicated patron.

6. **The Art Journal**, 1 March 1855.

7. R A Vic. Add. MSS A14/22, 19 July 1830.

Works consulted
The Works of Raphael Santi da Urbino as represented in the Raphael Collection in the Royal Library at Windsor Castle, formed by HRH The Prince Consort, 1853–1861 and completed by Her Majesty Queen Victoria. Introduction by Carl Ruland. Published in 1876.
Julia Margaret Cameron, 1815–1879 by Dr Mike Weaver (Herbert Press, 1984).

45.
View from the Ketschenbrücke, Coburg, 1857
By Francis Bedford

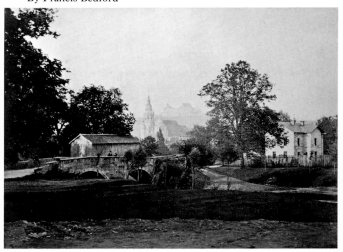

46.
The Terrace at the Rosenau, Coburg, 1857
By Francis Bedford

viii.
Coburg peasants at the Rosenau, 1857
By Francis Bedford

47.
Coburg peasants at the Rosenau, 1857
By Francis Bedford

48.
Duke August of Saxe-Gotha's State Coach, Gotha,
1858
By Francis Bedford

49.
View from the Prince's window, Gotha, 1858
By Francis Bedford

A present from Coburg

For some years before his marriage in 1840 Prince Albert of Saxe-Coburg-Gotha had known that the possibility of a union between him and his English cousin Queen Victoria was being considered by their relatives, and he had dreaded the parting from his home and native land that it would entail. In spite of the early loss of their mother, who left their father, Duke Ernest I of Saxe-Coburg-Gotha, in 1824, when Prince Albert was five, he and his elder brother, Prince Ernest, had spent a happy childhood in the Duke's country residences, the Rosenau, Callenberg, Ketschendorf and Reinhardtsbrunn. Their attachment to their father, their homes and each other was perhaps closer because of the shared misfortune of their mother's departure and subsequent death.

The two princes had a broad general education, in which the usual academic subjects were supplemented by music, drawing and natural history. Prince Ernest and Prince Albert had their own little gardens and particularly enjoyed collecting shells, stones, souvenirs, autographs and other objects, which became the nucleus of the Kunst und Naturalien Cabinet (or Ernest-Albert Museum), later placed in the Festung at Coburg. Prince Albert continued to add to this collection after his marriage: Queen Victoria refers in her Journal for 23 August 1845 to his 'continually making additions', and says that she had helped him. His souvenirs included photographs: on 11 September 1854 he sent to the museum three daguerreotypes of antiquities found in St Domingo by the traveller Sir Robert Schomburgk.[1]

Prince Albert enjoyed his life as a student at Bonn, where he made rapid progress in his studies as well as taking part in musical evenings and amateur dramatics. His contemporaries discovered that he liked discussing law and metaphysics, but also that he had a great sense of humour and a kind heart.

The influence of the Prince's upbringing can be seen in many aspects of his later life. His early experiences became a model for his own children to follow: they too built a miniature fort, as their father and uncle had done, tended their own gardens and started a museum at Osborne, where they kept articles which they had collected or been given. When the Queen and the Prince were looking for a residence in Scotland, he was attracted to the countryside around Balmoral because it reminded him of his native Thüringen forests, and the new castle which was to be built there, and whose design owed much to his influence, was more German than Scottish in appearance. In the same way, elements in the design of the terrace at Osborne bore a strong resemblance to that at the Rosenau.

His family life gave Prince Albert the greatest happiness, but despite this, and the opportunities, which he was quick to grasp, for realizing his plans and ideals in his new country, he was often homesick. He described his feelings in a letter of 24 March 1858 to his recently married eldest daughter as

a painful yearning, which may exist quite independently of, and simultaneously with, complete contentment and complete happiness ... The identity of the individual is, so to speak, interrupted, and a kind of dualism springs up by reason of this, that the *I which has been,* with all its impressions, remembrances, experiences, feelings, which were also those of youth, is attached to a particular spot, with its local and personal associations, and appears to what may be called *the new I* like a vestment of the soul which has been lost, from which nevertheless *the new I* cannot disconnect itself, because its identity is in fact continuous. Hence, the painful struggle, I might almost say, spasm of the soul.[2]

Queen Victoria understood her husband's feelings well, particularly as he had often spoken to her of his home.[3] She had visited Coburg and Gotha with him in the late summer of 1845 and had been charmed by all she had seen. While at the Rosenau she wrote in her Journal on 20 August that she had told the Prince 'how delighted & thankful I was to be able to come here at last. We had *so* wished it & had so feared it might never come off. If I were not who I am, *this* would have been my real home, but I shall always consider it my *2nd* one. Albert is so, so happy to be here with me, – it is like a beautiful dream.' At the end of their stay in Coburg the Prince celebrated his twenty-sixth birthday at the Rosenau on a beautiful summer day. The band played a number of pieces, including *O Isis und Osiris* from Mozart's *The Magic Flute,* and the Prince's presents were displayed on a table wreathed with flowers. In the evening a concert was given, during which one of his own compositions was sung.

The Queen, whose own childhood had often been lonely and restricted, took a particular pleasure in the birthday celebrations which she and Prince Albert arranged for each other and their growing family. On these occasions the children often dressed up, presenting plays or reciting verses, and gave their mother or father drawings and pieces of work they had done themselves. There was always a table of presents, decorated with garlands of flowers and greenery, to which the person celebrating a birthday would be led with some ceremony. The Queen and Prince Albert often gave each other paintings and, later, photographs. For her birthday, 24 May, in 1854, the Queen received from her husband a 'crimson velvet portfolio containing coloured photographs of the Children's 5 Tableaux, exquisitely done, the painting done by Haag. Nothing could have given me more pleasure.'[4] In 1857 she was given 'a beautiful coloured photograph of the dear little Baby [Princess Beatrice] in her cradle.'[5] The Queen was then already making plans for future birthday presents for Prince Albert. Knowing of his love for his old home, she decided to have some photographs taken, first in Coburg and later in Gotha, showing the familiar and favourite views which he had so often described and which she herself had seen in 1845. The photographer chosen for this commission was Francis Bedford.

Bedford was a gentleman of private means, from an upper-middle-class professional family. As a young man he had worked with his father in archi-

1. RA Coburger Kunst und Naturalien Cabinet Correspondenz, 1854–61.

2. RA Y195/10.

3. RA Queen Victoria's Journal: 27 August 1845.

4. ibid.: 24 May 1854.

5. ibid.: 24 May 1857.

30.
Table of presents, the Queen's Birthday, Osborne,
24 May 1859
By William Bambridge

Prince Alfred as 'Autumn' in the Tableaux of
the Seasons, 10 February 1854. By Roger
Fenton; coloured by Carl Haag

tecture; later his interest in drawing and painting
led to his exhibiting works at the Royal Academy
between 1833 and 1849, and he took up lithography,
sometimes working with the firm of Day & Son, who
were lithographers to the Queen. His work in this
field, notably his coloured lithographs for *The Indus-
trial Arts of the Nineteenth Century at the Great
Exhibition, 1851* by Digby Wyatt, would have
brought him to the Royal Family's notice. Prince
Albert's plans for the Raphael Collection meant that
he was keenly interested in ways of reproducing
works of art, including lithography and photogra-
phy. The Royal Family visited Day & Son's estab-

lishment several times, and it is possible that they
encountered Bedford on one of these occasions.

By the early 1850s Bedford was also beginning
to establish himself as a photographer. He was a
modest, unassuming man, reserved in manner and
a perfectionist in his work: three years older than
Prince Albert, he was, in some respects, not unlike
him in character. By 1854 Bedford had received a
commission from the Queen and the Prince to photo-
graph works of art from the Royal Collection, com-
prising objects in ivory, terra-cotta and silver, and
some weapons and medallions. All are included in
a surviving album of eighty-three albumen prints by
Bedford of works of art shown at an exhibition in
1854 at Marlborough House, which was not at that
time in use as a royal residence. Bedford later
described his pictures of items from the Royal Col-
lection as some of the best negatives he had ever
taken. Other works by Bedford were purchased by
the Queen and Prince Albert in 1854, including
York Minster from Lord Mayor's Walk [**78**] and
*Fountains Abbey from the South East. A Study of
Plants* [**69**] was bought in 1856. Two prints, *At Port
Aberglaslyn, North Wales* and *The Baptistery of
Canterbury Cathedral* [**80**], were acquired after being
shown at the Manchester Exhibition of Art Treas-
ures in 1857. The Queen's consequent knowledge of
Bedford's work, and perhaps of his character too,
would have been important factors in choosing him
to carry out her wishes.

Having accepted the commission, Bedford and
his wife set off for Coburg. Herr Fischer, financial
secretary at Coburg, who acted as agent in the pro-
ceedings, wrote to Dr Becker on 13 June 1857 to let
him know that they had arrived safely, and so had
Bedford's photographic equipment and belongings,
which he had received the day before from the
Customs Office. Bedford's position had evidently
been made quite clear: he was not a tradesman, but
a gentleman who took photographs for pleasure.
Fischer accordingly arranged that the import duty
payable on his equipment should be put on the bill
of expenses, as Bedford would otherwise have had
to 'register himself as a professional photographer
at the Police Bureau, which would only have been
unpleasant for Mr Bedford, who practises this art
for his own pleasure, and I therefore thought this
should at all costs be avoided.'[6]

The visit was to be as private as possible:
Fischer had told Becker on 5 June that, as requested,
he had mentioned to the Duchess of Saxe-Coburg-
Gotha, Baron Stockmar and Prince Albert's former
tutor, Florschütz, that Bedford would be coming to
take the photographs, but that this was to be kept
secret from Prince Albert. Fischer had given instruc-
tions through the Police Bureau that the editors of
local newspapers should not accept any articles sent
to them about Bedford's presence in Coburg. For
this, 'a small gratuity' was sent to the officials con-
cerned. During their stay the Bedfords lodged with
Frau Ferdinande Hausmann and her two daughters,
'who keep a decent house here, speak English excel-

6. RA Coburger Privat-
kasse Correspondenz,
1856–7.

69.
A Study of Plants, 1856
By Francis Bedford

78.
York Minster from Lord Mayor's Walk, 1854
By Francis Bedford

80.
The Baptistery of Canterbury Cathedral, 1857
By Francis Bedford

lently, know the English way of life, and will try to make the stay here as pleasant as possible for Mrs Bedford.'[6] Fischer promised to make himself useful to Bedford in any way he could, and began by recommending certain views for him to take.

On 29 June Fischer again wrote to Becker to say that Bedford would complete most of the work on that day and would leave Coburg in two days' time. He was to go again to the Rosenau on the Thursday to photograph Duke Ernest II, Prince Albert's brother, who had earlier been away at Heilbrunn, so that there would be a portrait of him to accompany the one of his wife, Duchess Alexandrine, that Bedford had already taken. At the same time Bedford would photograph the waterfall, which had previously been impossible because of windy weather. Fischer would help Bedford to pack his boxes, which were to be sent straight to Dr Becker at Buckingham Palace, to be unpacked later by Bedford himself. Mrs Bedford, who possibly had not looked forward to being alone in a strange country while her husband was out most of the time taking photographs, had apparently enjoyed her stay much more than she had expected.

The Bedfords finally left Coburg at midday on 3 July: the four boxes, one containing glass plates, the others instruments and materials wrapped up in old clothes, followed the next day, on the first stage of their journey, to the carriers, G. L. Kayser, at Mainz. Careful and detailed instructions were given as to how they should be handled, and how they were not to be opened by Customs. The expenses of the trip were to be met by the Queen, and Fischer suggested various presents for people who had given assistance to the Bedfords. These included a gratuity to a Herr Benda, who had made 'considerable efforts on Mr Bedford's behalf', and a brooch to Frau Hausmann. The Court Gardener, Herr Eulefeld, had arranged that several Coburg peasants, 'who of course dressed up specially for the occasion', should pose for Bedford at the Rosenau: these refused payment, saying that they would prefer a memento. Fischer suggested silk kerchiefs for the women and waistcoats for the men, including Herr Eulefeld. The presents were later distributed when the other expenses were met. Frau Hausmann was delighted with the brooch, which she said she would leave to her youngest daughter, born and brought up in Kingston, Jamaica, and therefore a British subject, who was a great admirer of the Queen.[6]

The photographs were apparently presented to Prince Albert on his birthday, 26 August 1857: unfortunately no record of his reaction to the present has survived. A companion set of photographs of Gotha, taken by Bedford during June and July 1858, was given to the Prince on his birthday of that year, which he and the Queen were spending in Berlin with their eldest daughter, Victoria, Princess Frederick William of Prussia, and her husband's family. The Queen noted in her Journal for 26 August that Prince Albert had been 'particularly delighted' with her present of 'a complete collection of photographic

views of Gotha and the country round it, which I had had taken by Bedford.'[7] Two volumes, one for Coburg, containing sixty photographs, and one for Gotha, containing sixty-three, still exist: several additional copies of the prints were made within a few years of their being taken, for use as gifts. Some of the photographs were shown at the Photographic Society's exhibitions in 1858 and 1859.

The pictures [**viii, 45–9**] are all albumen prints: as mentioned elsewhere (see page 17), many of them are not equal to Bedford's best work, reflecting the fact that he was probably working under pressure of time. However, they undoubtedly gave pleasure and fulfilled their purpose in reminding Prince Albert of his home, as well as recalling for the Queen the 1845 visit. Many of the places described in her Journal of that visit are represented in the albums, which thus give us a fascinating insight into the experiences of herself and the Prince. They also show how the Queen commissioned photographers to record particular places for her in much the same way as she commissioned artists to paint favourite scenes and views; and their interest is enhanced by the documentary evidence which survives to show how the albums came into being and the sequence of events which followed the Queen's decision about a birthday present for her husband.*

* Bedford's association with the Royal Family continued. He made the chromolithographs illustrating **Art Treasures of the United Kingdom, from the Art Treasures Exhibition, Manchester,** edited by J. B. Waring, which was 'dedicated by permission to HRH the Prince Consort' and published by Day & Son in 1858. In 1862 he was asked to act as official photographer on the Prince of Wales's tour of the Near East; this was to be his most prestigious assignment.

7. Quoted by Sir Theodore Martin, **The Life of His Royal Highness The Prince Consort** (1875–80), Vol. IV.

Works consulted
The Life of His Royal Highness The Prince Consort by Sir Theodore Martin, published in five volumes between 1875 and 1880 by Smith, Elder & Co.
Dissertation on Francis Bedford by Bill Jay (MFA Thesis, University of New Mexico, 1976).

41 (top).
View from the foot of the Round Tower,
Windsor Castle, 1860
By Roger Fenton

43.
View in the Slopes, Windsor, 1860
By Roger Fenton

Roger Fenton's views of Windsor Castle

By an appropriate coincidence, 1851, the year in which the Victorians finally shook themselves free from the anxieties of trade depression, social unrest and the economic uncertainties that so bedevilled the 1840s, was also the year in which photography came of age and entered into a new relationship with the industrial world.

The Great Exhibition and Frederick Scott Archer's announcement of the collodion photographic process both took place in 1851, and in their different ways both reflect a single cultural impetus that sought to bring together science and art in the service of mankind.

Scott Archer knew the processes of art from first-hand experience as a silversmith and later as a sculptor; his interest in science had grown from his use of photography to record his work as a sculptor. Dissatisfied with the processes then available, the daguerreotype and calotype, he was inspired to apply lateral thinking to collodion, borrowing it from the world of medicine and introducing it successfully into the art of photography.

In so doing he was drawing together known technologies and materials from several countries, using and adapting them to create a new industrial process. This fusion of materials and technology was an apt example of Prince Albert's concept of the Great Exhibition. For him, the gathering together of raw materials, machinery and manufactured goods would demonstrate the fundamental Victorian truth that 'Science discovers [the] laws of power, motion, and transformation; industry applies them to the raw matter, which the earth yields us in abundance, but which becomes valuable only by knowledge. Art teaches us the immutable laws of beauty and symmetry, and gives to our productions forms in accordance with them.'[1]

Through these principles of applied capitalism, Britain would demonstrate an industrial supremacy that was 'not merely national in its scope and benefits, but comprehensive of the whole world'.[2] Above all else the Prince hoped that the exhibition would be a 'true test and a living picture of the point of development at which the whole of mankind has arrived'.[3] This would serve to remind the individual 'of that great and sacred mission which he has to perform in this world. His reason being created after the image of God, he has to use it to discover the laws by which the Almighty governs his creation, and, by making these laws the standard of action; to conquer nature to his use; himself a divine instrument.'[3]

Perhaps these ideals were subliminally absorbed by some of the six million visitors to the Great Exhibition, though perhaps on the whole they were too enthralled by the spectacle to draw the moral lessons. But the more astute observers must have recognized the potential of the social and economic forces exemplified within the exhibition. At the refreshment stands, where only soft drinks were sold, the profitability of serving a mass-market was agreeably demonstrated to Messrs Schweppes, who supplied the bottled drinks. The very fabric of the exhibition building was proof of the triumph of standardization and mass-production over the more traditional forms of construction (and fortuitously, since the collodion process used glass for its negatives, it could capitalize on the advances made by Messrs Chance Brothers, who supplied the 300,000 sheets of plate glass for the Crystal Palace).

These new methods of production and standardization were all part of the triumph of the machine and Victorian Britain's commitment to the concept of progress. Progress in the 1850s was measured in terms of speed: faster travel, speedier means of communication and more efficient means of production. Progress was also seen as the adaptation of the old to the new, a bringing up-to-date, combining old ideas with new technologies.

The collodion process retained those qualities that were universally recognized as being the advantages of the daguerreotype and calotype whilst overcoming the major drawbacks each possessed. It retained the ability to render the fine detail beloved of the daguerreotype, and it lent itself perfectly to the mass-production methods suggested by the calotype. However, none of this was achieved without some cost and disadvantage to the photographer.

The nature of the materials used in the collodion process demanded that the emulsion of the negative should be kept moist or 'wet' at every stage, right up to the point where the negative was developed; otherwise it would be spoilt. In practice, this meant that for each exposure the photographer had to coat, sensitize, expose and develop the plate in one continuously choreographed sequence. Of necessity, most of these steps had to be carried out in a darkroom close to the camera. If the photographer wanted to work in the landscape, then he had to take his darkroom with him. With typical Victorian ingenuity and 'fitness to purpose', these darkrooms ranged from the elaborate to the ridiculously impractical, coming in a variety of forms and sizes based upon converted carriages, specially designed hand-carts, or even diminutive tents into which one crawled on all fours.

Paradoxically, the very restrictions of the process which created these mobile darkrooms encouraged photographers to leave their studios to explore and record the world visually. So successful were the results that by 1856 it was possible for one London publisher to offer views 'in Africa, Portugal, France, Milan, Verona, Genoa, Nice, Heidelberg, Como etc., consisting of cathedrals, statues, monuments [all] collected with taste and care.'[4] This was just as Prince Albert had predicted when proposing the Great Exhibition, declaring that '. . . all quarters of the globe are placed at our disposal, and we have only to choose which is the best . . . for our purposes, and the powers of production are entrusted to the stimulus of competition and capital.'[5]

Companies such as Negretti & Zambra and the London Stereoscopic and Photographic Company

1. Sir Theodore Martin, **The Life of His Royal Highness The Prince Consort** (1875–80), Vol. II, p. 248.

2. Prince Albert, 1849, quoted under 'Exhibition of 1851', **Haydn's Dictionary of Dates . . . to August 1873** (London, 1873), p. 255.

3. Martin, loc. cit.

4. Catalogue, London Stereoscopic and Photographic Company, 1856, p. 8.

5. Martin, op. cit., Vol. II, p. 248.

had quickly recognized the potential market for photographs and were soon in vigorous competition to exploit the new-found prosperity of the middle classes.

There were other photographers who were equally adventurous in their travels but whose ambitions for their work were not so fiercely commercial. More often than not they came from the upper levels of society, and their background, education and wealth gave them the independence and opportunity to develop the aesthetic taste and judgement of connoisseurs. For this group there was little point in making distinctions between a fine-art print and a fine-art photograph, as the differentiation lay in the mechanics of technique and not in the appreciation of it.

The control which they exercised over the exhibiting and publication of their photographs exactly paralleled that of the print-trade. For the reputable printsellers like Thomas Agnew, Peter and Dominic Colnaghi and Henry Graves,[6] photography was a wonderful new medium which could enjoy equal status with engraving, lithography or the mezzotint; it was a way of adding to the range of techniques without detracting from the more traditional forms of representation. Photography differed from these in one important way: it could take its subjects 'from life'. The collodion process, with its exquisite detail, harmonic rendering of tones, and good, rich colouration, made it ideal for these ambitions.

Engravers and printmakers occupied an unenviable position within the fine arts in nineteenth-century Britain. Their abilities had been dismissed as early as 1812 by the leading authority of the Royal Academy, who had roundly stated that engraving lacked 'those intellectual qualities of Invention and Composition, which Painting, Sculpture and Architecture so eminently possess'.[7] Similar attitudes were turned against photography, looked upon by many artists with apprehension and mistrust: to them 'the camera was ... a first step towards the making of pictures by machinery alone'.[8]

The engravers sought the assistance of the Queen and Prince Albert, who brought their influence to bear upon the Royal Academy; it relented in 1853 by creating a new class for Academician Engravers.[9] The photographers, equally anxious about the status of their art, also sought influential help, and the Photographic Society of London formed in 1853 had the Queen and Prince Albert as Patrons and Sir Charles Eastlake, President of the Royal Academy, as President (see page 13).

An active promoter of the Photographic Society, and later its first secretary, was Roger Fenton, son of a Lancastrian banking family, a lawyer by profession but an artist by inclination. He had been responsible, along with two colleagues, Joseph Cundall, a publisher, and Philip Delamotte, an artist and lithographer, for bringing together the first large-scale photographic exhibition to be seen in Britain. It was held under the auspices of the Society of Arts in their rooms from December 1852.

In the paper which Fenton read at the opening ceremony of the exhibition, he affirmed that photography, far from being purely mechanical, was, in fact, a faithful servant of art; many artists, as devoted practitioners, had recognized that 'the camera will present them with the most faithful transcript of nature, with detail and breadth in equal perfection, while it will leave to them the exercise of judgement, the play of fancy, and the power of invention.'[10]

From 1852 to 1862 Fenton was a central figure in British photography, and his work was held in high regard by many of his contemporaries, who used the quality of his prints as the standard to which they should aspire. Critics visiting the Photographic Society's annual exhibitions repeatedly drew attention to his virtuoso performances with the camera:

No one can touch Fenton in landscape: he seems to be to photography what Turner was to painting – our greatest landscape photographer; not that there is any similarity between the aerial perspectives of Turner, and the substantial and real we get transferred by Fenton ... There is such an artistic feeling about the whole of these pictures, the gradations of tint are so admirably given, that they cannot fail to strike the beholder as being something more than mere photographs.[11]

When Paul Pretsch announced in the report of the Society of Arts for 25 April 1856 a new method for engraving photographic images on to metal plates so that they were capable of printing the image with a full range of tones,[12] Fenton's interest was immediately aroused. He gave his full support to the Photo-Galvanographic Company established in 1857, and by June of that year, the company announced the publication of the first four parts of *Photographic Art Treasures*, available from leading printsellers throughout Britain.[13] Fenton's photographs were well represented, but, despite the enthusiastic response from the press, the process never really caught on with the public and the company failed before the publication of the fifth part.

Fenton's interest in the process clearly stemmed from his personal commitment to establishing photographs as the artistic equal of engravings; and the chance to have his photographs offered to the public as engravings was too good an opportunity for him to miss. But the failure of the company did not discourage him, and he remained as active as ever, producing views of landscape and architecture right up to 1860, when he began, for the first time, to photograph elaborate still-life arrangements of fruit and flowers in his studio.

When Fenton visited Windsor during the early summer of 1860 he would have sought permission from the Lord Chamberlain's Office to photograph within the Castle grounds; but in selecting his subjects and viewpoints he chose not to invoke the special relationship he had built up over the years with the Royal Family and did not seek access to gardens and areas normally barred to the public. This was no self-effacing gesture but arose from Fenton's understanding of the audience for his photographs, who would prefer images that con-

6. See PP2 accounts in the Royal Archives for evidence of the trade in photographs and prints.

7. Quoted in Hilary Beck, **Victorian Engravings** (London, 1973), p. 12.

8. Roger Fenton, Introductory Remarks, **Catalogue of an Exhibition of Recent Specimens of Photography,** Society of Arts (London, 1852), p. 3.

9. Beck, op. cit., p. 13.

10. Fenton, op. cit., p. 4.

11. **Journal of the Photographic Society**, 21 May 1858, p. 208.

12. J. M. Eder, **History of Photography** (Dover reprint, New York, 1972, p. 579).

13. **The Athenaeum,** 13 June 1857, p. 742.

formed to their understanding and perception of the Castle. Among the twenty-two subjects that feature in his series of thirty-one views of Windsor, there is not a single image that would contradict the conventional point-of-view.

The camera that Fenton used for the *View in the Slopes* [43] was a mammoth affair that took negatives 20 × 16″. The choice of a camera of these proportions was not made lightly. The sheer bulk and inconvenience of its size made it difficult to use, and composing the image on the ground-glass screen so that everything was harmoniously arranged was no easy matter. Preparing a negative of this scale for the wet collodion process required an extraordinary deftness and a manipulative skill that few photographers possessed. Furthermore, the technical problems of exposure were multiplied ten-fold, as the need for extremely small apertures created inordinately long exposures.

But the disadvantages of the large camera were outweighed by two major considerations. The technical problems of enlarging negatives to make large prints were still not fully resolved, and it was almost universal practice to make contact prints. This produced the optimum quality from the negative but it also meant that the photographer needed different-sized cameras in order to make different-sized prints. Fenton used two cameras for the Windsor series, the 20 × 16″ already mentioned and a smaller 15 × 12″, giving him the choice of formats which allowed him to offer the views to the public in two different sizes.

The second consideration behind Fenton's choice of camera reflects the Victorian taste for large-scale works of art rendered in fine and sumptuous detail, allowing the viewer to appreciate the structure of the whole composition and to find equal enjoyment in the close study of individual elements. Fenton's landscape photographs meet both demands: they are formally successful while being charged with the detail and information that allowed the viewer to indulge in reverie, the Victorian conceptual practice of using the image as a starting point for contemplation leading to 'a loose or irregular train of thoughts' that could fashion 'any wild, extravagant conceit of the fancy or imagination.'[14]

The print of the *View in the Slopes* invites close inspection. It begs one to participate in the sensual enjoyment of its detail and totality. Formally the image works at a number of levels, some visually apparent and others subliminally suggested. The dominant element is the light diagonal of the gravel pathway that runs away to the left, its vanishing point neatly marked by the stonework of a small bridge. In the top right, set amongst the branches, is the elaborate, massive structure of the Castle, luminescent in the sunlight. The stonework of the bridge and that of the Castle are visually linked by the dark diagonal of branches that work in opposition to the diagonal of the pathway. At either side of the image side-screens of foliage arch and curve inwards to restrain the eye from escaping to the brightness of the sky. This enclosing device is mirrored by the arched corners of the print.

At another level, the image is one of contrasts: the difference between light and dark – between the natural and the man-made. In this photograph Fenton chose to set the camera off the pathway so that it is grass rather than gravel that is beneath the viewer's feet. The darkness of the grass combines with that of the foliage to suggest the coolness and serenity of forest shade. The lighter gravel of the pathway is an open invitation to recommence the journey and emerge once more into the heat and brightness of a summer's day.

The metaphoric connotations of stillness and tranquillity, as distinct from motion and toil, are further reinforced by the contrast of the hard, bright, man-made forms of the Castle, bridge and pathway, against the softer, natural elements of grass and foliage.

Just how elaborate an impression the metaphoric significance of this depiction would make must have depended upon the education, taste, and spiritual attitudes of its original audience. Bringing conceptual frameworks to bear upon the picture, each viewer would change the essential meaning of the image and adapt it to personal needs and ideals, and a close study of Fenton's photograph could thus be as rewarding for his Victorian audience as any engraving of an allegorical subject.

14. **Handbook of Literature and the Fine Arts** (New York, 1852), p. 52.

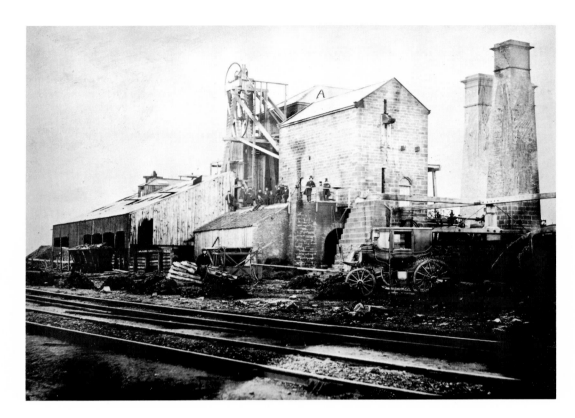

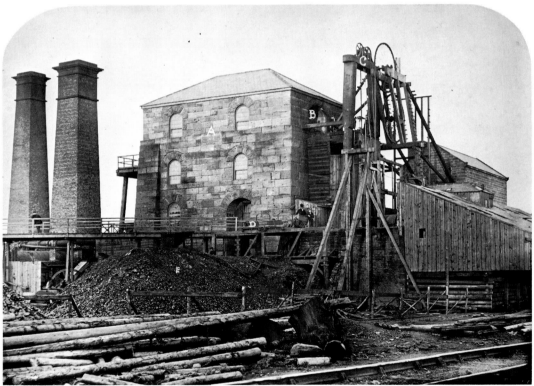

95, 96.
Hartley Colliery after the accident, 30 January
1862
By W. & D. Downey

The Hartley pit disaster, January 1862

Most of the common maxims and sayings about photography are concerned with its supposed ability to tell the truth. 'The camera never lies' and 'One picture is worth a thousand words' are two examples. Both sayings have the ring of slogans and were probably intended as catch-phrases rather than proverbs.[1] But the public always has an ear for good catch-phrases, and these were soon taken into everyday use, where they have comfortably settled and are accepted at their face value.

On examination, both phrases begin to sound hollow, and once put to the test they soon collapse under the weight of logical argument, especially when they are applied to Victorian photographs, since the restrictions imposed by the early techniques produced visual qualities that are far removed from truth.

Before the 1880s it was well-nigh impossible for photographers to record a news event like a riot or disaster and communicate the immediacy of the scene through their pictures. By the time they had set up their cumbersome equipment and gone through all the chemical manipulations to prepare a plate for exposure, the event would be over or the action would have moved elsewhere. Of necessity, photographers usually contented themselves with recording the aftermath of an event or making portraits of the leading personalities.

We may find these photographs passive by modern standards, but they served their contemporary audience well. The vigorous and detailed reporting in the Victorian press compensated for the inert quality of the photographs. In the nineteenth-century mind, image and text fused together to create a mental picture and set of associations that it is hard for us to evoke. For the Victorians, no picture alone was worth a thousand words; instead the picture required a thousand words to make it live.

Today we blithely show Victorian photographs out of context and stripped of information, re-appropriating them in fashionable compendiums designed to inspire nostalgia. Without access to the original context, the modern reader has little to work upon other than the formal qualities and sumptuous appearance.

However, if the context of a particular photograph is reconstructed through contemporary records and letters, then it is just possible for us to capture some of the emotional and associational values that it may have held for the Victorians. Such is the case with the photographs of New Hartley Colliery, 1862.

Here we have two general views [95–6] of the pit-head with its functional collection of buildings, chimneys and winding gear. On the surface of the prints there are the inked letters A–E, indicating specific locations and objects, suggesting that one should pay particular attention to those areas.

The other image [94] is quite different in character and shows us a group of six men standing uneasily at the mouth of a pit-shaft. This is indicated, rather than shown, by the guard-rail, the massive timbers and the ropes passing into the darkness behind them. Four of the men are dressed in occupational clothing and two in the everyday attire of the period. The difference in status between the men is suggested, not only by their dress, but also by posture and gesture. The figure on the extreme left appears to be an afterthought to the formal composition of the main group, someone who does not really belong and yet has a right to be there.

More is revealed in the original captions and a note accompanying the prints about the reason why the photographs were taken.

The general views are entitled *Hartley Colliery after the accident, 30 January 1862*, and there is a key to the letters:

A. The Engine House.
B. Part were [sic] the beam projected which broke and fell down the pit-shaft.
C. Machinery over the shaft.
D. The gangway leading to the shaft.
E. Pit Heap.

The group photograph, we are told, is of *W. Coulson, Master Sinker, and four of his men. Photographed at the Pit Mouth, Hartley Colliery, 30 January 1862.* This implies that W. Coulson is the central top-hatted figure and that those in working clothes are his men. There is no reference to the figure on the left. However, research has shown that this caption is incorrect and that all the people in the image played important roles throughout the disaster.

On the extreme left is Mr Humble, the pit manager, who after the accident stayed continuously on duty supervising the rescue attempts. Next to him are the Coulsons, father and son, celebrated sinkers, or makers of mine-shafts, the equivalent of our mining engineers today. The central figure is Charles Carr, owner of the pit, on whose shoulders the responsibility for the rescue lay. Next to him is a sinker, anonymous but probably Mr Emmerson, and, finally, another sinker, David Wilkinson.[2]

Note on the title: 'A vigil kept' is a quotation from 'The Hartley Calamity', a ballad written by the miner Joseph Skipsey to be read at meetings in aid of the widows and orphans of the disaster.

1. The history of the phrase 'One picture . . .' is given in M. Hiley, **Seeing through Photographs** (1983), p. 21 and footnotes.

2. N. McCord, 'Photographs as historical evidence', **Local Historian,** 1978, Vol. 13, No. 1, p. 35.

94.
W. Coulson, Master Sinker, and four of his men.
Photographed at the Pit Mouth, Hartley Colliery,
30 January 1862
By W. & D. Downey

New Hartley Colliery was close to the Northumberland coast, a few miles to the north of Newcastle upon Tyne, in one of the richest and most productive coalmining areas in Britain. Being so near the sea, it was a 'wet-pit', requiring constant and vigilant pumping to maintain a low water level and to keep the lower seams sufficiently dry for work. Above the pit-shaft a massive horizontal beam engine was employed to pump out the lower reaches by lifting an impressive 180 tons of water at each stroke, its average rate being five to six strokes per minute.[3]

On Thursday 16 January 1862, at eleven o'clock in the morning, just when the day-shift had gone underground to take over from the night-shift, the beam of the horizontal engine broke in two, and the detached part fell into the mouth of the pit-shaft. Its twenty-one tons gave it sufficient force and velocity to carry away the timbers, stonework and hydraulics that lined the shaft. It also carried away the cage bringing men to the surface from the night-shift. Had the beam continued to the very bottom of the shaft, then the disaster would have been serious enough, but at least it would have passed beyond the seams where the men were just beginning work or were waiting to return to the surface. As it was, the beam gathered an increasing amount of debris during its fall, and this tangled mass finally brought it to a halt at a point above the working seams,

The fatal accident at New Hartley Colliery: entrance to the shaft, viewed from the horse-hole. From the *Illustrated London News*, 1 February 1862

effectively plugging the shaft and trapping 199 men and boys below.

Once the enormity of the situation had sunk in and the inertia of shock had passed, Mr Humble sent out a call for volunteers and skilled help to mount a rescue attempt.

The Coulsons were well respected for their skill and experience in mining matters, and on their arrival they were put in charge of operations underground. With them were two other experienced sinkers, Messrs Emmerson and Wilkinson. On hearing the news, men came from the nearby pits to volunteer their help.

The first task was to free the cage and locate any survivors from it. Miraculously three of the eight men in the cage had survived the impact, and one of these, Watson, was left dangling in mid-air from a rope. As he hung there he heard two of his colleagues calling out the Lord's Prayer from the debris below. By means of a signal wire Watson lowered himself to his colleagues, and 'found them all but dead; but he had the satisfaction of remaining with them until their death took place, and of frequently engaging with them in earnest prayer'.[4]

The rescue work was perilous and hampered by the awful conditions then prevailing in mines, where the only sources of light were candles and lanterns. Further complications arose from the fear of other falls of debris from the lining of the shaft and of the plug itself suddenly giving way.

Every two hours a relay of men, are lowered one by one, perilously and slowly, down the black pit, by means of a heavy chain. Two of them being suspended by ropes, in order not to touch the rubbish, which might fall at any moment, go down as far as possible, and then as quickly and as gently as they can, clear away the obstruction, placing it in a 'corf' which is at once received by their comrades stationed at intervals above them.[5]

Despite this laborious way of working from ropes and slings, progress was rapid, and hopes grew the next day because the trapped miners had been able to move up to a higher seam to escape the rising water levels. From here they 'jowled' to their rescuers by hammering and knocking on the ironwork of the pumps.

Mr Carr and Mr Humble reckoned that 'in addition to air and water, there was in the pit a large supply of oil, and some corn in the stables. At worst there is a chance of the men being able to get at some of the horses, upon which they might subsist.'[6]

Hopes ran so high that by late on Saturday the 18th it was generally agreed that the trapped men would be brought out in a matter of hours, and everything that could be done in preparation for them, brandy, tea, blankets and stretchers, was waiting in readiness.

Drawn on by this optimism the rescuers worked feverishly all night amongst the debris, while on the surface groups of exhausted but hopeful men clustered by the fires they had lit all around the pit-heap in an effort to keep warm. There was no proper shelter from the bitter east wind which brought in flurries of snow from the North Sea.

3. **Illustrated London News,** 1 February 1862, p. 107.

4. T. Wemyss Reid, **A personal narrative of the appalling catastrophe at Hartley New Pit, January 16, 1862.** (Newcastle upon Tyne, 1862), p. 6.

5. ibid., p. 3.

6. ibid., p. 7.

By morning it was clear that they were still a long way from clearing the debris, and the pessimism that swept over the rescuers was not helped by the 'morbid curiosity' of the train-loads of sightseers who came to the mine throughout Sunday. All the spectators did was to wander aimlessly about and get in the way. They were eventually kept at a distance with barriers, hurriedly erected by joiners.

The large timbers that were wedged across the shaft and further falls of stone from its lining delayed progress so much that it was proposed, out of desperation, to throw the remaining beam down the shaft in the hope that it would carry away the plug of debris. Common sense at last ruled this out, and the back-breaking labour continued.

On Tuesday the 21st, five days after the accident, David Wilkinson managed to 'sink' a way through the debris, but almost immediately there was a huge up-rush of choke-damp (carbonic acid gas), the lethal, invisible enemy of coalminers. This 'stythe', as it was called locally, overcame the whole team underground, including Wilkinson, who had put his head to the hole to check the passage. Only with great difficulty was everyone brought to the surface, either dizzy or unconscious.

It was now clear to all that there could be little hope for the trapped miners: the build-up of gas must have taken its effect. This recognition brought about a change in tactics. The priority now was to ventilate the shaft so that the mine could be safely re-entered.

This was achieved by lighting a fire close to a branch of the main shaft, creating an up-draught like a flue. To direct it, and to create a down-draught, a canvas screen subdivided the main shaft. By these simple means, fresh air was drawn down to the level of the plug, and the foul air from below it was removed.

The following day a brave group ventured beyond the debris and reached the uppermost seam, where they found the men's tools. Spurred on by this discovery and heedless of fresh dangers to themselves, the party pressed further along the seam. Opening a ventilation door they came upon a few bodies, and beyond another door they found the remaining 150 men and boys, either sitting or lying next to each other. They had all been overcome by gas, and though the majority had died peacefully it was clear that some had died in extreme agony.

An event of this magnitude inevitably caught the nation's attention through the widespread reporting in the newspapers of the day-by-day developments. These accounts were followed with a keen interest and deep concern about the outcome.

At Osborne, Queen Victoria, in a state of traumatic grief at the death of Prince Albert only six weeks earlier, felt a personal identification with the anguish of the wives and families as well as the trapped miners. On 22 January she sent a telegram saying that 'The Queen is most anxious to hear that there are hopes of saving the poor people in the colliery, for whom her heart bleeds.' Mr Carr felt obliged to reply: 'There are still faint hopes of the men, or a portion of them, being recovered alive'[7]; but by this time he must have held very little real hope for the miners.

It was just after he had dispatched his reply that the bodies were discovered. On hearing this news, the Queen's thoughts immediately turned to the widows and orphans and she telegraphed to ask 'what is doing for them?'[8] A public relief fund was immediately established and the Queen headed the subscription lists. It was hoped to raise £30,000 for the support of the 406 women and children left destitute and orphaned by the disaster.

The depth of Queen Victoria's feelings for the plight of those concerned was very real indeed; and keeping in touch with the developing tragedy at Hartley may have brought, in some small way, a consoling sense of companionship in her own sufferings.

The Home Secretary, Sir George Grey, reported that 'The Queen's expression of sympathy with the poor sufferers in this terrible calamity at Hartley Colliery has been very sensibly felt throughout the District, and most gratefully appreciated'. He went on to assure the Queen that he would personally '. . . send down a competent person to attend the inquest, with a view to the suggestion of all practicable measures for preventing the re-occurance [sic] of such an appalling loss of life.'[9]

On 7 August 1862 Parliament passed an Act which ensured that in future no pit would rely on a single shaft as its only means of access.

7. ibid., p. 31.

8. ibid., p. 39.

9. RA B20/4a, Sir George Grey to Sir Charles Phipps, 27 January 1862.

167.
**Mr John Moore and his wife Jane, married for
seventy years,** 6 September 1894
Photographer unknown

Queen Victoria's portrait collection

One of the outstanding features of the Victorian part of the Royal Photograph Collection is its role as a portrait gallery. It contains not only several thousand photographs of the Royal Family, but a large number showing foreign royalty, the Royal Household, the nobility and gentry, politicians, soldiers and sailors, artists and actors, musicians and other people remarkable in one way or another. This sheds an interesting light on the characters of the owners, especially Queen Victoria, whose concern with photography spanned sixty years, but whose fascination with people was life-long.

Queen Victoria recalled in 1872 that her childhood had been 'rather melancholy'. Her mother, the Duchess of Kent (who already had two children from a previous marriage), had been widowed for the second time when the young Princess Victoria was less than a year old. The Duchess was not on good terms with her brothers-in-law, King George IV and King William IV, and, although they were both kind to their niece, she was disturbed by the constant friction between them and her mother. The Comptroller of the Duchess of Kent's Household was Sir John Conroy, overbearing and ambitious, whom the Princess hated because of his presumptuous, domineering manner. In this difficult situation, the Princess, as heir to the throne, was carefully brought up under constant surveillance and with few companions of her own age. She had a large collection of dolls, which took the place of friends: these she dressed as characters in stories or people in society, with the help of her governess. This lady, Louise, Baroness Lehzen, was a great influence on the Princess, who in later life always acknowledged the debt she owed her. Lehzen, however, while in many ways giving excellent guidance, allowed her devotion to her pupil to make her possessive, exacting and jealous, alienating the Princess from her mother.

One of the more positive aspects of Princess Victoria's upbringing was that she was taught to consider the feelings of others and encouraged to help those in need. In 1836 she took a great interest in a poor gipsy family whom her mother had helped, and wrote in her Journal for Christmas Day that 'Their being assisted makes me quite merry and happy today, for yesterday night when I was safe and happy at home in that cold night and today when it snowed so and everything looked white, I felt quite unhappy and grieved to think that our poor gipsy friends should perish and shiver for want, and now today I shall go to bed happy, knowing they are better off and more comfortable.' Queen Victoria would always be concerned for the welfare of her subjects, from the widows and orphans of the Hartley Colliery disaster, to the wounded soldiers from the Crimean War and the slaves in Africa, and did what she could to help them. This was partly because she felt it to be her duty as Queen, but also because she really cared that they should be happy. With complete absence of pride (which she considered was 'the bane of the present day'), she once

wrote that 'I do feel so strongly that we are before God all alike, and that in the twinkling of an eye, the highest may find themselves at the feet of the poorest and lowest. I have seen the noblest, most refined, high-bred feelings in the humblest and most unlearned.'[2]

In fact the Queen's lonely, restricted childhood had given her a tremendous curiosity about other people. As a young girl she loved her singing lessons with Luigi Lablache [**207**] partly because of his entertaining conversation, and, on becoming Queen,

207.
Signor Lablache, 1856
By Caldesi

she found similar pleasure in her dealings with her first Prime Minister, Lord Melbourne, who would amuse her with gossip and anecdotes. She possessed acute powers of observation, and nowhere is her interest in people revealed so clearly as in her Journal, where she invariably wrote down her impressions of those she met, just as they appeared to her at the time. She sometimes complained that her children did not tell her enough about what they thought of the people they met, especially the Prince of Wales, although his brothers 'are all so amusing and communicative'.[3]

With the advent of photography, the Queen could not only record her impressions of other people but also collect their likenesses. She and Prince Albert compiled albums of carte-de-visite portrait photographs, which the Prince arranged 'according to Rank – Nation etc.'[4] (see page 46) and

1. Queen Victoria to the Crown Princess of Prussia, 9 October 1866. See **Your Dear Letter: Private Correspondence of Queen Victoria and the Crown Princess of Prussia, 1865–1871**, edited by Roger Fulford (1971).

2. R A Vic. Add. MSS U32, Queen Victoria to the Crown Princess of Prussia, 30 August 1868.

3. R A Vic. Add. MSS U32, Queen Victoria to Princess Frederick William of Prussia, 4 December 1858.

4. R A Z491.

215.
**Dmitri Slaviansky d'Agreneff's celebrated
Russian Choir,** July 1885
Photographer unknown

216.
**Dmitri Slaviansky d'Agreneff with his wife and
family,** July 1885
Photographer unknown

which were a great pleasure to them both. They were, of course, in a position to obtain as many portraits as they wished; but the Queen also understood the value to those in different circumstances of photographs which could be bought fairly cheaply. While suggesting to Lord Beaconsfield in 1879 that large photographs might be subjected to a temporary tax, she added that 'the small ones are so great a boon to poor people that that might be hard'.[5]

Prince Albert's arrangement of the photographs was straightforward. He divided them into subjects and placed them in the appropriate albums. Portraits of the royal children were mounted in a set of volumes which began in 1848 (and eventually reached 1899), and the carte-de-visite portrait photographs of 1860 and 1861 were placed in a series of albums comprising Royal Portraits, Royal Household Portraits, English Portraits, Austrian, Belgian, Coburg, French, Prussian, Spanish and Portuguese Portraits, and portraits of artists, actors and musicians. Photographs of an earlier date and slightly larger size, including some royal or other groups and portraits but more usually views, works of art and genre pictures, were placed in the so-called calotype albums. In the front of all the albums for which the Prince had been responsible was written the legend 'All the photographs in this volume were collected and arranged by His Royal Highness the Prince Consort' with the date: this may have been added after his death.

As with everything else, the Prince had a systematic plan for the photographs, with which the Queen complied. In a letter to their eldest daughter four days after his death she wrote in inconsolable grief of how she had depended on him for everything and had done 'nothing, arranged not a print or photograph, didn't put on a gown or bonnet if he didn't approve it'.[6] The Queen's own very strong character, likes and dislikes, had been subordinated to those of her husband, at first unwillingly, but with increasing dependence on his judgement. After 1861, although she determined to follow his precepts in every way, she unconsciously began to reassert her independence and, while believing herself to be acting solely in accordance with his wishes, was really following her own inclinations. Thus, to give only a minor example, although the Photograph Collection was continued broadly along the lines laid down by the Prince, a subtle change can be seen before many years had passed after his death.

Prince Albert had seen photography both as an art form and as a recording system: the Queen gave greater importance to the latter aspect and far less to the former. Like the Prince she showed an interest in new processes, but those which seem to have claimed most of her attention were those which rendered images permanent. In 1865 she saw 'some beautiful new kinds of Photos: called Wothleytypes, printed in carbon, & which are supposed to be permanent, besides being so beautifully smooth'.[7] The carbon process was taken up with enthusiasm and

from the 1860s onwards much material was either re-photographed or re-printed from the original negative in carbon, several duplicates often being made. The Queen was just as anxious to preserve what she already had as to acquire new prints. However, perhaps the most obvious development in the collection was that it became increasingly a gallery of portraits, the scope of which was much wider than before. Some of the Prince's carte-de-visite albums were completed (a note being put in to the effect that the photographs up to such and such a page had been arranged by him). In the case of the 'Royal Household' albums, which originally held only portraits of the higher officials, two volumes of portraits of servants such as coachmen and nurses were added.

A series of portrait albums, begun during the Prince's lifetime but annotated by the Queen, was continued and, as time went on, included portraits of all kinds of people: not only those related to, or well known to, the Queen, but also those of whom she had heard or had recently met: guests or celebrities would often be asked to supply a photograph of themselves. These albums included such people as Dmitri Slaviansky d'Agreneff and his celebrated Russian Choir [215–16]; Étienne Jaquinot, Director of the Establishment at Aix-les-Bains; Mrs Kevett, of St Breward, Cornwall, who had six sons in the Duke of Cornwall's Light Infantry and one in the Royal Marines, 'all serving with exemplary characters'; the Gordon Boys at the Orphanage, Dover; the Zanzibari Survivors of the Emin Pasha Relief Expedition; and Miss Louisa Journeaux, 'who was for 2 days and 2 nights exposed in a small boat which floated away with her from St Helier's Harbour, Jersey. On the second day she was picked up 20 miles out at sea, by the French ship Zombola, April 1886'. Musicians held a special place in the Queen's esteem and many portraits of them were collected. Another album was composed mainly of people who had achieved unusual distinctions, including eleven centenarians, a couple who had been married for seventy years [167], a blind carpenter, one of Napoleon's custodians at St Helena, twin brothers of eighty-five, and the last surviving officer of the Peninsular Campaigns. These people, their relatives or friends would often send an explanatory letter which was bound into the album with the photograph.

Her collection of portraits must have been a source of great pleasure, as well as perhaps an aid to memory, to the Queen. Just as she was interested in the public, so she realized that the fascination was mutual, and during her lifetime many of her portraits were issued for sale. Of these, the majority depict her as a woman rather than as a queen: those of 1860 and 1861, showing her with Prince Albert, give no indication of their rank. What was probably the first photograph for public distribution which showed her as queen was one taken by Charles Clifford on 14 November 1861, when she 'dressed in evening dress, with diadem and jewels' and was

5. R A B61/28, 28 July 1879.

6. R A Vic. Add. MSS U32, 18 December 1861.

7. R A Queen Victoria's Journal: 27 March 1865.

175.
Queen Victoria: Diamond Jubilee portrait, 1897
By W. & D. Downey

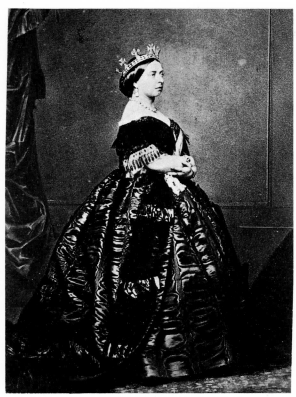

Queen Victoria, 14 November 1861. By Charles Clifford

photographed for the Queen of Spain, who had sent a portrait of herself.[8]

This was only a month before the Prince Consort's death, and the Queen's subsequent mourning meant that no more state portrait photographs were to be issued for several years. Instead, portraits showed her as a widow: at first in deep black with a black headcovering over a white cap, holding a portrait of the Prince and weighed down with grief; later with a white cap and black dress, sometimes holding a fan or a book, or accompanied by a dog. In 1863 she appeared as *The Highland Widow*, riding a pony and attended by her servant John Brown. As time went on, she was shown riding in carriages, reading, or writing, with portraits of her mother and husband beside her, and once, in a *Home Photograph* of 1889 by Byrne, working on a piece of crochet.

In 1876 the Queen was proclaimed Empress of India, and a portrait was issued showing her seated upon an ivory Indian throne. From this time state portrait photographs were issued more frequently, especially when she celebrated her Jubilees in 1887 and 1897. In the latter case the official photograph used [175] was one taken in 1893 at the time of the marriage of the Duke of York (the future King George V). Towards the end of her life, however, the portraits issued showed her just as she was, an elderly lady, sometimes holding a stick. It is as though throughout her life she wished to show her feelings to the world: first as a wife; then as a broken-

hearted widow who never forgot her husband but gradually accepted his loss; her renewed confidence in herself; and finally her apotheosis as a Queen Empress who was also the 'grandmother of Europe' and the mother of her people.

An article in *The Photographic News* for 12 August 1887 complained that photographs of the Queen were often retouched: 'indeed it is hard that the public cannot purchase a real photograph of the Queen, but have to be content with a mixture of photography and monochrome drawing.' Queen Victoria would have sympathized with this point of view. Her truthful nature and genuine lack of pride and vanity led her to allow the publication of portraits which were not flattering, and her children were sometimes unhappy about this. On 26 August 1896 the Queen wrote to her eldest daughter, Victoria, Empress Frederick of Germany, that she was 'sorry you are again dissatisfied with my photograph, but you are very fastidious'.[9]

The Empress hastened to explain in a letter written three days later that 'You say I am so particular about photographs. Perhaps I am, but as I admire my dear Mama and want others to see her as I see her, I feel vexed when a portrait does not do her justice or when there is a little fault in the arrangement which spoils the picture or the likeness. Most photographers are not artistic and are so occupied with the technical part of their work that they overlook many an artistic consideration. There is no reason why a photo should not be a good portrait *and* a work of art to be quite successful and satisfactory.'[10]

To this the Queen replied on 31 August with devastating candour that 'I fear I do not think . . . much of artistic arrangements in photographs and God knows there is nothing to admire in my ugly old person.'[11]

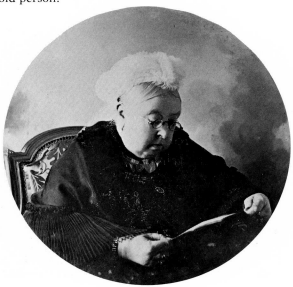

161.
Queen Victoria wearing spectacles, late 1890s
Photographer unknown

8. ibid.: 14 November 1861.

9. Queen Victoria to Empress Frederick, 26 August 1896.

10. RA Vic. Add MSS U305, 29 August 1896.

11. Queen Victoria to Empress Frederick, 31 August 1896.

Work consulted
The Girlhood of Queen Victoria, edited by Viscount Esher (1912).

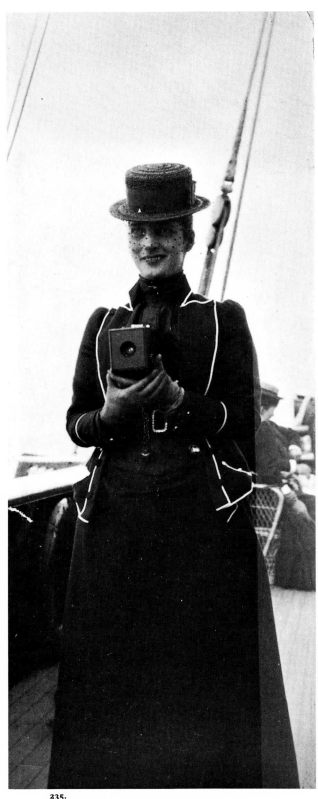

235.
Alexandra, Princess of Wales, with her camera,
c. 1889
Photographer unknown

Queen Alexandra's photographs

Queen Alexandra, whose interest in photography was well known in her lifetime, and who is still remembered for her *Christmas Gift Book*, was born in 1844, the daughter of Prince and Princess Christian of Schleswig-Holstein-Sonderburg-Glucksburg. Her parents, who became King and Queen of Denmark in 1863, were by royal standards relatively poor in their earlier years. Because of this, their children received a simple upbringing in which physical education, including riding, gymnastics and dancing, took precedence over more academic subjects. They were taught music by their mother and given religious instruction. They began learning English at an early age from their English nurses, and the girls sometimes made their own dresses.

It was a happy childhood, and even as an adult Princess Alexandra still found her greatest pleasure in the family circle and in simple amusements, although she at first revelled in the social life which her marriage to the Prince of Wales offered her. But these delights were not long to be unalloyed. As time went on, the Princess was sometimes hurt by her husband's neglect, although their deep affection for each other was never destroyed. The deafness which she had inherited from her mother became progressively more marked after a serious attack of rheumatic fever following the birth of her eldest daughter, Princess Louise, in 1867, when she was still only in her twenty-third year. The illness also left her with a stiff knee. These two physical disabilities threatened to restrict all the activities she most enjoyed: her deafness was a great drawback in her social life and hindered her pleasure in music, and her lameness, although she was able to disguise it with a graceful gliding walk, hampered her, not only in dancing and active sports, but also in commonplace actions like walking up and down stairs.

To anyone less determined than the Princess these misfortunes would have been tragedies, but all her life she was sustained by her religious faith, and she also possessed a cheerful optimistic nature, as well as a strong streak of obstinacy. One of her favourite sayings was 'Nothing like perseverance.' She largely succeeded in making the best of things: from her surviving letters it is difficult to tell that anything was wrong, as she rarely mentions her disabilities, except sometimes as a joke. Nevertheless, her life was increasingly centred on her family and the few close friends whose voices were familiar to her.

From 1877 to 1882 both the Princess of Wales's sons were away at sea for long periods of time. Prince Albert Victor was more often at home after this, but Prince George continued a naval career. Their mother wrote them infrequent but charming letters, which reveal her sense of fun and also, considering her foreign birth and increasing deafness after coming to England, a remarkable grasp of idiomatic English. Although she loved all her children she had a particular rapport with Prince George, and her letters to him give a vivid picture of her life and interests. One of these was painting and drawing: she was a great enthusiast who, on a visit to Athens in May 1877, got up early and while still in her nightgown made 'a beautiful sketch of the Acropolis' from the window of her room in the Palace.[1] The Princess was staying in Athens with her second brother, who had been chosen to be King of Greece in 1863. She also frequently went back to Denmark for holidays and visited her two sisters in Russia and Germany. Her devotion to her widespread family made travelling essential, and, after having a fairly restricted life in her youth, she began to enjoy seeing new places. In 1869 she and the Prince of Wales visited Egypt, which 'seemed to me the end of the world, but I did enjoy myself there ... Everything was so very different from Europe and the bronzed and black people so nice.'[2] When the Prince went to India without her in 1875–6, she never forgave him. Prince George's naval life took him to many foreign countries and the Princess was always eager to hear his impressions of them, especially when he visited the West Indies and Japan.

Unlike many aristocratic Victorian women, the Princess of Wales spent as much time with her children as she could. She enjoyed reading to them and encouraged them in riding, painting and music. Because of her sons' absences she was most often with her three daughters, Princesses Louise, Victoria and Maud, and they often all joined in the same activities. On 15 May 1886 she wrote to Prince George that 'I have just been having a lovely singing lesson with Tosti – what do you think of that! – & now *Louise* is having hers and shouting away behind me – & then Victoria will have hers – it is great fun & we all mean to sing beautifully when you come back'.*[3] In April 1891 they all 'attended classes & lectures on First Aid – St John's Ambulance Society & passed our examinations thank goodness which was alarming. You ought to have the same on board yr. Thrush for yr. men and yr. self – it is so useful and most interesting.'[4]

Another pleasure which the whole family shared was photography, which by chance had influenced Princess Alexandra's destiny many years earlier. When Queen Victoria and Prince Albert were considering potential brides for their eldest son, Albert Edward, Prince of Wales, the invention of photography had made it possible for them to see portraits of the young ladies before any further commitments were made. They had already heard of the beauty and charm of Princess Alexandra, from their eldest daughter, Victoria, Princess Frederick William of Prussia, and upon receiving photographs of her [232–4] they were immediately captivated. In spite of political difficulties, communications with the Princess's parents began, the young couple were introduced, and were eventually

1. R A Geo. V AA28/5, 2 May 1877.

2. R A Geo. V AA29/15, 24 February 1882.

3. R A Geo. V AA30/18, 15 May 1886.

4. R A Geo. V AA31/17, 18 April 1891.

* The Italian composer Sir Francesco Paolo Tosti (1846–1916) had been appointed Teacher of Singing to the Royal Family in 1879 and thereafter settled in England. His many songs, the most famous of which was *Goodbye*, had great popular success.

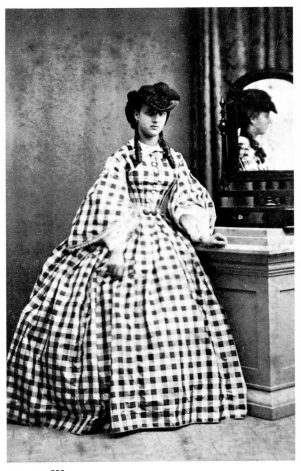

232.
Princess Alexandra of Denmark, 1860
By E. Lange

233.
Princess Alexandra of Denmark, January 1861
Photographer unknown

married on 10 March 1863. The photographs, though obviously not the deciding factor in the match, had given evidence in the Princess's favour at a crucial moment.

It seems like poetic justice that Princess Alexandra later took up photography herself with such enthusiasm and success, but in fact for many years before she did so, she, like the rest of the Royal Family, had enjoyed collecting photographs. There are numerous references to this in her letters to Prince George: she promises to get some photographs of all the places in Greece in 1877[5]; she sends him some of himself which he has asked for in 1878[6]; and in 1881 she encloses one of herself, 'in all my grandeur done the other day going to the drawing room.'[7] A photograph of a future sister-in-law seems to show that she is not pretty, but is later proved to have done her an injustice.[8] Later, the Princess promises to send some photographs of the alterations at Sandringham.[9] She comments in 1886 that Prince George looks so funny in the beard which his latest photograph shows,[10] and in 1889 that a recent profile by Downey gives him 'a kind of lemon shaped

head.'[11] Prince George often sent home photographs of himself, frequently taking care that they arrived when he was absent on special occasions, as in 1891, when his mother wrote that she was '*so* delighted to find your excellent photograph on my table – & I was so touched yr. having had it sent for the occasion – There was one on everybody's table – so it felt quite like a little bit of yr. self peeping at us from every corner to wish us a happy Xmas!'[12]

Meanwhile, a revolution in techniques was bringing photography increasingly within the reach of amateurs. Following the introduction of gelatine emulsions in the 1870s it had become possible to expose photographic plates much more rapidly than before. A gelatine emulsion required only a fifteenth of a second's exposure as compared to half an hour for a daguerreotype, two or three minutes for a salted paper print and ten or fifteen seconds for collodion. By 1878 ready-made plates could be bought, and within two years the new process had become very popular. It could be used with small portable cameras, which as a result were soon being made in large numbers. In 1888 the Eastman

5. R A Geo. V AA28/5, 2 May 1877.

6. R A Geo. V AA28/19, 8 July 1878.

7. R A Geo. V AA29/2, 20 May 1881.

8. R A Geo. V AA29/16, 3 March 1882.

9. R A Geo. V AA29/41, 14 December 1883.

10. R A Geo. V AA30/25, 21 November 1886.

11. R A Geo. V AA31/6, 7 March 1889.

12. R A Geo. V AA31/16, 10 January 1891.

234.
Princess Alexandra of Denmark at Neu Strelitz,
3 June 1861
Photographer unknown

formality; and she was able to record amusing incidents, animals and the movement of the waves of the sea, with equal enjoyment. Her deafness and lameness were no disadvantage to her in photography, and soon she was taking a camera with her on every possible occasion.

According to an article in *Photography* on 21 August 1902, she was taught how to use a camera by a Norfolk photographer, Frederick Ralph, who was also Usher of the Servants' Hall at Sandringham from 1863 to 1902. The Princess, with other members of the Royal Family, is also said to have attended the London Stereoscopic School of Photography in Regent Street. By 1889 the Princess possessed a No. 1 Kodak camera, introduced in that year, which used a roll film to take little round photographs $2\frac{3}{8}$ inches in diameter. Over the next few years she made a number of prints with this camera: an album containing 240 prints survives.

Some of these are particularly appealing, such as one of Queen Victoria taken at Abergeldie in Scotland, probably on 9 October 1890 [**206**]. This and a number of other photographs were sent to the firm of Brown-Westhead, Moore & Co., of Cauldon Place, Hanley, makers of 'Cauldon Ware', and were used as designs on a tea set, appearing as terra-cotta-coloured pictures on a cream background. As Cauldon Ware, the china was later supplied to the Princess through the firm of Mortlocks Ltd, of Oxford Street and Orchard Street, one of the principal London retailers of china. This tea service still exists [**204**].

In her photographic transactions Princess Alexandra appears to have dealt almost exclusively with the Eastman Photographic Materials Company (Kodak Ltd). Very little of her archive survives, but remaining accounts show that Kodak developed negatives for her from July 1897 to September 1914.[13] During this time she used No. 2 Bull's-Eye Kodak and No. 4 Bull's-Eye Special Kodak cameras; one of the latter, covered with purple leather [**219**], had been presented to her in 1892 by the Kodak Company. One or other of these would accompany her on her journeys, and on receiving the prints from Kodak she would allow no one else to touch them. She would personally select some for her albums, pasting them in herself and writing the text underneath, sometimes in the form of a diary of the tour or cruise.

In October and November 1897 the Princess, her two elder daughters, the Duchess of York (later Queen Mary) and Beatrice, Princess Henry of Battenberg, allowed some of their photographs to be shown in a Kodak exhibition held at the New Gallery in Regent Street. Their collection of about forty-four photographs and photogravures was mounted at one end of the gallery, the remaining walls being filled with other entries. Contemporary photographs of the display show that the work by the Princesses was of a high standard, well able to bear comparison with the rest of the exhibits.

13. R A Vic. Add. MSS A21/219–221.

Company of Rochester, U.S.A., introduced portable roll-film cameras, which were lighter and more convenient than those using heavy glass plates. Photography, which had been the province at first of a few scientifically-minded people, generally of aristocratic or professional background, and, later, of a larger number of photographic tradesmen, was now available to all who wanted to try their hand at making pictures but had not the time or inclination for lengthy chemical processes.

Sketching had long been a popular amateur accomplishment, particularly for ladies, and the new medium soon showed a similar appeal. Many took it up with enthusiasm, including members of the Royal Family: of these the Princess of Wales is still considered to have been among the most gifted. As one who loved collecting souvenirs and mementoes, and also enjoyed drawing and painting, photography had a particular attraction for her. The informal aspect of the new techniques, by which fleeting moments could, without too much difficulty, be caught for posterity, was ideally suited to her light-hearted approach and dislike of pomposity and

225.
Off the Irish Coast
By Queen Alexandra

227.
Off the Coast of Scotland
By Queen Alexandra

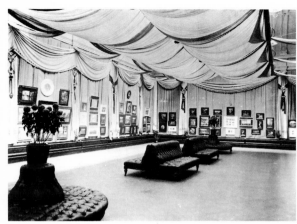

Exhibition hall of the 1897 Kodak Exhibition, showing the work of members of the Royal Family at the far end of the room. Photograph copyright Kodak Ltd

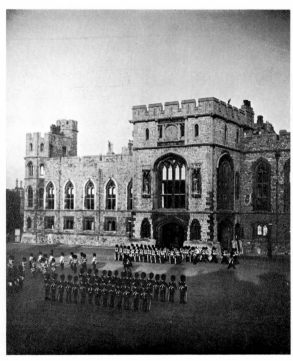

226.
Changing Guard at Windsor Castle
By Queen Alexandra

Within a few years Queen Alexandra and other royal photographers had taken part in two more exhibitions at Kodak Galleries, one in the Strand and the other in Oxford Street. Most of the Queen's prints showed views at sea, which she seems to have been particularly fond of taking; others were photographed at various royal residences [**225–7**]. These exhibitions must have given her pleasure, but she rarely mentioned her own photography in her letters to Prince George, possibly because the occupation was so habitual that it did not need stressing.

By this time it was well known that the Queen enjoyed photography, and public curiosity was stimulated by press articles which reported how skilful and assiduous an operator she was. A report in the *Daily Mirror* for 11 April 1905 included a picture of her taking a photograph, and told how this was not the first time that she had been snapshotted while taking a snapshot. Gracious as the Queen is to all, her fondness for photography seems to make her exceptionally condescending to photographers. Not long since she levelled a camera at part of a crowd gathered to welcome her. A correspondent with a camera promptly levelled his lens at Her Majesty, who seemed greatly amused and smiled upon him as the cameras clicked simultaneously. Unfortunately for the correspondent the weather was very dull, and his snapshot was a failure. It is to be hoped Her Majesty was more successful.

Soon afterwards, in August and September 1905, the Queen gave permission for nine of her prints (including some shown in the Kodak exhibitions) to be published in three special supplements of *The Graphic*, an illustrated weekly magazine. The prints, some showing views at sea, others taken in Denmark and at Sandringham and Marlborough House, were provided by Kodak, who also undertook to display copies of the prints in their dealers' windows. The popular interest caused by their appearance was soon to receive an even greater stimulus.

Following his coronation in August 1902, King Edward VII had gone on a cruise up the west coast of England and Scotland, accompanied by Queen Alexandra. One of their stopping places was the Isle of Man, and while there they had met the celebrated author Hall Caine, who lived at Greeba Castle. Either the Queen or Princess Victoria took some snapshots of him, which are still preserved. It seems that a friendly acquaintanceship between the royal party and the author began at about this time, which led to an introduction to Hall Caine's son, Ralph, who was the managing director of the publishers Cother and Co. With her habitual kindness, generosity and real concern for those in trouble, Queen Alexandra frequently gave sums to charities and funds to aid the distressed. It seems highly probable that at some later time Hall Caine or his son suggested that a gift book associated with her and produced for Christmas might be sold in aid of her 'Unemployed Fund'.

Whatever the source of the idea, the sale in 1905 of *The Queen's Christmas Carol*, an anthology of poems, stories, essays, drawings and music by British authors, artists and musicians, brought in a large sum for the Fund, much to the Queen's surprise and delight. Her Woman of the Bedchamber Miss Charlotte Knollys wrote to Hall Caine on 20 February 1906 to say that the Queen (then in Denmark following her father's death) recognized that it was entirely through his efforts that such a large amount of money had been raised, and that she wanted to thank him personally on her return to England.[14]

Encouraged by this, Hall Caine then seems to

14. Hall Caine Papers, Manx Museum Library.

Hall Caine and his younger son, Derwent, in front of the ruined St German's Cathedral on St Patrick's Isle, 25 August 1902.
Probably by Princess Victoria

have suggested, at some time early in 1907, a royal photograph album to be published in aid of the poor. Miss Knollys wrote to him on 3 July 1907 to say that the Queen approved of this idea, but as she had taken 'literally thousands of "snapshots"', which were naturally of unequal merit, it would take a long time to sort them all out and make a suitable selection. As the Queen was then too busy to undertake this, Miss Knollys asked Hall Caine to renew the subject later, enclosing with her letter a book of photographs which he had sent for the Queen to see, and which she had 'admired extremely'.[14]

It is clear that the idea of publishing her photographs had really gripped the Queen's imagination, as, apparently without waiting for Hall Caine to renew the subject, Miss Knollys wrote to him again on 27 November to ask whether he would need the negatives or printed copies of the snapshots for the book. However, by 10 December it was obvious that the Queen was far too busy to select the photographs before Christmas. In any case, she felt that it would be better to wait a little longer, as it was not a good moment to appeal to the public when they had 'probably already distributed their charities & gifts and their purses [were] consequently empty.'[14] The Queen was able to spend some time after Christmas in choosing suitable photographs, and by 26 February 1908 Miss Knollys reported that she had selected 107.[14]

In May 1908 three photographs by Queen Alexandra had appeared, with her permission, in *The Flag*, as a result of a personal request to her during a visit to the Union Jack Club. Ralph Hall Caine was concerned, but Miss Knollys assured him that there was no danger of more being published before 'your father's book appears'.[14] By September the Queen was again in Denmark, staying at Hvidöre, the villa which she and her sister, the Dowager Empress of Russia, had purchased for themselves after their father's death. As there was still much to be settled, Ralph set off for Copenhagen towards

the end of the month, staying at the Hotel d'Angleterre, and later described the results of the trip in a letter to his father of 29 September. He had met Miss Knollys on board the Royal Yacht (the Queen being at Hvidöre) and they had had a long preliminary talk, lasting about three hours, on the subject of the book. Miss Knollys was to report back to the Queen in the evening and if possible obtain some more photographs. Next morning Ralph learnt that the Queen wished him to stay a day longer, as she would come on board the yacht that night to select more photographs and would see him at eleven on the following day. He arrived promptly, and spent the next three hours with the Queen, discussing everything to do with the book. He found her 'charming and delightful. She showed me exactly what she wanted, and it was very easy to see she was taking the deepest possible interest in connection with every detail of its production. In fact she said more than once to me "As this is to be *my* book, it must give that impression." In other words, the idea that she should name the photographs "Photograph of my Father", &c., &c., immensely appealed to her. (Miss Knollys told me, afterwards, that she had never seen the Queen interest herself so much in anything.)'

Ralph was delighted with the results of this interview: best of all, he had got thirty or forty more photographs, 'many of which are much the most interesting in the book', including some taken only three months earlier during the meeting of the King and Tsar Nicholas II of Russia at Reval. Queen Alexandra had wished the Church Army to appear in the book as the beneficiary of sales, and Ralph had the greatest difficulty in persuading her to replace this with 'Charity', as she 'could not understand why anyone should object to so good an Organisation as the Church Army, and she went to great pains to prove to me the good work of an undenominational character which the C. A. were doing. However, finally she consented.' Ralph failed to per-

suade the Queen to allow a preface to the book, or to write any long account or give any extensive descriptions of the pictures, but as she had written a fairly long 'underline' on the back of each photograph, he was quite content.[14]

The book was already 'being whispered about', so it was agreed that some sort of press announcement should be made soon, 'before it should leak out in paragraphs in the Halfpenny press.'[14] *Queen Alexandra's Christmas Gift Book* was announced in the *Daily Telegraph* on 12 October 1908, being described irresistibly as a book of royal photographs which 'are simply snap-shots – informal, unofficial, every-day, human snap-shots. And it is this which will make this Royal Gift Book so intensely interesting. Her Majesty proposes to take the public into her confidence, and will herself show them how she has spent some of the lighter moments of vacant hours.'

The *Daily Telegraph*, who were to publish the album, had employed Hall Caine as a part-time journalist for many years, and now he and Ralph had carefully prepared the ground. Within twenty-four hours orders for more than 100,000 copies had been received: ten days later the *Telegraph* announced that 358,000 copies had been sold.

The whole first edition was sold out before it had even been published. Thousands more orders were to follow. Miss Knollys wrote from Denmark on 16 October that the Queen was delighted to know the success of the album, which was 'much greater than anything we could have hoped for!' On 22 October she placed orders on behalf of the Queen and Princess Victoria, adding that the Queen hoped that one copy would be ready for her to give to the King on his birthday, 9 November. She repeated to Hall Caine on 26 October 'how gratified H. M. is with the wonderful reception which has been accorded to the announcement of her Book & she quite recognises & is most grateful for, the able and energetic manner in which Lord Burnham [the proprietor of the *Daily Telegraph*] has so kindly taken the matter up. Nor does the Queen by any means overlook the ability, the zeal & the *tact* which your son has displayed. At the same time the Queen always remembers that to *your* initiative the Album owes its birth.'[14] Hall Caine had asked whether the King might be prepared to contribute some kind of introduction to the book, but the King declined, feeling that 'any work which may emanate from the Queen should stand entirely on its own merits.'[15] At the last moment the Queen was dismayed to find that she had mixed up the names in two photographs taken at Balmoral, and anxiously gave instructions for the insertion of a corrective footnote.

The book [231] was finally published on 12 November, to be sold at 2s 6d (12½p) a copy. On 18 December Miss Knollys sent, on Queen Alexandra's behalf, a watch and chain to Ralph and 'a large framed likeness' of the Queen to his father, as 'the originator of a scheme which has been crowned with such brilliant success.'[14] This success did indeed owe much to astute and carefully organized publicity. The book was published simultaneously in England and America: large orders were also dispatched to Russia, Denmark, Sweden, Norway, Germany, France and throughout the British Empire. Copies could be bought not only from booksellers but also from many other businesses, including chemists and theatrical agencies, as well as in military and naval canteens. Several steamship companies purchased copies to sell on board their ships; Kodak Ltd ordered a number to be sold by their dealers; several companies gave whole stocks of the books away as presents to their customers, and copies were given to everyone in the audience at a matinée performance of *The Merry Widow* at Daly's Theatre. In the words of *Page's Weekly*, 'The Queen's kindly thought has crystallised into the most remarkable book of the year.'

The album, which was entirely produced in Britain, was bound in cream-coloured cloth, with the title 'Queen Alexandra's Christmas Gift Book. Photographs from My Camera' printed in dark green. A photograph of the Queen appeared as a frontispiece, and the book contained reproductions of 136 snapshots, ninety printed in photogravure and forty-six mounted by hand on to dark green pages, to look like a real photograph album. Over thirty charities (including the Church Army) ultimately benefited from sales, and this gave the Queen the greatest satisfaction.

Queen Alexandra once described a picture she had done as 'a beautiful sketch' and referred to one of her own photographs 'which I think is excellent'.[16] This apparent vanity was meant in fun, but nevertheless may show that she would have liked to be thought capable of more than people usually allowed. Her beauty, simplicity and prolonged appearance of youth, as well as her deafness (the results of which sometimes seemed like stupidity), often caused them to take her less seriously than she deserved. She resented the fact that matters were sometimes kept from her, and was deeply hurt when the King, on first succeeding to the throne, seemed reluctant to let her take her proper share of public duties. The incredible success of *Queen Alexandra's Christmas Gift Book*, a book which was virtually all her own work, must have given her peculiar satisfaction. Regarding her photographs as particularly personal to her, and taking a special pride in them, she must have seen this triumph almost as a justification of her efforts, not to mention the fact that these efforts had been the means of raising huge sums for charity. The record sales and the extravagant praise were no doubt largely because the book was by a member of the Royal Family, but even allowing for this it was proved that she had more than average ability and a strong feeling for design and composition in her photography. The public, whose curiosity had initially been excited by the rare opportunity of seeing private royal snapshots, would discover that the Queen's work could give them pleasure on its own merits.

15. R A P P Ed. VII D28119, November 1908.

16. R A Geo. V AA33/14, 7 December 1905.

Works consulted
Queen Alexandra by Georgina Battiscombe (1969).
Edward VII and Queen Alexandra by Helmut and Alison Gernsheim (1962).

Frances Dimond

Catalogue of the exhibition

Photographs are shown with either roman or
arabic numbers. Those with roman numbers
are the copy photographs on the display boards
in the passage outside The Queen's Gallery;
those with arabic numbers are the original prints
in the main part of the exhibition

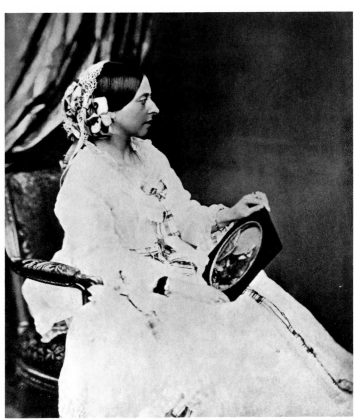

ii.
Queen Victoria, Buckingham Palace, dated 13
July 1854
By B. E. Duppa, printed in carbon by Mullins,
1889
16.6x21.7cm

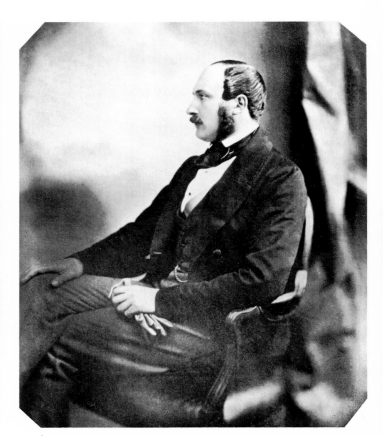

i.
Prince Albert, May 1854
By B. E. Duppa, printed in carbon by Mullins,
1889
16x20.1cm

i, ii. These companion portraits of the Queen and Prince Albert were taken by Duppa on two separate occasions in 1854. That of the Prince was taken first: the Queen's portrait shows her holding a framed copy of it. In her Journal for 5 July 1854 she noted that she 'was photographed, as a surprise for Albert, by Mr Duppa, & I hope successfully.' Two portraits were taken of the Queen; these were dated 13 July, but it seems certain that they are the ones to which she refers on 5 July, as there is no mention in the Journal of her being photographed again by Duppa on 13 July.

A number of the Victorian photographs in the Photograph Collection were re-photographed, or sometimes reprinted from the original negative, presumably to guard against fading, after the discovery of the permanent carbon process in the 1860s. Much of this work was undertaken by the firm of Hughes & Mullins, of Ryde in the Isle of Wight. In some cases, the original photographs are preserved underneath the carbon prints.

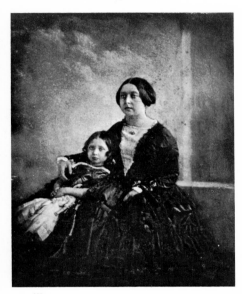

iii.
Queen Victoria and the Princess Royal, *c.* 1844–5
Attributed to Henry Collen
8x10.3cm
Carbon print
This is probably the earliest photographic likeness of the Queen and her eldest daughter.

iv.
The Queen, the Prince and eight Royal Children in Buckingham Palace Garden, 22 May 1854
From left to right: Prince Leopold, Prince Alfred, Princess Helena, Princess Alice, Prince of Wales, Prince Arthur, Princess Louise, Queen Victoria, Princess Royal, Prince Albert.
By Roger Fenton. Instantaneous photograph 10x12cm
Albumen print
Illustrated above on p. 30
This photograph was taken at Buckingham Palace before lunch on 22 May, and at two in the afternoon the Royal Family left for Osborne in the Isle of Wight. Queen Victoria noted in her Journal that it had been 'a very windy, dull morning, after much rain. We were photographed with all the children, an instantaneous picture, which is very curious, as it even seizes & fixes motion.'

v.
The Royal Family at Osborne, 26 May 1857
Left to right: Prince Alfred, Prince Albert, Princess Helena, Prince Arthur, Princess Alice, Queen Victoria with Princess Beatrice, Victoria, Princess Royal, Princess Louise, Prince Leopold and Albert Edward, Prince of Wales
By Caldesi
20.8x15.9cm
Albumen print
Illustrated on p. 18
This is one of the few photographs which show Queen Victoria and Prince Albert with all their nine children. It was taken two days after the Queen's birthday. She noted in her Journal that they 'were occupied for 2 hours being *all* photographed, (we & the 9 children) on the Terrace, by Caldesi.' A month later, in June 1857, Prince Albert was given the official title of Prince Consort.

vi.
Thames Street, Windsor, 1856
By Arthur J. Melhuish
49x38.3cm
Salted paper print
Illustrated on p. 33

42 (below).
Henry III Tower, Windsor Castle, 1856
By Arthur J. Melhuish
49.3x38.7cm
Salted paper print

vi, 42. Two Windsor views taken in 1856 by Melhuish, who was an 'Optician and Photographist' in Blackheath. These photographs are part of a series (of which there are three complete copies) of twenty-six prints showing Windsor Castle and its surroundings. Some of the prints are also included in an additional series of thirty-seven photographs by Melhuish of the Castle and Home Park. Melhuish also made a number of prints from Raphael Collection negatives for Prince Albert.

vii.
The Queen's Christmas Tree, Windsor Castle, 24
December 1857
By Dr E. Becker
21.9x16.4cm
Albumen print made from a dry collodion plate
Queen Victoria and the Prince Consort did
much to popularize the German custom of deco-
rating fir trees at Christmas time, which had
originally been introduced into England by
Queen Charlotte, the wife of King George III.
The Royal Family generally spent Christmas at
Windsor Castle, where they had several Christ-
mas tables with trees for each other and for
members of the Royal Household. Presents were
distributed on Christmas Eve, which in 1857
was a fine day, more like spring than winter. The
Queen, occupied with choosing and arranging
the presents, was 'kept in suspense by some of
the things not turning up', but eventually 'there
was a great display of things, & *all* seemed much
pleased.'[1] This picture, taken by Dr Becker,
Prince Albert's German librarian and a keen
photographer, shows that among the many gifts
presented to the Queen in 1857 were some
photographs of actors.

Reference
1. RA Queen Victoria's Journal: 24 December
1857.

viii.
Coburg peasants at the Rosenau, 1857
By Francis Bedford
21.2x16.8cm
Albumen print
Illustrated on p. 50

47.
Coburg peasants at the Rosenau, 1857
By Francis Bedford
22.5x18cm
Albumen print
Illustrated on p. 50
viii, 47. Prince Albert would have been
familiar with the sight of the Coburg peasants,
dressed in their native costume, from his earliest
years. In 1848 he used them as an example when
writing to Baron Stockmar on 31 January about
the apparent decline of national individuality,
which, he argued, was really the transition from
one age to another. This brought change, but
did not necessarily alter national characteristics.
'The alteration of the Coburg peasant's dress
(the men's, for example) will seem, as far as
feelings go, to be a decline of individuality, but
what gave that costume individuality was only
the fact, that it dates from the last century; then,
however, it was *universal*, and simply a copy of
the dress of the upper classes, and this dress of
the upper classes is what the peasantry of the
present day are bent on assuming *at once*.'[1] This
argument is borne out in the two groups: the
two seated men still wear the old-fashioned
costume, but the younger man, who is standing,
wears nineteenth-century clothes, which never-
theless have a typically German appearance.

Reference
1. RA Y148/43.

ix.
The Sailor Boy, 1855
By O. G. Rejlander
16x19cm
Carbon print
Illustrated on p. 44
This photograph was the first by Rejlander
to be acquired by Prince Albert. It was shown
at the second exhibition of the Photographic
Society, which the Prince visited on 11 January
1855.

x.
Stonehenge, 1853
By Russell Sedgfield
22.3x15.3cm
Albumen print from a paper negative
A view of Stonehenge by Sedgfield, on
waxed paper, was shown in 1854 at the first
Photographic Society exhibition.

xi.
Ramsgate
Attributed to W. Lake Price
19.8x13.9cm
Albumen print

Before her accession to the throne, Queen Victoria had spent two holidays at Ramsgate with her mother, the Duchess of Kent, and their suite. In 1835, Princess Victoria described in her Journal for 29 September how the people of Ramsgate had received the royal party 'in a most friendly and kind way. The whole was very well conducted, and the people were very orderly. The streets were ornamented with arches of flowers and flags. The open, free, boundless (to the eye) ocean looked very refreshing. There is nothing between us and France but the sea, here. We have got a small but very nice house, overlooking the sea.' The Princess enjoyed her holiday, particularly as her uncle, King Leopold I of the Belgians, and his wife, Queen Louise, joined the party; but while at Ramsgate she became seriously unwell with an illness which may have been either typhoid or severe tonsillitis, and was unable to return to Kensington Palace until January 1836. She and her mother spent another holiday at Ramsgate in the autumn of 1836. This photograph may be one of four views of Ramsgate supplied to Queen Victoria in 1861 by Lake Price.

xii.
The *Fairy* steaming through the Fleet. *Fairy* in the middle, 11 March 1854
By Roger Fenton
20.5x14.6cm
Albumen print

This photograph is part of a set made by Fenton at the time of the departure of the fleet for the Crimea, under the command of Admiral Sir Charles Napier. The Royal Family, on board the *Fairy*, watched the sight with interest, and the Queen recorded in her journal how 'Sir C. Napier was in a great fuss & hurry, having hardly got any of his things. He told Capt. Denman he had only got a *fur cap* & he actually got out of the train with a pair of worsted stockings dangling in his hand. He came on board without any epaulettes & his cocked hat worn the contrary way to what it is now.' As the ships prepared to depart, the Royal party, on board the *Fairy*,

> went on a little way towards St Helen's & then lay to, to see the ships pass by, which, 15 in number, they did, one by one, most beautifully, quite close, giving three hearty cheers, which went through one . . . The 'Duke of Wellington' was immensely cheered as she glided along, towering majestically above the blue waters, her figurehead (a very good likeness) being I am sure, a harbinger of glory. One gazed & gazed, till the noble ships could scarcely be discerned on the horizon . . . We got home by 5, much impressed by the wonderful, inspiriting & solemn sight we had witnessed, & which we would not have missed for worlds. Besides it was our duty to be there to encourage the Navy, just as we did the Army. There is no doubt it gives satisfaction, & I am sure every sailor's face seemed brightening as he cheered. The man on the very topmost mast of the 'Duke of Wellington', waved both his arms as she passed by!

Fenton's set of eight pictures of the Fleet at Spithead represent an early attempt to record several stages of a particular occasion. Six prints taken by him at Spithead were exhibited by the Photographic Society in 1855.

xiii.
**Wounded soldiers seen by the Queen at Brompton
Barracks, Chatham**
Photographer unknown
20.5x15cm
Albumen print
Illustrated on p. 38

104.
**Private Jesse Lockhurst, 31st Regiment, and
Thomas O'Brien, 1st Royals, seen by the Queen
at Chatham**
By Cundall & Howlett
17.3x21.2cm
Carbon print, reproduced from the original by
Hughes & Mullins, 1883
Illustrated on p. 36

On 16 April 1856, Queen Victoria visited
Brompton Barracks at Chatham to see con-
valescent soldiers recovering from wounds
received during the Crimean War. Four
hundred of them were assembled in the court-
yard, and the Queen noticed that 'all were
suffering from some wound or another, but yet
were able to get about, poor fellows.'[1] On
making a more detailed tour of the barracks the
Queen was horrified to see how serious some of
the injuries were. The experiences of two men
particularly impressed her.

Thomas O'Brien (resting on the bed in the
photograph) had been wounded at the Redan
on 8 September 1855, when a grape shot weigh-
ing $6\frac{3}{4}$ ounces (about 190 g) had destroyed his
left eye and fractured his jawbone. Jesse Lock-
hurst had been wounded in the advanced tren-
ches on 16 August 1855, when he had received
a grape shot in his right eye, which had
destroyed the sight of the eye and also his upper
jawbone. The shot weighed $18\frac{1}{2}$ ounces (about
525 g). In the photograph both men are holding
the shot which caused their injuries, and which
they gave to the Queen to hold in her own hand.
At the conclusion of her visit to Chatham, she
reflected that 'one could not wish the war to have
continued when one looked on these brave,
noble fellows, so cruelly mutilated and suffer-
ing.' Photographs of a number of the men were
placed in the same album as the portraits of
their more fortunate fellow soldiers.

Reference
1. RA Queen Victoria's Journal: 16 April 1856.

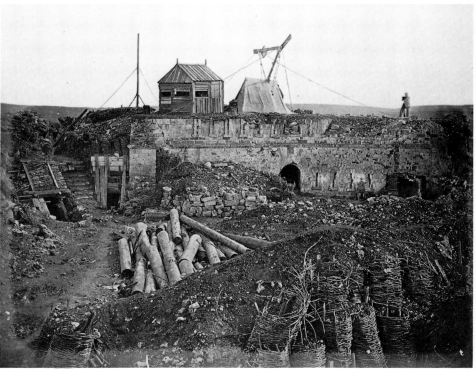

108.
Tower of the Malakoff
By James Robertson
28.9x23.6cm
Salted paper print

xiv.
British graves in the Crimea
By James Robertson
28.6x24.5cm
Salted paper print

109.
Breach in the Redan
By James Robertson
29.1x20.5cm
Salted paper print

xiv, 108, 109. These three photographs are from a set of 150 views taken by Robertson in the Crimea. Some of his Crimean photographs were exhibited at the Manchester Art Treasures Exhibition in 1857, and earlier, on 28 February 1856, the Prince of Wales refers in his diary to having seen 'Robertson's Photographs of the Crimea and Constantinople at Mr Kilburn's'.

xv.
Greenwich Pensioners, 1854
By John Havers
28x18.4cm
Carbon print made by Mullins, 1893

The Royal Hospital at Greenwich was opened in 1705 for veterans of the Navy. Queen Victoria and Prince Albert visited it on 27 June 1840: 'we were rowed down the river to Greenwich, getting there before ½ p. 12 ... Greenwich is a beautiful place & it was a very interesting sight, & I am so glad to have visited the Royal Hospital. In the Dining Halls, we tasted the soup prepared for the men, which was excellent.'[1]

After the passing of an Act in 1869, the pensioners were moved elsewhere, and the building was used to accommodate students of the Royal Naval College at Greenwich, which came into being in 1873.

Reference
1. RA Queen Victoria's Journal.

xvi.
Last survivors of Waterloo at the Royal Hospital, Chelsea, June 1880
1. Naish Hanney, 7th Hussars, aged 88. Served in the Peninsula. Present at Waterloo.
2. John McKay, 42nd Regiment, aged 95. Wounded at Badajoz. Wounded at Waterloo.
3. Benjamin Bumstead, 73rd Regiment, aged 82. Present at Waterloo, 18 June 1815.
4. Robert Norton, 34th Regiment, aged 90. Served in Germany, Holland and France.
5. Sampson Webb, 3rd Foot Guards, aged 82. Present at Waterloo, 18 June 1815.
May be by Charles Hinxman
15.1x9.1cm
Albumen print

The Royal Hospital, Chelsea, had been founded in 1682 by King Charles II, as a retreat for veterans of the regular army who were no longer fit for duty, either after having served for twenty years, or as a result of wounds. Queen Victoria and Prince Albert visited the hospital in 1840, and the Prince inspected the pensioners on parade in Hyde Park in 1847. The Queen maintained an interest in the hospital: when in 1882, a Committee of Enquiry was set up to consider changes similar to those carried out at Greenwich Hospital, she expressed a hope that there would be no question of abolishing the hospital.[1]

Reference
1. RA E29/166, 28 January 1882.

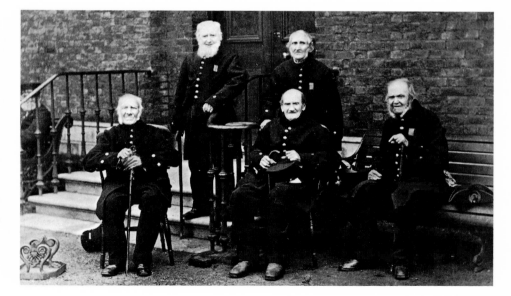

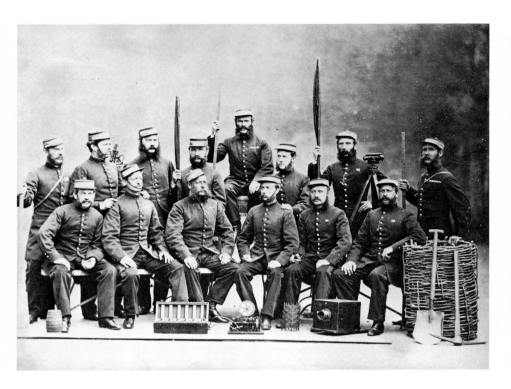

xviii, 116, 117. Three photographs from an album recording the progress of the Peshawar Valley Field Force in 1878–9, during the second Afghan War. In the late 1870s Britain and Russia were each trying to establish political influence in Afghanistan. In 1878 the Russian government sent an envoy to Kabul to make a treaty with the Amir, who refused to see a British mission which was to be dispatched from India at the same time. When the British envoy was turned back at the Afghan frontier, hostilities were declared by the Viceroy of India and the second Afghan War began. Three separate British forces converged on Afghanistan and the Amir fled into the northern province, where he died in February 1879. During the next six months, desultory fighting between British and Afghan troops failed to achieve any definite results. Meanwhile, the Amir had been succeeded by one of his sons, Yakoob Khan, and the Treaty of Gundamuck, establishing British influence in Afghanistan, was signed by him and Major Louis Cavagnari, the political agent at the headquarters of the British army, on 26 May. Cavagnari, who was knighted for his part in securing the treaty, was sent to Kabul as the British envoy in July. His reception was friendly but in September several Afghan regiments mutinied, attacked the British Embassy and massacred Cavagnari with his staff and escort, thus making a resumption of hostilities between Britain and Afghanistan inevitable.

xvii.
The Staff Sergeants, Royal Engineers, Chatham,
1868
Photographer unknown
24.9x19cm
Albumen print
 The Royal Engineers were often employed as photographers during military campaigns. On 17 May 1854 Queen Victoria and Prince Albert, with their two elder daughters, visited Gore House 'to see the progress of the Students' department of Practical Art. It is in fact an Exhibition of drawing patterns of all kinds, as well as of modelling & photography. Some of the Sappers & Miners are practising photography there, before being sent out to the East.'[1] On 17 December 1857, Prince Albert went to see a lithographic press run by an Engineer officer in Southampton. Among the military material in the Photograph Collection are seven photographs taken in China in 1868 by Corporal Wotherspoon of the Royal Engineers.

Reference
1. RA Queen Victoria's Journal.

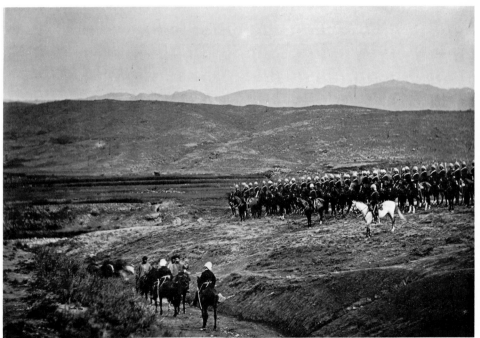

xviii.
Meeting of Cavagnari and Yakoob Khan before the Treaty of Gundamuck
By J. Burke
28.8x21.1cm
Albumen print

116.
Officers of the 51st, the King's Own, Light Infantry Regiment
By J. Burke
29x23.3cm
Albumen print

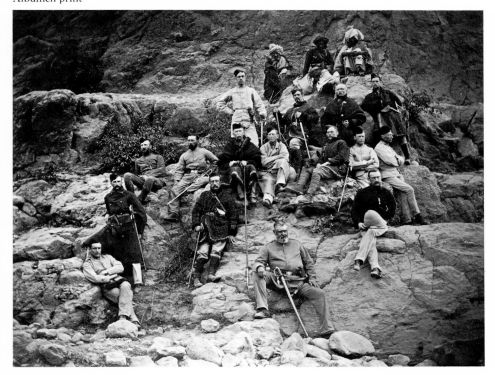

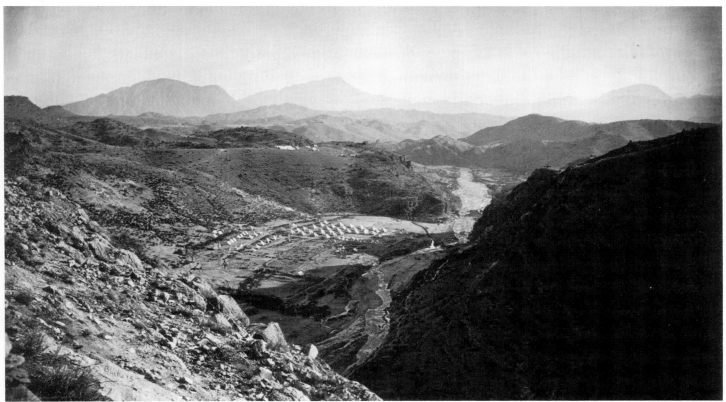

117.
Shahgai heights and our camp from the Fort
By J. Burke
31x17.9cm
Albumen print

xix.
The Ship's Company of H.M.S. *Serapis*
By Westfield & Co.
27.7x20.8cm
Albumen print

xix, xx. These photographs come from an album of groups, views and portraits presented to the Prince of Wales by the Captain and officers of H.M.S. *Serapis* in remembrance of his voyage to India and back in the ship in 1875–6. The Prince embarked on the *Serapis* at Brindisi on 16 October 1875, when she was escorted by the frigates *Hercules* and *Pallas*, with the Royal Yacht *Osborne* in attendance, and he returned home in her in May 1876, escorted by the frigate *Raleigh* and attended by *Osborne*.

xx.
The R.M.L.I. Band, Portsmouth Division, embarked on board H.M.S. *Serapis*. **Mr C. Kreyer, Bandmaster**
By Westfield & Co.
27.6x21.2cm
Albumen print

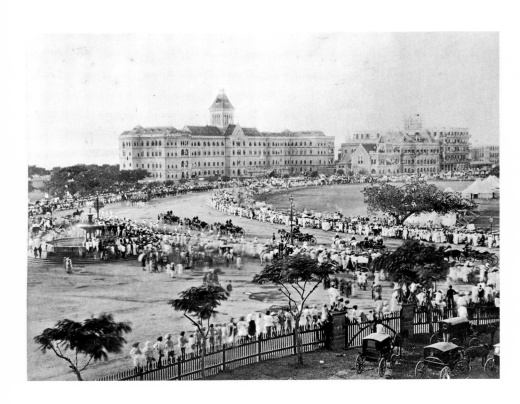

xxi.
Arrival of the Prince of Wales at Bombay, 8 November 1875
Photographer unknown
28x21.3cm
Albumen print
xxi, xxii, 61–6. See p. 90.

61.
Ceylon. One of the Arches erected in Kandy for
H.R.H. the Prince of Wales, 1875
Photographer unknown
21.2x27.5cm
Albumen print

62.
Royal Yacht *Osborne* in Hooghly River, 22
December 1875
By Bourne & Shepherd
26.1x19.3cm
Albumen print

63.
Madras Fishermen
Photographer unknown
25.2x20.3cm
Albumen print

xxii.
a. **Pathan Chiefs**
13.4x9.4cm
b. **Beloochie Chiefs**
13.3x9.5cm
c. **Yarkund Shooting Pony**
13.4x9.5cm
d. **H.R.H.'s Charger, Coomassie**
12.8x8.9cm
By Bourne & Shepherd
Albumen prints

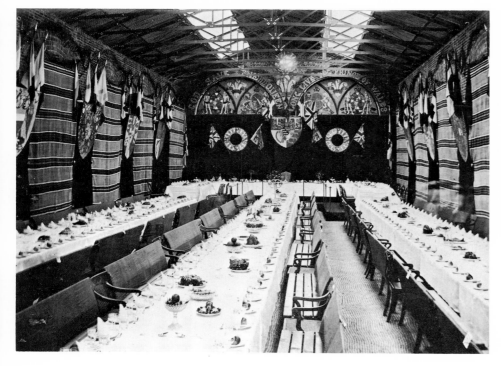

66.
Banquet in the Railway Station, Wuzeerabad,
1876
Photographer unknown
28.3x21.5cm
Albumen print

64.
The Maharanee Jumabai of Baroda
By Bourne & Shepherd
23.5x26.8cm
Albumen print

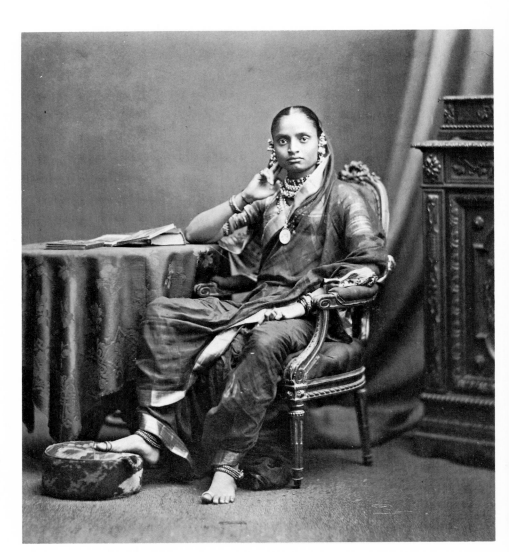

xxi, xxii, 61–6. By his own wish, the Prince of Wales made a tour of India from 8 November 1875 until 13 March 1876. During his stay he received and visited many Indian princes and officials, held receptions and levées (including an investiture of the Order of the Star of India) and went on hunting and sightseeing expeditions. This tour, carried out with the Prince's customary tact, courage and ease of manner, to the satisfaction of Indians and British alike, showed him as a symbol of British rule who was worthy of respect and admiration, preparing the way for the proclamation of Queen Victoria as Empress of India later in 1876.[1]

As a result of the visit, six photograph albums were compiled of portraits, groups and views. Some of the photographs were commercial prints already available; others were specially taken to commemorate the tour. There seems to be no evidence that the Prince took a photographer from England with him in his suite, as he had done in 1862, but, according to the *British Journal of Photography*,

> The Athenaeum says that the Prince of Wales's visit to India will give birth to a novelty in the shape of 'specials'. It is said that Messrs Bourne and Shepherd, the best known of Indian photographers, will depute the chief of their staff to accompany His Royal Highness throughout his tour through India. This 'photo-special' will be assisted by a large number of skilled native photographers, who hope in concert to produce a perfect panorama of the royal progress.[2]

References
1. See **King Edward VII** by Sir Philip Magnus (1964).
2. **British Journal of Photography**, 8 October 1875.

65.
The Maharajah Holkar of Indore, G.C.S.I.
By Bourne & Shepherd
21.8x27.6cm
Albumen print

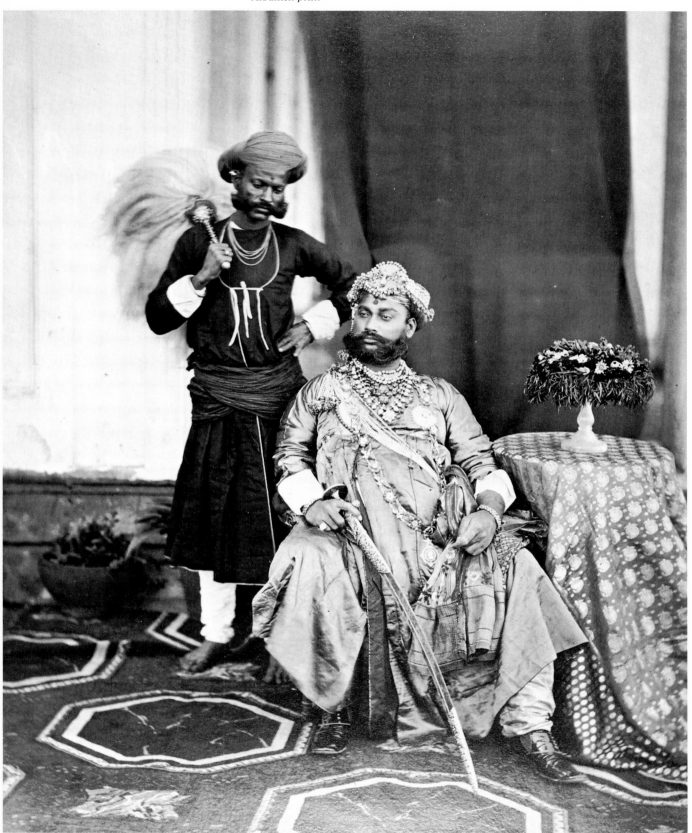

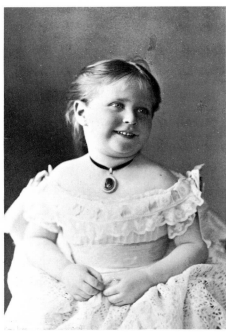

xxvi (opposite).
Ernest Louis, Hereditary Grand Duke of Hesse (centre), **Prince George of Wales** (right) and **Prince Alfred of Edinburgh, Coburg,** April 1890
By E. Uhlenhuth
9x14cm
Albumen print

Three of Queen Victoria's grandsons, in a light-hearted group, taken probably on 1 April 1890, when Prince George noted in his diary that 'we three went . . . & were photographed in various groups at the photographers.' The young Princes were staying at the Palais Edimbourg in Coburg, the residence of Alfred, Duke of Edinburgh, and his family. The Duke of Edinburgh later succeeded his uncle, Ernest II, as Duke of Saxe-Coburg-Gotha. His son, also Prince Alfred, can be seen on the left of the photograph. Ernest Louis, Hereditary Grand Duke of Hesse, the only surviving son of Princess Alice (Queen Victoria's second daughter), later married the Duke of Edinburgh's second daughter, Princess Victoria Melita. Prince George, younger son of the Prince of Wales, became second in line to the throne on his brother's death in 1892 and succeeded his father as King George V in 1910.

xxiii.
Prince Ernest Louis of Hesse, November 1871
By Hills & Saunders
5.7x8.7cm
Albumen print

Prince Ernest Louis, elder son of Princess Alice and Prince Louis of Hesse, taken by a Windsor photographer during a visit to England with his family. At this time his mother was at Sandringham, helping to nurse her brother, the Prince of Wales, then seriously ill with typhoid fever.

xxiv (top right).
Princess Alix of Hesse, May 1875
By Hills & Saunders
5.8x9cm
Albumen print

The fourth daughter of Prince and Princess Louis of Hesse stayed in England with her family during the summer of 1875. Princess Alix is said to have had beautiful colouring and large deep blue eyes: she was known as 'Sunny' to her family. Her grandmother, Queen Victoria, attempted a sketch of 'dear beautiful amusing little Alix' on 9 May, but she 'sat very badly'.[1]

Reference
1. RA Queen Victoria's Journal.

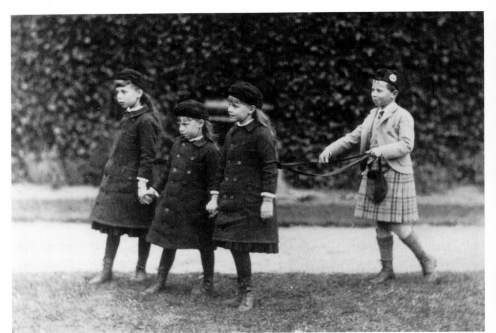

xxv.
Prince Alfred and Princesses Marie, Victoria Melita and Alexandra of Edinburgh, September 1884
By W. Watson
13.2x9cm
Probably a gelatine silver print

The son and three of the daughters of the Duke and Duchess of Edinburgh: Princess Marie is on the right of the foreground group, Princess Victoria Melita on the left and Princess Alexandra in the centre.

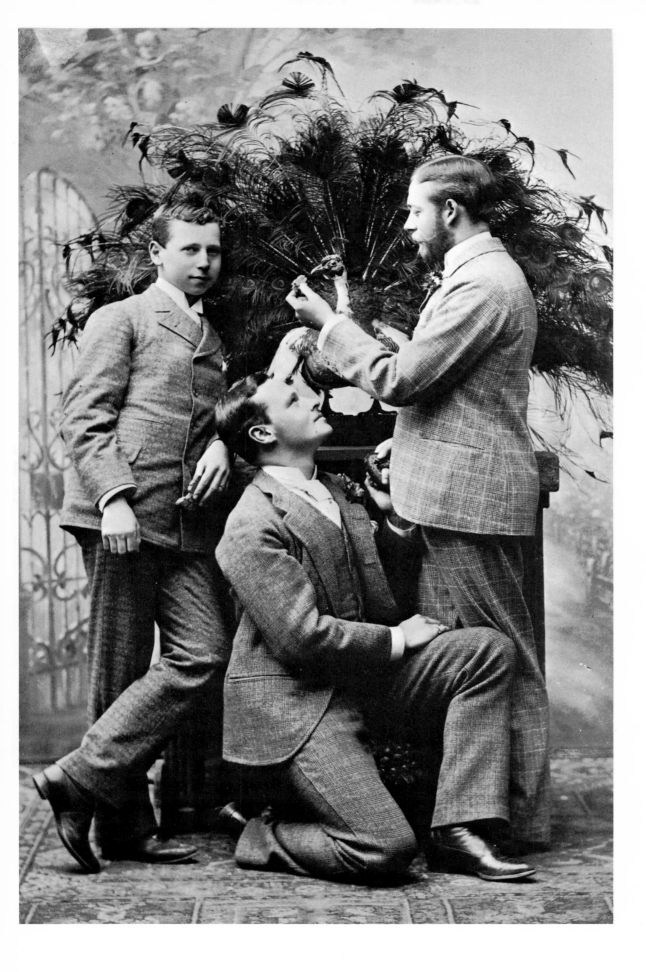

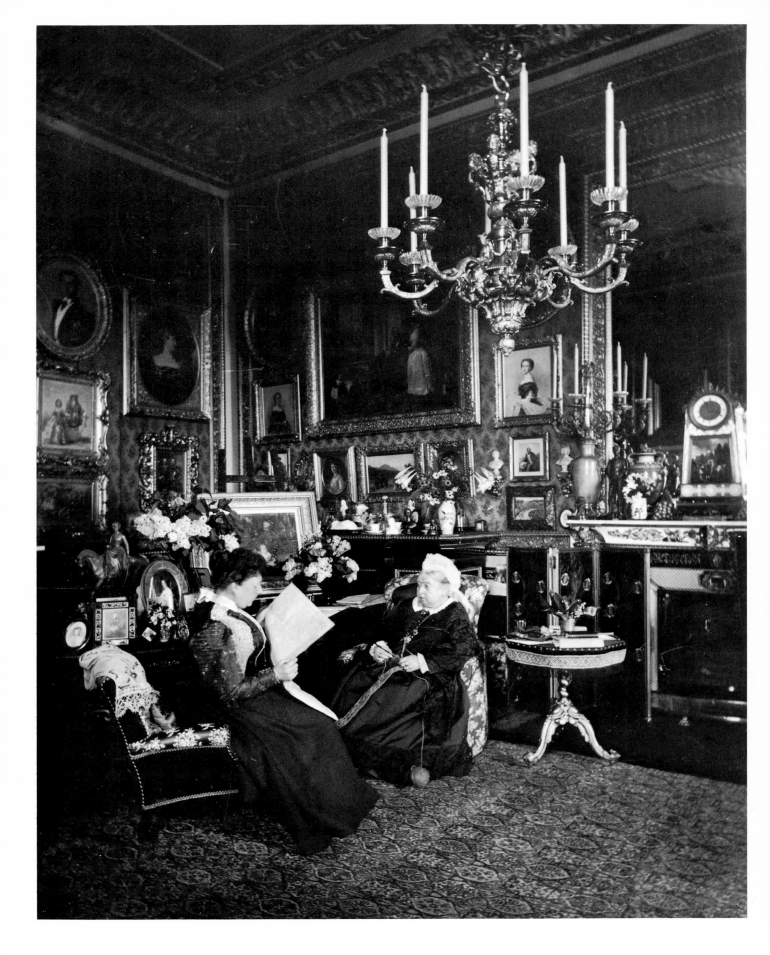

xxvii (opposite).
Queen Victoria and Princess Beatrice in the Queen's Sitting Room, Windsor Castle, 1895
By Mary Steen
17x22.5cm
Probably a gelatine silver print
 This photograph was taken after breakfast on 21 May 1895, by a Danish photographer who had been specially recommended by the Princess of Wales, herself a Danish Princess.

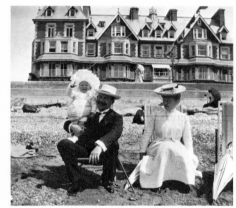

xxix
Constantine, Duke of Sparta, with his wife, Sophie, Duchess of Sparta, and younger daughter, Princess Irene of Greece, Seaford, July 1905
By Princess Victoria
8.3x7.7cm
Printing out paper
 This is one of a number of snapshots taken by Princess Victoria (probably with a No. 2 Bull's-Eye Kodak camera) between 12 and 14 July 1905, when she was visiting Seaford with her cousins, the Duke and Duchess of Sparta (later King Constantine I and Queen Sophie of the Hellenes), and their children. The Duchess of Sparta's sister, Margaret, Princess Frederick Charles of Hesse-Cassel, was also of the party.

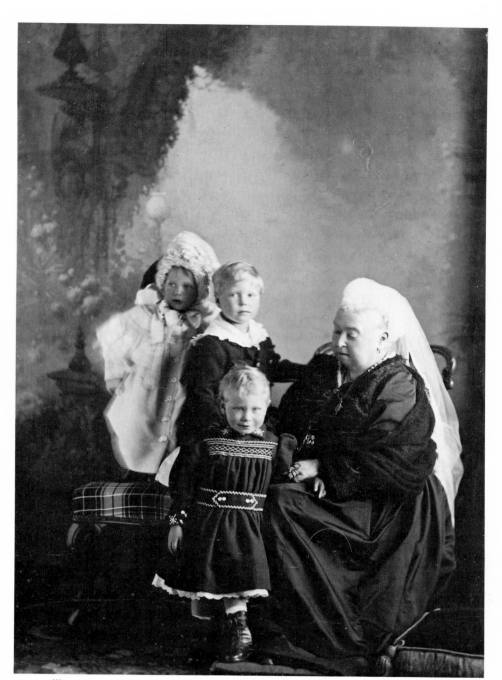

xxviii.
Queen Victoria with Prince Edward, Prince Albert and Princess Mary of York, Balmoral, September 1898
By Robert Milne
9.1x13.2cm
Enamelled albumen print
 The Queen with her great-grandchildren, the children of the Duke and Duchess of York. Prince Albert (later King George VI) stands in the foreground, with the future Duke of Windsor behind him.

1 (above).
The Royal and Imperial Visit to the Crystal Palace, 20 April 1855
By Hy. (Henry) Negretti & Zambra
19.3x14.2cm
Albumen print

Napoleon III, Emperor of the French, and his wife, Empress Eugénie, paid a state visit to England from 16 to 21 April 1855, at a time when England and France were fighting together as allies in the Crimea. The visit, which was a great success, and the return state visit to Paris by Queen Victoria and Prince Albert in August of the same year symbolized the alliance between two countries which had formerly been bitter enemies. During the Emperor and Empress's visit to England they were taken by their hosts to the Crystal Palace, the site of the 1851 Exhibition of the Works of all Nations, with which Prince Albert had been closely involved. The Palace had been moved from Hyde Park to Sydenham and reopened in June 1854. It was empty when the royal party arrived, so that they were able to go quietly through the Nave and all the Courts (that of the Alhambra particularly appealing to the Empress, who was partly Spanish), and to see the fountains play for the first time. Later, however, large crowds collected and the Queen reported in her Journal that 'we walked all through the Transept, where there were between 30 & 40,000 people assembled, cheering very loudly, & went on to a dais, where we sat down for a few minutes, & then left.'

2.
The Queen at the Manchester Exhibition of Art Treasures, June 1857. **The Address**
By Alfred Brothers
24.4x19.5cm
Albumen print
Illustrated on p. 41

This photograph was one of two taken by Brothers during the royal visit to Manchester. Several of his photographs were on display in the Exhibition, and he was asked by Alderman Agnew (of the firm of fine-art publishers) to take some photographs while the royal party was in the building. This proved unexpectedly difficult, as, having left his camera, with prepared wet collodion plates, in the correct position up some stairs at the corner of the galleries facing the platform, Brothers found it impossible to get back to it when the royal party had arrived and the way up the stairs was blocked by people who refused to let him through. Luckily, he found a ladder and was able to climb over the railing in time to reach his camera and expose the plates, making two successful pictures, one while the Town Clerk was reading his address, and one while the Queen was making her reply. Copies of both were later presented to the Queen.

Reference
Memoirs of Alfred Brothers (City of Manchester Cultural Services Department).

3.
Princess Beatrice taking her first ride on her second birthday, 14 April 1859
By Caldesi
16x13.4cm
Albumen print

Princess Beatrice, the youngest child of Queen Victoria and Prince Albert, spent her second birthday at Buckingham Palace, and her mother wrote an account of the day in her Journal:

> ... We went to fetch her from the school-room, where she stood with 2 nosegays in her hand, surrounded by her sisters, looking a great duck in a little pink silk frock, with her little curls so nicely arranged ... Baby was delighted with her toys, running about with a Pussy, she called a rabbit. After breakfast watched Lenchen & Louise being photographed in their costumes, then Baby, on her pony, – on her 1rst. ride.

Princess Beatrice later had a party of four little girls of her own age, and they 'ran about in the Lower Corridor, after their supper & had great fun together.'

4.
The Queen, the Princess Royal, Princess Alice and the Prince of Wales, Windsor, 10 February 1857
By William Bambridge
20.9x15.7cm
Albumen print

This group was taken before luncheon on the seventeenth wedding anniversary of Queen Victoria and Prince Albert. Earlier in the day the royal couple had been greeted by their children in honour of the occasion:

> We went into our sitting-room, where the 7 Children were assembled, all in different costumes, Vicky, in the mother's dress from 'Little Red Riding Hood', Bertie & Alice in the costumes of James V and his Queen, from last year's Tableau, all the others in costumes worn before. Vicky gave me a magnificent bouquet with white flowers, which the good Child had taken such trouble to get for me, & a lovely drawing: 3 fairies, representing an orange flower, lilac, rose & forgetmenot. She & Alice also gave their Papa drawings & the latter gave me a bouquet, – Louise a drawing, – her 1rst. production. Arthur had specially written out the dates of the Kings.[1]

Reference
1. RA Queen Victoria's Journal: 10 February 1857.

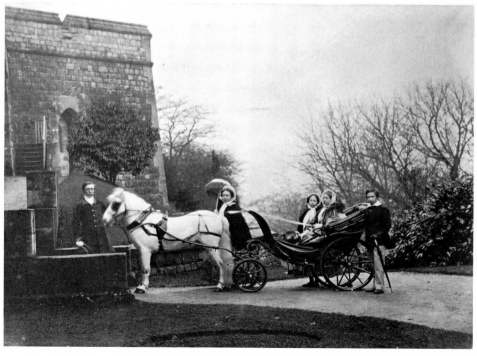

5.
Prince Arthur, 1857
By Caldesi
14x18.5cm
Albumen print

Prince Arthur, later Duke of Connaught, the third son of Queen Victoria and Prince Albert, enjoyed a long life of distinguished military and public service. He shared his birthday, 1 May, with his godfather, Arthur Wellesley, first Duke of Wellington, and his predilection for the Army was encouraged from an early age. He was given drumming lessons by a succession of Army drummers: his mother noted in July 1856 that he had 'got on splendidly with his drumming & his new master was very happy today at having been promoted to the Band, & appeared in a gold embroidered tunic!'[1]

Reference
1. RA Queen Victoria's Journal: 15 July 1856.

6 (opposite).
The Princess Royal (left) **and Princess Alice,** 1855
By Roger Fenton
28.1x33.8cm
Albumen print

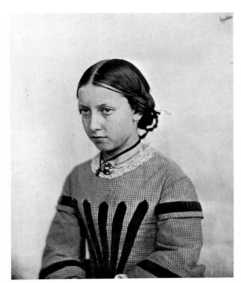

8.
Prince Alfred, probably taken in 1855
By Roger Fenton
26.1x31.4cm
Albumen print

7.
Princess Louise, April 1859
By Caldesi
14.5x18cm
Albumen print

9.
Princess Helena, April 1859
By Caldesi
14.4x18.1cm
Albumen print
 7, 9. Companion portraits of the third and fourth daughters of Queen Victoria and Prince Albert. Princess Helena later married Prince Christian of Schleswig-Holstein in 1866, while Princess Louise became the wife of the Marquess of Lorne in 1871.

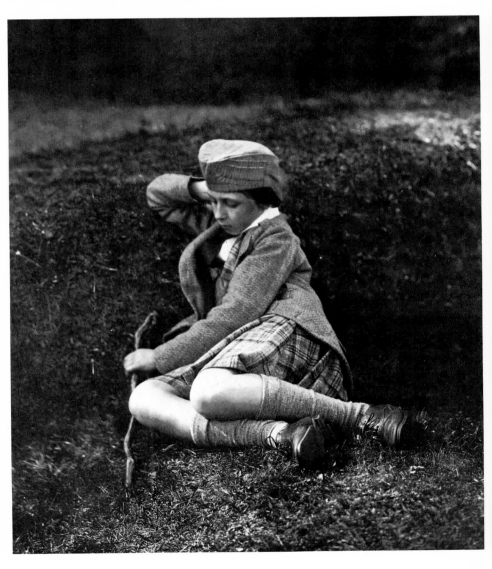

10.
Princess Helena (right) **and Princess Louise,**
probably taken in 1855
By Roger Fenton
29.1x34.7cm
Albumen print

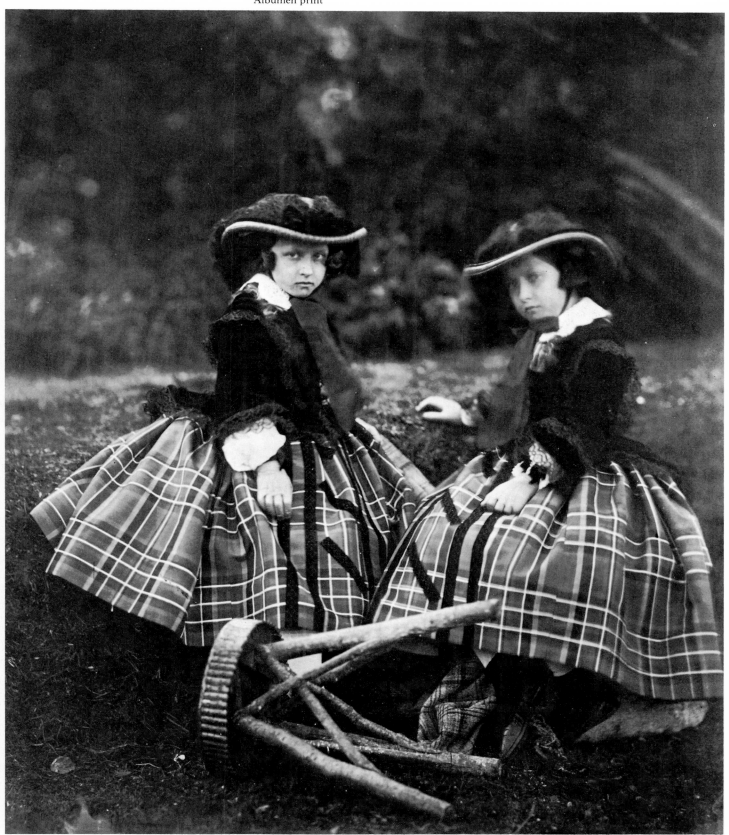

11, 12.
Two views of the Great Chartist Meeting on Kennington Common, 10 April 1848
By W. E. Kilburn
(11) 14.2x10.1cm; (12) 13.7x10.7cm
Daguerreotypes
Illustrated on on p. 26

Few public events in early Victorian England caused so much concern to the authorities as the Great Chartist Meeting. The Chartists (so called because they had drawn up a Charter of six points) were campaigning for electoral and parliamentary reforms, most of which were subsequently carried out and which would now be taken for granted, such as payment for Members of Parliament, the abolition of the property qualification for them, manhood suffrage and voting by ballot. However, they were seen by many of their contemporaries as a dangerous threat to the established order, and as riots were expected at the time of the meeting, the Royal Family was advised to leave London. As it happened, the meeting was far less well attended than had been expected, it started to rain, and the crowd was soon dispersed. When a petition bearing nearly two million signatures, of which many were found to be fictitious, was presented by the leaders to Parliament, the movement was exposed to ridicule and the reforms being sought were delayed for longer than might otherwise have been the case.

Kilburn made two daguerreotypes of the scene, from which engravings were made to illustrate press reports. The daguerreotypes themselves, probably among the earliest photographs ever taken of a public meeting, were acquired by Prince Albert, who was deeply concerned about the condition of working people, although he deplored the Chartists' violent means of seeking reform.

13.
Viscount Gough, 1850
Photographer unknown
6.5x8.9cm
Daguerreotype

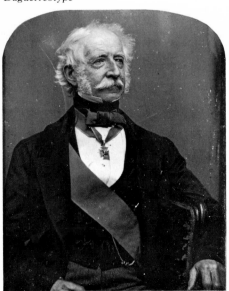

Field Marshal Sir Hugh Gough, first Viscount Gough, who in this portrait is wearing the Army Gold Cross and the broad riband of a G.C.B., was said to have commanded in more general actions than any other British officer in the nineteenth century, except the Duke of Wellington. He was of Irish birth and descent and first became a soldier in his fourteenth year, when he received a commission in the Limerick city militia in 1793. From there he progressed upwards through several regiments, taking part in actions in Southern Africa, the West Indies and the Peninsular War. He was commissioned as a Lieutenant-Colonel after the Battle of Talavera in 1809, when he was serving with the Second Battalion of the 87th Regiment (later the Royal Irish Fusiliers). This battalion, with Gough in command, joined Wellington's army in October 1812 and was present at the Battle of Vittoria. Gough was knighted in 1815 at the close of the Napoleonic Wars. After his battalion was disbanded in 1817, he commanded another regiment in Ireland from 1819 to 1826. In 1830 he became a Major-General, and seven years later he was appointed to command the Mysore division of the Madras army. In 1841 he was sent from India to China to command the troops at Canton during the first China War in operations which ended with the capture of Chingkeang-foo and the signing of the peace treaty at Nanking. Gough was made a baronet and returned to India, where he was appointed Commander-in-Chief in 1843. After several controversial battles, Gough finally re-established his reputation by defeating the Sikh armies at Goojerat in 1849 and returned to England in the same year. In 1855, after the death of Lord Raglan, he was made Colonel of the Royal Horse Guards, and in 1856 he was sent on a special mission to Sevastopol. By 1862 he had become successively a viscount, a general, a Knight of the Order of St Patrick, a privy councillor and a field marshal.

Gough was said to be a man of 'singularly noble presence', with a generous nature and great courage. Sir Charles Napier, who took over his command in India, wrote that 'Everyone who knows Lord Gough must love the brave old warrior, who is all honour and nobleness of heart.' In 1842 Queen Victoria noted in her Journal for 18 August that she had read to Prince Albert 'despatches from Sir Hugh Gough giving very interesting accounts of our victories in China & of the gallant behaviour of our troops, both military & naval.' She met Gough on several occasions and seems to have been impressed by his youthful appearance, writing on 1 March 1850, when he was seventy, that 'he is very young & active looking for his age',[1] and on 1 November 1861, when he was two days away from his eighty-second birthday, that 'he does not look more than 70.'[2] On this last occasion Gough had come to Windsor Castle from Ireland on purpose to attend the first investiture of the Order of the Star of India, when he was the first non-royal knight to receive the Order from the Queen. He died eight years later, when he was nearly ninety.

References
1, 2. RA Queen Victoria's Journal.

14 (opposite).
Mademoiselle Jenny Lind, 1848
By Kilburn
9.1x11.6cm
Daguerreotype

Johanna Maria Lind (1820–87), the Swedish soprano, nicknamed 'The Swedish Nightingale', made her London début at Her Majesty's Theatre on 4 May 1847 in *Robert le Diable*. Her performance was a complete triumph, and the audience, which included Queen Victoria, was enraptured. The Queen wrote in her Journal that 'she has a most exquisite, powerful, & really quite peculiar voice, so round, soft & flexible & her acting is charming & touching & very natural. Her appearance was very ladylike & sweet & though she is not beautiful, she has a fine tall figure, is very graceful, has fine blue eyes & fine fair hair.' Two days later, when the Queen and Prince Albert were in conversation with the Queen's singing teacher, Lablache, he told them that Jenny Lind had been 'in a dreadful state of alarm, before her 1rst. appearance, but he had encouraged & reassured her.'[1] During the next few years the Queen and Prince Albert heard Jenny Lind many times, including several occasions when she sang for them at Windsor Castle. Queen Victoria described one such performance on 17 January 1849, when 'she came to my room, & I feel quite proud that she played on my piano, & sang from my own music ... She sang 1rst. one of her Swedish songs, 2nd, 'Das erste Veilchen', which is so lovely, 3rd. Taubert's 'Wiegenlied', & 2 of Mendelssohn's songs, finishing up with that delightful simple little song by Taubert 'Ich muss einmal singen', which has been composed on purpose for her. All the songs she sang at my request.'[2] Jenny Lind told the Queen and Prince Albert that she had begun 'singing & playing at 2 years old', and also that she had decided to retire from the stage, which she found distasteful. Her farewell performance (as Alice in *Robert le Diable*) was given on 10 May 1849, when she was not yet twenty-nine: she then embarked on a career as a recitalist and oratorio singer. In 1852 she married her accompanist, Otto Goldschmidt, and they settled in England. Queen Victoria heard her sing on several occasions after her retirement from the stage.

The daguerreotype, which is one of two portraits of Jenny Lind by Kilburn, was shown with other daguerreotypes by him in the photographic section of the Great Exhibition in 1851, when it elicited a comment later published in the *Reports by the Juries*:

> For novelty of design we may mention a small picture of the interior of a room, including a whole-length portrait of Jenny Lind: beside, and near her, is a large mirror, in which the figure is reflected. That the reflection in the glass is equally perfect with the original is the point worthy of remark and commendation ... The Jury awarded a Prize Medal to Mr Kilburn.

References
1, 2. RA Queen Victoria's Journal.

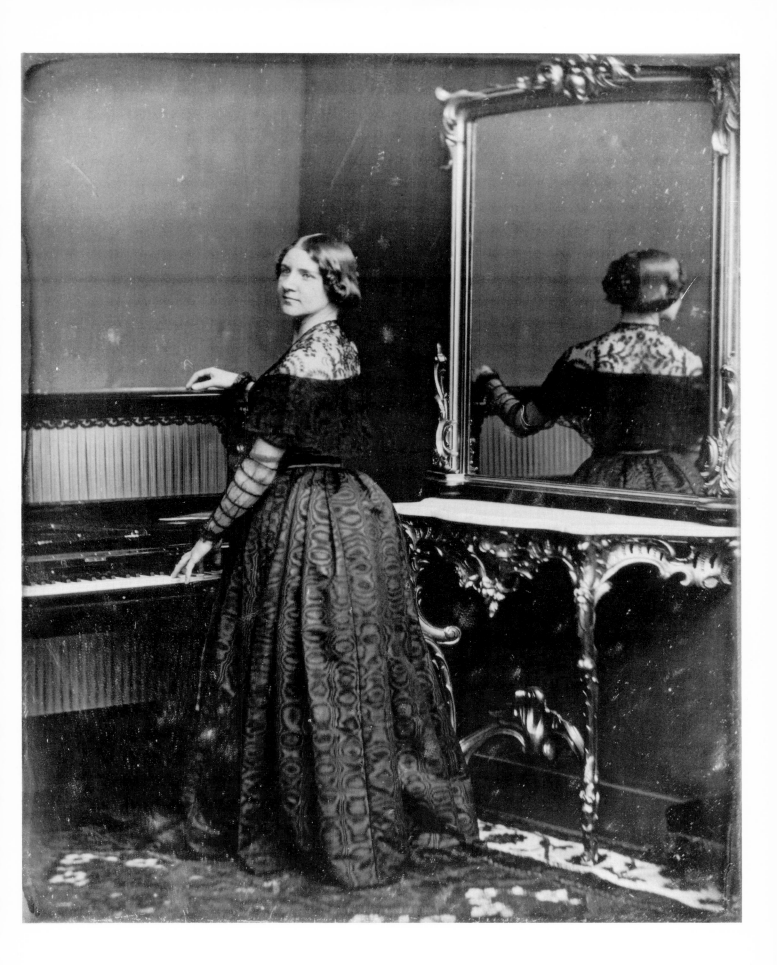

15.
The Prince of Wales (left) **and Prince Alfred**, 1852
By Brunell
8.7x11.3cm
Daguerreotype

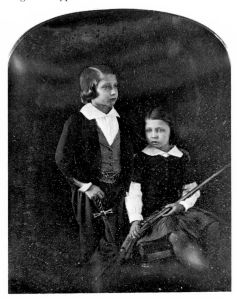

19.
The Princess Royal (left) **and Princess Alice**, 1852
By Brunell
8.3x11cm
Daguerreotype

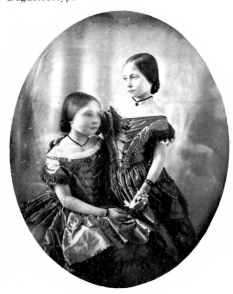

15, 19. Two daguerreotypes of the royal children, made by the Windsor photographer Brunell in 1852. There were originally two versions of the picture of the Princesses; one, described as 'imperfect', is probably the one that remains. Brunell also made daguerreotypes of Princess Helena, Princess Louise and the Duchess of Kent in the same year.[1]

Reference
1. RA Vic. Add. MSS C4/2, list of daguerreotypes belonging to the Queen.

16.
Signor Mario, 1851
Photographer unknown
5.6x6.9cm
Hand-coloured daguerreotype

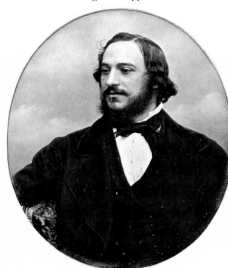

Giovanni Matteo Mario, Cavaliere de Candia, the Italian tenor, was 'a gentleman who has taken to the stage'. He made his London debut as Gennaro in Donizetti's *Lucrezia Borgia* on 6 June 1839 and was seen in that role by Queen Victoria two days later: she found his voice 'very fine and full of feeling' and noticed that he was 'tall, quite young and very handsome'.[1] During the next twenty-eight years the Royal Family heard Mario on many occasions, sometimes at Covent Garden, where he sang from 1847, and sometimes in concerts performed at Buckingham Palace. The last time the Queen heard him sing was at the ceremony to mark the laying of the foundation stone of the Horticultural Hall on 20 May 1867, when he 'sang his solo beautifully'.[2] Mario, whose stage partner, Giulia Grisi, with whom he acted for twenty years, was another of the Queen's favourite singers, retired in 1871. On 15 December 1883, the Queen was

> much grieved to hear of poor Mario's death, which occurred on the 13th. He was 73. He was the greatest Tenor that ever existed, & had a most heavenly, rich, full voice ... & sang with such feeling. Who could ever forget him as Gennaro in 'Lucrezia Borgia', or as the Prophète, in which he looked so magnificent in the Coronation scene. But above all, his rendering of Raoul in the 'Huguenots'. That duet with Valentine, given by him & poor Grisi (she, also gone) was the finest thing possible ... We used to go again & again to the Opera, only for that scene. He died of inflammation of the lungs. We heard the news through Mr Cusins, & I had him telegraphed to, to attend the funeral, & place a wreath from me. Mr Cusins saw Mario, the day before his death, & he still sent me a message.[3]

References
1–3. RA Queen Victoria's Journal.

17.
Two portraits of Prince Albert, 1842
Attributed to William Constable
a. Oval portrait, 3.8x5.1cm (carbon print)
b. Oblong portrait, 3.9x5.2cm (carbon print)
3.8x5.1cm (daguerreotype)
Illustrated on p. 10

On Monday, 8 November 1841 (by coincidence the day before the birth of the Prince of Wales), William Constable's studio, the Photographic Institution, which was one of the eight operated under licence by Beard, opened at 57, Marine Parade, Brighton. Constable was a man of widely varying interests and abilities, both scientific and artistic (he became renowned for some watercolours of American scenes), who had devoted himself to photography. He enjoyed experimenting with this medium, and it is known that he attempted cross-lighting effects in his work, as well as other innovations. His establishment had been in existence only three months when Queen Victoria, Prince Albert and the Court came to take up residence at the Royal Pavilion on 10 February 1842. It is probable that the Prince soon became aware of Constable's studio on arriving in Brighton, if he had not heard of it before. On 25 February a young man called at the Photographic Institution and had his portrait taken, but it was not until a servant came in the evening to collect the picture that Constable discovered that his customer had been the Prince's Private Secretary, George Anson. Just over a week later, on 5 March, the Prince himself came unannounced to the studio, accompanied by two German cousins. According to Constable's sister, Mrs Susanna Grece, the day was 'an unlucky one for portrait taking'. Constable's two assistants were unwell, and the Princes 'like others this day could not get a good picture.' The German cousins were not deterred, however, and Prince Ferdinand of Saxe-Coburg, with his sons, Princes Augustus and Leopold, came back the next day: the *Sussex Advertiser* reported in its Court column on 14 March that they had 'expressed their astonishment at the rapidity of the process and the fidelity of the likenesses.' The fate of these portraits is not known. On 7 March Prince Albert returned to the studio 'in the afternoon to be photographed. He had eight pictures not all good.' It is almost certain that the oblong portrait of the Prince, dated February [sic] 1842, is one of these eight: the oval portrait may be another, or it may be one of those taken at Beard's main studio in London later in March. It seems likely that the other daguerreotypes made on these occasions were discarded as failures: if they had survived as long as the two in question they would probably have been copied at the same time. Whatever the case, these two remaining images would appear to be the earliest surviving photographs of a member of the Royal Family.

Reference
I am indebted to Philippe Garner for information relating to William Constable.

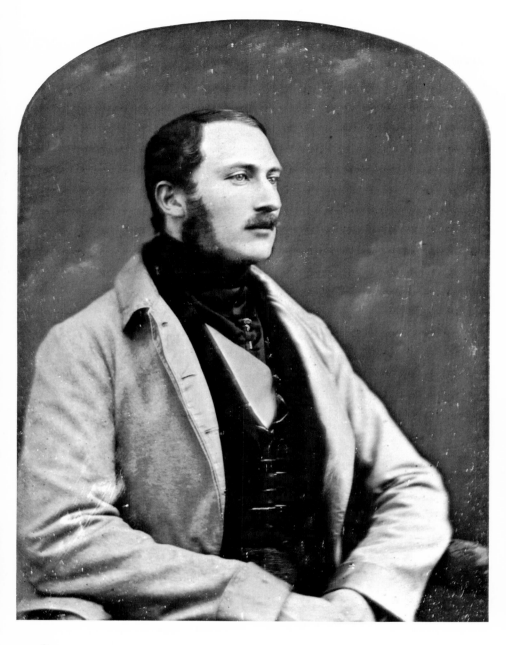

18.
Prince Albert, 1848
By W. E. Kilburn
6.3x8.7cm
Hand-coloured daguerreotype
One of a pair of portraits of Prince Albert, taken when he was in his twenty-ninth year. Comparison of this portrait with those taken in 1842 shows an improvement in technique and a greater formality, which results in a photograph not unlike a traditional miniature painting.

19.
See **15** (opposite).

20.
Victoria, Princess Royal, in her wedding dress, Buckingham Palace, taken just before the ceremony on 25 January 1858
By T. R. Williams
Image approximately 2.8x3.5cm. Case 8.8x4.9cm (when open)
Hand-coloured copy print from a daguerreotype
Illustrated on p. 19
This picture was one of two made by Williams to mark the occasion of the Princess Royal's marriage to Prince Frederick William of Prussia. The Queen noted in her Journal that 'Vicky was daguerreotyped in my room, & she & her dear father & I, together, but I trembled so, that it has come out indistinct.'

21.
Queen Victoria, Princess Mary, Duchess of Gloucester, the Prince of Wales and Princess Alice, Gloucester House, June 1856
By Antoine Claudet
5.2x6.4cm
Hand-coloured daguerreotype

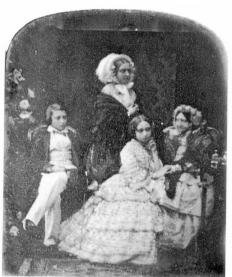

Queen Victoria, accompanied by two of her children, visited her aunt, the Duchess of Gloucester, on 30 June 1856. She recorded in her Journal that she 'went in the afternoon to Gloucester House & was daguerreotyped with dear Aunt Gloucester, Bertie & Alice, several times.' The Duchess, who was the last surviving child of King George III, died on 30 April 1857.
By Claudet's request,[1] a notice to say that he had 'had the honour of daguerreotyping a group at Glocester-house [sic] on Monday' was included in the Court Circular for 2 July 1856. At least four daguerreotypes were made by him on 30 June.

Reference
1. RA PP Add. Vic. 46/June 1856.

22.
Balmoral Castle, from the north-west
By George Washington Wilson
6.9x7.4cm
Albumen print

22, 39. After several visits to Scotland in the 1840s, Queen Victoria and Prince Albert decided to establish a permanent residence there. The lease of the Balmoral estate was acquired in 1848, and Prince Albert finally took possession of the property in 1852. However, the existing castle soon proved too small for the Royal Family, and it was decided to build a larger one nearer the River Dee. The Prince was deeply involved in the designs for the new castle and grounds, and he and the Queen watched their progress with great interest. On 7 September 1853 they 'examined the new house, of which a great part is completed, in some parts 2 stories. The stone which is not to be "harled" (painted over white) is beautiful, – fine strong granite & so well turned & worked, but its great hardness makes it a very difficult job. Looked at the plans on the spot & the house will certainly be a charming one.'[1] On 1 October 1854 the Queen noted that her husband was 'much occupied with the exterior decorations of the Castle, or rather more with the laying out of the terraces & small flower gardens. He pointed it all out to me. The house will really be beautiful, – unlike anything of the kind.'[2] Before they left for Windsor later in the month, the Queen reflected that 'it was the last time we should live in the old house, which has been a good old friend. We went to the new house, Albert's favourite resort, whence the view is so very beautiful.'[3] A series of photographs recording the progress of the building was made by the firm of Wilson & Hay: in the one shown here, the fence has been used to create a foreground in what would otherwise have been a bare patch of earth. The second photograph is from an album of sixty-one prints by Wilson, which was arranged by the Prince Consort in 1860–61. It shows the completed castle and was originally intended as one half of a stereoscopic photograph: seen through a viewer, the well-defined foreground, middle distance and background would give a convincing impression of three-dimensional depth.

References
1, 2. RA Queen Victoria's Journal.
3. ibid.: 12 October 1854.

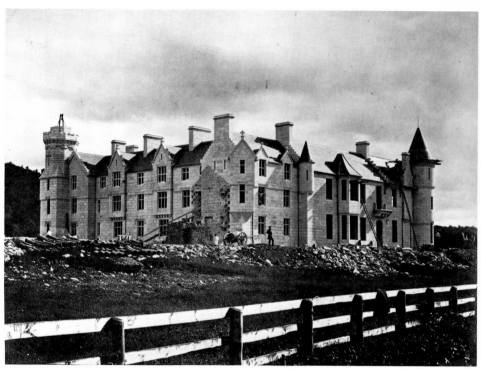

39.
The new Castle at Balmoral, June 1854
By Wilson & Hay
21.4x16.8cm
Albumen print

23.
The Prince of Wales and Prince Alfred with their companions, the Hon. V. Dawson, Frederick St Maur, Lord Arthur Clinton, Stanley Dawson, Maitland Dawson, John Athole Farquarson, Henry Farquarson and Charlie Phipps, in Buckingham Palace gardens, June 1854
By Dr E. Becker
12.4x9.6cm
Albumen print
The children of families with whom the Royal Family was on friendly terms were sometimes invited to the royal residences as companions for the young Princes and Princesses. On 24 June 1854, Albert Edward, Prince of Wales, wrote in his diary that 'in the afternoon the 2 Farquarsons, the 3 Dawsons, Charlie Phipps, St Maur, Arthur Clinton came to play with us.'

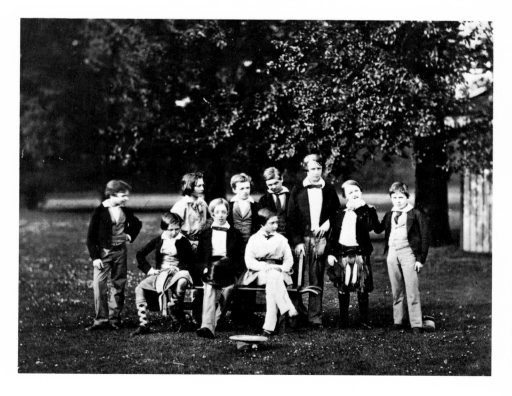

24.
Group of Prince Albert's 2 Jägers, McDonald and Cowley, and his Head Keeper, Turner, and some of the other Keepers, Beaters etc., Windsor, February 1852
By Brunell
10.9x8.4cm
Daguerreotype
 A group of keepers and beaters, taken by a Windsor photographer.

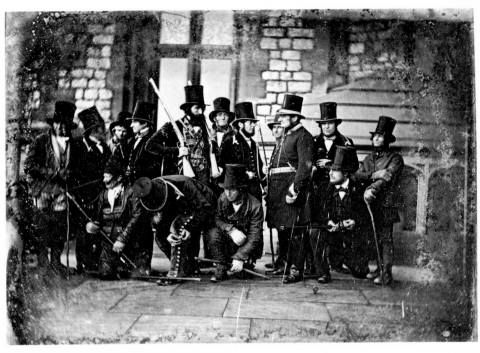

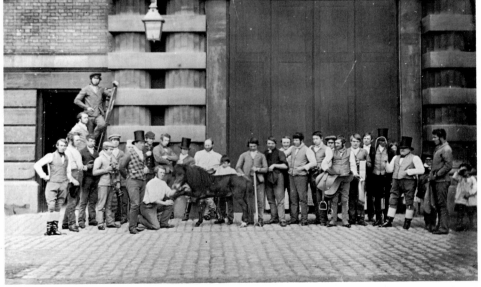

25.
Group of Grooms etc. with the little pony, Webster, taken at the Royal Mews, Buckingham Palace, 1848
Photographer unknown
14.3x9.3cm
Daguerreotype
 This is one of several daguerreotypes taken at the Royal Mews in 1848. Queen Victoria mentioned in her Journal for 31 May that 'we went to the stables to see the horses daguerreotyped, which really was curious, particularly to see how badly the horses placed themselves, when they had to stand still.'

26 (opposite).
The Prince of Wales, April 1860
By the Earl of Caithness
15.5x19.8cm
Carbon print
 This photograph was probably taken during the Easter vacation, while the Prince, aged eighteen, was down from Oxford. Lord Caithness, then a Lord-in-Waiting, had been known to the Royal Family for a number of years. He was keenly interested in scientific matters and was a Fellow of the Royal Society of London. He was apparently on friendly terms with the young Prince of Wales: in 1854 the Prince noted in his diary for 3 May that 'in the afternoon Lord Caithness brought a model of a steam boat which answered very well.' The Prince had been given a turning lathe for his birthday in 1856, and between 24 November and 4 December Lord Caithness, who had 'shewed me how to use my lathe', helped him to make several small wooden articles with it, including 'a nice little box which I gave to Papa', 'three bobins . . . for Mama' and 'an ebony snuff box . . . for the Baron' (Stockmar). In the following year Lord Caithness showed the Prince his own turning lathe on 14 March. He also used to join Prince Albert, the Prince of Wales and others at hockey or skating while he was in waiting at Windsor, and during these periods he sometimes dined with the Royal Family. On 1 January 1860 the Queen noted that at dinner she had sat next to Lord Caithness, 'who has much to say for himself, as he knows so much.' A few days later she went to see 'a curious steam carriage which Lord Caithness is much interested in.'[1] It is not surprising that Lord Caithness's skills included photography: nor was he alone in the Royal Household in this, as at least two others, Dr Becker and Colonel de Ros, were keen practitioners.

Reference
1. RA Queen Victoria's Journal: 10 January 1860.

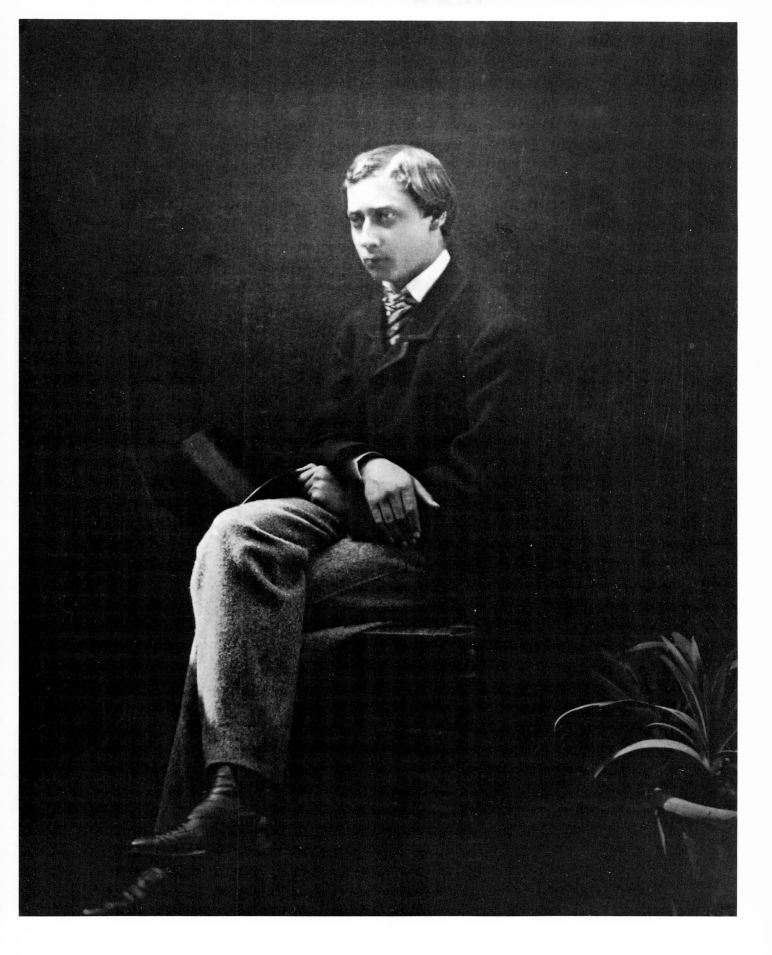

27.
Prince Leopold, Princess Louise, Prince Alfred,
Princess Alice and Princess Helena, Buck-
ingham Palace, 29 February 1860
By Colonel the Hon. Dudley de Ros
15.2x10.7cm
Albumen print

28.
Princess Louise, Princess Helena, Princess
Beatrice, Prince Alfred, Princess Alice and
Queen Victoria, Buckingham Palace, 29 Feb-
ruary 1860
By Colonel the Hon. Dudley de Ros
14.9x11.5cm
Albumen print

27–8. These photographs were taken the day
after the return home of Prince Alfred, who was
training for a career in the Royal Navy, had just
passed 'a brilliant examination', and was now a
midshipman.[1] Colonel de Ros, at that time
Equerry to the Prince Consort, was a keen pho-
tographer, and much of his work was placed in
the royal photograph albums.

Reference
1. RA Queen Victoria's Journal: 28 February
1860.

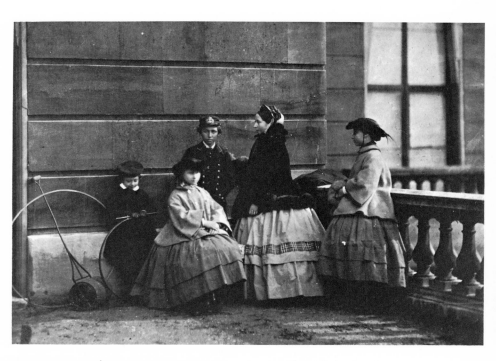

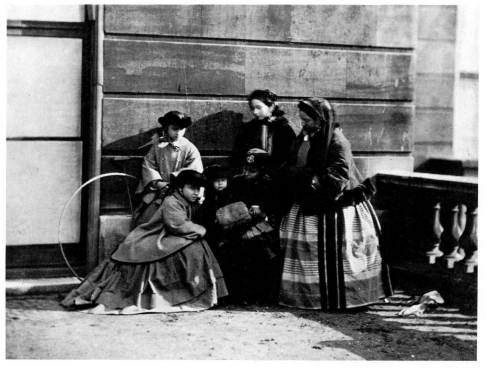

29 (opposite).
Baron Stockmar, April 1857
By Caldesi
18.2x24.7cm
Albumen print
 Baron Christian Friedrich von Stockmar
was a native of Coburg, born in 1787, who had
entered the service of Prince Leopold (later King
Leopold I of the Belgians) as private physician
in 1816, at the time of the Prince's first marriage
to Princess Charlotte of Wales. After her
untimely death, Stockmar remained with the
Prince, giving him sympathy and support and
acting as his private secretary and Comptroller
of his Household until 1831. At that time Prince
Leopold was still living in England, and Stock-
mar thus gained a thorough knowledge of this
country, its people and its constitution. When
the Prince became King of the Belgians in 1831,
Stockmar would take no official post in Belgium
but returned to Coburg in 1834; the King,
however, continued to rely on his judgement,
especially with regard to the projected marriage
of the King's niece, the future Queen Victoria,
and his nephew, Prince Albert of Saxe-Coburg-
Gotha. Stockmar had known Princess Victoria
as a child, and had begun to form a high opinion
of Prince Albert's character after accompanying
him on an Italian tour in 1838. He played an
important part in arranging the terms of the
royal treaty of marriage, and was to become the
trusted friend and adviser of both the Queen and
Prince Albert whose opinion on many matters
they frequently sought. At his death in July
1863, within two years of that of the Prince,
Queen Victoria wrote to King Leopold that his
loss was 'totally irreparable'.[1]

Reference
1. RA Y110/2.

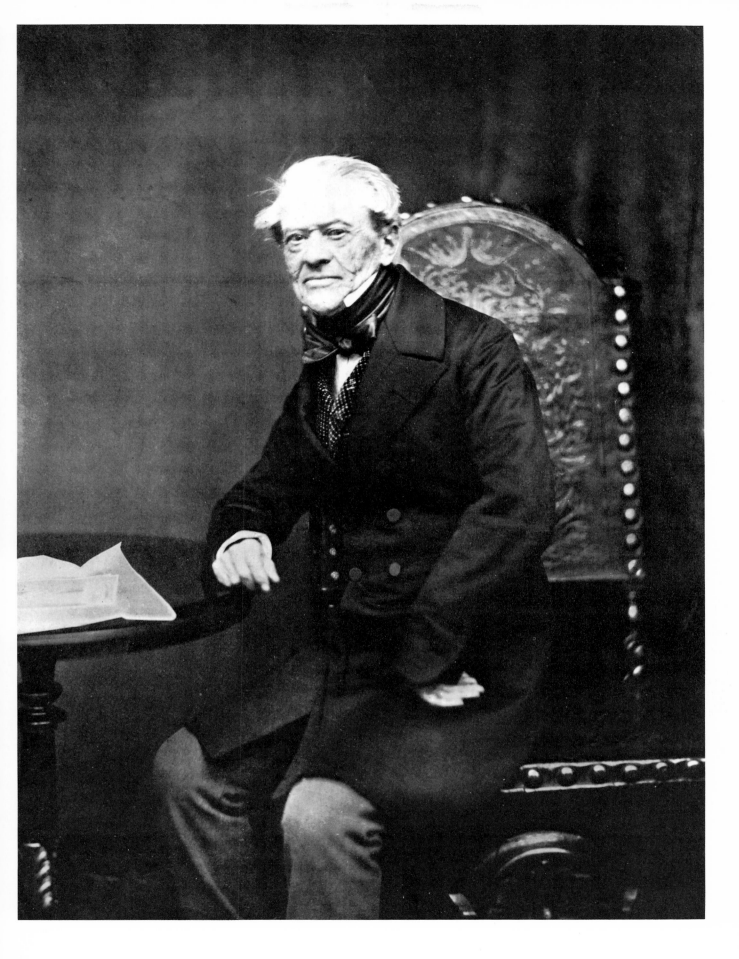

30.
Table of presents, the Queen's Birthday, Osborne,
24 May 1859
By William Bambridge
19.8x14.6cm
Albumen print
Illustrated on p. 52

Queen Victoria's fortieth birthday was
spent at Osborne in the Isle of Wight. Her two
eldest sons were away, but the remaining chil-
dren had all done 'pieces of work, or drawings'
for the Queen, and, meeting her with nosegays,
they escorted their mother to her present table
'full of charming gifts'.[1] Bambridge later photo-
graphed the Royal Family on the Terrace.

Reference
1. RA Queen Victoria's Journal: 24 May 1859.

31.
The Maharajah Duleep Singh, Osborne,
23 August 1854
By Dr E. Becker
13.1x16.4cm
Albumen print

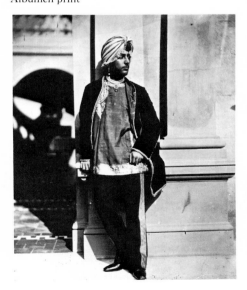

32.
Sally Bonetta Forbes, 1856
By William Bambridge
11.7x13.2cm
Albumen print

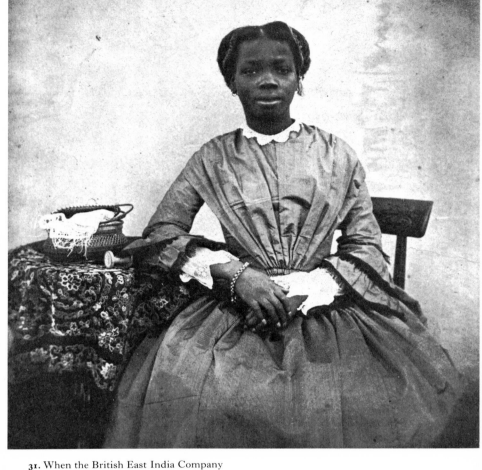

31. When the British East India Company
annexed the Punjab in 1849, at a time of disorder
and unrest, they deposed the Maharajah Duleep
Singh of Lahore (aged ten and a half), gave him
a pension and appointed Dr John Login as his
guardian. The Maharajah became a Christian
and was baptized in 1853. He was later to settle
in England, to which he paid his first visit in
April 1854. He met Queen Victoria at Buck-
ingham Palace in July of the same year and later
stayed with the Royal Family at Osborne House
from 21 to 24 August. On the last day of his
visit, the Queen recorded in her Journal that

... after breakfast, we walked with the Mahara-
jah, taking him round the pleasure grounds,
showing him the plants & flowers in the garden,
all of which he was pleased and interested in.
He planted a fine Deodara & was amused at
having to shovel in the earth with a spade. When
we came in we took leave of the Maharajah,
shaking him warmly by the hand & wishing him
many happy returns of his approaching birthday,
when he will be 16 ... I was quite sorry to see
him go.

The friendship between the Maharajah and
the Royal Family was to last for the rest of his
life, which was, however, not invariably happy
or free from difficulties. These led to dis-
agreements between him and the Queen, but
they were reconciled before his death in 1893.

32. This African girl, who was about thirteen in 1856, was the daughter of a chief. In 1848 the King of Dahomey captured the neighbouring city of Okeadon, sacrificing many inhabitants and leading the rest away into slavery. One of the latter was this young girl, who was about five years old. All her relatives had been killed, but as she was of high rank, she was kept in captivity as a state prisoner, either to be presented to an important visitor, or to be sacrificed at the death of a minister or official, to become his attendant in the next world.

Queen Victoria was aware of the situation in Dahomey and was determined that slavery should be stamped out, but there was little that she could do to achieve this. In June 1850 Captain Forbes, on board the *Sally Bonetta*, arrived in Dahomey on a mission to negotiate the suppression of the slave trade. While there, he asked the King for the little girl as a present, whether for himself or on behalf of the Queen is not clear. The request was granted and the child was brought to England, being given the names of Sally Bonetta, after the ship, and Forbes, after the Captain. She lived at first with Captain Forbes's family, then, on 9 November, she was taken to Windsor Castle and received by Queen Victoria and Prince Albert. The Queen described her as being 'sharp & intelligent' and mentioned that she spoke English.[1] Between 9 November 1850 and 11 January 1851 the Queen saw Sally four times; on the last occasion she 'showed me some of her work.'[2] The Queen paid for Sally to be educated, and saw her next on 9 December 1855, when she described her as being 'immensely grown, & has a nice slim figure.'[3] It is clear that Sally was highly intelligent: Captain Forbes had described her in 1850 as being 'far in advance of any white child of her age, in aptness of learning and strength of mind and affection.' She had a particular talent for music and, according to a sermon preached after her death by Archdeacon Henry Johnson at Lagos on 19 September 1880, she became 'in every respect a thoroughly finished and accomplished lady' who was 'always active, lively, buoyant with animal spirits, full of energy of purpose, there was no one who could help being in some way influenced by her.' She married Mr James Pinson Labulo Davies in 1862 and later had a daughter, Victoria, to whom the Queen acted as godmother. On 9 December 1867 Mrs Davies and her daughter visited Windsor Castle, the Queen noting in her Journal that she 'saw Sally, now Mrs Davies, & her dear little child, far blacker than herself, called Victoria & aged 4, a lively intelligent child, with big melancholy eyes.'[4] She saw Victoria Davies again in 1873: the rest of the family was then living in Lagos, but later they moved to Madeira. On 23 August 1880, Queen Victoria was shocked to hear that Mrs Davies was 'hopelessly ill', and on the following day Victoria Davies came to her in great distress to report 'the death of her dear mother at Madeira . . . Her father has failed in business, which aggravated her poor mother's illness. A young brother & a little sister, only 5, were with their mother.'[5] Mr Davies, who was involved in a court case, was later exonerated, and the Queen continued to take an interest in his daughter.

References
'Presentation of the Dahoman Captive to Her Majesty', from the **Britannia** newspaper, 9 November 1850.
1–5. RA Queen Victoria's Journal.

33.
Prince Arthur (left) **and Prince Alfred in the costume of Sikh Princes, Osborne,** 6 September 1854
By Dr E. Becker
13.8x10.9cm
Albumen print

Prince Alfred (later Duke of Edinburgh and of Saxe-Coburg-Gotha) and Prince Arthur (later Duke of Connaught) were the second and third sons of Queen Victoria and Prince Albert. Although the royal children often took part in plays and tableaux vivants, which they sometimes presented on special occasions, such as their parents' wedding anniversary, there seems to be no special significance about the date of this photograph. It was, however, taken soon after the visit to Osborne of the Maharajah Duleep Singh in August 1854, and it is probable that the costumes were a gift from him.

34 (opposite).
King Leopold I of the Belgians, 1857
Attributed to Caldesi
16.3x21.8cm
Albumen print

King Leopold I (born a Prince of Saxe-
Coburg-Saalfeld and elected King of the
Belgians in 1831) was the uncle and mentor of
Queen Victoria and Prince Albert. His first wife
had been Princess Charlotte, the only daughter
of King George IV, who, had she lived, would
have been Queen of England. He might thus
have held the same position in England that his
nephew, Prince Albert, later occupied as the
husband of Queen Victoria.

35.
**Whiting, Page of the Back Stairs, in the 52nd year
of his service**, 1858
By Thomas Pearce
11.2x14.4cm
Albumen print

John Whiting first entered the Royal
Household during the reign of King George
III. He was appointed Page of the Back Stairs
in 1821, his service continuing under King
George IV, King William IV and Queen
Victoria. After suffering a stroke in July 1859
he was obliged to resign. The Queen kept her-
self informed of his progress and was able to
see him a few days before he died in April 1863.
Mr Whiting and his family lived for some
years in the cottage near the Fishing Temple
at Virginia Water.

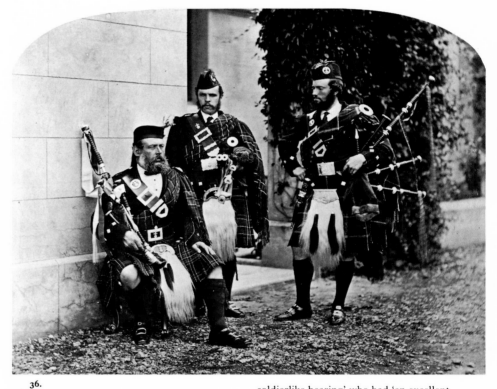

36.
**William Ross, C. Cameron and William Mac-
Donald: Pipers to the Queen, the Duke of Edin-
burgh and the Prince of Wales, Osborne**, 1867
By Jabez Hughes
20x15.8cm
Albumen print

During their first visit to Scotland, in the
autumn of 1842, Queen Victoria and Prince
Albert, who at that time had no Scottish resi-
dence of their own, stayed at Taymouth Castle
with the Marquis of Breadalbane. It was the
custom there for pipers to play during meals:
the Queen and the Prince developed a liking for
this, and the Queen wrote to her mother, the
Duchess of Kent, that she had become so fond
of hearing the bagpipes that she intended to
have her own piper. Angus Mackay was engaged
the following year (his brother was piper to the
Queen's uncle, the Duke of Sussex) and acted as
piper till 1853, when he became mentally ill. In
May 1854 the Queen engaged her second piper,
William Ross, who was thirty-one and had been
Pipe-Major in the 42nd Highlanders. He was a
'fine, respectable looking man with a very

soldierlike bearing' who had 'an excellent
character . . . both as a soldier, & a man', and
played for the first time as the Queen's Piper
during a Court Ball at Buckingham Palace on
17 May.[1] He remained in royal service for many
years, finally retiring in 1883. In June 1891 the
Queen wrote in her Journal that she had been
shocked to hear of his death, although he had
been ill. 'He . . . was an excellent Piper &
musician, & his well known stout figure, white
hair & beard, gave him a presence, which looked
so well as Royal Piper. I can't believe he is really
gone & am very grieved.'[2]

The Queen's example was followed by other
members of her family: the pipers employed by
her two elder sons are shown with Mr Ross in
the photograph.

References
1. RA Queen Victoria's Journal: 3–17 May
1854.
2. ibid.: 20 June 1891.

Also see **Queen Victoria's Life in the Scottish
Highlands, depicted by her Watercolour Artists**
by Delia Millar (Philip Wilson, 1985).

37.
Glenelg: Clydesdale Stallion at Osborne, June 1855
By William Bambridge
12.6x10.3cm
Albumen print
 Following the purchase of Osborne House in the Isle of Wight in 1845, Queen Victoria and Prince Albert acquired several neighbouring farms, including Barton Manor Farm, which eventually increased the size of the estate to more than 2,600 acres. The Prince was keenly interested in new farming methods and set about developing the estate to the fullest advantage. A new range of farm buildings included stalls for thirteen horses, mostly Clydesdales, and a prize-winning stallion was kept there at stud. The field work at Barton was done by several teams of Clydesdale horses: the Prince also kept a number of horses of this breed, including a prize stallion, at the Royal Farms at Windsor.

Reference
Royal Farmers by Ralph Whitlock (1980).

38.
White Stag in Windsor Park, 3 November 1854
By William Bambridge
11.3x9.1cm
Albumen print
 Prince Albert was appointed Ranger of Windsor Great Park in 1840, and one of his enterprises there was to improve sporting facilities by the purchase of more land and sporting rights. Herds of deer, which were hunted by the Royal Buckhounds, had been kept in the Park since the thirteenth century.

39.
See 22 (p. 107).

40.
St George's Chapel and the Round Tower,
Windsor Castle, 1860
By Roger Fenton
43.4x30.7 cm
Albumen print

41.
View from the foot of the Round Tower, Windsor
Castle, 1860
By Roger Fenton
42.7x29.7cm
Albumen print
Illustrated on p. 56

42.
See **vi** (p. 79).

43.
View in the Slopes, Windsor, 1860
By Roger Fenton
42.3x34.8cm
Albumen print
Illustrated on p. 56

44.
The Long Walk, Windsor, 1860
By Roger Fenton
42.4x32cm
Albumen print

40, 41, 43, 44. These are four of the thirty-one prints made by Fenton in 1860 of Windsor Castle, the Home Park and Great Park. They all show conventional views, emphasizing the Castle's role as a public monument rather than as a private royal residence. Queen Victoria in fact disliked Windsor, finding the Thames Valley climate oppressive after the bracing air of Balmoral. She wrote on 22 October 1859 to her eldest daughter, who had written regretfully of the Castle, that

> I must say that . . . the appellation of 'dear, dear Windsor', coming at this moment, when I am struggling with my homesickness for my beloved Highlands, the air – the life, the liberty – cut off for so long – almost could make me angry. I cannot ever feel the slightest affection or tendre for this fine, old dull place, which please God shall never hold my bones! I think I dislike it more and more though I am quite aware of its splendour.[1]

Reference
1. **Dearest Child: Private Correspondence of**
Queen Victoria and the Crown Princess of Prussia,
1858–1861, edited by Roger Fulford (1964).

45.
View from the Ketschenbrücke, Coburg, 1857
By Francis Bedford ·
24.3x18.2cm
Albumen print
Illustrated on p. 50

This idyllic scene is one of the most attract-
ive of Bedford's Coburg views, commissioned
by the Queen in 1857 as a birthday present for
Prince Albert, but it is less romantic than it
appears. The wooden building (beyond the
bridge) belonged to a timber yard, and on the
right is the office of the municipal gas works,
built in 1854.

46.
The Terrace at the Rosenau, Coburg, 1857
By Francis Bedford
24.2x18.4cm
Albumen print
Illustrated on p. 50

This is one of the sixty photographs com-
missioned by Queen Victoria as a birthday
present for Prince Albert in 1857. The bal-
ustrades show some similarity to those at
Osborne, which appear in Caldesi's Royal
Family group taken in May of the same year
(see **v**).

47.
See **viii** (p. 80) and p. 50.

48.
Duke August of Saxe-Gotha's State Coach, Gotha,
1858
By Francis Bedford
24.2x19.2cm
Albumen print
Illustrated on p. 50

Duke August of Saxe-Gotha was Prince
Albert's maternal grandfather. In the last
decade of the eighteenth century and at the
beginning of the nineteenth, there was a fashion,
possibly of French origin, for circular-shaped
carriages. This particular example was appar-
ently built, by order of Duke August, for the
public entry into Gotha in 1808 of Napoleon I,
who refused to use it. The undercarriage is of a
type known as a 'Berlin', thus called because it
was first built in that city. It is said to have been
invented in about 1660 by Colonel Philip de
Chiese, a Piedmontese in the service of the
Elector of Brandenburg. Berlin carriages did
not become popular in Europe until almost a
century after this, but their construction
allowed for ease in turning while restraining the
lateral sway of the body, so that they would have
afforded a greater degree of comfort than some
other carriages. It would be interesting to know
whether the story of Cinderella's pumpkin coach
owed anything to the appearance of such
vehicles as this one.

49.
View from the Prince's window, Gotha, 1858
By Francis Bedford
24.9x19.4cm
Albumen print
Illustrated on p. 50

One of the sixty-three photographs of
Gotha commissioned by Queen Victoria as a
birthday present for Prince Albert in 1858.

50.
Tombs of the Memlooks at Cairo, 25 March 1862
By Francis Bedford
28.7x23cm
Albumen print
50–56. See p. 120.

51.
Grand Gateway of the Temple of Luxor, 18 March
1862
By Francis Bedford
29.1x24.2cm
Albumen print

52.
View from the Mosque of Mehemet Ali: Mosque of Sultan Hassan, Cairo, 3 March 1862
By Francis Bedford
29.4x24.3cm
Albumen print

53.
The Garden of Gethsemane, 2 April 1862
By Francis Bedford
28.3x22.9cm
Albumen print
 'We rode to the Garden of Gethsemane, in wh. there are 8 olive trees, & a very nicely kept garden' (Prince of Wales's diary, 2 April 1862).

54.
Group at Capernaum, April 1862. The Prince of
Wales (centre) and his party
By Francis Bedford
27.4x20.1cm
Albumen print

'We lunched under a fig tree at 12 o'clock
on the site of where once the city of Capurnaum
is said to have stood, & Mr Bedford photo-
graphed us "en groupe"' (Prince of Wales's
diary, 21 April 1862.

55.
**The Sphinx, the Great Pyramid and 2 lesser Pyra-
mids, Ghizeh,** 4 March 1862
By Francis Bedford
29.2x23 cm
Albumen print
'We then proceeded on dromedaries (not at
all an unpleasant mode of conveyance) to the
celebrated Pyramids of Ghizeh – They quite
exceeded my expectations, & are certainly won-
derful mementoes of our forefathers. We visited
the Sphinx just before sunset, which is also very
curious and interesting. We had a charming little
encampment just below the Pyramids where we
slept for the night' (Prince of Wales's diary, 4
March 1862).

50–56. In the spring of 1862, according to a
plan made by his father, who had died in
December 1861, the Prince of Wales was sent
on an educational journey to Palestine and the
Near East. The grief and desolation which over-
whelmed the Queen after Prince Albert's death
had apparently caused the question of sending a
photographer with the party to be overlooked;
however, it seems that Francis Bedford was
hastily summoned to Osborne on 22 January,
two weeks before the Prince was due to leave,
and commissioned to act as official photogra-
pher. The choice of Bedford for this task was
doubtless made on the basis of his previous work
for the Queen: it may even be that Prince Albert
had mentioned his name as a suitable person for
the assignment,
 Bedford's task was fraught with some
difficulty. Because of the short time spent at
each site he was obliged to take photographs
regardless of whether prevailing conditions
were suitable. His work was hindered by heat,
rain, dust, insects and transport difficulties. On
the other hand, since he was with the royal party,
he was able to photograph in places not open to
ordinary tourists. The Prince of Wales showed
a great interest in the photographs, and
occasionally mentioned Bedford in his diary of
the tour. 210 plates were the final result.
Bedford was subsequently invited to show his
work to the Queen at Osborne on 18 July.
 172 prints were later exhibited at the
German Gallery in Bond Street, where they
were acclaimed by the photographic press. They
undoubtedly represented some of Bedford's
best work, and, like his Coburg and Gotha pic-
tures, fulfilled their purpose as records. It is
true that more emphasis was given to depicting
relics of past civilizations in a way that would
be understood by Europeans, rather than to
showing the contemporary life of the people
living in the Near East, but this was in keeping
with the purpose of the tour as a means of
studying history and the origins of Christianity.[1]
The photographs were later issued as albumen
prints, published by W. Day and Sons, and some
were used to illustrate books about the Near
East.[2]

References
1. See the catalogue of the exhibition **Romantic
Lebanon – the European View, 1700–1900,** shown
at Leighton House, London, 1986 (British
Lebanese Association).
2. Details of Bedford's life and work are from
the dissertation by Bill Jay (MFA Thesis, Uni-
versity of New Mexico, 1976).

56.
Saracenic Gateway, Nabulous, 7 April 1862
By Francis Bedford
23.8x29.2cm
Albumen print

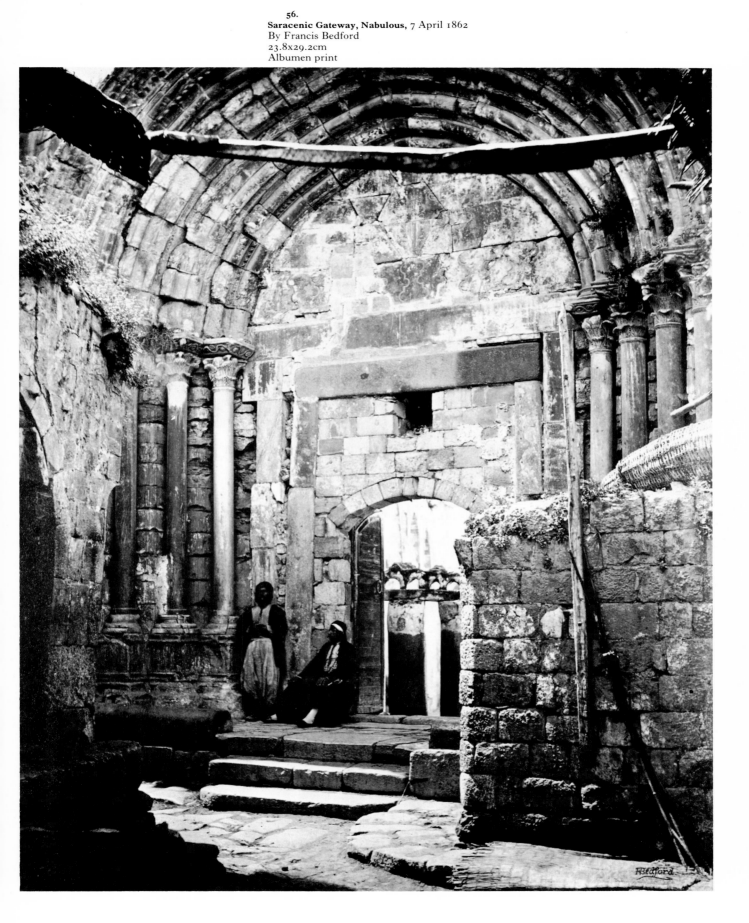

57·
Gare de Paris
By Édouard-Denis Baldus
44.5x27cm
Albumen print

59·
Enghien
By Édouard-Denis Baldus
39.8x26.6cm
Albumen print

58 (opposite).
Cathédrale d'Amiens
By Édouard-Denis Baldus
34x44cm
Albumen print

57–9. These photographs are part of an album of prints presented to Queen Victoria and Prince Albert as a memento of their state visit to France from 18 to 27 August 1855, showing landmarks on the route of the Chemin de Fer du Nord, by which they travelled between Boulogne and Paris. From the Queen's description, this journey, although almost a triumphal progress, was not always comfortable:

> There was a tremendous crowd at the station [at Boulogne], – & endless ladies. We got into a saloon with the Empr. who was all kindness & civility. The heat & dust, in the train, were very great, – really dreadful, & I never felt hotter. We passed through uninteresting flat country, intersected with rows of poplars. Stopped at Abbeville, a large town, with fortifications, where a very fat Préfet gave me an Address, & the autorités were standing, the Garde Nationale, & a Regt. of Dragoons being drawn up. I admire the troops very much, who all shout: 'vive la Reine d'Angleterre', – 'Vive l'Empereur', – 'Vive le Pce. Albert'. Reached Amiens at $\frac{1}{2}$ p. 4. An immense crowd at the handsomely decorated station: The Bishop, the authorities, many ladies, &c, & the Garde Nationale & troops. All, most enthusiastic. We got out for a moment, & I received a nosegay, then started off again at $\frac{1}{2}$ p. 4. We next came to Clermont, where the Mayor recognised Albert from former times ... The day seemed fast closing, & our impatience to arrive was great. At length we passed St Ouen, Montmorency, – both charmingly situated, – then got a glimpse of Montmartre, *my 1rst*. sight of *Paris* – came to Enghien, a small place, near a lake, with many pretty villas, & at last passed the fortifications & Paris opened upon us. Numbers of people about, – houses, people, *everything* so different to England, – so gay & lively. We entered the Gare du Chemin de Fer de Strasbourg, at Paris, which [was] beautifully lit up & decorated, – lined with troops & filled with people.[1]

Twenty-five copies of the album were made by order of Baron James de Rothschild, who was President of the Railway Corporation: Baldus, whose other work includes a number of topographical and architectural views, had completed the photography in three days. Some of his prints, such as the view of the Gare de Paris, seem to reflect national pride in a new, industrial France, rising out of the ashes of the Revolution of 1848: others, particularly the view at Enghien, owe more to Baldus's early training as a painter.

Reference
1. RA Queen Victoria's Journal: 18 August 1855.

60.
The Summum Boorj: the exterior Pavilion of the Zenana of Shah Jehan's Palace, Agra, 1857
By John Murray
45.3x35.1cm
Salted paper print

This view is one of thirty prints, taken during the year of the Indian Mutiny, and published by Hogarth, London, in 1858 under the title *Agra and Its Vicinity*. This followed an exhibition, set up by Hogarth in December 1857, of thirty-five Indian views by Dr Murray, who was civil surgeon at Agra and one of the earliest photographers in India. There is no mention in Queen Victoria's Journal of Murray's photographs or of a royal visit to the exhibition, but her former Lady of the Bedchamber, Viscountess Canning, then in India as the wife of the Governor-General, wrote to the Queen from Calcutta on 25 November 1857: 'I think it is possible that Your Majesty has lately seen some photographs of Dr Murray of Agra. He left 800 negatives with Hogarth to print & has just returned here. I hope he will be immediately employed to photograph everything to be demolished at Delhi.'[1] On 23 February 1858 Lady Canning sent the Queen some stereoscopic photographs by Murray 'done in the dry Collodion process – the details of which I shall send to Dr Becker. The specimens are not very good but they give an idea of Bengal vegetation & scenery.'[2]

The Queen had followed the Indian situation and the events of the Mutiny with deep concern. The administration of India was at that time divided between the East India Company (which was responsible for an army, navy and tax collecting system) and the Crown: it had now become clear that the Company could no longer maintain control over a territory which had, mostly by annexation, doubled its size over the previous twenty years. The outcome was

that the Queen in 1858 assumed full direct responsibility for the government of India, promising in a Proclamation to protect the religions and customs of her subjects and to promote their welfare. She was to be proclaimed Empress of India in 1876.

References
1. RA Z502/24.
2. RA Z502/34.

61–6.
See **xxi** (pp. 86–91).

67.
Two small elephants presented to H.R.H. the Prince of Wales
Photographer unknown
27.8x20.9cm
Albumen print

During his tour of India in 1875–6, the Prince of Wales was given a number of animals, including these two young elephants. In a letter of 31 December 1875 to his sons, Prince Albert Victor and Prince George, he described some of his new presents:

> A Native Gentleman here has made me a present of two little elephants & I saw them arrive on board the 'Serapis' yesterday. They are both together in 'Coomassie's' box [Coomassie was the Prince's horse]. I have also got 4 dogs on board without any tails – & they look very funny.

> Today two young leopards have been offered me – so I hope to bring home quite a Zoological Gardens. You two will be able to ride races at Sandringham on the elephants.[1]

It was quite usual for animals to be given to members of the Royal Family during foreign tours. The more exotic species, if they survived the journey home, were generally presented to the London Zoo, but the smaller creatures, particularly dogs or birds, were often given a comfortable home with other household pets.

Reference
1. RA Geo. V AA13/10.

68 (opposite).
Near Edinburgh, 1849
By Ross & Thomson
15x20cm
Salted paper print

This is one of a set of views of Edinburgh made by Ross & Thomson in 1849 and sent to the Queen as 'Calotype Specimens'. In a talk which James Ross gave to the Edinburgh Photographic Society, entitled 'A Few Extracts from a Photographer's Old Ledger', he told how on 12 May 1849 he had paid a Mr Seaton £1 10s. for binding calotypes for London, adding that 'these were specimens sent to Windsor Castle for inspection previous to our being appointed photographers to the Queen – a small investment which soon gave large returns.'[1] James Ross and John Thomson were granted a Royal Warrant as 'Photographers at Edinburgh to Her Majesty' on 14 June 1849.

Reference
1. **British Journal of Photography,** 14 February 1873, p. 75.

69.
A Study of Plants, 1856
By Francis Bedford
21.4x15.8cm
Albumen print
Illustrated on p. 53
 Some of Bedford's studies of plants were
shown at the Manchester Art Treasures Exhi-
bition in 1857.

70.
A small chapel in Tintern Abbey, 1854
By Roger Fenton
22x18.3cm
Albumen print
 Several pictures by Fenton of Tintern
Abbey were shown at the Photographic Soci-
ety's first exhibition in 1854 and at their 1855
and 1859 exhibitions.

71 (opposite).
Study of Trees, Avenue in the Parc, Pau, 1853
By F. Maxwell Lyte
16.3x21cm
Albumen print
 Shown in 1855 at the second exhibition of
the Photographic Society.

72.
Alberca Court, Granada
By Charles Clifford
39x28.3cm
Albumen print
72–6. See p. 131.

73 (opposite).
Door of the Giants, Zaragoza
By Charles Clifford
31.6x41.2cm
Albumen print

74.
Wedding group in Estremadura
By Charles Clifford
38x26.2cm
Albumen print

75.
Ruins of Monastery of Yuste, Estremadura
By Charles Clifford
33x42.6cm
Albumen print

76.
Devil's Bridge, Martorell, Catalonia
By Charles Clifford
43.2x30.7cm
Albumen print

72–6. Queen Victoria and Prince Albert first purchased some of Clifford's Spanish photographs in 1854. These particular five prints are from a series of 159, published in two volumes in Madrid in 1861, under the patronage of Queen Victoria, the Prince Consort, the Queen and King of Spain, the Emperors of France, Russia and Austria, the Duc de Montpensier and others.

77.
Fleet Street and Ludgate Hill
Attributed to W. Lake Price
16.2x22cm
Albumen print
Illustrated on p. 34
On 26 November 1858 Queen Victoria bought two photographs from Lake Price, one a view of Ludgate Hill.[1]

Reference
1. RA PP2/33/9664.

78.
York Minster from Lord Mayor's Walk, 1854
By Francis Bedford
24.5x18.9cm
Albumen print
Illustrated on p. 53
This study, which was shown at the Photographic Society's exhibition in 1855, is a reminder of Bedford's early architectural experience and consequent interest in church buildings. In 1843 he had exhibited a picture of the interior of York Minster at the Royal Academy, and in the same year his lithographs appeared in *Sketches in York* and *The Churches of York,* both published by H. Smith of York. In 1849 he exhibited another picture of York Minster at the Royal Academy.

79.
St Paul's on a Misty Morning, 1854
By Alfred Rosling
19.5x15.6cm
Albumen print
This photograph was shown in 1854 at the first exhibition of the Photographic Society, where it received high praise. A review in *The Athenaeum* descibed it as 'truthfulness itself',[1] while another in *The Art Journal* called it 'beautifully artistic and at the same time natural.'[2] When reviewing the Photographic Society's exhibition in 1855, *The Art Journal* made a further reference to the picture:

We see in the exhibition many most charming effects produced. We scarcely think them reflexes of the natural conditions. To express clearly what we mean, we must refer to a striking picture exhibited by Mr Rosling last year, – it was a View of St Paul's, seen through the light veil of mist which grows over London on a bright summer morning. What was the fact? The original negative was produced by long exposure on a very gloomy day.[3]

References
1. **The Athenaeum**, 7 January 1854.
2. **The Art Journal**, 1 February 1854.
3. **The Art Journal**, 1 March 1855.

80.
The Baptistery of Canterbury Cathedral, 1857
By Francis Bedford
17.6x23.2cm
Albumen print
Illustrated on p. 54
This photograph, which appeared with three others in *The Sunbeam* in the spring of 1857, was reviewed with great enthusiasm in *Photographic Notes* as

a GEM; perfect in execution, and one of those 'choice bits', which the true artist appears so frequently to stumble upon ... [It] is, with the exception of the two figures, picturesque in every part ... What would become of our picture if the reverend authorities of Canterbury had ordered a gardener before it was taken, to fresh gravel the path and clear away the litter and rubbish from the lawn to the right? ... The Baptistery of Canterbury would still be there, with its crumbling stones, and clumps of ivy, and quiet old windows, and it would have a better approach, and stand better, and look more respectable. But would this *improve the picture*? Certainly not.[1]

The photograph also appeared at the Photographic Society's exhibition in 1856, the Architectural Photographic Association's exhibition in 1857, and the Manchester Art Treasures Exhibition in the same year.

Reference
1. **Photographic Notes**, 1 March 1857: review of **The Sunbeam**, a Photographic Magazine, edited by P. H. Delamotte, F. S. A. (Chapman & Hall).

81a.
A Romance. No. 1. 'Strong flirtation of which one Spectator highly disapproves', 1854
By Roger Fenton
21.4x18.1cm
Albumen print

81c.
A Romance. No. 3. 'Sealing the Covenant', 1854
By Roger Fenton
20.7x17.7cm
Albumen print

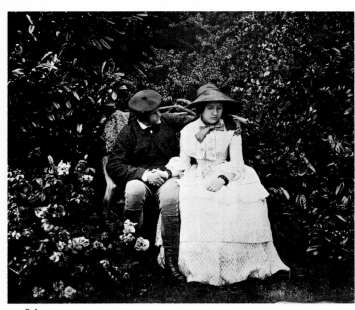

81b.
A Romance. No. 2. 'Popping the Question', 1854
By Roger Fenton
19.7x18.4cm
Albumen print

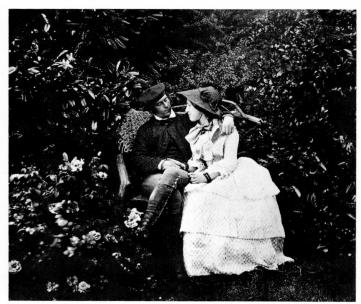

81d.
A Romance. No. 4. 'The Honeymoon', 1854.
By Roger Fenton
19.9x18cm
Albumen print
Two items by Fenton, entitled *Photographic Romance*, were shown at the exhibition of the Photographic Society in 1855. This series may be the work referred to: it may also be the only example of Fenton's achievements in this genre, although posed narrative sequences were popular with other photographers. It was made in the same year as Fenton's eight pictures of the fleet at Spithead [xii], an early attempt to record several stages of a particular occasion.

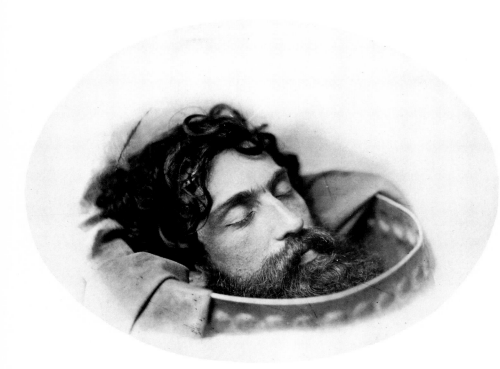

84.
Study of the Head of John the Baptist in a Charger, late 1850s
By O. G. Rejlander
20.3x15.7cm
Albumen print
This photograph was intended by Rejlander as part of a composition, which he never completed, although a study for Salome was made at about the same period.[1] In 1862 it was announced in the *British Journal of Photography* that 'this beautiful photographic art production of Mr Rejlander has been enlarged by him, and reproduced in lithography: it is about to be published by Mr James Wood, of George Street, Edinburgh.'[2] In February 1869 Queen Victoria bought twenty-two of Rejlander's prints, including *St John the Baptist's Head*.[3]
References
1. See **Father of Art Photography: O. G. Rejlander, 1813–1875** by Edgar Yoxall Jones (1973).
2. **British Journal of Photography**, 1 April 1862.
3. RA PP2/139/15415, February 1869.

82.
A Quiet Moment, dated 1854
By C. Thurston Thompson
7.2x7.2cm
Albumen print
This photograph was one of those shown at the first exhibition of the Photographic Society, held in Suffolk Street in London during the first weeks of 1854. The Queen and Prince Albert visited the exhibition on 3 January, when they 'evinced much more interest in the specimens exhibited than is ordinarily displayed on the occasion of a Royal visit, and expressed their wish . . . to become the possessors of some of the more select specimens.'[1] One such picture was a small portrait of a child, called *A Quiet Moment*, by C. Thurston Thompson, which, according to a press review, 'was as pleasing to us as it is said to have been to Her Majesty'.[1]

Reference
1. **The Athenaeum,** 7 January 1854.

83.
A Polish Lady, 1855
By Dolamore & Bullock
14.1x17.4cm
Albumen print
Illustrated on p. 32
Shown in 1855 at the second exhibition of the Photographic Society.

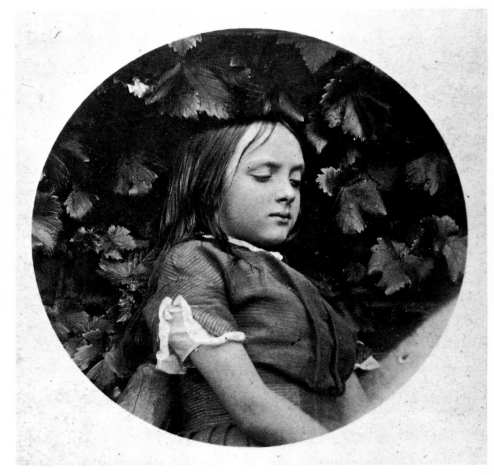

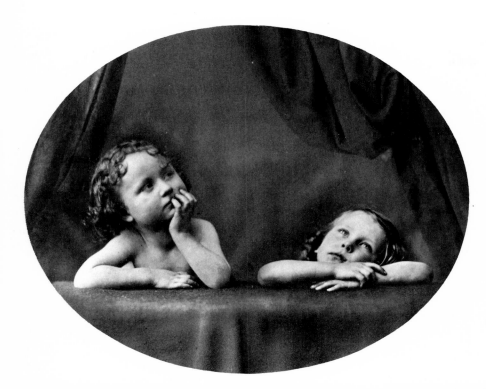

85.
Non Angeli sed Angli, 1857
By O. G. Rejlander
20x16.1cm
Albumen print

85–7. This picture, by a photographer whose work Prince Albert greatly admired, comes from an album personally arranged by the Prince. It is based on two putti from Raphael's *Sistine Madonna*, and reflects the Prince's enthusiasm for his Raphael Collection project. The title has a double significance: it is a pun, as these are indeed not the angels from the *Sistine Madonna* but ordinary English children; it also refers to the comment reputedly made by St Gregory the Great when he saw some English children in a slave market in Rome: 'He . . . asked, what was the name of that nation? and was answered, that they were called Angles. "Right", said he, "for they have an angelic face, and it becomes such to be coheirs with the angels in heaven." '[1]

The accompanying portraits of Prince Arthur, on the same theme, were taken by Caldesi in the same year.

Reference
1. **The Venerable Bede's 'The Ecclesiastical History of the English Nation',** translated by J. A. Giles (1840), Book I, Chapter 1.

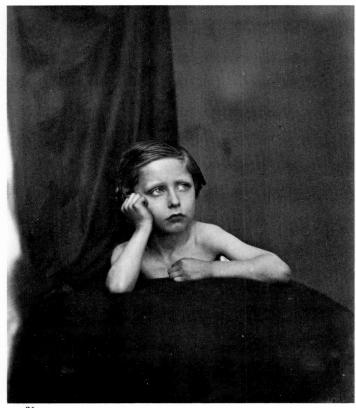

86.
Prince Arthur, 1857
By Caldesi
15.1x17.7cm
Albumen print

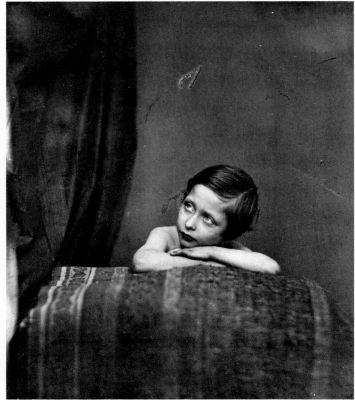

87.
Prince Arthur, 1857
By Caldesi
15.1x17.8cm
Albumen print

88.
The Garden Chair. Portraits. 1854
Photographed by the collodion process by
Henry White
13x18cm
Albumen print

This photograph also appeared as one of
forty-four pictures by members of the Photo-
graphic Club in their *Photographic Album* for
1855, printed for them by Charles
Whittingham. The plates were accompanied by
a text and descriptions of the processes by which
they had been made. *The Garden Chair* has a
poem on the same theme by Dinah Maria
Mulock, and the notes reveal that it was 'taken
on Collodion, September 11 1854, about 1 pm
in fine sunshine; exposure five seconds;
developed with Pyrogallic Acid. Lens by Ross,
focal length ten inches, diameter three inches,
double Lens; Diaphragm three inches.'

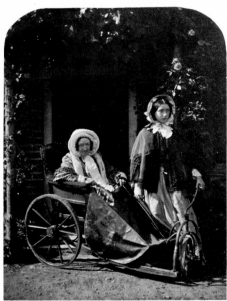

89.
Les Billes
By Disderi
17x11.3cm
Salted paper print

This photograph, showing a game of
marbles (*billes*), probably belongs to the series
showing childhood amusements, which Disderi
took at the Institution de l'Assomption at Nîmes
in 1853.[1] Works by Disderi were shown at the
Paris Exposition of 1855, which Queen Victoria
and Prince Albert visited in August of that year.

Reference
1. See **After Daguerre: Masterworks of French
Photography, 1848–1900, from the Bibliothèque
Nationale** (Metropolitan Museum of Art, New
York, 1980–81).

90 (opposite).
Study from Life, 1854
By Moulin Atelier Photographique
15.3x20.7cm
Albumen print

A number of portraits and studies by
Moulin were shown at the exhibitions of the
Photographic Society in 1854 and 1855. At least
nineteen of his prints were acquired by the
Queen and Prince Albert.

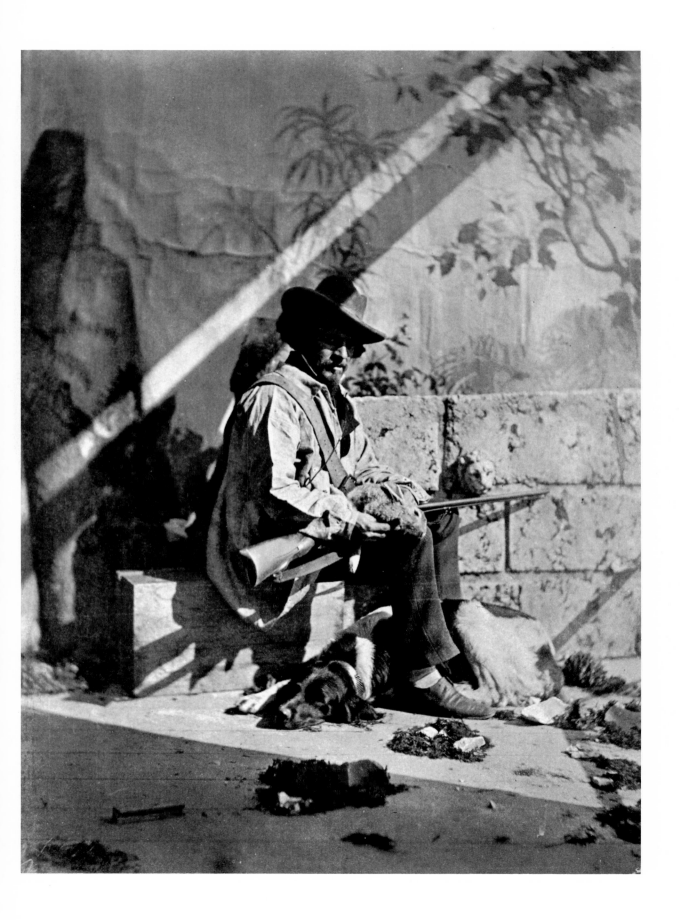

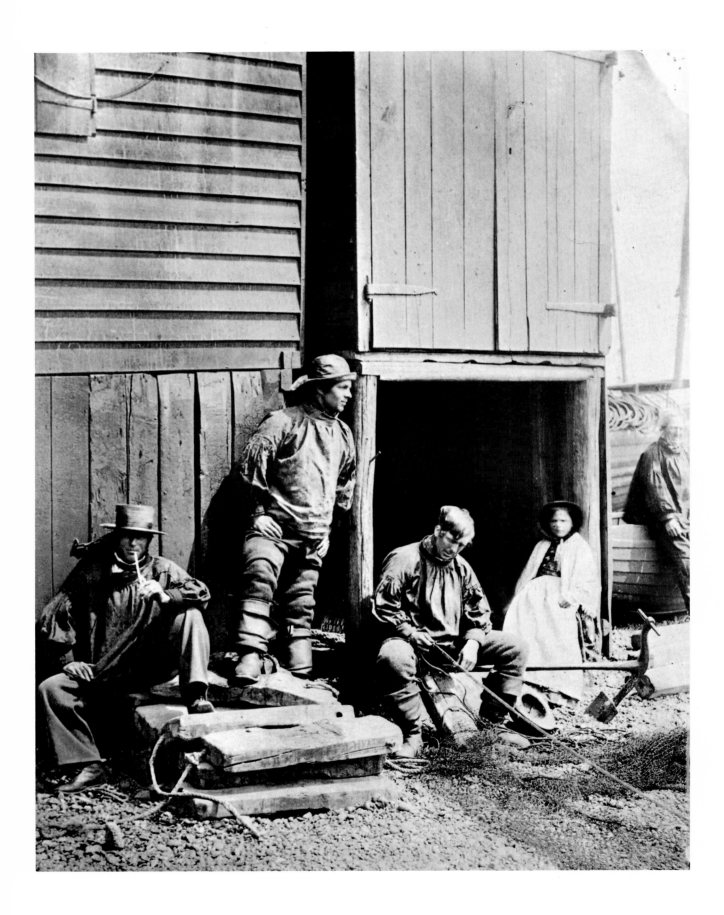

91 (opposite).
A Study taken at Hastings, 1854
By Joseph Cundall
18.8x24cm
Albumen print
 Cundall's premises at 168, New Bond Street, from which he worked as a publisher, editor, author and photographer, were known as the Photographic Institution[1] and were several times visited by Prince Albert. In 1854 *The Athenaeum* printed a review of some of Cundall's work, produced by the Photographic Institution, which included three views of Hastings, two showing groups of boatmen. The reviewer considered these to be 'the gems of the series ... The sailor smoking, the boy in his norwester and big boots, standing on a pile of ship's timbers, the old man by the anchor pulling at a rope, – and, not least, the paling, behind, with the pitch cracked and seamed, form an admirable picture.'[2]

References
1. See **Joseph Cundall: A Victorian Publisher** by Ruari McLean (Private Libraries Association, 1976).
2. **The Athenaeum**, 7 October 1854.

92 (top right).
Ichthyon, **an experimental model steam ship, 3 tons burden, invented by Captain Beadon, R. N., A. I. N. A., of Creechbarrow, Taunton,** 1858
By E. C. Dyer
19.1x14.1cm
Albumen print

93.
The *Great Eastern* **lying opposite New Milford,** 1857-8
By Robert Howlett
21.4x17.6cm
Albumen print
 Two examples of Victorian technology, both of sufficient interest to the Prince Consort to be included in one of his albums. The inventor of the *Ichthyon,* Captain George Beadon, was a naval officer from Taunton who had built Creechbarrow House in 1848. He also invented the double hook and an improved lifebuoy and claimed to have devised the screw propeller.[1]
 The *Great Eastern,* known as 'Leviathan' before its launch in 1858, was the last major work of the engineer Isambard Kingdom Brunel. It was five times the size of any contemporary ship, and its construction and design were revolutionary.[2] Victoria, Princess Royal, went to see it at Millwall on 5 December 1857. The photograph is one of five of the ship preserved in the same album.

References
1. **Jeboult's Taunton: A Victorian Retrospect** by Robin Bush (Barracuda Books, 1983).
2. **Brunel's Kingdom** by Rob Powell (Watershed, 1985).

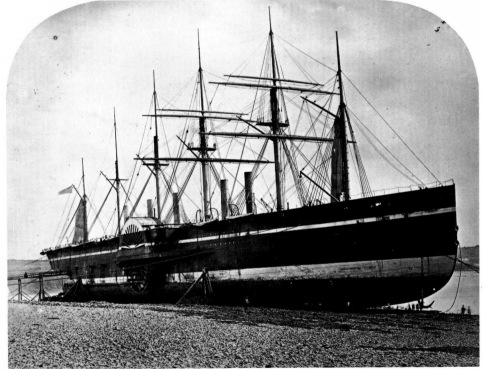

94.
W. Coulson, Master Sinker, and four of his men.
Photographed at the Pit Mouth, Hartley Colliery,
30 January 1862
By W. & D. Downey
20.1x14.6cm
Albumen print
Illustrated on p. 61

95.
Hartley Colliery after the accident, 30 January
1862
By W. & D. Downey
20.7x15.4cm
Albumen print
Illustrated on p. 60

96.
Hartley Colliery after the accident, 30 January
1862
By W. & D. Downey
20.4x15cm
Albumen print
Illustrated on p. 60

94–6. The tragic events at Hartley Colliery
began on 16 January 1862 when part of the
pumping mechanism fell into the pit shaft, trap-
ping over two hundred miners, and ended over
a week later with the recovery of their bodies.
The imagination of the public was captured by
this disaster, and for the Queen, who had become
a widow herself on 14 December 1861, the
agony suffered by the wives and families of the
trapped miners must have seemed even more
heartrending. She followed events with great
concern, writing in her Journal for 22 January
that 'there has been a dreadful accident in the
north, at Shields, in a coal mine, 215 men having
been buried alive since Thursday & until now
nothing has been able to be done to get them
out. How terrible!' The next day she added that
'the accounts of the colliery accident are
terrible, – such awful misery', and on hearing of
the fatal outcome, she telegraphed at once to
learn what was being done for the dead men's
families. Later she subscribed to the relief fund
set up for their assistance. W. & D. Downey had
taken four photographs of the mine, and these
were sent to the Queen with explanatory details.
Recent research has, however, revealed that the
names given for the men in the group photo-
graph are misleading; the true order is:
Mr Charles Carr (centre), the owner of the
pit, with Mr Humble, the pit manager, in the
background (left). The four sinkers are (left to
right) Mr W. Coulson; his son; (probably) Mr
Emmerson; Mr Wilkinson.

97.
Field Marshal Fitzroy James Henry, Lord Raglan,
G.C.B., 1855
By Roger Fenton
15.1x20.2cm
Albumen print

Lord Fitzroy Somerset was the youngest
son of the fifth Duke of Beaufort. He entered
the Army at the age of sixteen in 1804 and later
acted as A.D.C. and military secretary to the
Duke of Wellington in the Peninsular War and
Belgium. In 1815 he was present at Waterloo
and lost his right arm: thirty-seven years later,
on 31 October 1852, he told Queen Victoria how
it happened:

> The ball went right through his arm, but he
> felt no pain at the time, only his arm fell to his
> side. Then, after a little, the pain began, & he
> rode into the village, where the Surgeon said the
> arm must come off.[1]

Lord Fitzroy Somerset afterwards went on
several diplomatic missions, became military
secretary at the Horse Guards and received
honours which culminated in his being raised
to the peerage as Baron Raglan of Raglan in
1852. In the spring of 1854 he was selected to
command the British troops sent to the Crimea:
although he had never led troops in the field,
his diplomatic and military experience, com-
bined with his personal character and charm of
manner, seemed to make him the obvious choice.
However, although he acted with calmness and
fortitude and won the confidence of his army, he
was, as later described by Sir Evelyn Wood, 'the
victim of England's unreadiness for war.' The
early victory at the Alma raised hopes for the
prompt capture of Sevastopol, but as conditions
worsened and casualty figures mounted, the
inevitably slow progress caused increasing criti-
cism in the press and elsewhere. The attack on
the Malakoff and the Redan, which was to lead
to the assault on Sevastopol, was a disastrous
failure, and Lord Raglan felt it deeply. His
health broke, and he died on 28 June 1855.
Queen Victoria and Prince Albert received the
news at Buckingham Palace on 30 June and
'were dreadfully shocked & startled ... He pos-
sessed inestimable qualities, & many, which *no-
one* else, now eligible, possesses, – added to

which, his name, his experience, his birth, – his
very conciliatory manners, & amiable charac-
ter, – gave him such weight with the French.
To die thus, of disease, when in a very short
time he would have been rewarded for all his
anxieties and sufferings, & would have been able
to return in triumph, – a moment, I looked
forward to with pride, – is really too cruel &
heartbreaking ... Poor dear Ld. Raglan, – he
still remains the victorious General who led the
bravest of armies.'[2] These sentiments would
have been echoed by most of the Army. General
Sir George Brown, who visited the Royal
Family at Osborne on 1 August, deeply regretted
Lord Raglan's death, 'though he admitted his
defect, in having been so reserved & too diffi-
dent. Whenever Ld. Raglan had been most
fiercely attacked in the newspapers, the men had
made a point of cheering him more than usual,
when he rode through the Camp.'[3]

References
1. RA Queen Victoria's Journal: 31 October
1852.
2. ibid.: 30 June 1855
3. ibid.: 1 August 1855

98 (opposite).
Omar Pasha, 1855
By Roger Fenton
15.1x18.5cm
Albumen print
Omar Pasha was originally an Austrian
subject, born in Croatia, whose surname was
Lattas. He was converted to Islam in 1830,
taking the name of Omar, and went to Turkey,
where he entered the regular army. He served
with distinction in campaigns in Syria, Albania,
Kurdistan and the Balkans, and was appointed
to the command of the Turkish forces fighting
on the side of the Allies in the Crimea. He
achieved some popularity with the British
soldiers: Queen Victoria heard in July 1854
that 'Omar Pasha is delighted with our troops,
who in their turn, cheered him immensely when
he came to the Camp.'[1] Omar Pasha later com-
manded a force against the insurgents in Crete
in 1867. The Prince of Wales, during a tour of
the Near East, wrote to his mother from Con-
stantinople on 4 April 1869 telling her that 'I
made the acquaintance of Omar Pasha ... & he
is very agreeable to talk to – & is a very fine
looking old man. He commands all the troops in
Turkey – but there is the "Seraskier" or Com-
mander in Chief & also Minister of War over
him.'[2] Omar Pasha died at Constantinople on
18 April 1871.

References
1. RA Queen Victoria's Journal: 22 July 1854.
2. RA Vic. Add. MSS A3/131.

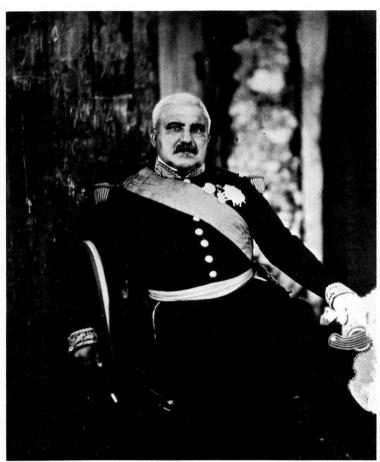

99.
General Alphonso Ferrero della Marmora, 1855
By Roger Fenton
10.1x14.1cm
Albumen print

General La Marmora commanded the Sardinian force which fought on the side of the Allies in the Crimean War. He had a distinguished military career, and held the post of Minister of War before and after the campaign. During a visit to England he had several conversations with Queen Victoria at Windsor Castle between 23 and 25 January 1856. She found him 'so gentlemanlike, sensible, agreeable & amiable, he is the "beau ideal" of a "grand Seigneur et preux Chevalier", – so quiet & modest.' They discussed the troops and the conduct of the war, and the situation in Italy. General La Marmora spoke highly of the British forces and 'thought the greatest care should be taken *not* to lose the peculiarities & characteristics of our Army, by imitating that of others.' The Queen considered him 'most sensible in all he said', and by 25 January was referring to him as 'a universal favourite'.[1] She had invested him with the Order of the Bath on the previous day.

Reference
1. R A Queen Victoria's Journal: 23–5 January 1856.

100.
Marshal Pélissier, 1855
By Roger Fenton
14.6x18.5cm
Albumen print

General Aimable Jean Jacques Pélissier, later Duke of Malakoff and a Marshal of France, was appointed commander-in-chief of the French forces after Canrobert's resignation in May 1855. Following her return home after the state visit to France in August 1855, Queen Victoria met on 2 September a former attaché at the French headquarters, Major Clarmont, who reported his impressions of the various commanding officers. The Queen learnt from him that Pélissier was

> a clever, energetic & honourable man, friendly towards the English, & as regards them, not difficult to deal with, but very rough & tyrannical with his own Officers. He is very unwieldy & cannot ride fast, the consequence of which being, that he could not be where he ought to have been on June 18th [the date of the attack on the Malakoff Tower] ... Pélissier is perhaps rather Orléanist, but such an honourable man that it would never lead him to do anything against the Emperor. He had all through the reign of Louis Philippe, worn the Croix de St Louis, which he saw no reason, he said, to give up wearing.[1]

Reference
1. R A Queen Victoria's Journal: 2 September 1855.

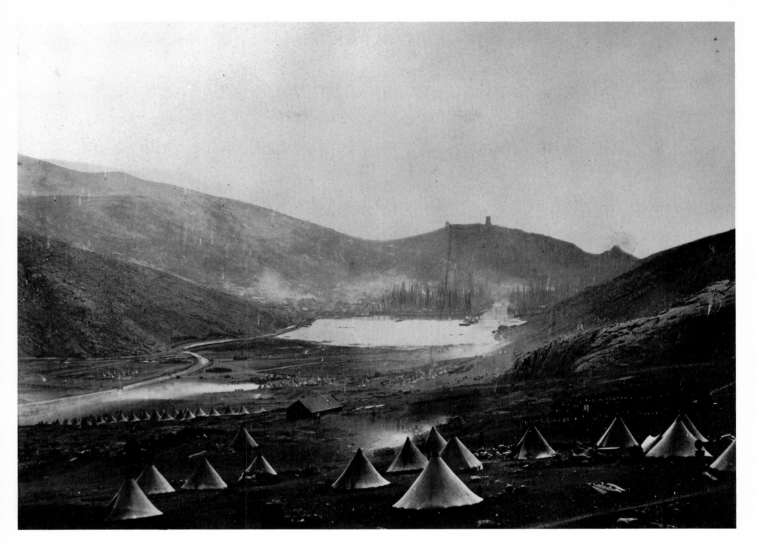

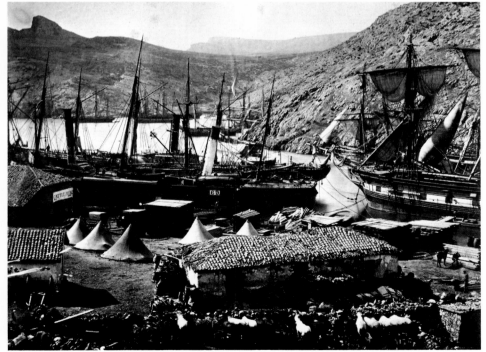

101.
Guards' Hill, Church Parade. Balaklava in distance, 1855
By Roger Fenton
35.3x26.2cm
Salted paper print

102.
Cossack Bay, Balaklava, 1855
By Roger Fenton
35.8x27cm
Salted paper print

101-2. While staying at Osborne in 1855, Queen Victoria noted in her Journal for 8 August that she and Prince Albert had 'looked at some most interesting photos, taken by Mr Fenton, in the Crimea, – portraits & views, extremely well done, – one, most interesting, of poor Ld. Raglan, Pelissier & Omar Pasha, sitting together, on the morning, on which the Quarries were taken.' The Prince of Wales also refers in his diary to having seen an exhibition of Fenton's Crimean photographs in Pall Mall on 21 February 1856 and again on 28 June in the same year. These two views, with the picture of Captain Morgan, are part of a set of Fenton's Crimean prints which is now in the Photograph Collection.

103.
Captain Morgan on the winner of the Crimean races, 1855
By Roger Fenton
14.2×17.2cm
Albumen print

In the spring of 1855, between sporadic bouts of action, the British and French officers in the Crimea amused themelves with duck-shooting, dog-hunts and horse-racing. William Howard Russell, Special Correspondent of *The Times*, whose accounts of the appalling conditions in the Crimea revealed the true meaning of war to the British public at home, reported in a lighter vein that the Russian pickets at Kamara and on Canrobert's Hill had been much interested in the racing; 'They evidently thought at first that the assemblage was connected with some military demonstration and galloped about in a state of excitement, but it is to be hoped they got a clearer notion of the real character of the proceedings ere the sport was over.'[1] It may have been episodes like this which led a former attaché at the French headquarters to report to the Queen in early September 1855 that 'the discipline in our army had got too lax, – there was not enough severity, – everybody having become too good-natured.'[2]

When Fenton's Crimean photographs were exhibited in 1855 at the Old Watercolour Society's rooms in Pall Mall, a reviewer took note of this particular photograph, mentioning that 'we have the winner of the Crimean cup, the High flyer, the Doctor Syntax of the Crimean Spring Meetings – ignoble to look at, but said to be one of the best that ever went before a tail.'[3]

References
1. **The Noise of Drums and Trumpets** by Elizabeth Grey (1971).
2. R A Queen Victoria's Journal: 2 September 1855.
3. **The Art Journal,** 1 October 1855.

104.
See **xiii** (p. 82) and p. 36.

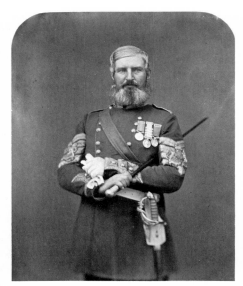

105.
Sergeant Major Edwards, Scots Fusilier Guards, 1856
By Cundall & Howlett
17.4×22cm
Albumen print

Sergeant Major Edwards had acted since March 1852 as Drilling Sergeant to the Prince of Wales and Prince Alfred, and when he left for Turkey in February 1854 they gave him a cane as a memento. After distinguished service in the Crimean War, having gained the French Military Medal, Sergeant Major Edwards returned home and took part in the triumphant march of the Guards Regiments to Buckingham Palace, which was watched by the Queen and Royal Family on 9 July 1856:

> There was a momentary pause between the Grenadiers and Scots Fusiliers, the crowds, breaking through, & the troops had great difficulty in getting along, being almost cut off, so that they had to run singly, & reform as they entered the railings. The worn & tattered colours were amazingly spontaneously cheered, several being crowned with laurels & flowers, & some of the soldiers carried flowers on the tops of their bayonets. Sergeant Edwards marched proudly at the head of the Regt., carrying a bouquet of roses.[1]

The Sergeant Major soon resumed his former duties: on 10 July he gave the royal children an account of his experiences in the Crimea, and then, according to the Prince of Wales's diary for 12 and 15 July, 'Sergeant Edwards drilled me.' He later became drilling sergeant to the younger royal children.

Reference
1. R A Queen Victoria's Journal.

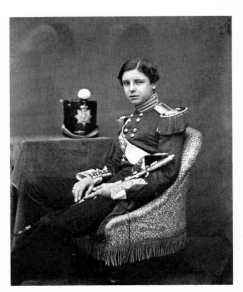

106.
Lieutenant W. Herbert J. Disbrowe, 17th Regiment
Photographer unknown
14×18.1cm
Albumen print

William Herbert J. Disbrowe entered the Army in 1854, serving with the 17th (the Leicestershire) Regiment of Foot, and becoming a Lieutenant on 8 December of the same year. He took part in the siege of Sevastopol from January to August 1855, and in the assault of the Redan on 18 June. His elder brother, Lieutenant Edward Amelius Disbrowe (Coldstream Guards), of whom there is also a photograph in the same collection, was killed at Inkerman, but Lieutenant W. H. J. Disbrowe survived the Crimean War. He became an Adjutant on 1 February 1856 and remained with the 17th Regiment, but he is mentioned in the Army List of 1859–60 as having died, whether or not in action is not specified.

The portraits of these two young soldiers make a poignant contrast to those of the ageing and experienced officers. The Disbrowe family would have been known to Queen Victoria, since several of its members had served in the Royal Household. Colonel Edward Disbrowe was first Equerry (1799–1802) and later Vice Chamberlain (1802–18) to Queen Charlotte; Lieutenant-Colonel G. Disbrowe was mentioned as having been a Secretary to Frederick, Duke of York, in 1827; and J. G. C. Disbrowe was a Page of Honour to Queen Adelaide in April 1837.

107.
Joseph Numa, John Potter and James Deal, Coldstream Guards
By Cundall & Howlett
18.7x23.4cm
Albumen print
 This print is part of a series of photographs of soldiers, taken for Queen Victoria by Cundall & Howlett in the summer of 1856, when the men had returned to England after the end of the Crimean War. The series forms a substantial part of the album of Crimean portraits chosen by the Queen for her collection, and she had given specific instructions as to how groups were to be photographed. Regimental group photographs, showing three or four of the most distinguished and handsome men, were to be taken as soon as possible, as the Queen was afraid that they would shave, or otherwise change their warlike appearance. It was arranged that groups of the men should be sent successively to Mr Cundall at 168, New Bond Street, London, in July 1856, giving him a day's notice beforehand.

108, 109.
See **xiv** (pp. 82–3).

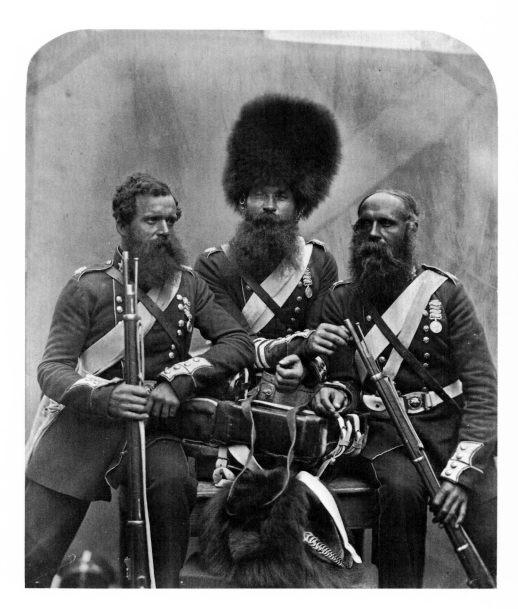

110.

Delegates at the Peace Conference at Paris,
25 February 1856
From left to right:
Seated: Baron Hübner, Ali Pasha, Lord
Clarendon, Count Walewski, Count Orloff,
Baron de Bourqueney, Lord Cowley
Standing: Count Cavour, Marquis de Villa-
marina, Count Hatzfeldt, M. Benedetti,
Mehemet Djemil Bey, Baron Brunow, Baron
Manteuffel, Count Buol
By Mayer Frères & Pierson
24.4x18.1cm
Albumen print

Representatives of the countries involved in
the Crimean War, who met in Paris to negotiate
the terms of peace in 1856. The peace treaty was
finally signed on 30 March and was proclaimed
by the firing of a salute of 101 guns. The birth
of the Emperor's son and heir shortly before
this gave further cause for public jubilation in
France. The news of peace was received in
England with more moderate satisfaction, but
the errors of judgement and lack of military
preparation which the war had revealed were not
forgotten. Prince Albert wrote to Baron Stock-
mar on 31 March that 'now our object must be
to establish a permanent Military Organisation,
on which I am hard at work.'[1]

Reference
1. RA Y150/35.

111.

Part of the English Cemetery, near Sevastopol,
1900
By Ivan Ermolaevitch Grigoriev
23x17cm
Gelatine silver print: 'photo-aquarelle'

Forty-four years after the end of the
Crimean War, Charles J. Cooke was about to
relinquish his post of British Vice-Consul at
Sevastopol. He commissioned a local photo-
grapher to take some views of the former battle-
fields, which he hoped to present to Queen Vic-
toria. Ten 'photo-aquarelles' were taken, most
of them in 1900 but at least one in the following
year. However, the Queen died before they could
be sent to her. Mr Cooke kept the photographs,
finally bringing them back with him to England,
until 27 December 1917, when he sent them to
Lord Hardinge of Penshurst (who was then Per-
manent Under-Secretary of State for Foreign
Affairs), asking him to 'let me trouble you with
the disposition of a set of Crimean photographs,
which I had prepared for Her Majesty Queen
Victoria seventeen years ago, when in Sebas-
topol, but which you may deem worthy of
acceptance by His Majesty King George, for
the Royal library, as they are absolutely unique.'

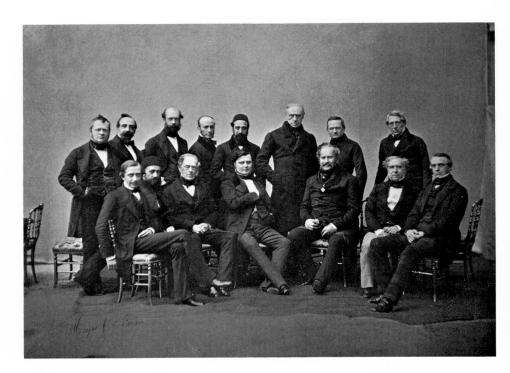

Two photographs from an album of thirty-five prints, showing the army camps at Boulogne and Aldershot, which were probably all taken during the middle or late 1850s. It is likely that the Aldershot photographs were taken by Corporal Church, of the Royal Engineers: 'a series of Photographs showing the progress of the New Barracks at Aldershot' by him was shown at the Photographic Society's exhibition in 1858.[1]

Prince Albert took an active interest in all aspects of army organization. In the early 1850s no camp existed in England for the training or concentration of a large number of troops. This inadequacy was deplored by the Army and the government alike, and steps were soon taken to remedy it. The Prince had suggested that an army training camp should be set up as an experiment, and a camp was established at Chobham with highly satisfactory results. Following this, the Prince, supported by the Queen, played a decisive part in encouraging the establishment and selection of a permanent site for the camp. The place chosen was Aldershot, with its surrounding heath and common land. Between 1854 and 1861 over 7,000 acres were purchased. The first permanent barracks to be erected were the Wellington Lines, built between September 1854 and 1859, and a large number of wooden huts were built for the militia. In due course the camp was fully equipped, including the Royal Pavilion (the site and design of which had been chosen by the Prince) and a library, of which he bore the cost. He made several visits to the camp, which was formally opened by the Queen in July 1855. In April 1856 they stayed for the first time at the Royal Pavilion: this was to be the start of many royal visits to Aldershot.[2]

It is clear that Aldershot was a source of great interest and pride to Prince Albert. In September 1854 he had a chance to see how such matters were arranged in France when he visited Boulogne and discussed the Crimean War with Emperor Napoleon III. During this time the Prince went to see two army camps, each consisting of an infantry division of 8,000 men. The Emperor was deeply concerned about his army, which the war had found unprepared, although improvements were being made. The camps were to be maintained during the whole winter, to harden the troops for war. At the close of their state visit to France in 1855, the Queen and the Prince paid a further visit to the French army at Boulogne, first watching a review and then inspecting the camp, which the Queen described in her Journal for 27 August as extending over a wide area. 'The huts are very low, small, & ill-ventilated, – made of mud, & with no flooring. Went into one of the officer's & one of the men's & tasted some of their excellent brown bread.'

The juxtaposition of the Boulogne photographs with those taken at Aldershot shows that the French camp was far more picturesque than the British one. The most attractive views at Aldershot show, not the men's accommodation, but provision for the horses, such as the artillery field forge. However, as Prince Albert looked at the trim wooden huts, with glass-paned windows and brick chimneys, he may have reflected that it was not the business of a modern working barracks to be picturesque.

References
1. Catalogue of the Photographic Society's exhibition for 1858.
2. **The Story of Aldershot** by Lt.-Colonel Howard N. Cole (Gale and Polden, 1951).

112.
Barracks, Boulogne
By C. Thurston Thompson
29.1x22.5cm
Albumen print

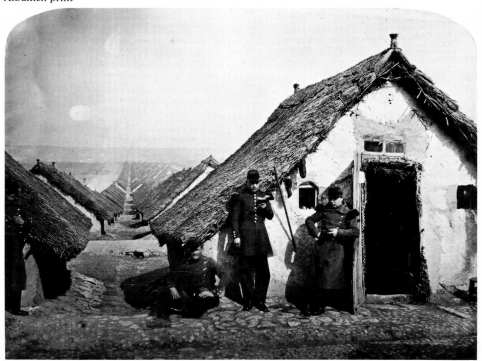

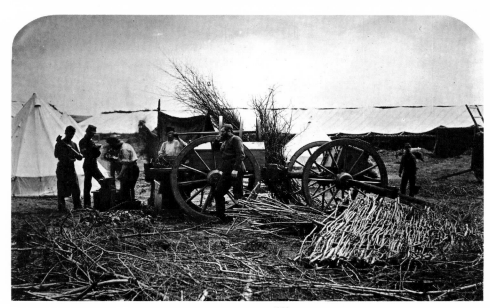

113.
Artillery Field Forge, Aldershot
Attributed to Corporal Church, R. E.
28.4x17.8cm
Albumen print

114.
**Shooting for the Duke of Cambridge's Prize,
Wimbledon,** July 1860
By Roger Fenton
29x23.8cm
Albumen print

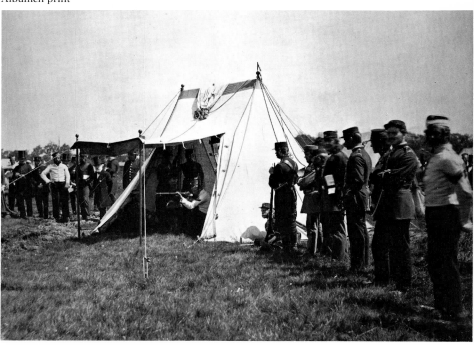

115.
The Queen's Target, Wimbledon, 2 July 1860
By Roger Fenton
24.5x28.1cm
Albumen print

114–15. On 2 July 1860, the royal party attended the inaugural meeting of the National Rifle Association at Wimbledon (now held at Bisley), an event which the Queen described in her Journal:

> We went over the new suspension bridge, through Battersea Park, Wandsworth & Wimbledon, through Wimbledon Park (Ld. Spencer's property) on to the Common, where there was an immense concourse of people. George [the Duke of Cambridge, who was the Queen's cousin, and Commander-in-Chief of the Army], with the Committee, at the head of which were Mr. S. Herbert, Ld. Spencer, & Ld. Elcho, the most active members, received us at the entrance of a fine large tent, through which we walked. In one part of it were drawn up in 2 lines all the Volunteers, who were going to compete today, the Swiss, who had come over, standing beside them. We received Addresses, read by Mr. S. Herbert & afterwards walked up the line to another small tent, where the Rifle was fixed by Mr. Whitworth himself. I gently pulled a string & it went off, the bullet entering the bull's eye at 300 yards!! Ld. Elcho gave me the medal. We then returned to the big tent, remaining there some time, the Bands playing, while the shooting began. We also visited a tent, with new rifle inventions.

The royal party then drove away in their carriages, occasionally stopping to watch the firing from a distance.

116, 117.
See **xviii** (p. 84).

118.
Robert Baden-Powell, 13 October 1901.
Inscribed: 'Mafeking 13 Oct. 1899 to 17 May
1900.'
By Duffus Brothers
12.2x18.3cm
Gelatine silver print

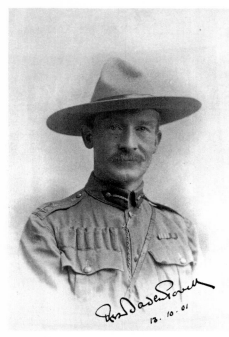

119.
**Imperial Yeomanry Field Hospital and Bearer
Company,** 8 June 1900, at General de Wet's
farm
By Lieutenant A. Langman
35.1x25.1cm
Gelatine silver print

During the South African War of 1899–
1902, the Imperial Yeomanry Field Hospital
and Bearer Company were captured by General
Christiaan de Wet on 7 June 1900, when he took
Roodewal Station. While in captivity, an officer
with the company, Major Stonham, requested
permission to go to the General Hospital at
Kroonstad, taking with him six or eight ambu-
lance wagons, some of the wounded and a
number of his men of the 4th Derbyshire Militia
(Sherwood Foresters), and to return with some
wagons of provisions for use by the Field Hos-
pital. General de Wet wrote him a pass, which
would enable him to travel unmolested and
receive any necessary assistance, on 10 June.
The pass, with an account of the incident, is
mounted with the photograph. Lieutenant
Langman, of the Langman Hospital, who took
the photograph, accompanied Major Stonham
on the journey.

118. Robert Stephenson Smyth Baden-
Powell, first Baron Baden-Powell of Gilwell
(1857–1941), became renowned not only as the
founder of the Boy Scouts and Girl Guides, but
also as a popular military hero. His army career
began in 1876, when he joined the 13th Hussars
in India. His duties also took him to Africa and
elsewhere, and he made a speciality of
reconnaissance and scouting, preferring to use
initiative rather than the rule book. Baden-
Powell was also a keen polo player and enjoyed
amateur theatricals and painting.

While at home on leave in 1899 he was
gazetted for extra duties: war seemed likely in
South Africa and he was sent out to raise two
regiments for the defence of Bechuanaland and
Matabeleland. When war broke out he was at
Mafeking, a small town of strategic importance,
which was promptly besieged by the Boers under
General Cronje. Using his genius for organ-
ization and improvisation, Baden-Powell sus-
tained the siege for 217 days. News of the
situation was eagerly followed at home, and his
sister wrote to him: 'Everybody is talking of
you. You are the hero of the day . . . Your photo
is in all the shops now, and on enquiring they
say yours is the first favourite, then Roberts,
Buller, White etc., but yours sells best.'[1] When
Mafeking was finally relieved on 17 May 1900,
there was wild rejoicing and 'mafficking' in
London.

Baden-Powell retired from the army as a
Lieutenant-General in 1910, but meanwhile, in
1907, he had held the first experimental camp
for a group of boys, on Brownsea Island. This
led to the beginning of the Boy Scout movement,
which, as it developed, claimed all his time. He
had visited Balmoral on several occasions, and
King Edward VII had shown a great interest in
the new movement, suggesting that a royal
review of Scouts should be held at Windsor.
The King's death in May 1910 postponed this
event until 4 July 1911, when it was held with
great success. Baden-Powell enjoyed the friend-
ship of the Duke of Connaught (who acted as
godfather to his son) and was supported in his
work for the Boy Scouts by King George V and
the Royal Family, as well as by foreign rulers,
such as Tsar Nicholas II, whom he visited in
1911. The Tsar had read *Scouting for Boys* and
encouraged the formation of Scout groups
through the schools in Russia.

Baden-Powell's part in the Scout and Guide
movements (in which he received the support
of his wife, as Chief Guide) brought him inter-
national fame and hero-worship. He remained
a friendly, unassuming man, whose greatest
pleasures were painting and outdoor recreations.
He also wrote over thirty books, nearly all illus-
trated by himself, as well as many articles and
pamphlets, before his death in 1941.

Reference
1. See **Baden-Powell: the two lives of a hero** by
William Hillcourt with Olave, Lady Baden-
Powell (1964).

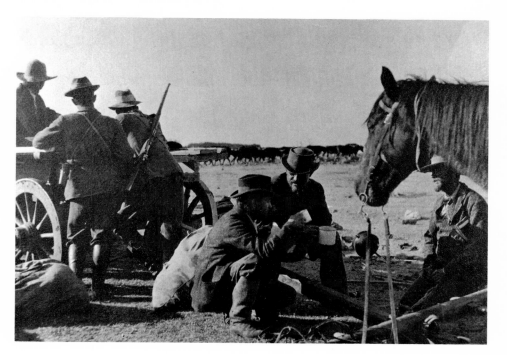

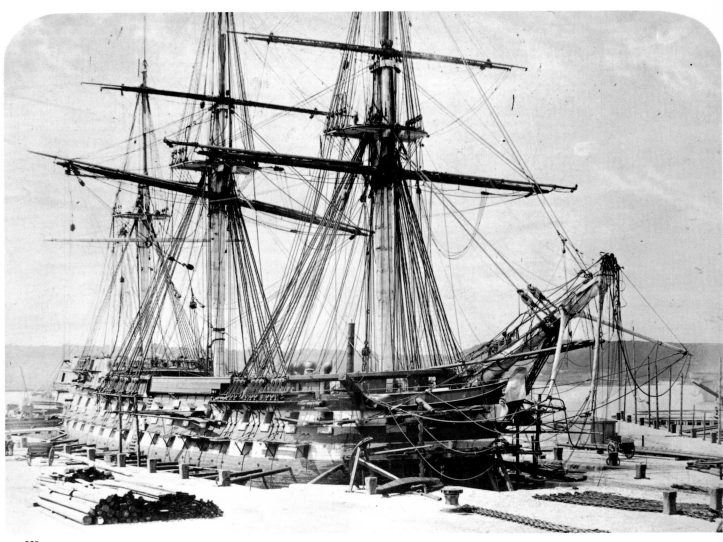

120.
H. M. S. *Hannibal* fitting for the Black Sea fleet,
December 1853
By C. Thurston Thompson
22.4x17cm
Albumen print
 A British ship preparing to leave for the
Black Sea at the time when a Russian force had
destroyed part of the Turkish fleet during the
Battle of Sinope, precipitating events which led
to the outbreak of the Crimean War.

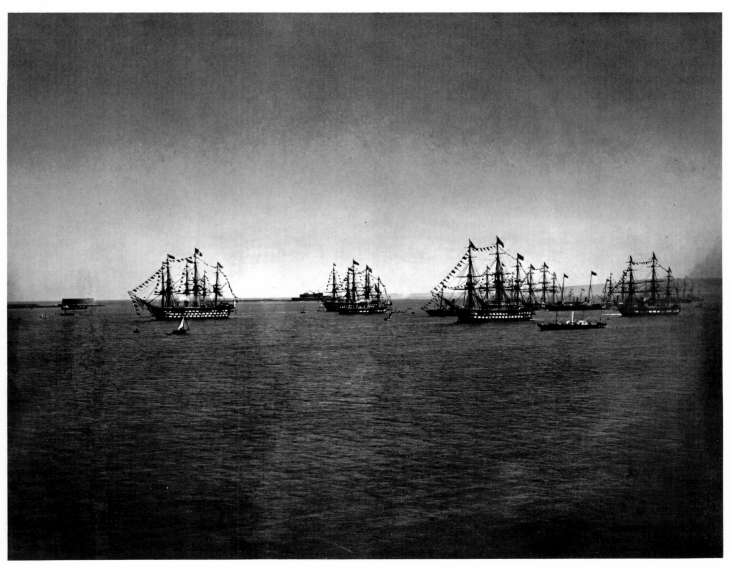

121.
The English Fleet at Cherbourg, 5 August 1858
By Gustave Le Gray
38.4×30.5cm
Albumen print

Queen Victoria and the Prince Consort paid a state visit to Cherbourg on 4–6 August 1858 on board the Royal Yacht *Victoria and Albert*. They were accompanied by a squadron of ships of the British fleet acting as escort to the Royal Yacht during the visit: this consisted of H. M. S. *Royal Albert*, H. M. S. *Renown*, H. M. S. *Diadem*, H. M. S. *Euryalus*, H. M. S. *Curaçoa* and H. M. S. *Racoon*. In immediate attendance on the Royal Yacht were the *Fairy*, the *Banshee*, the *Black Eagle*, the *Vivid*, and the Trinity House yacht *Irene*. An unofficial contingent of at least 150 vessels from England, including steamers and boats from the Thames, Victoria and Royal Yacht Clubs, and a hundred Members of Parliament in a ship chartered by themselves, also joined the fleet in the harbour at Cherbourg.

On its arrival the Royal Yacht received a resounding salute from the French fleet, which, according to *The Times*' correspondent, 'as much surpassed expectation as it defied description', and which the Queen described as 'truly splendid'.[1] Shortly afterwards the Queen and the Prince received the Emperor and Empress of the French on board the Royal Yacht. On the following day the Queen and the royal party, with their hosts, drove through Cherbourg and later saw and admired the view of the town from Fort La Roule. That evening a state dinner was given on board the French yacht *Bretagne*. Relations between England and France were at that time less cordial than they had been in recent years: the Emperor, sensitive to criticism from England and elsewhere, was in low spirits, and Prince Albert was particularly nervous at having to make a speech in reply to the Emperor's, knowing (in the words of his biographer Theodore Martin) that 'every word which fell from [his] lips was sure to be searched for latent meanings by the diplomatists and journalists of Europe.' Fortunately the speeches were a success, and the banquet ended with the mutual reaffirmation of friendship between the two countries. The evening finished with a magnificent display of fireworks, which the royal party watched from the deck of the *Bretagne*, and on the following day, 6 August, the Royal Yacht returned to England.

Reference
1. R A Queen Victoria's Journal: 4 August 1858, as quoted in **The Life of His Royal Highness The Prince Consort** (1875–80), Vol. IV, by Sir Theodore Martin.

124.
Midshipmen at Physical Drill
By Chief Petty Officer T. M. MacGregor
22.7x17.5cm
Printing out paper, contact print

123.
Captain's Fore Cabin
By Chief Petty Officer T. M. MacGregor
23.4x18.1cm
Printing out paper, contact print

122–5. These four photographs come from an album of fifty prints, showing life on board H. M. S. *Crescent* during a voyage, under the Duke of York's command, from June to August 1898. The journey was of special significance in the naval life of the future King George V, since it was his first command as a captain and was to prove his last assignment as an active officer in the Royal Navy. The voyage, during which the *Crescent* travelled between Portsmouth, Devon, Ireland and the Orkneys, was largely taken up with exercises in target practice, but also included manoeuvres with the Channel Squadron at Kirkwall. As a final duty, the *Crescent* acted as guardship during Cowes Week.

The Duke of York wrote to his mother, the Princess of Wales, on 25 August that 'I shall indeed be sad when tomorrow morning comes & I have to give up the command of this beautiful ship on bd. of which I have spent close on three very happy months . . . May [the Duchess of York] is coming over here today to say goodbye to everybody & to see the ship for the last time. I feel quite low about it all.'[1] On the same day he made a short speech to the officers and crew, and one of the officers, Commander Campbell, asked the Duchess of York to accept the album of which these four photographs are a part. The photographs had all been taken by Chief Petty Officer T. M. MacGregor, Chief Torpedo Instructor of H. M. S. *Vernon* and photographer to the training school.

With some cinematograph pictures made by a Mr West, these photographs were also used in a film which entertained first the crew of the *Crescent* and later Queen Victoria and other members of the Royal Family at Osborne House. Both shows were described in *The British Journal of Photography* for 2 September. The one on 23 August to the crew of the *Crescent* made use for the first time of a cinematograph invented by Mr Adams, who was connected with the firm of West & Son. This instrument was fixed on the boat-house jetty alongside the *Crescent*, and the pictures were projected on to a sheet so that they could be seen by the crew watching from the ship. One of the most popular sequences showed the ship's company marching round the quarter-deck. The men's faces could be seen very clearly and the audience greeted this with 'roars of delight'. Another 'very taking thing' showed the 'Two best dancers in the Navy', to which the band played accompaniments. There were also shots of torpedo explosions, sailors at field-gun drill and single-stick exercises, and 'a remarkably good view' of the boats of the Channel Squadron pulling round the fleet; the spectators 'grew quite excited as the crews swept past them'. Interspersed with the moving pictures were lantern slides of Mr MacGregor's photographs. The entertainment was much appreciated by the crew, 'who gave vent to their delight in an impromptu dance on the jetty after the affair was over'.

The display at Osborne House lasted just over twenty minutes, the pictures being 'thrown upon a screen fixed up in the doorway' of the drawing room, where the Queen and party were sitting, by the lanterns, which were being operated from the dining room. The Duke of York explained the pictures to the Queen as they were projected, and she later sent a message to Mr West that she was 'greatly pleased' with them.

Reference
1. RA Geo. V AA36/41.

122.
Issuing Rum
By Chief Petty Officer T. M. MacGregor
23.8x18.3cm
Printing out paper, contact print
 The tradition of issuing 'grog' to the Navy
was reputedly started by Admiral Edward
Vernon in 1740 while he was stationed in the
West Indies. When at sea, sailors were usually
allowed a ration of spirits instead of water (which
would not keep fresh for long enough), but
because the local West Indian rum was too
strong, Vernon ordered that it should be
diluted. The resulting drink became known as
'grog', from Vernon's nick-name of 'Old Grog',
which referred to his coat made of grogram
(grosgrain) cloth. The last issue of grog was
made in 1970.

125.
Pay Day!
By Chief Petty Officer T. M. MacGregor
22.8x17.8cm
Printing out paper, contact print
 Able-bodied seamen, such as the man
receiving his money in this photograph, would
have earned 1s. 4d. (6½p) a day in 1898.

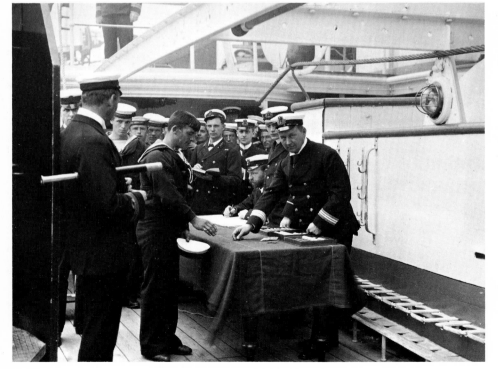

126–9. The Photograph Collection contains seven prints by Mrs Cameron, all portraits of men. (The three not shown here are of Tennyson, Sir John Simeon and Herbert Wilson.) In 1865 Queen Victoria purchased five of Mrs Cameron's prints through John Mitchell, Bookseller and Publisher to Her Majesty. Two were portraits of Tennyson and Henry Taylor and the remaining three were *Paul and Virginia*, *A Child* and *First Whisper of the Muse*. It is likely that the portrait of Longfellow was acquired at about the time of his meeting with the Queen at Windsor Castle on 4 July 1868, when she described him as a 'fine looking, intelligent & pleasing old man, with quite white hair & beard. He is much gratified by his reception in this country & the feeling shown by the working classes in their anxiety to see him is quite striking.'[1]

The Queen never seems to have met Mrs Cameron, although there were at least two areas of common interest, apart from photography, which might have brought them together. The Queen and Prince Albert subscribed to the Arundel Society, of which Mrs Cameron was a member for many years, and both ladies had houses in the Isle of Wight. It seems significant that, apparently, the majority of Mrs Cameron's photographs purchased by the Queen were portraits, as befitted her interest in people. Prince Albert died in 1861, two years before the start of Mrs Cameron's career as a photographer: he admired Tennyson's *Idylls of the King*[2] (which the poet subsequently dedicated to him), and it is interesting to speculate on how many more of Mrs Cameron's prints, particularly her studies interpreting religious and literary themes, including Tennyson's poems, would have been acquired had he lived another fifteen years. Queen Victoria was also an admirer of Tennyson's work: in November 1863 she bought two copies of a photograph of *In Memoriam*, taken by J. Dixon Piper.[3] In November 1867 she bought copies of Tennyson's *Vivien* and *Guinevere* from steel plates by Doré, a copy of a photograph of *Vivien* and another of *Guinevere*, from Messrs Moxon, as Christmas presents.[4] The prints by Mrs Cameron of *Paul and Virginia*, *A Child*, and *First Whisper of the Muse*, which are not in the Photograph Collection, may have been intended as a present for her eldest daughter, Victoria, Crown Princess of Prussia, whose taste in art was more like that of her father. The Queen's preference was for realism in art and photography: she had less sympathy for the 'artistic' approach. The bill for the three prints is dated 16 November 1865,[5] and the Crown Princess's birthday, which in 1865 she spent with her mother, was 21 November. It seems that she admired Mrs Cameron's work, as in *Annals of My Glass House* the latter reported her delight at being asked to photograph the Crown Princess and her husband. It would be interesting to know how the Crown Princess viewed the results, but unfortunately these portraits appear not to have survived.

References
1. RA Queen Victoria's Journal: 4 July 1868.
2. Sir Theodore Martin, **The Life of His Royal Highness The Prince Consort** (1875–80), Vol V, pp. 90–91.
3. RA PP2/77/6176.
4. RA PP2/124/13218.
5. RA PP2/104/10370.
See **Julia Margaret Cameron. 1815–1879** by Dr Mike Weaver (Herbert Press, 1984).

126.
G. F. Watts. From life, not enlarged, Freshwater Bay, 1865
By Julia Margaret Cameron
29x37cm
Albumen print

127.
Clinton Parry, Esq., from life, Freshwater, 1868. 12/6
By Julia Margaret Cameron
25.7x30.1cm
Albumen print

128.
Thomas Carlyle, from life, 1867
By Julia Margaret Cameron
24.7x31.9cm
Albumen print

129 (opposite).
Henry W. Longfellow. From life, registered photograph. Taken at Freshwater Bay, July 1868.
Thirty shillings being genuine written autograph
By Julia Margaret Cameron
27.7x35.5cm
Albumen print

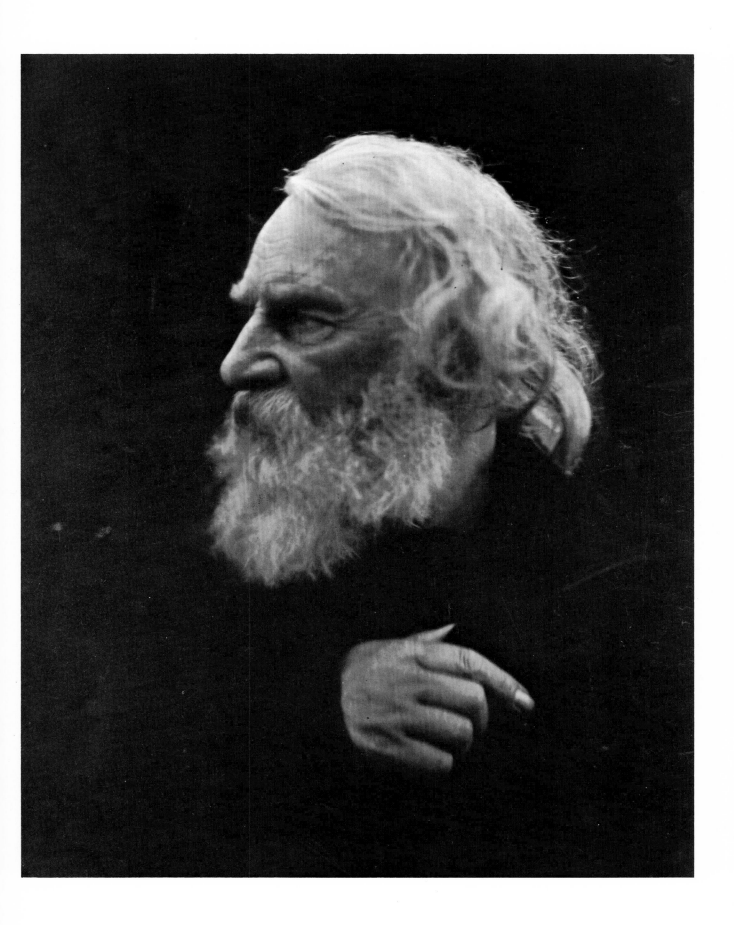

131.
Archduchess Marguerite of Austria, aged nine
By Koller K. Tanár (Professor K. Koller)
9.2x11.7cm
Albumen print
 Archduchess Marguerite Clementine Marie
(1870–1955) was the third daughter of Arch-
duke Joseph of Austria and his wife, Arch-
duchess Clotilde (formerly a Princess of Saxe-
Coburg-Gotha), whose father, Prince Augustus,
was a first cousin of Queen Victoria and Prince
Albert. In 1890 Archduchess Marguerite
married Albrecht, eighth Prince of Thurn und
Taxis; they had six sons and one daughter.

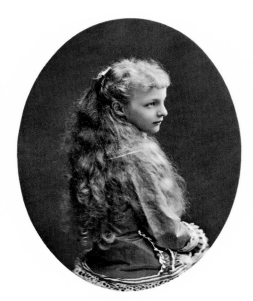

130.
Landscape with sheep, *c.* 1890s
By Charles Reid
43.3x34.3cm
Carbon print
 Charles Reid was known for his photo-
graphic studies of animals. This idealized
country scene is reminiscent of some of the work
of the Linked Ring Brotherhood which was
being produced at about the same time. The aim
of this group was to use photography as art,
some members preferring to produce work
which was true to nature as it was, and others
attempting representations which were true to
idealized conceptions of nature as it might be.[1]
Reid was not a member of the group, but this
photograph shows that he was inspired by the
spirit of the time.

Reference
1. See **The Linked Ring: The Secession Move-
ment in Photography in Britain, 1892–1910** by
Margaret F. Harker (1979).

132 (opposite).
**The Marquess of Granby and his daughter, Lady
Victoria Marjorie Harriet Manners,** June 1888
By Byrne & Co.
10.3x14.9cm
Albumen print
 Henry Manners, Marquess of Granby, later
eighth Duke of Rutland, with his eldest
daughter, who married the sixth Marquess of
Anglesey in 1912.

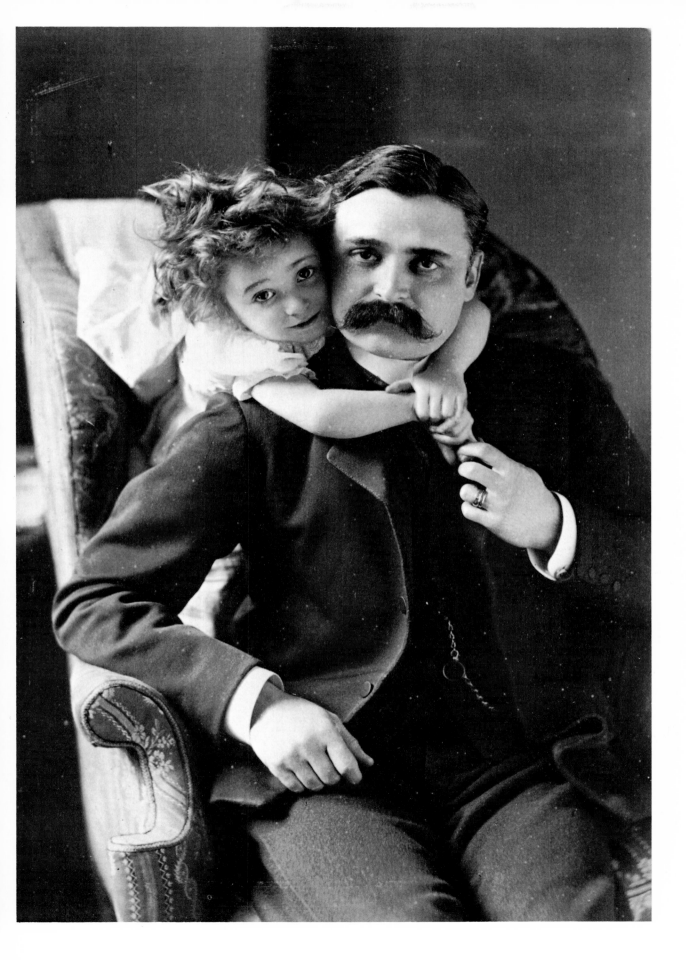

133.
Miss Beatrice Carpenter, daughter of the Bishop of Ripon, January 1888
By Walter Davey
10.2x14.3cm
Albumen print

William Boyd Carpenter was Bishop of Ripon from 1884 to 1911, having earlier been a Chaplain to Queen Victoria from 1879 to 1884 and a Canon of Windsor from 1882 to 1884. He and his wife had four sons and six daughters, one of whom was Beatrice.

134.
Marie, Princess Aloys of Liechtenstein (Miss Fox), undated
By Adèle
7.4x10.4cm
Albumen print

134. The Hon. Mary Fox was the adopted daughter of Henry Edward Fox, fourth and last Baron Holland, and was the authoress of an account of Holland House and its art treasures. In 1872, when she was twenty-two, she married Prince Aloys of Liechtenstein; they had four daughters. Princess Marie died in 1878 at the early age of twenty-eight.

135.
Dr Henry Benjamin Whipple, Bishop of Minnesota, 7 December 1890
By Elliott & Fry
10.4x14.7cm
Albumen print

Queen Victoria met the Bishop of Minnesota on 7 December 1890 at Windsor Castle and described the occasion in her Journal:

> After tea, Dean Davidson brought the Bishop of Minnesota, (Dr Whipple) an American. The Dean said he was reverenced throughout America for his extraordinary work & influence, as a sort of father & guide to the Red Indian Tribes, among whom he had spent many years of his long life. He was much liked & beloved by the late Archbishop Tait & his wife. The Bishop is very tall & thin, with very fine regular features, bald, but with longish hair at the back of his head. He spoke with affection of the Red Indians, & of their trials, their attachment & devotion.

136.
Queen Wilhelmine of the Netherlands, c. early 1890s
By Adolphe
9.7x13.5cm
Gelatine silver print

Queen Wilhelmine succeeded to the Dutch throne at the age of ten on the death of her father, King William III, in November 1890. In May 1895, accompanied by her mother, Queen Emma, and her aunt, Helen, Duchess of Albany (widow of Queen Victoria's youngest son), she met Queen Victoria at Windsor Castle. Queen Victoria recorded the occasion in her Journal for 3 May:

> ... Shortly before 2, went downstairs to receive the Queen Regent of the Netherlands and her

daughter, the young Queen Wilhelmine. Beatrice had been to meet them at the station & Helen came with them. The young Queen, who will be 15 in August, has her hair still hanging down. She is very slight & graceful, has fine features, & seems to be very intelligent & a charming child. She speaks English extremely well & has very pretty manners. After luncheon we went into the corridor, & took coffee, after which the Queen Regent presented the 3 Ladies in attendance on herself & her daughter, including the English governess, & 3 gentlemen. I then presented my Ladies & Gentlemen. Drove at 4.30 with the Queen Regent, who is very amiable & 'sympathique', so clever & sensible. Helen & Beatrice drove with the young Queen. We took tea all together at Virginia Water. They left again after we got back at 7.

137 (opposite).
Countess Sydney, c. late 1880s
By G. & R. Lavis
9.8x13.7cm
Gelatine silver print

Emily, Countess Sydney, was the wife of the first Earl Sydney, who served in Queen Victoria's Household, first as Lord Chamberlain and then as Lord Steward. At his death in February 1890, the Queen described him in her Journal as 'a loyal devoted servant of the Crown ... full of knowledge & experience, to whom one could turn at all times.' On seeing his widow on 8 July 1892, the Queen referred to her in her Journal as 'dear Ly. Sydney' and noted that she still 'looked so pretty & unaltered'; and in general Lady Sydney shared the affection and esteem which members of the Royal Family showed to her husband.

139.
Princess Louise, Marchioness of Lorne,
November 1878
By Notman, Montreal
10x13.9cm
Albumen print

Queen Victoria's fourth daughter, Princess Louise, had married John, Marquess of Lorne (later ninth Duke of Argyll), in 1871. This photograph was taken during their residence in Canada from 1878 to 1883, when Lord Lorne was Governor-General.

138.
Princess Beatrice, March 1872
By W. & D. Downey
10.2x14cm
Albumen print

140 (opposite).
Prince Leopold, March 1872
By W. & D. Downey
9.6x13.5cm
Albumen print

138, 140. These portraits of Queen Victoria's two youngest children show them in the clothes they wore at the Thanksgiving Service for the recovery of the Prince of Wales from typhoid fever, which was held at St Paul's Cathedral on 27 February 1872. Prince Leopold is wearing the collars of the Order of the Garter and the Order of the Thistle, with Highland dress. He had a particular association with Scotland: one of his names was Duncan, and the Dukedom of Albany was conferred on him by the Queen in 1881. This title had previously been borne by Charlotte Stuart, Duchess of Albany, the daughter of Prince Charles Edward ('Bonnie Prince Charlie'). Prince Leopold's posthumous son was christened Charles Edward, according to a wish he had often expressed.

Princess Beatrice's costume was described in the press as 'a dress and jacket of rich mauve silk, trimmed with swan's down, and a white hat trimmed with mauve and white feathers.' Queen Victoria commented that 'Beatrice looked very nice.'[1]

Reference
1. RA Queen Victoria's Journal: 27 February 1872.

162

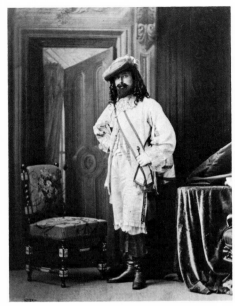

141.
Prince Arthur in Canada. The Prince in the fancy costume worn by him on the occasion of the Skating Carnival, January 1870
By Notman, Montreal
10.1x14cm
Albumen print

Prince Arthur, who was appointed a Lieutenant on 3 August 1869, left England for Canada later in the month to join his regiment, the First Battalion of the Rifle Brigade, which was then stationed in Montreal. At the beginning of 1870 he paid a short official visit to America, during which he met the President, Ulysses S. Grant, and then returned to his regiment in Canada until July, when he came back to England. While stationed in Montreal he attended a number of parties, including the Skating Carnival, at whch he seems to have appeared as King Charles I. In a letter to Queen Victoria of 9 January 1870, he told her that 'I practise skating a great deal in the Rink and get fonder of it every day, but I am afraid I shall never be able to skate as well as they do here.'[1] The Prince, who was later created Duke of Connaught, returned to Canada as Governor-General from 1911 to 1916.

Fancy dress balls were popular entertainments during Queen Victoria's reign, both in England and abroad. The Queen's love of the theatre had helped to encourage her children to present plays and tableaux on special occasions, and as adults they would attend fancy dress parties or take part in private theatricals.

Reference
1. RA Vic. Add. MSS A15/1552.

142.
Princess Louise of Schleswig-Holstein, May 1884
By Byrne
18.1x25.7cm
Albumen print

Princess Louise (or, as she preferred, Marie Louise) was the second daughter and youngest surviving child of Princess Helena and Prince Christian of Schleswig-Holstein. She married Prince Aribert of Anhalt in 1891 but separated from him after nine years. Princess Marie

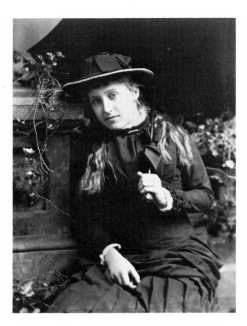

Louise was the originator of the idea which eventually led to the creation of Queen Mary's Dolls' House, and also wrote her autobiography, *My Memories of Six Reigns*, shortly before her death in 1956.

143.
Prince Alfred of Edinburgh, August 1876
By Bergamasco
7.9x10.7cm
Albumen print

Prince Alfred was the eldest child and only son of Alfred, Duke of Edinburgh (and later of Saxe-Coburg-Gotha), and his wife, formerly Grand Duchess Marie of Russia.

144.
Princess Victoria of Wales, May 1881
By Bassano
9.6x13.8cm
Albumen print

A striking portrait of the second daughter of the Prince and Princess of Wales, taken when she was nearly thirteen.

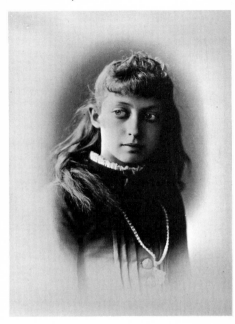

145 (opposite).
Princesses Sophie and Margaret of Prussia, August 1882
By Arthur Debenham
9.2x13.8cm
Albumen print

The two youngest children of the Crown Prince and Crown Princess of Prussia (Princess Sophie is on the left) visited the Isle of Wight in the summer of 1882 for, as Queen Victoria noted in her Journal for 21 July, 'change of air & sea bathing', while their mother was on holiday in Switzerland.

146.
The Prince and Princess of Wales, 1881
By Alphonse Liébert
8.5x13.3cm
Albumen print

Albert Edward, Prince of Wales, like his father, the Prince Consort, was keenly aware of the advantages of modern technology. He was the first member of the Royal Family to own a motor car, and the newly decorated rooms at Buckingham Palace into which he and Queen Alexandra moved on their accession promised to be 'lovely, with everything that modern art & science can produce.'[1] In the early 1880s the Prince was eager to investigate the possibilities of electricity. He wrote to his younger son, Prince George, on 20 October 1881 to tell him that 'on the 22nd Mama & I are going over to Paris for a week to see the Electric Exhibition'.[2] The Prince and Princess of Wales visited the Exhibition on 26 October. While in Paris they also went to see M. Liébert, a photographer who made use of electricity to light his studio, and this photograph is the result of the visit. On 31 March 1882 the Prince wrote to Prince George that he and the Princess had been to the Crystal Palace 'at 7 in the evening – & saw the Electric Exhibition which was most interesting.'[3] The Prince considered electric lighting 'an immense boon'[4] and had soon installed it at home; but the Princess was sometimes less than happy about the appearance of the fittings. She wrote to Prince George from Marlborough House on 5 May 1888 about the electric light in her rooms – 'which everybody tries to persuade me is perfectly charming. It is hidden by vulgar shells! which I have the pleasure of looking at all day long empty & hideous!!!'[5]

References
1. RA Geo. V AA37/3.
2. RA Geo. V AA14/2.
3. RA Geo. V AA14/7.
4. RA Geo. V AA15/48.
5. RA Geo. V AA30/37.

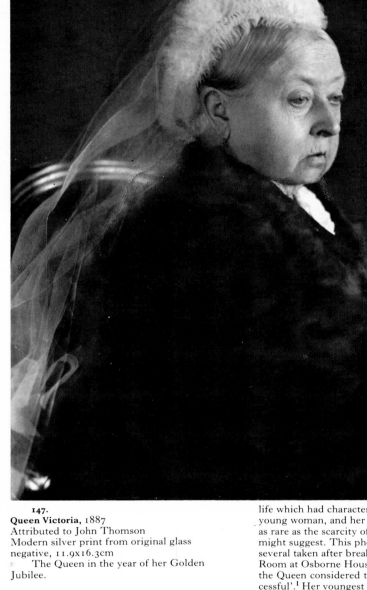

147.
Queen Victoria, 1887
Attributed to John Thomson
Modern silver print from original glass negative, 11.9x16.3cm

The Queen in the year of her Golden Jubilee.

148 (opposite).
The Four Generations: The Queen, Princess Beatrice, Princess Louis of Battenberg and Princess Alice of Battenberg, April 1886
By Gustav Mullins
9.6x13.1cm
Gelatine silver print

Despite her great and abiding sorrow at the untimely death of the Prince Consort, Queen Victoria never entirely lost the ability to enjoy life which had characterized her as a girl and young woman, and her smile was by no means as rare as the scarcity of photographic evidence might suggest. This photograph was one of several taken after breakfast in the Council Room at Osborne House on 26 April 1886, and the Queen considered them to be 'very successful'.[1] Her youngest daughter, Beatrice, Princess Henry of Battenberg, stands in the background, and a granddaughter, Victoria, Princess Louis of Battenberg (eldest child of the Queen's daughter, Princess Alice), is holding her daughter, Princess Alice of Battenberg. Princess Alice was in the future to marry Prince Andrew of Greece, and they would become the parents of Prince Philip, now Duke of Edinburgh.

Reference
1. RA Queen Victoria's Journal.

149.
Princess Alice of Albany, April 1886
By G. P. Cartland
8.8x13.7cm
Probably a gelatine silver print

Princess Alice was the elder of the two chil-
dren of the Duke and Duchess of Albany. In
1904 she married Prince Alexander of Teck, the
youngest brother of the future Queen Mary. In
1917 Prince Alexander assumed the title of Earl
of Athlone; his wife was known as Princess
Alice, Countess of Athlone, until her death in
1981.

151.
**Marie, Princess Ferdinand of Roumania, with her
children, Prince Carol and Princess Elizabeth,**
dated August 1895
By Gustav Mullins
9.7x13.8cm
Printing out paper

Princess Marie (known as Missy) and her
children were visiting the Isle of Wight in July
1895 at the same time as her sister, Victoria
Melita, Grand Duchess of Hesse (known as
Ducky). Their grandmother, Queen Victoria,
mentioned in her Journal for 22 July that 'Missy
and Ducky, with the 2 sweet little children of
the former, who are staying at Kent House,
came to see me directly after luncheon. The
Baby, of 8 months, is quite lovely, & little Carol,
a great darling, with very fair curly hair.'

Although the photograph is dated August,
the two sisters and children in fact left for
Germany on 31 July. In later years, Prince Carol
succeeded to the throne of Roumania, while
Princess Elizabeth married King George II of
the Hellenes.

150 (opposite).
Princess Patricia of Connaught, 3 February 1891
By Gustav Mullins
9.1x14cm
Carbon print

Princess Patricia was the third and youngest
child of the Duke and Duchess of Connaught.
She gained her Christian name, not only through
being the daughter of a Royal Duke with an
Irish title, but also because she was born on St
Patrick's Day, 1886. In later life the Princess
became an accomplished artist. She married
Captain Alexander Ramsay in 1919 and was
subsequently known as Lady Patricia Ramsay.

152 (opposite).
Princess Louise, Duchess of Fife, Mar Lodge.
September 1889
By W. & D. Downey
16.8x26cm
Albumen print
 Princess Louise, eldest daughter of the
Prince and Princess of Wales, had married the
Duke of Fife in July 1889, and is shown here at
their house in Scotland.

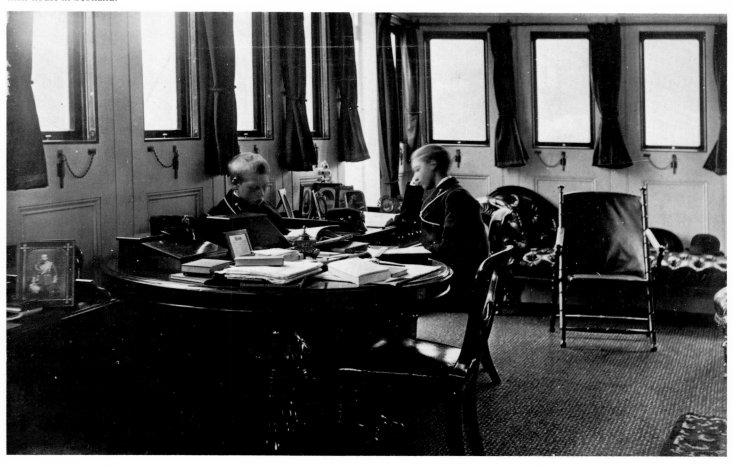

153.
**Prince Albert Victor and Prince George of Wales
on board H.M.S. *Britannia*,** December 1877
By W. & D. Downey
15.3x9.7cm
Gelatine silver print
 The future King George V (who can be
seen to the left of the photograph) and his elder
brother, later Duke of Clarence and Avondale,
who died in 1892, were entered together as
cadets in the naval training ship *Britannia* in
September 1877. It was the first time that the
two young Princes had been separated from their
family for so long a period, and their mother,
the Princess of Wales, wrote to Prince George
from Abergeldie on 15 November with some
advice and encouragement:

> My thoughts are always with you and I pray God
> you are getting on well at your studies. I am sure
> you must often feel as poor Walter Evson did at
> first at St Winifred's School – do you remember
> that charming book I was reading out to you just
> before you left. I hope you are trying to work as

well as he did – and all what may seem hard,
difficult and strange to you now will in a short
time seem quite easy to you – if once you put
your mind to it – and I need not say *how* happy
it will make us, to hear only good reports of both
our dear boys.[1]

 After leaving *Britannia* in 1879, the two
Princes embarked on a world cruise on board
the training vessel H.M.S. *Bacchante*. It lasted
from 1879 to 1882, after which Prince Albert
Victor studied at Cambridge and became an
officer in the 10th Hussars, and Prince George
continued with a naval career.

Reference
1. RA Geo. V AA28/11

154.
Prince Arthur and Princess Margaret of Connaught and Princess Alice of Albany, January 1884
By C. J. Hughes
21.6x15.7cm
Albumen print
 The two children of the Duke and Duchess of Connaught (Princess Margaret is on the left of the group in the carriage) with their cousin, Princess Alice of Albany (right), at Osborne in 1884.

155.
The Duchess of Albany, Princess Alice and the Duke of Albany, Princes Alexander and Leopold and Princess Victoria Eugénie of Battenberg, Claremont, April 1890
Photographer unknown
18.9x15.8cm
Gelatine silver print
 Helen, Duchess of Albany, was the widow of Queen Victoria's youngest son, Leopold, Duke of Albany, who had died in 1884. She and her two children, Princess Alice (riding on the rocking horse) and Charles Edward, Duke of Albany (wearing a kilt), lived at Claremont, near Esher in Surrey, and can here be seen with the three children of Princess Beatrice and Prince Henry of Battenberg.

 156 (opposite).
Double portrait of Princess Victoria of Wales, 1893
By W. & D. Downey
9.6x14.1cm
Albumen print
 Such a picture as this would have been achieved by making several exposures on the same photographic plate, masking the lens so as not to expose the same area twice.

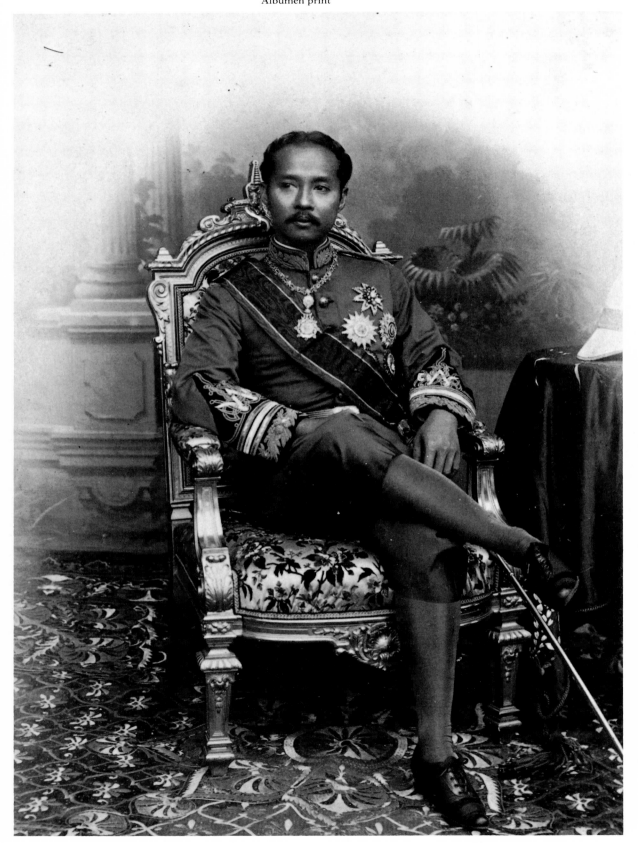

158.
The Queen of Siam and children, 1889
Photographer unknown
Albumen print

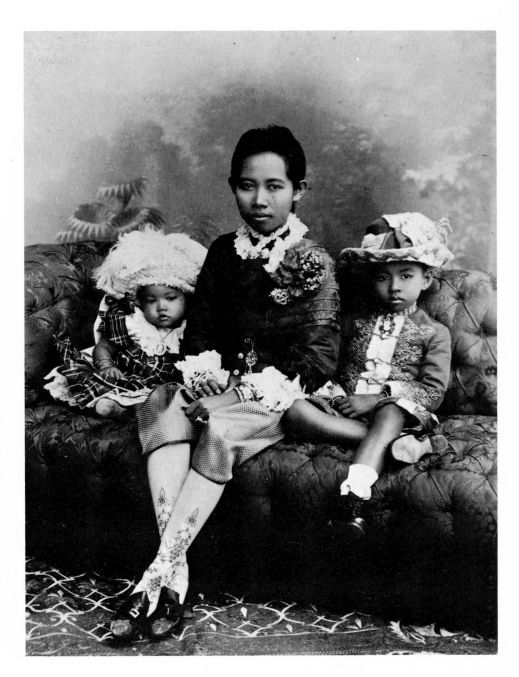

157–8. Chulalongkorn, King of Siam, was
born in 1853. He was educated by English
teachers as a child and acquired a good knowl-
edge of the English language and Western
culture. He succeeded his father, King
Mongkut, in 1868, and as an innovation allowed
Europeans to be present at his coronation. Real-
izing that change was essential if Siam was to
retain her independence and deal on equal terms
with Western nations, he instigated a number
of reforms, including the abolition of slavery and
the proclamation of liberty of conscience. Court
etiquette was simplified and many public works
were carried out. Several of his sons were edu-
cated in England and he visited this country in
1897, the year of the Diamond Jubilee, being
received by Queen Victoria at Osborne on 4
August. He died in 1910.

King Chulalongkorn had ninety-two wives
and seventy-seven children. Four of the wives
were known as Queen, but a portrait of only one
of them was sent to Queen Victoria. It is thought
that she may be Queen Sawang, with two of her
eight children, but this is not certain.

Reference
See **Lords of Life** by Prince Chula Chakra-
bongse (1967).

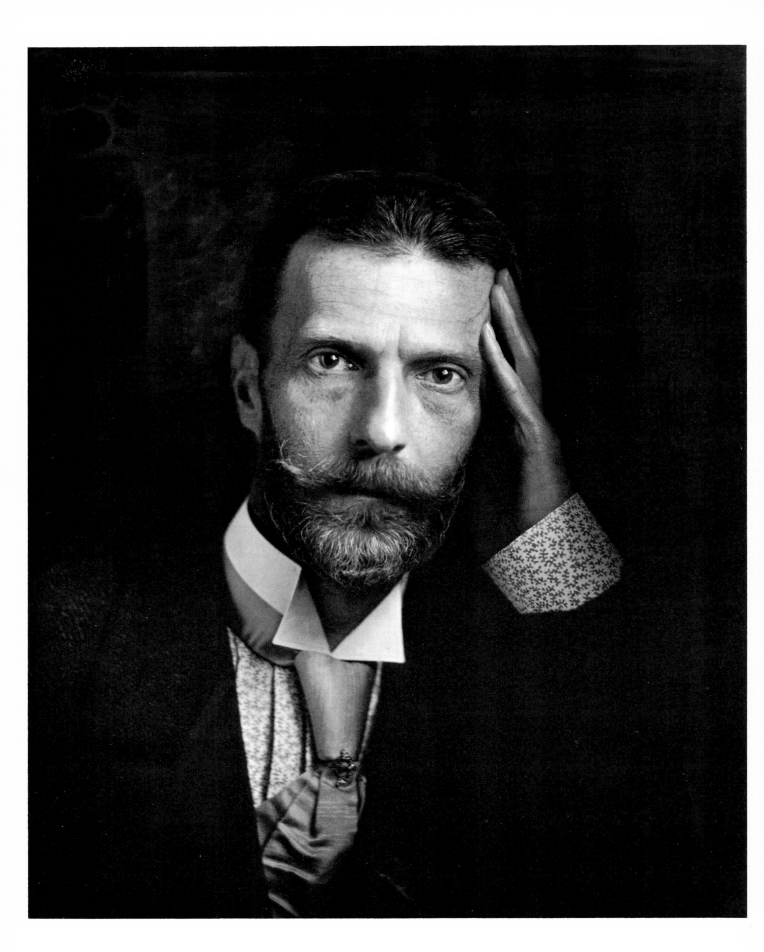

159.
The Princesses Amélie and Hélène of Orléans, daughters of the Count and Countess of Paris, with Prince Jean, Princess Marie and Princess Marguérite of Orléans, children of the Duke and Duchess of Chartres, 1884
Photographer unknown
22x15.8cm
Probably a glazed albumen print

Queen Victoria was on friendly terms with the family of King Louis-Philippe of France, to whom she was related by marriage: the King's daughter, Princess Louise, was the second wife of Queen Victoria's uncle, King Leopold I of the Belgians, and one of King Louis-Philippe's sons, the Duke of Nemours, married Queen Victoria's cousin, Princess Victoire of Saxe-Coburg-Gotha. The 1848 revolution in France forced the King to abdicate, and he fled with his family to England, where they lived for many years in exile. The young Prince and Princesses in the photograph were all great-grandchildren of the King. Princess Amélie (without a hat) later married King Carlos I of Portugal, and her sister, Princess Hélène (right), who at one time hoped to marry Albert Victor, Duke of Clarence and Avondale, later became Duchess of Aosta. Princess Marie (reclining in the foreground) later married Prince Valdemar of Denmark (the youngest brother of the Princess of Wales), and her sister, Princess Marguérite, married the Duke of Magenta. Prince Jean became Duke of Guise and married his cousin, Princess Isabelle of Orléans.

160 (opposite).
The Grand Duke Serge of Russia, 1898
By Histed
23.6x28.8cm
Platinum print

Grand Duke Serge Alexandrovitch of Russia (1857–1905) was the fifth son of Tsar Alexander II. According to his sister, Marie, Duchess of Edinburgh, he was 'an exceptionally nice young man, who ... has excellent principles and can be recommended in every possible way.'[1] In April 1884, the year of his marriage to Princess Elizabeth of Hesse, the Grand Duke met her grandmother, Queen Victoria, at Darmstadt. The Queen observed that he was 'very quiet, silent & serious & very delicate looking', and quite different from his brothers. She did not find him 'sympathique', but realized that he was probably shy.[2] By April 1885, however, the Queen was writing that she liked the Grand Duke much better since getting to know him.[3]

Grand Duke Serge was appointed Governor-General of Moscow in 1891, and became increasingly an unfortunate victim of the circumstances in which he found himself: he was a proud and sensitive man, introspective and capable of deep feelings, which because of his position he felt obliged to suppress beneath a stern, unimaginative and inflexible devotion to duty and autocratic principles. As a result he was detested by those over whom he held authority, and blamed, sometimes unfairly, for whatever went wrong, notably the disaster at Khodynskoe Field at the time of Tsar Nicholas II's coronation in 1896, when well over a thousand people were crushed to death in the vast crowd, which got out of control. According to his niece, Grand Duchess Marie Pavlovna, 'those few who knew him well were deeply devoted to him, but even his intimates feared him.'[4] By early 1905 Russia's losses in the

Russo-Japanese War had precipitated serious revolutionary disorder. The Grand Duke resigned his post as Governor-General of Moscow, but on 17 February he was assassinated when a bomb was thrown at his carriage.

References
1. RA Vic. Add. MSS A20/1066.
2. RA Vic. Add. MSS A15/4229.
3. RA Vic. Add. MSS A15/4469.
4. See **Education of a Princess. A Memoir** by Marie, Grand Duchess of Russia (Blue Ribbon Books, New York, 1930).

161.
Queen Victoria wearing spectacles, late 1890s
Photographer unknown
9.7x9.8cm
Printing out paper
Illustrated on p. 69

The Queen in old age.

162.
Princess Alice, 4 July 1861
By Camille Silvy
5.6x8.6cm
Albumen print

Princess Alice became engaged to Prince Louis of Hesse on 30 November 1860; their marriage took place in July 1862, having been postponed because of the death of the Prince Consort in December 1861. The Princess is wearing mourning in this photograph for her grandmother, the Duchess of Kent, who had died four months previously.

Silvy's Day Book for this period contains four portraits of the Princess, taken on 4 July 1861, but an album in the Photographic Collection shows that at least ten were made at this sitting.

163.
Grand Duchesses Olga and Tatiana of Russia,
1898
Photographer unknown
15.6x19.8cm
Platinum print

The Grand Duchesses were the two elder daughters of Tsar Nicholas II and Empress Alexandra Feodorovna of Russia (formerly Princess Alix of Hesse). Queen Victoria had met Grand Duchess Olga (left) in September 1896 when she visited Balmoral with her parents, and had described her in her Journal for 22 September as 'a most beautiful child & so big.' During this visit the first film of the Royal Family was made: the Queen recounted in her Journal for 3 October how they 'at 12 went down to below the Terrace, near the Ball Room, & were all photographed by Downey by the new cinematograph process, which makes moving pictures by winding off a reel of films. We were walking up & down & the children jumping about.'

165.
Empress Alexandra Feodorovna of Russia and her children (left to right)**: Grand Duchess Olga, Grand Duchess Anastasia, Grand Duchess Tatiana, Grand Duchess Marie and Tsarevitch Alexis,** 1906
Photographer unknown
13.4x8.3cm
Gelatine silver print

This postcard, in which the Empress is shown holding a camera, was sent by her to her cousin, George, Prince of Wales, as a Christmas and New Yard card for 1906/1907.

164 (opposite).
Tsar Nicholas II of Russia, c. 1900–1904
Photographer unknown
6.6x10cm
Platinum print

Tsar Nicholas II reading the *St Petersburg News* in the Mauve Boudoir in the Alexander Palace at Tsarskoe Selo. He was closely related to the British Royal Family, his mother, formerly Princess Dagmar of Denmark, being the sister of Queen Alexandra: he was thus a first cousin of King George V. In 1894 he married Queen Victoria's granddaughter, Princess Alix of Hesse. The Queen, knowing of the difficult and potentially dangerous situation in Russia (Tsar Alexander II had been assassinated in 1881), was at first dismayed at her granddaughter's choice, but on meeting the young man in the summer of 1894 she wrote to her daughter, the Empress Frederick of Germany, on 22 July: 'Tomorrow evng. dear Nicky embarks on board the Yacht *Polar Star* (the Russian of which I cannot write well) & we shall miss him vy. much. He has lived this month with us like one of ourselves & I never met with a more amiable, simple young Man, affte. sensible & attentive to me always. I think dear Alicky is vy. fortunate – only the position is an anxiety.'[1] The Russian Revolution of 1917, with its tragic outcome for the Tsar and his family, would prove that the Queen's fears were only too well founded

Reference
1. RA Vic. Add. MSS U32, 22 July 1894

166.
Lord Battersea, *c.* 1892
Photographer unknown
20.4x15.4cm
Platinum print

 Cyril Flower, first and only Baron Battersea of Battersea and Overstrand, was a Liberal Member of Parliament who held the position of a Junior Lord of the Treasury in 1886. His main interests were riding (he won the House of Commons Steeplechase in 1889 and was a keen huntsman) and art: he owned a number of paintings, including Burne-Jones's *Golden Stairs* and *Annunciation,* a Madonna and Child by Botticelli and another by Leonardo da Vinci, and works by Rubens, Moroni, Bassano, Sandys, Whistler and Moretti. He also enjoyed golf, tennis, yachting, botany and gardening, and was well known as an amateur photographer, gaining a diploma for photography at the Vienna Exhibition and taking part in at least one Kodak exhibition. This photograph carries no information apart from the name of the subject, but it would not be surprising to learn that the careful posing, reflecting several of Lord Battersea's interests, was arranged by the sitter himself, or even that it is a self-portrait.

167.
Mr John Moore and his wife Jane, married for seventy years, 6 September 1894
Photographer unknown
16.8x19.7cm
Gelatine silver print
Illustrated on p. 64

 Queen Victoria kept an album of photographs of people who had accomplished unusual feats. The album includes eleven centenarians, but Mr and Mrs Moore's achievement must have been even more rare. The couple came from Sussex, and the photograph was sent to the Queen's Private Secretary, Sir Henry Ponsonby, by the Reverend Arthur Mackreth Deane, Vicar of Ferring, near Worthing, explaining that 'Since I sent the photograph of John & Jane Moore, who have been married for 70 years, . . . we have had another photograph of the old couple taken, and as it is so much better than the former one, I venture to send it for the gracious acceptance of Her Majesty.'

168 (opposite).
The Marquess of Salisbury and grandchildren, the Hon. Beatrice and the Hon. Robert Cecil,
c. 1896
Photographer unknown
10.2x14.1cm
Platinum print

 Robert Gascoyne-Cecil, third Marquess of Salisbury, was at this time Prime Minister. His grandson Robert later became fifth Marquess of Salisbury, and his granddaughter Beatrice was to marry the fourth Baron Harlech, and to be appointed a Lady of the Bedchamber to Queen Elizabeth in 1941.

 While staying in the south of France in April 1895, Queen Victoria had called on Lord Salisbury and his family for tea at their residence, La Bastide. Lord Salisbury's daughter-in-law, Lady Edward Cecil, noticed that, whenever any woman's name was mentioned, the Queen commented on her looks and seemed to take a great interest in the subject. She also noted the esteem and deference shown by the Queen and Lord Salisbury to one another.[1]

Reference
1. See **My Picture Gallery, 1886–1901** by Viscountess Milner (1951).

169 (above).
Emmanuel Louis Cartigny, the last survivor of Trafalgar. Born at Hyères, 1 September 1791. Died at Hyères, 21 March 1892
By Henry Ellis
15.5x21.1cm
Albumen print

Queen Victoria visited Hyères between 21 March and 25 April 1892, when she stayed at the Grand Hôtel de Costebelle. Although her Journal gives no indication of the fact, she almost certainly heard during this visit of M. Cartigny's recent death. This photograph of a veteran of Trafalgar, who fought on the opposing side, is an interesting pendant to the group of survivors of Waterloo [xvi].

170.
Colonel Cody – Buffalo Bill, 1892
By Elliott & Fry
19.1x29.9cm
Platinum print

Colonel William Frederick Cody, who had led an adventurous life as a scout and guide for the American army, as well as serving in campaigns against the Red Indians, gained the name of 'Buffalo Bill' from being contracted to supply buffalo meat to the employees of the Kansas Pacific Railway while the line was being extended through the wilderness. In 1883 he organized his spectacular 'Wild West Show', and during a European tour four years later it was performed at Earl's Court in London, where it was seen by Queen Victoria on 11 May 1887. She found it 'a very extraordinary & interesting sight', describing in her Journal how the 'wild, painted Red Indians on their wild bare backed horses, ... cowboys, Mexicans &c, all came tearing round at full speed, shrieking & screaming, which had the weirdest effect. An attack on a coach, & on a ranch, with an immense amount of firing, was most exciting, so was the buffalo hunt, & the bucking ponies, that were almost impossible to sit.' The Queen was impressed by the equestrian skill of one young girl, the 'unvarying aim' of two others who shot at glass balls, and by the appearance of the cowboys, but found the Indians, 'with their feathers, & wild

dress (very little of it)', rather alarming, while their War Dance was 'quite fearful'. Colonel Cody she considered 'a splendid man, handsome & gentlemanlike in manner'.[1]

Five years later, on 25 June 1892, the Wild West Show was performed once more for the Queen, this time on the lawn below the East Terrace at Windsor Castle. The Queen, watching from a tent, noted later in her Journal that it had been 'a very pretty, wild sight, which lasted an hour'. On this occasion, as well as the 'Cow Boys, Red Indians, Mexicans [and] Argentinos' who took part, there was also a 'wonderful riding display by Cossacks, accompanied by curious singing.' At the end of the show 'all advanced in line at a gallop & stopped suddenly.' Colonel Cody was presented to the Queen, who observed in her Journal that he was 'still a very handsome man, but has now got a grey beard.'

Reference
1. RA Queen Victoria's Journal: 11 May 1887.

171.
Captain Oswald Ames, 2nd Life Guards, *c.* 1897
By Stuart
16.9x27.9cm
Gelatine silver print

Oswald Henry Ames, who at 6 feet $8\frac{3}{4}$ inches was the tallest man in the British Army, was born in London in 1862. He served first in the 4th Bedford Regiment, then the 5th Dragoon Guards, and transferred to the 2nd Life Guards as a Lieutenant in 1884. He achieved the ranks of Captain in 1892 and Major in 1902, retiring in 1906 but remaining on the Reserve List of officers. He married in 1901 and had a son and a daughter. Soon after the outbreak of war in 1914 Major Ames rejoined the 2nd Life Guards and was promoted Lieutenant-Colonel later that year to command the Reserve Regiment. He gave up his command in 1916 and died in 1927.

Lieutenant-Colonel Ames is chiefly remembered, not only for his height, but because he led the Queen's procession to St Paul's Cathedral for the Diamond Jubilee Service on 22 June 1897. An obituary notice referred to him as a friendly, kind-hearted and unselfish man, who was not only a brilliant shot and a fine rider but also enjoyed drawing, painting and music.

Reference
Biographical material from the Household Cavalry Museum, Combermere Barracks.

172.
John Meakin, Hosiery Weaver, born 1816. Has woven Her Majesty's hose for sixty years,
June 1898
By W. W. Winter
10.1x14.8cm
Platinum print

174 (opposite).
Queen Victoria, 22 June 1897
By Gustav Mullins
16.1x21.7cm
Gelatine silver print
A portrait of Queen Victoria as she appeared on the day of her Diamond Jubilee celebrations in 1897. She wrote in her Journal for that day, from Buckingham Palace:

> A never to be forgotten day. No one ever I believe, has met with such an ovation as was given to me, passing through those 6 miles of streets, including Constitution Hill. The crowds were quite indescribable & their enthusiasm truly marvellous & deeply touching. The cheering was quite deafening, & every face seemed to be filled with real joy. I was much moved and gratified.

173.
Ann Birkin, Hosiery Embroideress, born 1816. Has embroidered Her Majesty's hose for sixty years,
June 1898
Photographer unknown
9.6x13.8cm
Printing out paper

172–3. Two people who, while not employed in the Royal Household, had rendered a service to Queen Victoria for many years. Walter Winter, the author of Mr Meakin's portrait, was a well-known 'art photographer' in Derby.

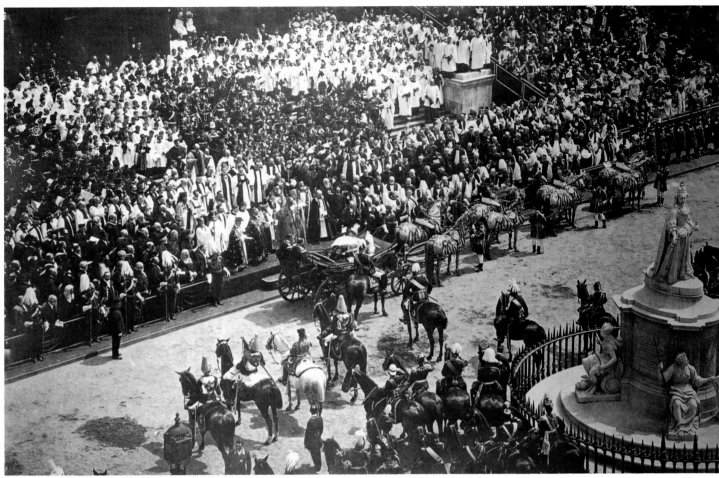

175.
Queen Victoria: Diamond Jubilee portrait, 1897
By W. & D. Downey
25.4x37.7cm
Carbon print
Illustrated on p. 68

This photograph of the Queen, which was used as an official Jubilee portrait, was actually taken in July 1893, on the occasion of the wedding of the future King George V and Queen Mary. In its portrayal of the Queen it is in strong contrast to the photograph by Mullins, which is a dignified but very touching portrait of an old lady, the light in the left background giving an impression of coming peace and tranquillity. Downey's portrait shows a Queen Empress, Sovereign of a vast Empire: in this picture the light is concentrated on the Queen herself as she gazes into the distance. This photograph is closely related to traditional painted state portraits.

176.
Queen Victoria's Diamond Jubilee Service in front of St Paul's Cathedral, 22 June 1897
Attributed to the London Stereoscopic and Photographic Company
95x64cm
Gelatine silver print

By 1897 Queen Victoria was very lame and walked with difficulty. It was decided that, as she would not easily be able to mount the stairs leading to St Paul's Cathedral, the Diamond Jubilee Service should be held outside the building, the Queen remaining in her carriage. The Queen found the scene 'most impressive', but her cousin Augusta, Grand Duchess of Mecklenburg-Strelitz, was horrified at the idea that, after sixty years' reign, she should 'thank God in the Street!!!'[1]

Reference
1. R A Vic. Add. MSS A8/2870

177.
Wooden box with a metal inlay. In the centre of the lid is an oval gilt hinged second lid, engraved with a crown, which opens to reveal a daguerreotype after a painting of Prince Albert by Sir William Ross. Inside the lid of the box itself is a design showing the Rosenau at Coburg, with the initials 'E', 'V' 'A', and 'A', 'E' (Ernest I, Duke of Saxe-Coburg-Gotha; Queen Victoria and Prince Albert; Albert Edward, Prince of Wales). In the main part of the box is a hinged shelf with a circular aperture in which is set a daguerreotype after a painting of Duke Ernest I of Saxe-Coburg-Gotha: the shelf lifts up, and an oval daguerreotype after a painting of Queen Victoria by Sir William Ross is set into the back. In the floor of the box is set a daguerreotype after a painting of Albert Edward, Prince of Wales, by F. X. Winterhalter. The date of the box is probably the mid-1840s.
Daguerreotypes: Prince Albert: approximately 1.8x2cm
Duke Ernest I: approximately 4.3x4.5cm
Queen Victoria: approximately 3.8x4.5cm
Prince of Wales: approximately 5x6.5cm
Box: 7.5x9.3x4cm
It is known that Queen Victoria considered Ross's miniature of her husband to be a particularly good portrait. In her *Reminiscences* written after the Prince's death, she refers to 'Ross's beautiful miniature' which was 'so like what [the Prince] then was! And it was always like.'[1]

Reference
1. RA Z491.

178.
A gilt metal easel-shaped strut frame, containing an oval photograph of Ernest I, Duke of Saxe-Coburg-Gotha, father of the Prince Consort, who died in 1844. Made by West of St James's.
Photograph: approximately 3.7x4.8cm
Frame: 6.5x11cm
This photograph is a copy of the daguerreotype which was the only known photographic portrait of Prince Albert's father. On 31 August 1861, Victoria, Crown Princess of Prussia, wrote to her father from Reinhardtsbrunn 'to say that Uncle Ernest sends you something very precious wh. I am sure will touch and please you very much – a Daguerreotype of your Father from nature! Uncle Ernest had no idea it existed and was looking over some old boxes and cupboards at Gotha and found among a heap of rubbish this little picture. He wanted to have it photographed here – I told him I thought it could be better done in England – so he makes you a present of the original and begs you will have it photographed and send him some impressions. Although of course I cannot recollect Grandpapa – yet it was impossible not to recognise this – from the likeness to Uncle Leopold, and to all the Pictures existing of Grandpapa. I am sure you will be very happy to have this – and I am so glad to have seen it as I can now form quite a good picture of him in my mind. He is standing before this house, Uncle Ernest says.'[1] Prince Albert was 'quite overwhelmed'[2] on receiving this precious souvenir of his father, and immediately had it copied. One print was sent to his brother, and several others still exist in the Photograph Collection.
References
1. RA Z4/26, 31 August 1861.
2. RA Y195/88, 3 September 1861.

179.
A gilt metal revolving photograph frame containing carte-de-visite photographs of Albert Edward, Prince of Wales, in January 1860; Prince Frederick William of Prussia and his wife, Victoria, Princess Royal, Princess Frederick William of Prussia, by L. Haase & Co., probably in the same year.
Photographs: Prince of Wales: 6x9.1cm
Prince Frederick William of Prussia: 5.1x8.3cm
Princess Frederick William of Prussia: 5.3x8.3cm
Frame: 9.5x21.6cm

180.
Memorial ring in gold and black enamel, the bezel containing a microphotograph, reversed, of the Prince Consort in 1861, which is attributed to J. J. E. Mayall. The cypher linking the initials 'V' and 'A' in white enamel is set into the shanks on either side of the bezel.
Photograph: approximately 0.9x1.2cm
Ring: 2x1.3x1.7cm
Illustrated on p. 23

181.
Gilt metal bracelet composed of twelve oval lockets containing photographs of the family of King Christian IX and Queen Louise of Denmark, with its original fitted red velvet case.
Bracelet: 22x8cm
Photographs: approximately 2x2.4cm each
The bracelet belonged to Queen Mary's grandmother, Augusta, Duchess of Cambridge, who inherited it from her sister, Princess Louise of Hesse-Cassel. The Duchess and her sister were aunts of Queen Louise of Denmark, the mother of Alexandra, Princess of Wales. On the backs of the nine linked lockets are the letters of the word SOUVENIR and the date 1868. Those depicted in the photographs are (left to right): Crown Prince Frederick of Denmark, Alexandra, Princess of Wales, Albert Edward, Prince of Wales, Queen Olga of the Hellenes, King George I of the Hellenes, Tsarevna Marie Feodorovna of Russia, Tsarevitch Alexander of Russia, Princess Thyra of Denmark, Prince Valdemar of Denmark.
The three pendant lockets contain photographs of (left to right): Prince Albert Victor, Prince George, and Princess Louise of Wales. In the back of the central locket is a photograph of Prince Christian of Denmark, eldest son of Crown Prince Frederick. All twelve photographs were taken between c. 1866 and 1872.

182.
A gilt metal strut frame in the form of an open fan, the central oval aperture containing a tinted photograph by W. & D. Downey of Alexandra, Princess of Wales, and her eldest daughter, Princess Louise, and a lock of hair.
Photograph: approximately 4x5.2cm
Frame: 15.2x10.5cm
This photograph was taken after the Princess's recovery from the severe attack of rheumatic fever which followed the birth of Princess Louise in 1867.

183.
An oval gilt metal locket decorated with simulated lapis lazuli cabochons. The bombé glass front protects a tinted photograph of Princess Victoria Mary of Teck (later Queen Mary), taken in 1868 by James Russell & Sons.
Photograph: approximately 2.3x3cm
Frame: 4x5cm

184.
A silver-plated strut frame decorated with blue and red *champlevé* enamel, in the form of the Star of the Order of the Garter. The centre of the star has hinged covers, which open to reveal a tinted photograph of Alexandra, Princess of Wales, and her three eldest children, Prince Albert Victor (left), Prince George and Princess Louise, c. 1870.
Photograph: approximately 6.5x6.5cm
Frame: 16x16cm

185.
A gilt metal frame in the form of a horseshoe, the nail heads in blue enamel, containing a photograph of Alexandra, Princess of Wales (right), and her sister, Tsarevna Marie Feodorovna of Russia, in 1873, by James Russell & Sons.
Photograph: 3.2x4cm
Frame: 5.2x5.6cm

186.
An openwork gilt metal strut frame containing, behind hinged doors, a photograph by W. & D. Downey of Princess Mary Adelaide, Duchess of Teck, and her youngest son, Prince Alexander, later Earl of Athlone, c. 1874.
Photograph: 5.7x8.8cm
Frame: 11.6x19cm

187.
A rectangular gilt metal picture frame surmounted by laurels, containing a transfer photograph on enamel of a large royal group, taken in September 1882. This shows, from left to right: Prince Albert Victor of Wales; Helena, Princess Christian of Schleswig-Holstein; Princess Alix of Hesse (with white collar), next to Alexandra, Princess of Wales; Princess Maud of Wales (foreground); Ernest Louis, Hereditary Grand Duke of Hesse; Albert Edward, Prince of Wales; Prince Albert of Schleswig-Holstein (foreground); Princess Victoria and Princess Elizabeth of Hesse; Princess Irene of Hesse (foreground); Princess Louise of Wales; Prince Christian of Schleswig-Holstein; Prince George of Wales; Prince Christian Victor of Schleswig-Holstein; Princess Victoria of Wales; Louis IV, Grand Duke of Hesse.
Photograph: approximately 10.5x7.5cm
Frame: 12.6x12.5
According to an entry in Prince George of Wales's diary, this photograph was taken in Darmstadt on the Grand Duke of Hesse's birthday, 12 September 1882. The Prince described how 'we ... all drove to the photographer's & we were all done in a large group, we were 17 relations together.'

188.
A silver strut frame in the form of a swallow, the eyes set with red pastes. Each wing of the bird contains a photograph of Albert Edward, Prince of Wales, the left-hand one taken in 1867, the other in the mid-1870s. London 1896. Made by James Samuel Bell and Louis Willmott.
Photographs: approximately 3.8x4.8cm
Frame: 10.7x12.2cm

189.

A silver frame in the form of a shamrock leaf decorated with green velvet. The three oval apertures contain photographs of Princess Marie (top), Princess Victoria Melita (left) and Princess Alexandra, daughters of the Duke and Duchess of Edinburgh, in 1883. London 1882. Made by Louis Dee. Retailed by West of 1, St James's Street.
Photographs: approximately 3x3.8cm
Frame: 11.5x11cm

190.

A rectangular metal paste set frame surmounted with a bow, containing a photograph of Alexandra, Princess of Wales, signed 'Alix 1885'.
Photograph: 6.5x10 cm
Frame: 8.2x13.5cm

This is one of the photographs which George, Duke of York, took with him during the voyage of H.M.S. *Crescent* in 1898.

191.

An oval strut frame set with pastes and surmounted with a bow, containing a photograph of Alexandra, Princess of Wales, on a swivel. The reverse is set with a mirror. The photograph was taken in 1887 by Lafayette.
Photograph: 8.1x12.1cm
Frame: 10.2x17.2cm

192.

A dark blue velvet frame with a photograph of two dogs. Gilt metal mounts: 'Wat' and 'Basco' 1886. Made by Thornhill of New Bond Street, London.
Photograph: approximately 3.5x4.5cm
Frame: 6.3x7.3cm

Wat and Basco belonged to Princess Beatrice and her husband, Prince Henry of Battenberg. Several albums of photographs exist showing dogs kept at the Royal Kennels in the Home Park at Windsor during Queen Victoria's reign.

193.

A rectangular silver strut frame surmounted by a bow, containing a transfer photograph in red, by Downey, on enamel or porcelain, of Albert Edward, Prince of Wales, wearing Masonic regalia. London 1896. Made by George Elisha Sumner.
Photograph: approximately 4x5.3cm
Frame: 4.4x6.9cm

194.

A gilt metal openwork frame containing a photograph from a painting of the Earl of Beaconsfield, and a lock of hair. Engraved: 'In memory of the dear Earl of Beaconsfield. Born Dec. 21st 1804. Died April 19th 1881.'
Photograph: approximately 3.8x4.8cm
Frame: 6.3x7.1cm

Benjamin Disraeli, first Earl of Beaconsfield, who first gained a seat in the House of Commons in 1837, became leader of the Tory party in 1848. After three joint periods in office with Lord Derby, he served as Prime Minister briefly in 1867 and later from 1874–1880. He also wrote a number of novels.

As a young man, Disraeli had appeared flamboyant and eccentric, but by patience and strength of will he developed into an astute and eloquent statesman. He understood the value of imaginative gestures, as when he advised Queen Victoria in 1876 to assume the title of Empress of India, thus enhancing Britain's position as an imperial power. The Queen much enjoyed her interviews and correspondence with Disraeli, whose wit entertained her and whose flattery amused but never entirely deceived her; and the esteem was mutual. At his death in April 1881 she wrote sadly that 'dear Ld. Beaconsfield was one of my best, most devoted, & kindest of friends, as well as wisest of counsellors. His loss is irreparable, to me & the country … Just this day, year, Ld. Beaconsfield left Windsor, having resigned, which he felt so much, & so did I, but I was full of hope he might be my minister again.'[1]

Reference
1. RA Queen Victoria's Journal: 19 April 1881.

195.

A silver strut frame in the form of an English crown, decorated with red enamel. The twin oval apertures contain photographs of Queen Victoria: one, from a painting, shows her as a young woman; the other is the official 1897 Diamond Jubilee portrait by W. & D. Downey. London 1897. Maker James Samuel Bell and Louis Willmott.
Photographs: approximately 3.1x4.1cm
Frame: 12.6x10.3cm

196.

A brown leather frame decorated with gold crosses and with a plaque bearing the date '4 September 1898'. It contains an oval photograph of General Gordon, set into a black watered silk mount with pressed flowers.
Photograph: approximately 3.5x4.5cm
Frame: 19x13.8cm

Major-General Charles George Gordon (1833–85) first entered the Army as a cadet at Woolwich when he was fifteen, obtaining a commission in the Royal Engineers four years later. He took part in the Crimean War, afterwards surveying frontiers in Bessarabia, Erzerum and Armenia. Between 1860 and 1865 he served with distinction in campaigns in China, earning the name of 'Chinese Gordon'. He spent the next six years as commanding Royal Engineer at Gravesend: during this relatively quiet spell he devoted his spare time to the relief of local poor people, especially those in the infirmary and ragged schools. He took many boys from the schools into his own house and started them in life by sending them to sea. After his death the 'Gordon Boys' Home' for destitute boys was set up in his memory.

Further assignments included a term as governor of the equatorial provinces of Central Africa and another as commandant of the colonial forces in Basutoland. He spent much of 1883 in the Holy Land, investigating the biblical sites: one of his strongest characteristics was an intense Christian faith which led him to submit himself entirely to what he believed to be God's will. In January 1884 he embarked on his last mission, which was to evacuate the Sudan, then held by the Egyptian government but threatened by the rebel forces of the Mahdi. The British government insisted that Egypt should abandon the Sudan, and on reaching Cairo, Gordon found that he was expected not only to arrange the evacuation but also to leave an organized independent government behind him. He arrived at Khartoum to carry out instructions and proclaimed the independence of the Sudan, but his requests to the British government for help were not granted. By March, having evacu-

ated over two thousand people, Gordon found that he was being hemmed in by the Mahdi's forces. The attack on Khartoum began on 12 March and Gordon fought to defend it for the next ten months. A relief expedition finally arrived too late to save Gordon, who was killed at the end of January 1885. His death caused an almost universal outburst of grief and indignation that a man regarded as a hero should have been sacrificed by what was seen as the government's neglect. Queen Victoria, who had followed Gordon's reports with growing anxiety, was 'dreadfully shocked' at the news of his death, 'all the more so, when one felt it might have been prevented.'[1] The thirteenth of March was observed as a day of national mourning.

Gordon's unusual character helped to foster the heroic legend. He was modest and retiring, but could be prompt, fearless and outspoken when circumstances required. He was indifferent to praise or reward but attracted people to him by his care and sympathy for those in trouble. His devotion to duty, regardless of his personal safety, was founded on sincere religious convictions.

On 4 September 1898, after the Battle of Omdurman and the reconquest of the Sudan by a force under Kitchener's command, the British and Egyptian flags were hoisted over the ruins of Gordon's palace in Khartoum. Queen Victoria wrote that 'surely he is avenged!'[2]

References
1. RA Queen Victoria's Journal: 5 February 1885.
2. ibid.: 5 September 1898.

197.

A rectangular silver frame surmounted by a wreathed crown and banners, containing a photograph of Field Marshal Earl Roberts by the London Stereoscopic Company. London 1899. Made by William Comyns
Photograph: 9.8x13.9cm
Frame: 13.7x20.7cm

Frederick Sleigh Roberts, first Earl Roberts of Kandahar, Pretoria and Waterford (1832–1914), began his long and distinguished military career in the Bengal Artillery in India, where his father was in command at Peshawar. At the time of the Indian Mutiny, Roberts won the Victoria Cross for his actions at Khudaganj. After serving as assistant quartermaster general of the expeditionary force in Abyssinia, he was appointed in 1878 to the command of the Punjab frontier force, later leading one of the columns for the invasion of Afghanistan. During the Afghan campaign of 1880 he led a column to relieve Kandahar, a small garrison threatened with attack by the Afghans. As a result of this he became a popular hero; he already had a high reputation as a tactician and organizer, while his charm and care for the welfare of his troops won their devotion.

During the next two decades Roberts served as commander-in-chief, first in India and then in Ireland. On the outbreak of the Boer War in 1899 he was appointed to the supreme command of the British forces in South Africa, at the age of sixty-seven. Although he did not succeed in bringing the war to an end by the close of 1900, when he handed over the command to Kitchener, he had made victory certain by the reorganization of the British transport system and by manoeuvring the Boers out of their positions. Every important Boer town was in British hands by 24 September 1900.

Roberts arrived back in England in January 1901 and was one of the last people to be received in audience at Osborne by Queen Victoria, three weeks before her death. On 2 January she gave him the Order of the Garter and an earldom, with a special remainder to his daughter, as his only son had been killed fighting in South Africa.

Lord Roberts was commander-in-chief of the British Army from 1901 until the office was abolished in 1904. He became convinced of the need for national service for home defence, campaigning for this until the outbreak of war in 1914. When India sent an expeditionary force to France, King George V made him its colonel-in-chief. Feeling that he should give his support to the men of the country where he had spent so much of his military life, Lord Roberts left for France in November 1914, where he caught a chill and died, as he would have wished, with an army on active service.

198.
A silver-plated strut frame containing a photograph of Lord Kitchener of Khartoum, *c.* 1899.
Photograph: approximately 10.2x14.2cm
Frame: 11.8x15.7cm

Horatio Herbert Kitchener, first Earl Kitchener of Khartoum and of Broome (1850–1916), rose to the rank of Field Marshal during a life of extensive and unusual service as a soldier and administrator. This began when he entered the Royal Military Academy at Woolwich in 1868; three years later, he gained a commission in the Royal Engineers, which was to take him to France, Palestine, Egypt and the Sudan, East Africa, South Africa, India and elsewhere. During the First World War, his inspiration and the poster bearing his portrait with the words 'Your Country needs you' encouraged thousands of men to volunteer for the Army. One explanation of his success was that he had a rare ability to judge situations correctly, and the courage to put his judgement to the test. He disliked 'red tape' and was sometimes considered callous, but a natural reserve concealed his true concern for the welfare of the ordinary soldier.

Kitchener was appointed A.D.C. to Queen Victoria in 1888, and his later responsibilities occasionally brought him into contact with the Queen. When she met him on 16 November 1896, she noted in her Journal that 'Sir Herbert Kitchener is a striking energetic looking man, with rather a firm expression, but very pleasing to talk to.' Kitchener was on friendly terms with other members of the Royal Family, particularly King George V and Queen Mary. At his death in June 1916 Queen Mary described his loss as 'a great blow & personal grief to us ... We had seen much of him during the last 22 months, he was a real friend, like a rock & always straight & full of confidence.'[1]

Reference
1. RA Geo. V CC26/111, Queen Mary to Grand Duchess of Mecklenburg-Strelitz, 9 June 1916.

199.
A pack of cards in its original box, entitled 'A Royal Game. Interesting and Instructive. Her Majesty the Queen, Empress of India, Children and Grandchildren, 1896.' Patent No. 17184. It consists of 52 cards with photographs of members of the Royal Family, divided into ten separate families. The aim was for the player to complete all ten families represented. This game was presented by a Miss or Mrs A. Pitcairn, of Bath, in 1939.

200.
A rectangular openwork gilt metal table box in the Art Nouveau taste. The lid is set with a photograph of King Edward VII, taken at the time of his Coronation in 1902 by W. & D. Downey.
Photograph: approximately 3.3x5.1cm
Box: 7.5x5.8x4.9cm

201.
A gilt metal trinket box in the Art Nouveau taste, decorated with flowers and a dragon. The lid is set with a photograph of the Emperor Francis Joseph of Austria. The box was brought from Vienna in April 1904, probably by Victoria Mary, Princess of Wales, who, with the Prince of Wales, paid a state visit to Vienna on 19–23 April in that year.
Photograph: approximately 4x5cm
Box: 6.7x5.6x4.6cm

202.
A rectangular silver photograph frame decorated with four translucent red enamel shields with the dates 8 April 1818; 25 Mai 1842; 15 Novb. 1863; 29 Jan. 1906. Danish, Maker S. and MB. Contains a photograph of King Christian IX of Denmark in later life by Elfelt.
Photograph: 5.5x7.2cm
Frame: 5.9x8.2cm

King Christian IX was the father of Queen Alexandra. The dates refer, in chronological order, to his birth, marriage, accession to the throne and death.

203.
A wedge-shaped silver photograph frame supported on two ball feet. A lightly tinted photograph on glass of King Edward VII is mounted against the light, and the projected image is viewed in the mirrored base of the frame. The whole is surmounted with a bow. London 1908. Maker probably Maple & Co.
Glass slide: 10x12.7cm
Case: 12.4x15.5x16.7cm

204 (above).
Tea service, made in 'Cauldon Ware' by the firm of Brown-Westhead, Moore & Co., and decorated with photographs taken by Alexandra, Princess of Wales, *c.* 1889–90. The china was supplied to the Princess by Mortlocks Ltd from their 'Pottery Galleries' in London, *c.* 1891. The service consists of:
 24 Tea cups and saucers
 24 Tea plates
 2 Bread and butter plates
 1 Slop basin
 2 Sugar basins
 2 Milk jugs
 2 Cream jugs
 2 Muffin jugs and covers
 2 Tea pots

205.
Mortlocks' list of the china supplied.

206.
Queen Victoria and her granddaughter, Princess Louise, Duchess of Fife, Abergeldie; probably taken on 9 October 1890
By Alexandra, Princess of Wales
6.4x6.3cm
Printing out paper
 This photograph was used to decorate a tea plate in the tea service made for the Princess of Wales [**204**].

207.
Signor Lablache, 1856
By Caldesi
12x16.1cm
Albumen print
Illustrated on p. 65.
 Luigi Lablache, the Italian bass, was born in 1794 at Naples, the son of a French father and an Irish mother. In 1830 he made his London début as Geronimo in Cimarosa's *Il Matrimonio Segreto* at the King's Theatre, where he subsequently appeared in opera every season until 1852, retiring from the stage in 1856. From 19 April 1836 he also gave Princess (later Queen) Victoria singing lessons, in which she delighted, finding him 'an excellent and very agreeable master'.[1] Many other references to Lablache survive in the Queen's Journal. She appreciated his 'ready good humour' and kindness, liking him 'not only as a Master but as a good and honest man; and I do *so* delight to hear him sing, and to sing with him.'[2] She was also entertained by his gossip about other musicians, learning with surprise in 1837 that Grisi, another of her favourite singers, was always nervous before every performance, and laughing 'very much' on hearing, in May 1849, that 'all the miseries in Italy were a punishment from God for having sunk so low as to adopt Verdi's music "after having been such a musical nation." '[3] The Queen continued her lessons with Lablache for a number of years. On his death in 1858 she wrote to her uncle, King Leopold I of the Belgians, that 'we are so grieved for the death of good Lablache. It is an immense loss.'[4]

References
1. RA Queen Victoria's Journal.
2. ibid.: 11 April and 19 August 1837.
3. ibid.: 29 July 1837 and 5 May 1849.
4. RA Vic. Y103/2, Queen Victoria to King Leopold I, 30 January 1858.

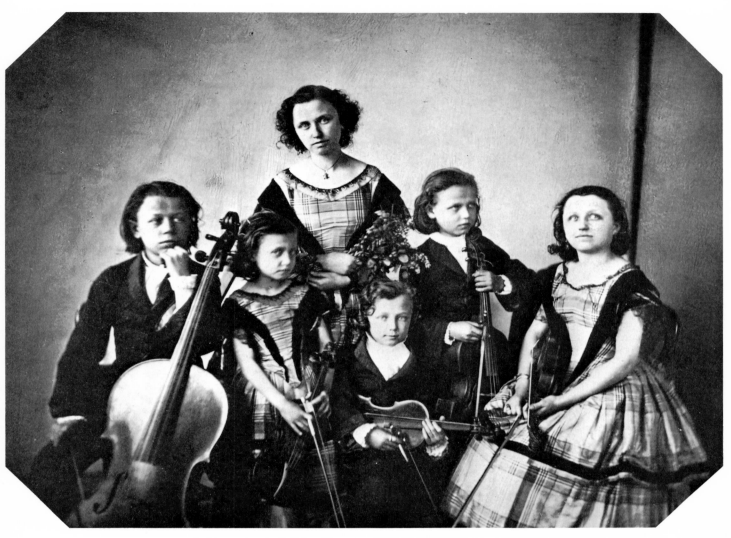

208.

The Family Brousil of Prague,
Mlles Bertha, violin solo, 14 years
 Antonia, piano, 17 years
 Cecilie, 2nd violin, 6 years
Messrs Albin, violoncello, 13 years
 Adolphus, viola gamba, 11
 years
 Aloys, 1st violin, 7 years
Photographer unknown
18.8x14.4cm
Albumen print

The Brousils were a family of young musicians from Prague who were in England in 1857 and played for Queen Victoria and her family on three occasions. It is not known how they were brought to the Queen's notice, but the Royal Family's own involvement with music was considerable and she may have been attracted by the idea of a group of musical brothers and sisters whose ages were so near those of her own children. Prince Alfred, then in his thirteenth year and learning the violin, might have been encouraged by the progress of Bertha Brousil, aged fourteen, on the same instrument. The first occasion when the Brousils played for the Queen was on 18 March 1857, at Buckingham Palace, and she wrote in her Journal: 'We all, & the Children, heard the family Brousil (3 girls, 17, 14, & 6, & 3 boys, 13, 11, & 7) play, & really beautifully. The eldest accompanied on the piano, all the others playing stringed instruments.' The programme included a fantasia, *Masaniello*, by Lafont; a violin solo, *Rêverie*, by Vieuxtemps; a sextet, *The Bird on the Tree*, by Hauser; a duo, arranged by Bertha Brousil for Aloys and Cecilie; and a quintet, *Carnaval Bohémien*, by Mildner. The family played again at Buckingham Palace on 31 March and at Osborne on the Queen's birthday, 24 May. Unfortunately no trace of their subsequent career has been found.

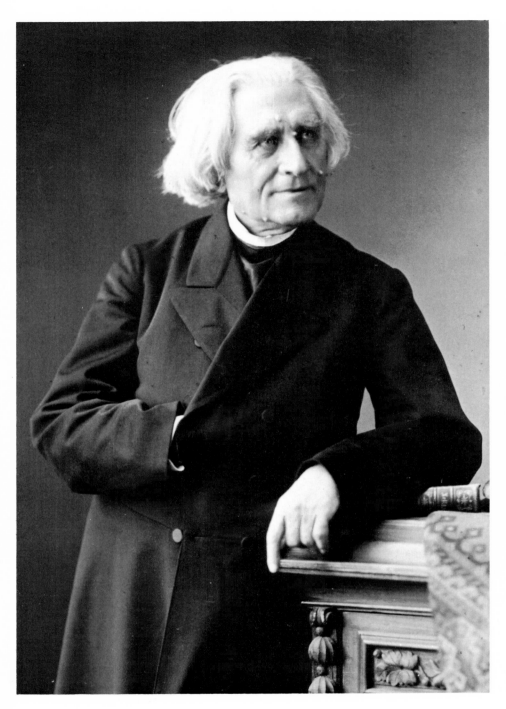

209.
Abbé Franz Liszt, aged seventy-five. Photographed in London, 1886
By F. Ganz
12.5x18.9cm
Albumen print

In the spring of 1886, the year of his death, Liszt visited England, thus causing great excitement in musical circles here, especially as he attended several performances of his works. On 6 April the Prince and Princess of Wales were present at a concert at St James's Hall, when Liszt's oratorio *St Elizabeth* was played. The Prince noted in a letter of 11 April to his son Prince George that 'the great Liszt' had been at the concert '& got a tremendous ovation – also at the Smoking Concert the day before yesterday when several of his pieces were played. He dined with us tonight – & played beautifully on the piano afterwards.'[1] On 7 April Liszt played for Queen Victoria at Windsor Castle, and the event was recorded in her Journal:

> ... After luncheon, we went to the Red Drawingroom, where we saw the celebrated Abbé Liszt, whom I had not seen for 43 years, & who, from having then been a very wild phantastic looking man, was now a quiet benevolent looking old Priest, with long white hair, & scarcely any teeth. We asked him to play, which he did, several of his own compositions. He played beautifully.

Reference
1. RA Geo. V AA15/46

210 (opposite).
Ignaz Jan Paderewski, undated
Photographer unknown
10.4x14.7cm
Platinum print

This photograph was almost certainly taken in 1891, and on 2 July of that year Paderewski first played at Windsor Castle before Queen Victoria. She described the occasion in her Journal:

> ... Went to the Green Drawingroom & heard M. Paderewski play on the piano. He does so quite marvellously, such power, & such tender feeling. I really think he is quite equal to Rubinstein. He is young, about 28, very pale, with a sort of 'auréole' of red hair, standing out. He played, Variations by Haydn, Mendelssohn's 'Spinnerlied', Liszt's arrangement of Schubert's 'Erlkönig'. Papillons, by Schumann, a Prelude, Mazurka & Valse by Chopin, a Melody & Minuet, of his own composition, & Liszt's 2nd Hungarian Rapsodie. His rendering of the 'Erlkönig' was marvellous, one could have thought one heard every word, also Liszt's Rapsodie.

Paderewski played again for the Queen at Windsor on 29 June 1900, when the programme included works by Chopin and Liszt and some of his own compositions. He was to achieve world-wide success as a musician, but never forgot his own country, Poland, and worked ceaselessly in her interest. He became the first Prime Minister of the newly independent Poland in 1919.

A Sa Majesté
Imperiale et Royale
La Reine Victoria

Son serviteur très humble et dévoué

R. Leoncavallo

Milan 18 Juillet 1897

211.
Leoncavallo, 18 July 1899
By Giulio Rossi
16x21.7cm
Albumen print

Queen Victoria had always enjoyed Italian opera, and she was a great admirer of the music of Ruggiero Leoncavallo. She met him on two occasions in 1899, while she was on a visit to Nice. On 29 March she wrote that 'after dinner we had a great treat, the celebrated Italian composer Leoncavallo came & played to us out of his new opera "La Bohème", & also 3 pieces out of "Pagliacci". He plays quite beautifully & the pieces out of his new opera are charming.'[1] Three days later, on 1 April, the Queen 'again had the pleasure of hearing Signor Leoncavallo play a number of lovely things from his operas. He plays most deliciously, with such entrain, & such extraordinary feeling & expression, & has such a beautiful touch. He is very pleasing & modest, & told us he wrote his own libretto as well as composed the music.'[2]

Leoncavallo was to have conducted his music at an opera concert in the Waterloo Gallery at Windsor Castle on 4 July 1899, but he was ill and unable to do so. Nevertheless, *Pagliacci* was performed, conducted by Mancinelli, and the Queen considered it 'eminently dramatic & very tragic & full of passion.' She thought the music 'beautiful, very descriptive, but chiefly sad, the orchestration very fine.' She decided however that 'I still prefer the "Cavalleria", though this is perhaps a more powerful composition.'[3]

References
1. RA Queen Victoria's Journal: 29 March 1899.
2. ibid.: 1 April 1899.
3. ibid.: 4 July 1899.

212.
Princess Beatrice, February 1881
By J. Thomson
9.7x14cm
Albumen print

This portrait shows Princess Beatrice playing the harmonium at Osborne during the winter of 1881, when she was nearly twenty-four. The Princess was a talented musician and composer: among her works were a *Kyrie*, some songs, a chant written for Psalm CXXVIII, and the hymn sung at the christening of Prince Henry, later Duke of Gloucester, on 17 May 1900. This was sung again at the christening of his son, Prince William, on 22 February 1942.

Arthur Sullivan. Ottawa. Feb: 1880.

to which Lord Lorne had written the words. The hymn was later published but was never used for the purpose for which it had been composed.

Reference
See **Arthur Sullivan. A Victorian Musician** by Arthur Jacobs (1984).

214.
Edvard Grieg and Nina Grieg. Signed, London, 28 May 1906.
By Karl Anderson
9.6x15.4cm
Platinum print
 Edvard Grieg, the Norwegian composer, and his wife, Nina, who was a singer, performed for Queen Victoria at Windsor Castle on 6 December 1897. The Queen recorded in her Journal that she 'after tea went to the White Drawingroom, where we heard the celebrated Norwegian composer Grieg, whose music I admire so much, play his own compositions. His wife sang some of his songs, very well, with a pretty voice and much feeling & Wolff played twice with him. Grieg is an elderly man, very small, nice and simple, but he has very delicate health. He played with great expression & wonderful power. Some of the things were well known to me. Both he & Mme. Grieg spoke German.' Grieg was in fact only fifty-four, but his ill health made him seem older.
 On 28 May 1906, during what may have been his last visit to England, Grieg arrived at Buckingham Palace with his wife. They were presented at 3.15 p.m. to King Edward VII and Queen Alexandra by Fridtjof Nansen, then Norwegian Envoy Extraordinary in England, and played and sang to the King and Queen, who were admirers of Grieg's music.[1] King Edward may also have chosen to receive Norwegian musicians at this time because of recent events in Norway, which closely affected his youngest daughter, Princess Maud. The Princess had in 1896 married her cousin, Prince Charles of Denmark. In 1905 Norway dissolved its union with Sweden, which had existed since 1815. A referendum was held in November in which Prince Charles was elected King of Norway by a large majority. In 1906 he was crowned King, taking the name of Haakon VII, and his wife became Queen Maud.

Reference
1. R A Ed. VII Calendar 1906, and Court Circular.

213.
Arthur Sullivan. Signed, Ottawa, February 1880
By Topley
10.1x14.4cm
Albumen print
 Sir Arthur Sullivan is now principally remembered for the light operas he produced in collaboration with W. S. Gilbert: however, he was not only the successful composer of a wide variety of musical works, but also a well-known figure in society, who was on friendly terms with several members of the Royal Family, including the Prince and Princess of Wales, Princess Louise and her husband, the Marquess of Lorne. Queen Victoria admired his music, and he enjoyed the patronage and friendship of Alfred, Duke of Edinburgh, an amateur violinist and President of the Royal Albert Hall Amateur Orchestral Society, of which Sullivan was the conductor.
 Following the staging in America of pirated versions of *H.M.S Pinafore*, Gilbert and Sullivan went to the United States in November 1879 to present the authentic version and to launch their new opera, *The Pirates of Penzance*, which opened on 31 December. Sullivan later went, by invitation of the Marquess of Lorne, who was Governor-General of Canada, to stay at Government House, Ottawa, in February 1880. During this visit he was photographed by Topley, enjoyed tobogganing and also wrote down his music for a Canadian national hymn,

215.
**Dmitri Slaviansky d'Agreneff's celebrated
Russian Choir,** July 1885
Photographer unknown
13.8x10.4cm
Carbon print
Illustrated on p. 66

216.
**Dmitri Slaviansky d'Agreneff with his wife and
family,** July 1885
Photographer unknown
15.4x9.4cm
Carbon print
Illustrated on p. 66

215–16. This famous choir was in existence
for a number of years, playing on several
occasions to members of the Royal Family. On
26 June 1886, the Prince of Wales wrote to his
son Prince George: 'Yesterday . . . in the evening
we went to the St James' Hall & heard M.
Slaviansky's celebrated Russian Choir – wh. was
well worth hearing. There were 80 performers
in the Russian National Dress – & wore most
gorgeous costumes.'[1] The Prince was so im-
pressed with the choir's performance that he
invited them to provide some of the music at a
garden party which he gave at Marlborough
House on 11 July.[2] Queen Victoria had been
present at a performance given by the choir in
St George's Hall, Windsor Castle, on 29 June,
when she found that 'the deep bass voices of the
men are quite extraordinary.'[3] She was similarly
impressed while staying at the Grand Hotel,
Cimiez, on 1 April 1895:

> . . . the splendid Russian Choir sang in the large
> Diningroom . . . The Choir consisted of 140
> members, both men & women & sang without
> accompaniment. They are in charge of a Mr Sla-
> viansky d'Agreneff & his wife, who have raised &
> trained the Choir. They sang entirely Russian
> compositions, & quite beautifully. The bass
> voices of some of the men are quite remarkable.
> Both the Choir & Mr Slaviansky wore their
> Russian national dress, but as it used to be worn
> in olden times.[4]

References
1. RA Geo. V AA15/57.
2. RA Geo. V AA15/59.
3, 4. RA Queen Victoria's Journal.

217.
Lamplighter at Patcham, March 1900
By Princess Victoria
9x8.8cm
Printing out paper

On 27 February 1900 Princess Victoria
went to Brighton for a holiday with her sister,
Princess Louise, Duchess of Fife, who, with her
husband and daughters, Lady Alexandra and
Lady Maud Duff, was staying at 11, Chichester
Terrace. During her stay, Princess Victoria took
a number of snapshots in and near Brighton,
probably using a No. 2 Bull's-Eye Kodak
camera. She returned with Princess Louise and
family to London on 27 March.

218 (opposite).
**Tsarevitch Alexis Nicholaievitch of Russia,
Reval,** June 1908
By Queen Alexandra
9.3x12.3cm
Printing out paper

Between 5 and 14 June 1908, King Edward
VII and his nephew-in-law, Tsar Nicholas II
of Russia, with members of their families, met
on board their yachts, the *Victoria and Albert*
and the *Standart*, off Reval in the Baltic. The
meeting had political significance, as Britain and
Russia had signed a friendly agreement in 1907,
but it was also a family party. Queen Alexandra
kept an album commemorating the occasion: she
had brought her No. 4 Kodak camera with her
and took a number of photographs, some
showing the children of the Tsar. The two fam-
ilies were to meet again at Cowes during the
summer of the following year.

219.
No. 4 Kodak Camera, formerly in the possession of Queen Alexandra. This is a box camera, to hold rollfilm of 5x5″. It has an RR type lens, sector shutter and two reflecting finders. It is covered in purple leather, with 'AA' monogram and crown in gold.
18x33x13cm
Lent by the Kodak Museum at the National Museum of Photography, Film and Television.

220.
Wynne's Infallible Exposure Meter, 1893, formerly in the possession of Queen Alexandra. This is a watch-type actinometer, in a solid silver case, hallmarked for Birmingham Gothic 't', 'A.W.'. The back is engraved with a crowned 'A' monogram and Prince of Wales's feathers, and has a rose, thistle and shamrock decoration. It has a plush-lined leather case.
Case measures 7.5x9.5x2cm
Lent by the Kodak Museum at the National Museum of Photography, Film and Television.

221 (opposite).
Prince Alfred, 1864
By Prince Alfred
Four portraits, each 5.3x8.3cm
Albumen prints
 One of four self-portraits made by Prince Alfred at the age of twenty.

222.
Mr Turnbull, Clerk of the Works at Windsor, April 1865
By Prince Alfred
10.1x13cm
Albumen print
 John Robson Turnbull was appointed Clerk of the Works for Windsor Castle, with responsibilities including the Royal Mews and the buildings in the Home Park, in 1846. He held the position until his death twenty years later. His duties were many: one particular task was superintending the erection of a temporary building attached to St George's Chapel for the use of the Royal Family at the time of the marriage of the Prince of Wales and Princess Alexandra of Denmark, which took place in the Chapel on 10 March 1863. This portrait, taken in the year before Mr Turnbull's death, is markedly different in style from the other work in Prince Alfred's photograph album, and is reminiscent of a genre picture.

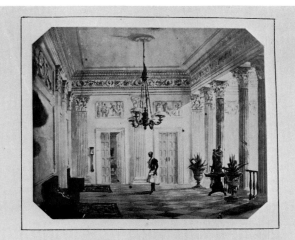

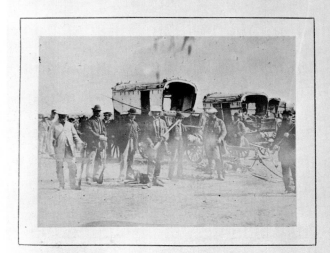

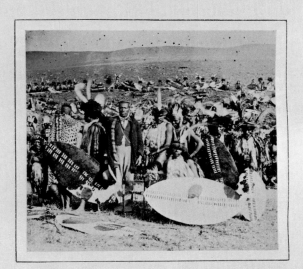

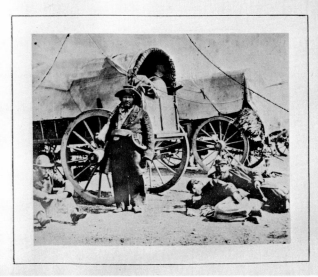

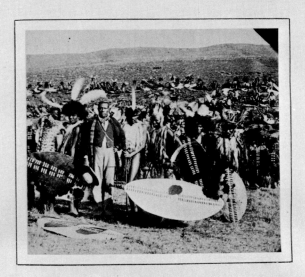

223.
Views in South Africa, 1860
By Prince Alfred

7.2x6.2cm	7.2x6.1cm
7.8x6cm	7.7x7cm
7.7x6.6cm	7.7x7cm

Albumen prints

In July to September 1860 Prince Alfred paid an official visit to South Africa while serving as a midshipman on board H.M.S. *Euryalus*. His tour took him through the Cape Colony, Kaffraria, Natal and the Orange Free State. Although a photographer, Mr Frederick York, was one of the party, the Prince, who had learnt the rudiments of photography before the visit, took with him a double stereoscopic box camera which, with other photographic materials and equipment, had been bought for him from Messrs Murray & Heath, of Piccadilly in London, in April 1860.[1] He also had with him a number of photographic portraits of himself to give away, on one occasion to Moshesh, the Basuto Chief, in return for a present of leopard skins. On 22 August, while encamped by the Kaffir River in the Orange Free State, Major John Cowell, travelling with the Prince, wrote to the Prince Consort that they had 'halted about noon to luncheon aside one of the many streams which wind through the plains, and here some photographs were taken of the Waggon Train, and Prince Alfred took a stereoscopic view of this and his party as we were about to start.'[2]

These photographs are probably some of the earliest surviving pictures by the Prince, and they are preserved in an album of his work, dating from 1860 to April 1865. Prince Alfred continued his interest in photography, writing to Queen Victoria from Kranichstein on 30 June 1865 to send her 'the 143 photographs of my doing which you wanted to have. I am sure you had no idea they were so many.'[3]

References
1. RA PP2/43/587.
2. RA Vic. Add. MSS A20/69.
3. RA Vic. Add. MSS A20/1257.

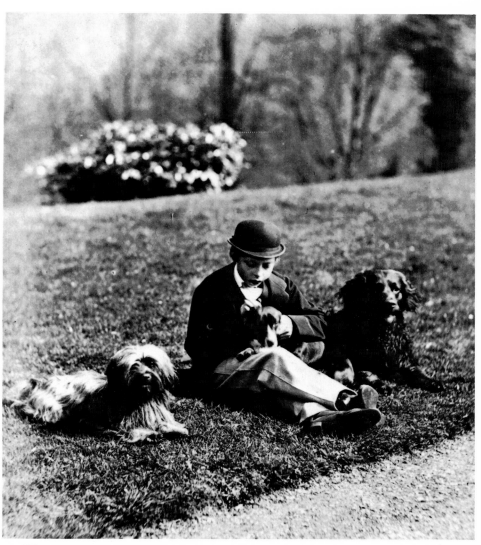

224.
Prince Leopold with Corran, Waldmann and Comet, Windsor, April 1865
By Prince Alfred
7.4x8.8cm
Albumen prints

One of four pictures of Prince Alfred's younger brother Prince Leopold, taken at about the time of his twelfth birthday.

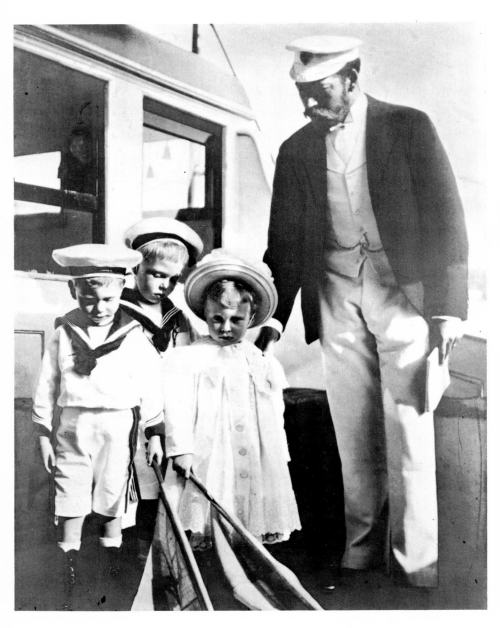

225.
Off the Irish Coast
By Queen Alexandra
37.9x30.4cm
Gelatine silver print
Illustrated on p. 74

226.
Changing Guard at Windsor Castle
By Queen Alexandra
30.4x38.1cm
Gelatine silver print
Illustrated on p. 75

227.
Off the Coast of Scotland
By Queen Alexandra
39x31cm
Gelatine silver print
Illustrated on p. 74

225–7. These prints, which bear inscriptions in Queen Alexandra's hand, were probably taken *c.* 1902, and may have been enlarged for display in one or more of the Kodak exhibitions. One of the Queen's photographs shown at the Kodak Gallery in Oxford Street was entitled *In the Quadrangle, Windsor Castle*, and one shown at the Kodak Gallery in West Strand was called *Off the Coast of Scotland*. The photographs were probably taken with a No. 4 Bull's-Eye Special Kodak camera.

228 (left).
George, Duke of York, and his children (left to right), **Prince Albert, Prince Edward and Princess Mary, on board the Royal Yacht *Osborne*,** August 1899
By Alexandra, Princess of Wales
23.8x31.3cm
Gelatine silver print
 A photograph by the Princess of Wales, showing her son and three grandchildren during Cowes Week, 1899.

229.
King Edward VII in a 24-horse-power Daimler of 1901, dated April 1902. Beaulieu and New Forest.
Distance travelled, 38 miles
By Lafayette Ltd
28.4x36.3cm
Carbon print
 During the spring of 1902, the year of his coronation, King Edward VII took a short holiday cruise in the Solent on board the Royal Yacht *Alberta*. On 31 March he disembarked at Buckler's Hard and was taken to Beaulieu Abbey in a motor car belonging to the Hon. John Douglas-Scott-Montagu (later the second Baron Montagu). Having called on Lord and Lady Montagu at Beaulieu, the King was driven in the car to Lyndhurst, Wilmsley, Brockenhurst, Lymington and Thorn's Beach. According to the 'Contour' Road Book of England for 1898, this route was 'a pretty road', with 'numerous short, steep hills' between Beaulieu and Lyndhurst. The road from Lyndhurst to Lymington had a 'usually fine surface' so was probably ideal for motor cars. After what must have been a very pleasant run, the King took tea with Mr Montagu and his wife at their bungalow at five p.m., afterwards returning to Buckler's Hard and rejoining the *Alberta* just under two hours later.
 Although this journey was doubtless a memorable one, it was not the King's first motor-car drive. He had acquired the first motor car to be bought by a member of the Royal Family, a Daimler Tonneau, in 1900. Queen Alexandra described a motor drive in a letter of June 1901 to her son, George, Duke of Cornwall and York, and told him: 'I did enjoy being driven about in the cool of the evening at 50 miles!! an hour! – when nothing in the way of course only! – & I must say I have the greatest confidence in our driver – I poke him violently in the back at every *corner* to go gently & whenever a *dog, child* or anything else comes in our way!'[1]

Reference
1. RA Geo. V AA32/30.

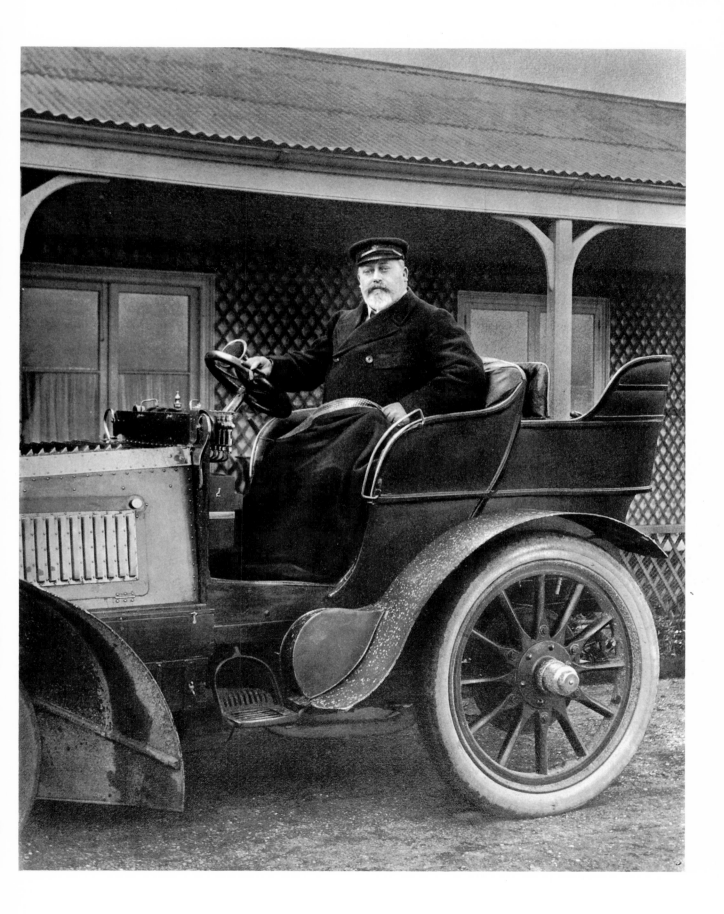

230 (opposite).
The Marquis de Soveral, 1900
Photographer unknown
18.4x28.1cm
Gelatine silver print

Luis Augusto Pinto de Soveral was born in Portugal in 1850. He was educated at the Royal Naval Academy and later at the Universities of Oporto and Louvain before following his father's profession as a diplomat. He was posted as attaché to Madrid, Vienna, Berlin and Rome before coming to London in 1890. At that time relations between Britain and Portugal were strained. Soveral showed great skill in drafting an agreement between the two countries, which was signed the following year, and he was consequently appointed Portuguese Minister at the Court of St James's. He became a close friend of the Prince of Wales (later King Edward VII) and of the Royal Family. This privileged position was largely due to Soveral's impeccable manners and remarkable tact, equal to the Prince's own.

In 1895 King Carlos of Portugal instigated Soveral's appointment as Foreign Minister: his friendship with both the Prince of Wales and the King cast a benign influence over relations between Britain and Portugal, which continued when he was again appointed Minister to London in 1898. Soveral was a great supporter of the *Entente Cordiale* between Britain and France, and accompanied King Edward on his first official visit to Paris as a member of his suite.

For some years, Soveral was a well-known and popular figure in society. He was honoured by several foreign governments as well as his own, and became a 'Fidalgo' (nobleman) of the Royal House. His friendship with the British Royal Family continued after Portugal became a republic, and when he died in Paris in 1922, the deposed King Manuel and his mother, Queen Amelia, were with him during his last moments.

231. Queen Alexandra's copy of her **Christmas Gift Book**, 1908. This volume, bearing the title 'Pleasant Recollections', was bound for the Queen by Messrs Mudie of 30, New Oxford Street, London. The front of the dark purple leather cover is heavily tooled in gold with an intricate lace pattern, leather inlays in pink, grey and green in the form of roses, thistles and shamrocks being incorporated in the design.
22.2x28.8x1.8 cm

232.
Princess Alexandra of Denmark, 1860
By E. Lange
5.6x8.8cm
Albumen print
Illustrated on p. 72

233.
Princess Alexandra of Denmark, January 1861
Photographer unknown
5.8x8.6cm
Carbon print
Illustrated on p. 72

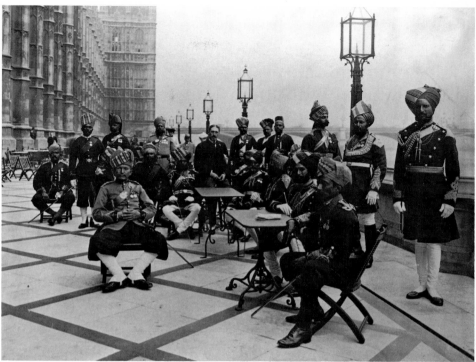

234.
Princess Alexandra of Denmark at Neu Strelitz, 3 June 1861
Photographer unknown
5.4x8.6cm
Albumen print
Illustrated on p. 73

232–4. Three photographs of the future Queen Alexandra, taken before her marriage to the Prince of Wales. According to inscriptions on the back in Queen Victoria's hand, these photographs were 'much admired' by the Prince Consort, and so helped to decide the Princess's destiny.

235.
Alexandra, Princess of Wales, with her camera, *c.* 1889
Photographer unknown
4.7x12cm
Albumen print
Illustrated on p. 70

In this photograph the Princess is holding a No. 1 Kodak, introduced in 1889, which took small circular photographs.

236.
Royal Warrant, dated 1 July 1901, appointing 'Mr George Eastman of 43 Clerkenwell Road London EC, trading as "Kodak"', purveyor of photographic apparatus to Queen Alexandra.
27.5x43.1cm
Lent by Kodak Ltd.

237 (above).
Indian officers on the terrace at the House of Commons, 1902
Photographer unknown
37x29.9cm
Gelatine silver print
See p. 207.

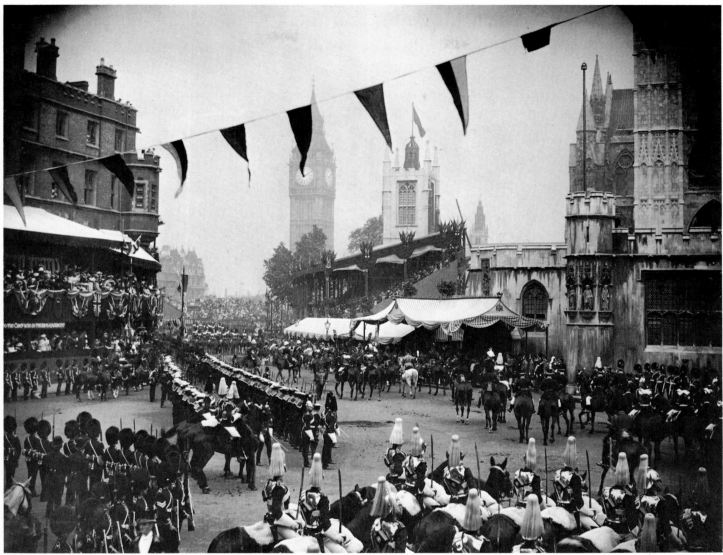

238.
Decorated arch in Whitehall, 1902
Photographer unknown
29.7x37.7cm
Gelatine silver print
 237–8. Two prints from an album of photographs taken at the time of King Edward VII's coronation in 1902. The album also contains other views of London streets, exterior and interior pictures of Westminster Abbey and portraits of several Indian personages, including Sir M. Bhonaggree, M.P., and Sir Jamsetjee Jeejeebhoy. The album, decorated in the Indian style, was bound by 'Qari Abdurrahman's Sons. Book Binders and Illuminaters. Alwar State, Rajputana'. It seems highly probable that the photographer was an Indian who was either working in England or here on a visit during the coronation celebrations.

239.
The State Coach, troops and crowds outside Westminster Abbey, 9 August 1902
Photographer unknown
36.6x28.9cm
Platinum print
 This photograph is one of forty-five prints made at the time of the coronation of King Edward VII and Queen Alexandra. The prints were bound into an album by the Guild of Women Binders, of Charing Cross Road, London.

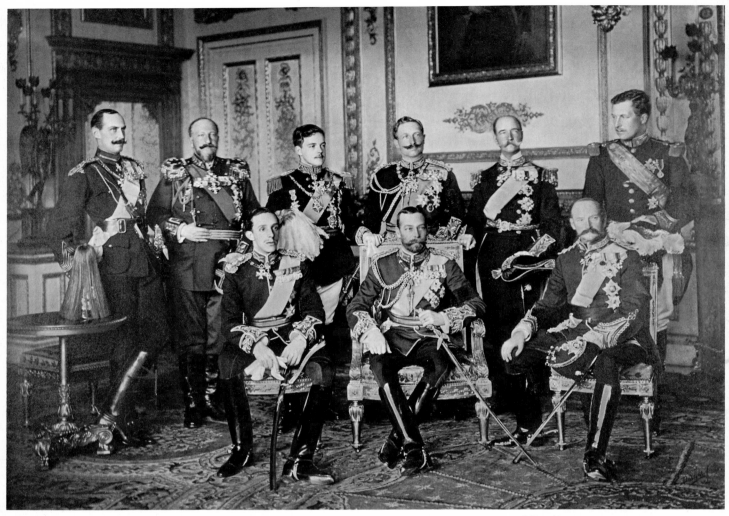

240.
Nine sovereigns at Windsor for the funeral of King Edward VII, 20 May 1910. Left to right:
Standing: King Haakon VII of Norway, King Ferdinand of Bulgaria, King Manuel of Portugal, Emperor William II of Germany, King George I of the Hellenes, King Albert of the Belgians.
Seated: King Alfonso XIII of Spain, King George V, King Frederick VIII of Denmark.
By W. & D. Downey
59x43.3cm
Probably a gelatine silver print
　　King George V was related by ties of blood or of marriage to most of the sovereigns of Europe, some of whom gathered at Windsor for his father's funeral in 1910. Here he can be seen with two uncles (the Kings of Denmark and of the Hellenes), a brother-in-law who was also a first cousin (the King of Norway), another first cousin (the German Emperor), a first cousin by marriage (the King of Spain) and three distant cousins, all descended, as he was, from branches of the Saxe-Coburg family (the Kings of Bulgaria, Portugal and the Belgians).

'Appointed to the place and quality of . . . ':

Photographers to Her Majesty

In 1848 the satirical magazine *Punch* drew attention to the large

number of butchers in and near the metropolis who are, or who call themselves, 'By Special Appointment, Purveyors to the Queen.' Presuming that HER MAJESTY most graciously keeps her appointments, the consumption of meat in the Royal household must be something truly terrific in order to give every Purveyor even an occasional turn. We have no doubt that the sale of a kidney for PRINCE ALBERT's breakfast, or a quarter of a pound of the thick end of neck of mutton to supply one of the Royal infants with a teacup full of broth, would be instantly taken advantage of by the fortunate butcher as a pretext for mounting the Royal Arms, collaring the British Lion with the golden collar, and writing up 'Purveyors to the Queen'.[1]

Butchers were not alone in making free with the Royal Arms and claiming the personal support of the Queen and the Royal Family. In the 1880s a photographer discovered that a cottage in one of his views had once been used by the Queen when she was Princess Victoria. He forwarded a copy to her at Windsor Castle, and on receiving the official acknowledgement of his gift, he felt himself entitled to display the Royal Arms on his premises and call himself thereafter 'Photographer to the Queen'.[2] In 1857 a Manchester photographer who had submitted a photograph to the Queen and Prince Albert wrote to ask Colonel Phipps, Keeper of the Privy Purse, whether he could now announce himself 'Photographer to the Queen', because at that time he was 'building a first class portrait gallery adjoining the Manchester Town Hall [and] such an announcement would ensure ... success.'[3]

Businesses of all kinds were able to make claims to royal patronage whether or not they held the Royal Warrant that alone conferred the right to do so. The principle by which the warrants were issued was based upon the well-established rule that the tradesman must have supplied, on a regular basis, goods or services ordered and paid for by a department of the Royal Household. The initiative for the granting of a warrant rested upon the tradesman, who made his application either to the Lord Chamberlain or to the Lord Steward's office, where it was assessed and acted upon. If the tradesman did not make an application, then there was no grant of a warrant. The onus for recognition, therefore, did not lie with the Queen.

However carefully these principles may have been applied, the system was being widely abused, not by the careless issuing of warrants but rather by the failure to take legal action against the many businesses who made fake or dubious claims about their status as suppliers.

The relationship between royal patronage and commercial success was widely recognized. Portrait photographers, among whom competition was particularly fierce, went to great trouble to elaborate on the various subtleties of meaning and sources of symbolism open to them when decorating the pasteboard mounts for their cartes de visite. 'Patronized by Her Majesty', 'By Special Appointment', 'Photographer Royal', 'Under Royal Patronage', were all in regular use.

So commonplace were such practices that it was accepted even in legal circles that 'the use of Royal Arms by a photographer means nothing at all.'[4] Although the Lord Chamberlain's office regulated the method by which warrants were issued, it was still powerless to take action against abuses, even after adopting a more rigorous line in 1858. There were no really effective Acts of Parliament to control the use of Royal Arms or the false wording of advertisements. Even if there had been, it was the rule that no officer of the Crown could prosecute. The vindication of Acts was left to members of the public, who received one half of the fine imposed by the court as a reward.[5]

Not only were more scrupulous and honest traders being penalized by the abuses committed by others, but members of the public were often misled into believing the price they paid for a photograph was justified by the prestige of royal patronage.

It was clear that some legal action would have to be taken, and these issues, along with many others, were gathered up for consideration by a Select Committee established by the House of Commons in 1862. The committee took evidence from manufacturers whose trade had been severely damaged by the fraudulent application of their trade marks to inferior goods not of their making. The outcome was the Merchandise Marks Act of 1862, but this soon proved to be totally ineffective; the misuse of Royal Arms and false claims of patronage continued unchecked.

Nothing more was done until 1883, when the Patents, Designs, and Trade Marks Act offered a glimmer of hope in the interpretation of one of its sections which, though ambiguously worded, stated that it was an offence to use 'the Royal arms, or arms so nearly resembling the same as to be calculated to "deceive" the public into believing that the trade was carried on under such authority'.[6] Many tradesmen were alarmed by this Act, and the Lord Chamberlain reported that his office had received 'numerous applications for the use of Royal Arms' all of which were declined.[7] Clearly there was a need to establish a precedent by testing the rigour of the new law.

This task fell to a portrait photographer, W. Turner of the City of London, who in 1884 brought a private prosecution against Messrs A. & G. Taylor for their use of the Royal Arms without authority. A. & G. Taylor were a particularly well-established firm of portrait photographers operating numerous studios throughout Britain. Their contact with the Royal Family was of fifteen years' standing, and their claim to use the arms was based upon the considerable trade they enjoyed from the sale of royal portraits.[8]

Turner felt that their use of the Royal Arms enabled them to monopolize a large portion of the photographic business in Britain to the detriment of their competitors.[9] In particular, he objected to the manner in which they canvassed for their business 'not only in London and its suburbs, but in all

1. **Punch, or The London Charivari**, Vol 14, 15 January 1848, p. 3.

2. This story was outlined in a letter to **The Photographic News**, 31 October 1884, p. 700.

3. RA PP2/22/7666/26, J. A. Deane to Col. Phipps, 28 May 1857.

4. Quoted from the *Solicitors Journal* in **The Photographic News**, 17 October 1884, p. 672.

5. Quoted in a letter to the **British Journal of Photography**, 31 October 1884, p. 702.

6. **Patents, Designs, and Trade Marks Act 1883**, 46 & 47, section 106.

7. **Report of the Proceedings in the Lord Chamberlain's Department, 1884**, Warrants given to Tradesmen.

8. 'Metropolitan Photographic Industries', **British Journal of Photography**, 28 January 1876, p. 39. This article describes the business operations of A. & G. Taylor and cites the sales of 20,000 copies of a portrait of the Princess of Wales.

9. Letter by W. Turner to the **British Journal of Photography**, 31 October 1884, p. 702.

provincial towns throughout the country, where you find their satellites actively at work in every railway station, market place, post-office, police station and all descriptions of workshops.'[9]

In taking this approach Turner raised issues about business rivalries that were beyond the scope of the Act. The magistrate, on hearing that A. & G. Taylor had removed the arms from their premises and their business documents, felt that this was a sufficient penalty and fined them a nominal one shilling, with two shillings costs.[10]

Taylors had already applied to the Lord Chamberlain in 1884 for the issue of a Royal Warrant, but their application was declined, perhaps because the case against them was impending. In 1886 they successfully reapplied and were granted a warrant on 26 October.

Concurrently with the court case, the Lord Chamberlain's office began to make a complete revision of the list of warrant holders. As this had not been done for many years, it was believed that many of the warrants had either lapsed through the death of the holder or had been improperly passed on within a business, although they were originally issued to an individual without rights of transfer. Town Clerks throughout Britain were given a list issued by the Lord Chamberlain to be checked against their local knowledge.[10] Despite the minimal fine against A. & G. Taylor, the court case and the Lord Chamberlain's initiative combined to bring about a reform in the warrant system and inhibit the future misappropriation of the Royal Arms.

Another effect of the court case was an increase in the number of warrants granted. In the five years after the trial, no fewer than fourteen were issued, nearly fifty per cent more than during the preceding thirty years. A further nineteen were granted in the 1890s.

The final act of regulation came in 1895, when the Queen gave her approval to the formation of an independent Association of Warrant Holders, whose express function was to suppress the illegal use of the Royal Arms and thereby protect their own rights.[11] This Association is still in existence, fulfilling much the same purpose.

The whole concept of issuing tradesmen with warrants in acknowledgement of their services to the Royal Family underwent a profound change during Queen Victoria's long reign. Initially, the effect of holding a warrant and displaying the Royal Arms would have been chiefly local in its influence. As the pattern of retail trading changed in response to the buoyant consumerism of the 1850s and 1860s, the Royal Warrant rapidly became a device from which businesses could gain national status and commercial advantage. In part, these changes in marketing and advertising practices arose from the metamorphosis of a society which, during the nineteenth century, saw the middle classes emerge as a powerful cultural and economic force.

Every aspiring photographer directed his attention towards this class: here lay his greatest oppor-tunity for financial success. If he belonged to the same class himself, he knew just what would appeal to their sense of taste, refinement and respectability, and, if he was astute, he would call his studio a 'salon' or 'atelier' in the French manner, and furnish his waiting room with great care to put his customers at ease by making them assume they were in his private drawing room. Above all, he must know how to appeal to their snobbishness – a term which came into being in the mid-nineteenth century and which captures perfectly that sense of insecurity which troubled the middle classes, and which they sought to control and formalize with social conventions, self-righteousness, and a subtle display of dis-tinctions. This was the appeal of being able to mention that one had just visited the elegant salon of the 'Photographer to the Queen'.

10. 'Photography in Court', **British Journal of Pho-tography**, 17 October 1884, p. 667.

11. R A PP122.

A chronology of photographers granted Royal Warrants in the reign of Queen Victoria

James Ross & John Thomson
Photographers at Edinburgh to Her Majesty, 14 June 1849.

Antoine Claudet
Stereoscopic Photographist to Her Majesty, 9 July 1855.

Messrs J. Horne & Thornthwaite
Opticians, Philosophical and Photographic Instrument Makers, 1 July 1857.

M. Adolfe Disderi
Photographer in Ordinary, 12 March 1867.

Robert Hills & John Henry Saunders
Photographers at Eton, 27 April 1867.

Robert White Thrupp
Photographer to Her Majesty at Birmingham, 9 October 1867.

James Valentine
Photographer to Her Majesty at Dundee in Ordinary, Personal Warrant, 28 November 1868.

H. J. Whitlock
Photographer at Birmingham, 1870.

Robert Charles Murray
Manufacturer of Scientific, Chemical, Physical apparatus, in Ordinary, 1872.

George Washington Wilson
Photographer to Her Majesty in Scotland, 17 July 1873.

Edwin P. Lee & Co
Photographers & Enamellers at Cardiff, 16 December 1875.

William & Daniel Downey
Photographers in Ordinary to Her Majesty, 24 March 1879.

Signor C. Marcossi
Photographer to Her Majesty in Ordinary at Milan, 14 December 1880.

John Thomson
Photographer to Her Majesty, 11 May 1881.

M. Eugène Degard
Photographer to Her Majesty at Nice, Personal Warrant, 26 June 1882.

A. L. Henderson
Photographic Enameller to Her Majesty, 21 November 1884.

Hughes & Mullins
Photographers to Her Majesty at Ryde, 15 January 1885.

Thomas Heinrick Voigt
Photographer to Her Majesty at Hamburg, 7 February 1885.

A. Braun & Co
Photographers to Her Majesty at Dornach and Paris, 19 March 1885.

Herr Karl Backofen
Photographer to Her Majesty at Darmstadt, 31 March 1885.

John Collier
Photographer to Her Majesty at Birmingham, 14 October 1885.

Stanilas Julien, Comte Ostorof, trading as **Valery**
Photographer to Her Majesty, 19 April 1886.

Brown, Baines & Bell
Photographers to Her Majesty at Liverpool, 1 July 1886.

George Taylor & Andrew Taylor, trading as **A. & G. Taylor**
Photographers to Her Majesty, 26 October 1886.

James Lafayette
Photographer to Her Majesty at Dublin, 5 March 1887.

Charles Albert Wilson
Photographer to Her Majesty in Scotland, 4 May 1887.

George Piner Cartland
Photographer to Her Majesty at Windsor, 2 August 1887.

Cavaliere Carlo Brogi
Photographer to Her Majesty at Florence, 12 May 1888.

J. & R. Annan
Photographers and Photographic Engravers to Her Majesty, 26 September 1889.

Lettsome & Sons
Photographers to Her Majesty, 12 February 1890.

William & Daniel Downey
Photographers to Her Majesty, 7 June 1890.

Alexander Bassano
Photographer to Her Majesty, 24 November 1890.

Mons. F. Burin
Photographer to Her Majesty at Grasse, 29 June 1891.

M. P. Poullan Fils
Artistic Photographer to Her Majesty at Hyères, 4 July 1892.

Frederick Saunders & Ernest Saunders, trading as **Hills & Saunders**
Photographers to Her Majesty at Eton, 16 March 1893.

C. A. Wilson, J. H. Wilson, & L. Wilson, trading as **G. W. Wilson & Co**
Photographers to Her Majesty in Scotland, 6 February 1895.

London Stereoscopic and Photographic Company
Photographers to Her Majesty, 7 August 1895.

Robert Milne
Photographer to Her Majesty at Ballater, 28 January 1896.

Mrs Mary Steen
Photographer to Her Majesty at Copenhagen, 21 May 1896.

Horatio Nelson King
Architectural Photographer to Her Majesty, 25 August 1896.

Charles Gunn & William Slade Stuart, trading as **Gunn & Stewart**
Photographers to Her Majesty, 24 September 1896.

Thomas Fall
Photographer to Her Majesty, 29 January 1897.

Professor E. Uhlenhuth
Photographer to Her Majesty, 5 March 1897.

William Oldham
Photographer to Her Majesty at Eton, 3 April 1897.

J. L. Russell, A. H. Russell, & E. G. Russell, trading as **Russell & Sons**
Photographers to Her Majesty, 3 May 1897.

Reja Deen Dayal & Son
Photographers to Her Majesty at Bombay, 19 September 1897.

William H. Grove
Photographer to Her Majesty, 21 November 1899.

Messrs Chancellor & Son
Photographer to Her Majesty at Dublin, 1899.

R. Welch
Photographer to Her Majesty at Belfast, 1 June 1900.

W. Abernethy
Photographer to Her Majesty at Belfast, 1 June 1900.

Messrs Herbert Fox & Fred Glover, trading as **Maull & Fox**
Photographers to Her Majesty, 5 September 1900.

Photographers represented in the exhibition

Studio ADÈLE, active *c.* 1865–75
This well-known portrait studio was owned by a woman who established premises within Vienna's leading hotels. Here she was patronized by the Emperor Francis Joseph and the Austrian court.

ADOLPHE, active 1880s
A portrait photographer with a studio in La Haye, Normandy. Winner of two prize medals.

Queen ALEXANDRA, 1844–1925
One of the most accomplished royal photographers. She acquired a No. 1 Kodak in 1889; prints made with this camera were used to decorate a tea service in Cauldon Ware. Later she used No. 2 Bull's-Eye Kodak and No. 4 Bull's-Eye Special Kodak cameras. Some of her prints were displayed in Kodak exhibitions in 1897 and later. In 1905 she allowed nine prints to be published in three special supplements of **The Graphic.** In 1908 she published **Queen Alexandra's Christmas Gift Book. Photographs from My Camera.**

Prince ALFRED, Duke of Edinburgh and of Saxe-Coburg-Gotha, 1844–1900
The second son of Queen Victoria and Prince Albert was given a complete 'photographing apparatus', supplied by Murray & Heath, in 1860. 224 prints taken by him between 1860 and April 1865 are preserved in an album. He took other photographs of his family, and sent 143 of his own prints to Queen Victoria from Germany in June 1865. He continued his interest in photography in later life.

Karl ANDERSON
A portrait photographer to the Norwegian court with a studio in Oslo. Winner of ten prize medals.

Édouard-Denis BALDUS, 1813–82
About 1849 Baldus turned from painting to devote himself exclusively to photography, which he practised until the mid-1860s, when he became increasingly interested in publishing his work by photomechanical reproduction. His best-known works are the large-format studies intended as a documentary record for the Commission des Monuments Historiques.

William BAMBRIDGE, 1819–79
Born in Windsor; worked as a schoolmaster with Bishop Selwyn's mission to New Zealand and returned to Windsor in 1848. From *c.* 1854 he was regularly employed by the Royal Family as their photographic factotum, acting as photographer, printer, calligrapher and organizer of the Queen's private negatives. Upon his retirement in 1874 she granted him a pension in recognition of his services.

Alexander BASSANO, 1829–1913
Established his first portrait studio in London during the 1850s, and became one of the leading practitioners in the 1870s and 1880s. His Regent Street studio was noted for the use of 'real' furniture as props rather than the papier-mâché imitations to be found elsewhere. He introduced the 13x8″ panel portrait during the 1870s. Royal Warrant 24 November 1890.

Richard BEARD, Jnr, 1801–85
Born in Devon, the son of a grocer in Newton Abbot. Moved to London in 1833 and profitably established himself in the coal trade until 1843.

Took up photography at an early stage of its development. Bought the rights to Wolcott & Johnson's mirror camera and the patent rights to the daguerreotype process in 1841. Opened England's first portrait studio on 23 March 1841, followed later that year by eight others, operated under licence. Fought vigorously for the protection of his patent rights. He declared himself bankrupt in 1849 and retired to Hampstead, where he later died.

Dr Ernst BECKER, 1826–88
Born in Darmstadt and educated in Edinburgh; took up his appointment as librarian to Prince Albert and assistant tutor to the young princes in May 1851. His interest in photography was probably well formed at the time of his appointment, and he continued to practise throughout his time at Court. A founder member of the Photographic Society of London in 1853. He left the service of Prince Albert in 1858 and became Treasurer to Alice, Princess Louis of Hesse, in 1862.

Francis BEDFORD, 1816–94
Having almost certainly come to the attention of the Royal Family with his impressive lithographic illustrations for Digby Wyatt's **The Industrial Arts of the Nineteenth Century at the Great Exhibition, 1851,** Bedford was commissioned to photograph the art exhibits at Marlborough House in 1854. His second commission in 1857 was of a more personal nature: to make a series of views of Coburg and its neighbourhood to be given by the Queen to Prince Albert. This was followed in 1858 by a similar commission for views of Gotha. In 1862 he accompanied the Prince of Wales on his educational tour of the Near East, where he was able to gain privileged access to photograph holy sites. He was more popularly known for the fine topographic studies he published through Catherall & Pritchard of Chester.

Charles BERGAMASCO, active during the second half of the nineteenth century
Born in Northern Italy, Bergamasco moved to St Petersburg in the 1840s with his mother, a painter who gave lessons in 'Indian painting'. Bergamasco started as an actor at the French Theatre in St Petersburg, but became interested in the daguerreotype process and went to Paris to study it. He returned to St Petersburg to open his own studio and after a few years became well-known there and in Europe, winning prizes at exhibitions, photographing at many courts and receiving several decorations. He visited England in 1877 and took a number of photographs of Queen Victoria and her family: the Queen noted in her Journal for 11 May that she had been 'photographed in the Orangery [at Windsor Castle] by Bergamasco, an Italian, established since 25 years at St Petersburg, & come all the way at his own request, to photograph me.' He did not, however, restrict himself to prominent people, and a story is told that one day a peasant burst into his studio, having walked a long distance, and sat down on a chair, straight as a ramrod, with his hands spread out on his knees. Bergamasco tried to adjust this rigid posture, but the old man exclaimed: 'God created me with ten fingers and they must all be in the picture.'

BOURNE & SHEPHERD, active from the 1860s to the present day
Commercial publishers of landscape and topographic views of India. Although based in Calcutta and Simla, where they operated portrait studios, their work was widely retailed throughout the subcontinent by agents and in Britain by wholesale distributors. This partnership between Samuel Bourne and Charles Shepherd was the last variant of earlier partnerships between Shepherd & Robertson, and Howard, Shepherd & Bourne.

Alfred BROTHERS, 1826–1912
Born in Kent. His life-long interest in photography and astronomy began in his youth. Following his marriage he moved to Manchester to work in insurance, but by 1856 he had given this up to establish a portrait studio in St Anne's Square. Photographed at the Manchester Art Treasures Exhibition of 1857, and experimented with magnesium as an illuminant *c.* 1864. His photographs of the solar eclipse on 22 December 1870 helped astronomers advance their understanding of the sun's corona.

BRUNELL, active early 1950s
A Windsor photographer of whom virtually nothing is known.

John BURKE, active *c.* 1860–*c.* 1907
A commercial photographer operating variously from Murree, Peshawar and Rawalpindi, India. In the Afghan War he was employed by the Army as a 'Photographic Artist' and recorded the exploits of the Peshawar Valley Field Force. Following a disagreement with the Army about his conditions of employment he promptly left Afghanistan. Some years later he formed a partnership with W. Baker, and together in 1872 they published an extensive catalogue of Indian views.

BYRNE & CO., active 1880–1900
Portrait photographers with a studio at Richmond, Surrey. Winners of twenty-four prize medals.

James Sinclair, 14th Earl of CAITHNESS, 1821–81
Lord Caithness was Lord-in-Waiting to Queen Victoria in 1856–8 and 1859–66. He was a Fellow of the Royal Society of London and devoted much of his leisure to scientific pursuits, including photography. In 1864 photographs by Lord Caithness and William Bambridge were used to illustrate **The History of Windsor Great Park and Windsor Forest** by William Menzies. He invented a steam carriage for travelling on macadamized roads, a gravitating compass and a tape-loom for use in weaving. In 1877 he published **Lectures on Popular and Scientific Subjects,** which reached a second edition in 1879.

CALDESI & MONTECCHI, active *c.* 1857–67
Florentines with a photographic studio at 38, Porchester Terrace from 1857, and later at Colnaghi's, Printsellers, 13, Pall Mall East. Worked extensively for the Royal Family as portraitists. Supplied photographs for book illustration and became established as leading photographers of works of art.

Julia Margaret CAMERON, 1815–79
Born in Calcutta and educated in Europe, returning to India in 1834. She married Charles Hay Cameron in 1838; following his retirement they returned to England in 1848 to live in Tunbridge Wells, and moved to Freshwater in 1860. There she 'took up' photography with great gusto, producing portraits and studies that stemmed from her profound Christian beliefs. Her autobiography, **Annals of My Glass House,** was published in 1874. In 1875 she returned to Ceylon, where she predeceased her husband.

George Piner CARTLAND, active c. 1880–1900
A portrait photographer with a studio in Windsor. Royal Warrant 2 August 1887.

CORPORAL CHURCH R.E., active 1856–1860s
One of three Royal Engineer photographers who had been instructed in photography by C. T. Thompson (q.v.) and later documented the building of the South Kensington Museums to designs of Captain F. Fowke, R.E.

Antoine François Jean CLAUDET, 1749–1867
Born at Lyons, where his family were glass makers. Came to London in 1829 to establish, with Houghton, a warehouse for the importation and retailing of sheet and decorative glass. One of the first to exhibit the daguerreotype, selling examples to Queen Victoria and Prince Albert in 1840. Never content to be a mere portraitist, he applied his scientific knowledge to the improvement and advancement of photography. Elected Fellow of the Royal Society 1853. Royal Warrant 9 July 1855.

Charles CLIFFORD, c. 1819–1862
From 1852 Clifford lived in Madrid, where he was court photographer to Queen Isabella II. He is best-known for his studies of Spanish architecture, landscape and peoples, on which he worked over a number of years; he published two volumes of them in album form in Madrid in 1861. Before that date his work had been purchased by the British Royal Family, who saw it displayed at the 1854 Photographic Society exhibition in London. Clifford also took one of the few early portraits of Queen Victoria which show her as a queen, wearing evening dress with her jewels and the riband of the Order of the Garter. This was taken on 14 November 1861 at the request of the Queen of Spain, who sent her own photograph to Queen Victoria.

Henry COLLEN, 1800–1875
Trained as a miniaturist under Sir George Hayter, winning a silver medal from the Royal Academy in 1821. By 1835 he was miniature painter to the Duchess of Kent and the Princess Victoria. He turned to photography during the spring of 1841, and in August 1841 he obtained from Fox Talbot a licence to operate the calotype process commercially. Under this licence Collen worked closely with Talbot, but by 1844 the business relationship had become severely strained, and soon afterwards Collen withdrew from photography.

William CONSTABLE, active 1840s
A licensee of Richard Beard's (q.v.) daguerreotype patent, he opened his studio in Brighton on 8 November 1841, hopeful of realizing the commercial potential of the new medium.

Joseph CUNDALL, 1819–95
Born in Ipswich, the son of a draper; apprenticed to a local printer. Moved to London in 1834; became a publisher and associated with Henry Cole to publish **The Home Treasury** (16 vols). In 1852 he established the Photographic Institution at 168, New Bond Street. As well as being a photographer in his own right, Cundall also employed Delamotte and Howlett to undertake work on behalf of the Institution. He was a sponsor of the 1852 Exhibition of Photographs at the Society of Arts and was a founder member of the Photographic Society of London, 1853. He actively promoted photography by publishing manuals and photographically illustrated books; he also mounted exhibitions and retailed the work of leading British and European photographers.

CUNDALL & HOWLETT, 1856–8
This partnership was one of many that Cundall formed under the auspices of the Photographic Institution, including Cundall, Howlett & Downes, 1857; Cundall & Downes & Co., 1858; and Cundall & Fleming, c. 1866. *See also* Howlett, Robert.

Walter DAVEY, active 1880s
A portrait photographer based in Harrogate.

Arthur DEBENHAM
A portrait photographer and miniature painter with studios at Ryde and Sandown, Isle of Wight.

André Adolfe Eugène DISDERI, 1819–89
Despite an earlier bankruptcy Disderi became one of the most financially successful portrait photographers, with studios in Paris, Madrid, Nice, and in London, where he had two establishments, one of them specially equipped for equestrian portraiture. With the decline of the carte de visite, from which he had made his fortune, his business dwindled, and he was forced to sell off part of his stock and turn over his studios to another photographer. Royal Warrant 12 March 1867.

DOLAMORE & BULLOCK, active mid-1850s
Primarily landscape photographers, specializing in studies of the castles and scenery of Wales. Periodically exhibited at the London Photographic Society, where they also showed examples of their portraiture. Published **Scenery of the English Lakes,** 1856.

William & Daniel DOWNEY, active c. 1860–early 1900s
Portrait photographers in Newcastle on Tyne and later in Eaton Square, London. Photographed at Balmoral and Frogmore throughout the late 1860s, particularly for the Prince of Wales. Their carte-de-visite portrait of the Princess of Wales with Princess Louise being carried on her back [**182**] was one of the most popular ever issued, with sales of 300,000. Royal Warrants 24 March 1879 and 7 June 1890.

DUFFUS BROTHERS, active c. 1900
Portrait photographers with studios in Johannesburg and Cape Town.

Brian Edward DUPPA, active 1832–54
A portrait painter who worked and exhibited in London. Nothing is known of his photographic work other than the portraits he made of Queen Victoria and Prince Albert in May and July 1854.

E. C. DYER, active 1858–66
A local printer, bookseller and stationer in Taunton, Devon, who became a 'photographic artist' at a time when it was a popular profession with which to diversify. Nothing more is known of his photographic work.

Peter ELFELT, active 1870s–1900s
Photographer to the Danish court, with a studio in Copenhagen.

ELLIOTT & FRY, 1863–1963
Joseph John Elliott and Clarence Edmund Fry established their portrait studio at 55, Baker Street, London in 1863, and the firm remained at these premises until it amalgamated with Bassano (q.v.) one hundred years later.

Henry ELLIS, active c. 1892
A portrait photographer with a studio in Hyères, France.

Roger FENTON, 1819–69.
A leading promoter and practitioner of photography who threw himself energetically into the formation of the Photographic Society of London, becoming its first secretary in 1853. His contact with the Royal Family probably came about through the Photographic Society; from 1854 he often undertook commissions on their behalf. His visit to the Crimean War in 1855 was made under the direct patronage of Queen Victoria and Prince Albert, and the images from this venture are amongst his best-known. However, they represent only one aspect of his pluralistic attitude towards the application and use of photography. For reasons which are not known, he retired completely from photography in 1862.

F. GANZ, active c. 1886
Nothing is known of this photographer.

Ivan Ermolaevitch GRIGORIEV, active c. 1900
A photographer patronized by Tsar Nicholas II, the Queen of Greece and the Emir of Bukhara. His studio was in Sebastopol, site of the Crimean War.

L. HAASE & CO., active c. 1860–1890s
Portrait photographers to the German court, with studios in Berlin and Breslau.

John HAVERS, active c. 1854
Nothing is known of this photographer.

HILLS & SAUNDERS, c. 1859 to the present day
Appointed as photographers to the Prince of Wales for his portraits of him while he was at Oxford University, Robert Hills and John Henry Saunders later opened their Oxford Photographic Gallery in Eton c. 1863. From that date their business flourished, and they were in constant demand when the Court was in residence at Windsor. The business continues today. Royal Warrants 27 April 1867 and 16 March 1893.

Charles J. HINXMAN, active 1880s
Nothing is known of this photographer.

HISTED, active c. 1898
Nothing is known of this photographer.

Robert HOWLETT, 1830–58
Nothing is known of Howlett's life before his partnership with Cundall (*q.v.*), but the virtuosity of his work suggests he was practising long before 1856. His best-known work is the series on the *Great Eastern* (1857), which includes the iconic portrait of Isambard Kingdom Brunel. At his death it was suggested that Howlett might have inadvertently poisoned himself with his own photographic chemicals: this was not at all uncommon.

Cornelius Jabez HUGHES, 1819–84
Hughes was an assistant to Mayall (*q.v.*) and purchased a studio on the Strand in London from him in 1855. He operated as a portraitist there until 1861, when he moved to Ryde, Isle of Wight. After 1862 he was regularly in attendance at Osborne, where he undertook a variety of photographic work including portraiture. The most famous of these portraits were made according to outline sketches by Sir Edwin Landseer, who needed the photographs to use as the basis for his painting of the Queen at Osborne entitled *Sorrow* (1866). *See also* Mullins, Gustav.

HUGHES & MULLINS, 1883–*c.* 1914
Partnership between Cornelius Jabez Hughes and Gustav Mullins, formed in 1883. In addition to other photographic work for Queen Victoria, the partners were responsible for re-photographing large numbers of photographs in her collection following the death of Prince Albert. They reproduced the images in the permanent carbon process. Royal Warrant 15 January 1885.

William Edward KILBURN, active 1846–62
Opened his portrait studio in Regent Street, London, in 1846 under licence from Beard (*q.v.*). Commissioned to make daguerreotype portraits of the Royal Family 1846–52. Awarded a prize medal for his photographs at the 1851 Great Exhibition.

Professor Karoly KOLLER, 1838–89
A court photographer with his studio in Budapest. Winner of nine prize medals.

LAFAYETTE Ltd, active *c.* 1880–1902
A fashionable firm of portrait photographers ('late of Paris'), with branches in London, Dublin, Glasgow, Manchester and Belfast. Winners of numerous prize medals. Royal Warrant 5 March 1887.

E. LANGE, active 1860
A Danish photographer, working from a studio in Copenhagen.

Lieutenant A. LANGMAN, active *c.* 1900
Nothing is known of this photographer.

G. & R. LAVIS, established 1860
A fashionable portrait studio in Eastbourne, Sussex, operated jointly by a husband and wife.

Gustave LE GRAY, 1820–82
Trained in the studio of Paul Delaroche but never became a successful painter; instead made his career in photography, establishing a studio in Paris. Resulting from his interest in science he invented the dry waxed paper process in 1851, and was using collodion as early as 1849,

although he did not disclose the formulae until after that of Archer. Best-known for his seascapes with natural clouds and studies in the Forest of Fontainebleau. Retired from photography when it became increasingly commercial. Died in Cairo following a fall from a horse.

Alphonse J. LIÉBERT, 1817–1914
Former naval officer, began in photography as a portraitist, first in San Francisco (*c.* 1853) and later in Paris (1863), where he operated three studios. Patented a mechanical device for colouring photographs. Published one hundred views of the destruction of Paris and the events of the Commune (1871).

The LONDON STEREOSCOPIC AND PHOTOGRAPHIC COMPANY, *c.* 1851–*c.* 1921
Founded by George Swan Nottage (1823–85), who later became Lord Mayor of London. Came to prominence during the mid-1850s with the rising popularity of the stereoscope, an apparatus they vigorously promoted. As retailers and wholesalers they commissioned, distributed and published the works of many photographers and instrument makers. Their 1856 catalogue offers over 1000 views, and their 1858 catalogue lists over 100,000 stereo cards in stock. Won the sole photographic concession for the 1862 International Exhibition. Operated three portrait studios in London. Royal Warrant 7 August 1895.

Farnham Maxwell LYTE, 1828–1906
A British photographer whose ill-health obliged him to live abroad, chiefly in the south of France and particularly in the Pyrenees. Experimented with methods of superimposing skies on to photographs as early as 1853, one of the first to do so. His work was widely exhibited, receiving much critical acclaim.

John Jabez Edwin MAYALL, 1810–1901
An extremely successful and talented portrait photographer who in 1846 returned to London from Philadelphia, where he had already been practising as a daguerreotypist. After working briefly as an assistant to Claudet (*q.v.*), he opened his own studio in 1847, naming it the American Daguerreotype Institution. As a business gimmick he styled himself as Professor Highschool. He went on to establish other studios, in London and Brighton, in his own name. Much of his reputation rested upon his technique and his introduction of various innovations to the daguerreotype process.

MAYER FRÈRES & PIERSON, active 1850s–1870
Parisian portrait photographers of repute, competitors to Disderi (*q.v.*). Patronized by the Emperor Napoleon III, having exhibited a life-size portrait of him in 1860. Involved in a protracted copyright case (1860–62) which centred on the question whether photography was a fine art or a copy of nature.

Chief Petty Officer T. M. MacGREGOR
Seconded to H.M.S. *Crescent* as an official photographer during her voyage of June–August 1898. His normal duty was as the Chief Torpedo Instructor of H.M.S. *Vernon*, where he also served as a photographer for the training school.

Arthur James MELHUISH, active *c.* 1850–*c.* 1890
In 1854 Melhuish patented a roll-back for waxed paper, and he demonstrated the device to Prince Albert in April 1856. Became Honorary Secretary to the Amateur Photographic Association, formed in 1861, which had the Prince of Wales as President. Operated with both Mclean and Haes and in a variety of other partnerships. Created 'Photographer Royal' to the Shah of Persia following his visit to London (1873).

Robert MILNE
A portrait photographer with studios in Ballater and Aboyne, Scotland. Royal Warrant 28 January 1896.

MOULIN Atelier Photographique, active *c.* 1851–69
Parisian studio photographer who specialized in elaborate genre and figure studies. The work was widely exhibited and won critical respect. Printed the work of other photographers, notably Fenton (*q.v.*), who transferred his negatives of the Crimean conflict to the studio *c.* 1862.

Gustav William Henry MULLINS, 1854–1921
A native of Jersey who went to Ryde in the Isle of Wight *c.* 1880 as assistant to C. J. Hughes (*q.v.*) in his studios at Regina House, 60, Union Street. The partnership of Hughes & Mullins (*q.v.*) was formed in 1883. Hughes, who had never recovered from the death of his only son in 1878, died in 1884. Mullins continued the business, purchasing the fittings and furniture from Hughes's widow. He traded as Hughes & Mullins until just before the First World War, when he moved to smaller premises at 64, Union Street, and traded under his own name only. He died on 27 December 1921. Mullins had earlier taken a partner, Mr Barry Newton, who continued the business under the name of Barry & Mullins until *c.* 1935.

John MURRAY, 1809–98
As a doctor for the British East India Company, Murray worked in the subcontinent for many years, eventually becoming Inspector General of Hospitals for the North Western Provinces (1871). He originally took up photography as a hobby, but the quality of his work and the demand for exotic subjects in Britain led to his photographs being published in London: most notable was the portfolio **Picturesque Views in the North Western Provinces of India** (1859).

NEGRETTI & ZAMBRA, 1850 to the present day
Henry (Enrico Angelo Ludovico) Negretti, born in Como, Italy, came to London in 1829 and established himself as an instrument maker and optician. Took Joseph Warren Zambra into partnership 1850. Prize Medal at the Great Exhibition 1851. Began trading in photography by 1855. Photographers to the Crystal Palace Company, also maintaining a portrait studio there. Competitors to the London Stereoscopic Company (*q.v.*) and Marion & Co., London.

William NOTMAN, 1826–91
Born in Scotland, where he learnt the daguerreotype process as a young man. Like many other Scots he emigrated to Canada to work as a merchant in Montreal. Lack of business prompted him to open his own portrait studio, which

proved immensely successful. Other studios were opened in Ottawa, Toronto and Halifax, helping Notman to establish himself as a leading portraitist. His company was also noted for its fine stereoscopic views, elaborate studio settings and for its documentary record of Canadian life.

Thomas PEARCE, active late 1850s
From his premises in Braemar, Scotland, Pearce visited Balmoral Castle several times and made some fine portrait studies there. Nothing more is known of his career.

The PHOTOGRAPHIC INSTITUTION
See Cundall, Joseph.

William Lake PRICE, 1810–96
Originally trained as an architectural and topographical artist in the studio of C. W. Pugin; exhibited in London at the Old Watercolour Society (1837–57). His interest in photography dates from the early 1850s, when he became renowned for his elaborate genre studies. He also made architectural and topographic views, including a series at Osborne for the Royal Family in 1859. His **Manual of Photographic Manipulation** (1858) and his essays in the **British Journal of Photography** reveal his interest in harmonizing technical skill and aesthetic judgement.

Charles REID, 1837–1929
A noted animal photographer active during the 1880s and 1890s. His studies of wild and domestic animals were printed by the photographic publisher G. W. Wilson & Co. (*q.v.*).

Oscar Gustav REJLANDER, 1814–75
Born in Sweden, the son of an army officer, he went to Rome to study painting and eked out a living copying Old Masters and painting portraits. Came to England, finally settling in Wolverhampton, where he established himself as a portrait painter. He was taught photography by Nicolaas Henneman, one-time assistant to Fox Talbot, and began taking portraits, *c.* 1854, winning a prize medal at the Paris Exposition of 1855. Came to prominence with the publication of his elaborate allegorical study **The Two Ways of Life** (1857). His work was much admired by the Royal Family, who consistently purchased his studies up to 1869. Following a long and debilitating illness Rejlander died on 18 January 1875 and was buried in Kensal Green Cemetery, London.

James ROBERTSON, active 1850s
Robertson's first published works to be distributed in this country were views of Constantinople, where he was working as the Chief Engraver to the Imperial Mint. These images were critically acclaimed and the Royal Family bought several sets. He photographed the Crimean War and had his work exhibited in London with Fenton's (*q.v.*) in April 1856. Continued working as a photographer travelling in company with F. Beato (his brother-in-law?) through Egypt and Palestine en route to India, where he recorded the aftermath of the Indian Mutiny. After this little is known of his career.

Dudley Charles Fitzgerald de Ros, 24th Baron de ROS, 1827–1907
Lord de Ros served in the Army and also held office in the Royal Household as Equerry to the Prince Consort, 1853–61; Extra Equerry to Queen Victoria, 1862–8; Equerry 1868–74 and Lord-in-Waiting 1874–80, 1885 and 1886–92 to Queen Victoria. He was a keen amateur photographer; over forty of his prints, showing the royal children and the Court circle, are preserved in albums of the late 1850s and early 1860s. An album commemorating the visit to Ireland in 1903 by King Edward VII and Queen Alexandra also contains three photographs by him and his second wife, showing their house, Old Court, in Strangford, Co. Down.

Alfred ROSLING, 1802–1880s
A successful timber merchant who took up photography as an enthusiastic amateur. Using the calotype process he made large-scale stereoscopic images for the Wheatstone viewer. A founder member of the Photographic Society of London; later became its Treasurer. In January 1854 he was one of the society members who conducted members of the Royal Family through its first exhibition, held at the Society of Arts.

ROSS & THOMSON, 1847–*c.* 1890s
Two of the many fine Scottish photographers who found the stimulating atmosphere of Edinburgh society during the 1840s conducive to their personal development. The partnership of James Ross and John Thomson became renowned for calotype studies of architecture and landscape as well as for commercial portraiture. Royal Warrant 14 June 1849. Medal winners at the 1851 Great Exhibition.

Giulio ROSSI, active *c.* 1899
A portrait photographer based in Milan.

James RUSSELL & Sons, active 1860s–1890s
Portrait photographers with their principal studio at Littlehampton and others at Chichester, Worthing, Bognor and Petworth. Also advertised themselves as landscape photographers and exhibited views at the International Exhibition, London, 1862. Royal Warrant 3 May 1897.

Russell SEDGFIELD, 1826–1902
Born in Devizes, Wiltshire, and trained as an engineer. His interest in photography began at the age of sixteen when he took out a licence to operate the calotype process as an amateur. From this early beginning he became a leading topographic photographer and publisher of stereoscopic views, *c.* 1852–72.

Camille SILVY, active 1860–70
Coming from a French aristocratic background, Silvy was able to establish himself rapidly as one of the leading portrait photographers in London. His studio in Porchester Terrace was renowned for its tasteful furnishings and elaborately painted backgrounds. Except for Queen Victoria, he photographed most of the Royal Family and British aristocracy. Because of his ill-health he retired to France, and during the Franco-Prussian War he was wounded on active service as a member of the Garde Mobile, which he had joined in order to defend his property.

Mary STEEN, active in the 1890s and early twentieth century
A Danish photographer with a studio in Copenhagen, where her work was known to the Princess of Wales. She was later commissioned to photograph members of the Royal Family in London. Royal Warrant 21 May 1896.

W. & J. STUART, active *c.* 1897
Nothing is known of these photographers.

Charles Thurston THOMPSON, 1816–86
Son of the respected engraver John Thompson (1785–1865), and brother-in-law of Henry Cole, whom he assisted in various aspects of the 1851 Great Exhibition and with whom he established a photographic studio at the South Kensington Museums. Best-known for his photography of works of art, especially the Raphael cartoons at Hampton Court (1858), where he employed a camera taking negatives 36x36".

John THOMSON, 1837–1921
Reputed to have studied chemistry in Edinburgh before taking up photography as a scientific aid during the 1850s. For ten years he travelled widely in the Far East, establishing commercial portrait studios in Singapore and Hong Kong, and recording the ethnography and topography of Cambodia and China. On his return to London he undertook his most famous project, **Street Life in London**, published in monthly parts from February 1877, which is regarded as a pioneering work of social documentary importance. Royal Warrant 11 May 1881.

William James TOPLEY, active *c.* 1850–*c.* 1900
After spending some time as an itinerant photographer, Topley joined Notman's (*q.v.*) studio in Montreal in 1854. He was later sent to Ottawa to establish a branch studio, which he subsequently bought from Notman. He diversified by selling topographic views of Ottawa and other regions of Canada.

Professor E. UHLENHUTH
A portrait photographer to the German court, with studios in Coburg and Schweinfurt. Winner of nine prize medals. Royal Warrant 5 March 1897.

Princess VICTORIA, 1868–1935
The second daughter of King Edward VII and Queen Alexandra was an enthusiastic and skilful photographer. She is said to have learnt photography at the London Stereoscopic School of Photography in Regent Street, and she showed her work at the Kodak exhibitions of 1897 and later. Princess Victoria probably used a No. 1 Kodak, as well as a No. 2 Bull's-Eye Kodak and a No. 4 Panoram Kodak camera. She kept albums of photographs from 1887 to 1933.

W. WATSON, active *c.* 1884
A portrait and landscape photographer with a studio in Ballater. Being in close proximity to Balmoral Castle, he undertook commissions for members of the Royal Family.

WESTFIELD & Co., active *c.* 1875–6
A firm of commercial photographers based in Calcutta.

Henry WHITE, 1819–1903
An amateur photographer whose studies of landscape and closely observed foliage won him the highest award for photography at the Paris Exposition of 1855. In that year he joined the Photographic Society of London and was for some time closely involved with its activities.

Glossary

Thomas R. WILLIAMS, 1825–71
Williams worked as assistant to Claudet (*q.v.*) before establishing his own studio in Regent Street, London. He is best known for his stereo-daguerreotypes of the Crystal Palace and for carefully composed genre studies and still lifes. Commissioned by Queen Victoria to photograph the 'Crimean Heroes' as they returned to Portsmouth (June 1855) and later the launching of H.M.S. *Marlborough* (July 1855). These and many of his other studies were issued by the London Stereoscopic and Photographic Company (*q.v.*).

George Washington WILSON, 1823–93
Born in Alvah, Banffshire, the son of a crofter, Wilson trained as a miniaturist and settled in Aberdeen (1848) to establish himself first as an artist and later as a photographic-artist (*c.* 1852–3). In this he was assisted by his partnership with John Hay Jnr, who was already practising as a photographer. This short-lived partnership (1853–4) saw the first of many commissions from the Royal Family when they were in residence at Balmoral. Wilson went on to build up a substantial business as a publisher of topographic views, the company reaching its prime during the 1870s; it then went into a gradual decline. Royal Warrant 17 July 1873.

WILSON & HAY, 1853–4
A brief business partnership between George Washington Wilson (*q.v.*) and John Hay Jnr.

W. W. WINTER, active in the 1880s and 1890s
A photographer based in Derby, winner of numerous medals from provincial exhibitions.

Albumen print (1850–*c.* 1900)
This process was an improvement upon the salted paper print (*q.v.*) and used a very thin paper coated with a layer of prepared egg-white, which acted as an absorbent medium and took up the silver salts during sensitizing. Albumen prints were commonly toned to a rich purplish brown with a gold solution and occasionally glazed or enamelled to give a high finish to the surface.

Following its introduction in 1850, this quickly became the most popular of all printing processes and accounts for the majority of nineteenth-century photographs that one sees today.

Cabinet print (1865–*c.* 1910)
Originally introduced as a new size for topographic views, this format was adopted by portrait photographers who recognized its commercial value in a market satiated with cartes de visite (*q.v.*). The card mounts ($4\frac{1}{4}$ x $6\frac{1}{2}''$) were invariably ornamented and served as advertisements for the photographer.

Calotype negative (1840–*c.* 1855)
An important elaboration by W. H. Fox Talbot of his original concept for photogenic drawing; for the first time it utilized the existence of the latent image.

High-quality writing paper was sensitized in solutions of potassium iodide and silver nitrate; after its exposure the latent image was developed in a solution of gallic acid and silver nitrate to produce a negative. This was fixed, washed, dried and finally waxed to give it a translucence that made it print more readily on to salted paper (*q.v.*).

Although Talbot's invention was the fundamental basis of subsequent photographic evolution the calotype did not enjoy the popularity or commercial success of the daguerreotype. It found most favour with 'amateurs' who preferred its characteristics for their photographs of landscape and architecture.

Carbon print (*c.* 1860–*c.* 1930)
Originally introduced in 1855; J. W. Swan's improvements of 1864 led to its wider use as the first permanent printing process. Rather than rely upon silver salts, which are susceptible to fading, this process used pigments or, as its name suggests, carbon black to form the image. During the 1870s and 1880s it became a popular form of book illustration, its rich colour and permanence endearing it to the public.

Carte de visite (*c.* 1859–*c.* 1890)
A format born out of a technological development in camera design and applied to commercial practice. It was the convention in portraiture to make the exposure on to a single large-format negative (10x8″), giving an image of impressive proportions and a corresponding high price. The new design had a camera with up to six lenses making either a multiple exposure or six consecutive exposures on a single negative. Each image was correspondingly small in scale ($2\frac{1}{2}$ x 4″) and low in price.

Having one's carte portrait made became *de rigueur* during the early 1860s, when countless portrait photographers thrived on the new fashion.

Collodion negative (1851–*c.* 1885)
Introduced by Frederick Scott Archer; popularly known as the wet collodion process. Its chief characteristic was the use of glass (rather than paper, as in the calotype, *q.v.*) as the support for the negative emulsion. This allowed the fine detail of the image to be clearly resolved.

The collodion process was both complicated and cumbersome and demanded that the photographer coat, sensitize, expose, develop, fix and wax the plate in one continuous sequence. This need gave rise to a variety of portable darkrooms which could be set up wherever the photographer wished to work.

The collodion process, more than any other, allowed the rapid commercial expansion of photography.

Contact print (1839 to the present day)
Even though enlarging was technically possible, the vast majority of nineteenth-century photographers preferred to contact-print directly from their negatives, which they placed in wooden frames with the sensitized printing paper. The frame was then placed in sunlight to print out. This method of printing maximized the qualities of the negative, and for this reason it is still used today.

Daguerreotype (1839–*c.* 1860)
The process introduced in 1839 by L. J. M. Daguerre in which the silvered surface of a copper plate was made sensitive to light by fuming in iodine vapour. After exposure in the camera the image was made visible by a further fuming over warmed mercury. The physically delicate nature of the image required that the plate be elaborately mounted behind glass for protection. It was often delicately hand-coloured to resemble a miniature. Each daguerreotype is a unique image.

Dry collodion negative (1855–*c.* 1870s)
A variant of the wet collodion process (*q.v.*) in which the emulsion was given a final coating of gelatine or albumen. This so reduced the sensitivity of the plate that it never found widespread acceptance and was superseded by the gelatine dry plate.

Enamelled albumen print
See Albumen print.

Gelatine silver print (*c.* 1880s to the present day)
Rather than coat the paper and then sensitize it just before use, as in the albumen process (*q.v.*), this process mixed gelatine and silver halides together in an emulsion that was then coated on to the paper. This could be stored for long periods before use. The complexity of the formulae and the coating techniques required that it be manufactured under controlled conditions.

Prints were sometimes toned to a rich brown in sulphide solutions.

This process is still in use for black-and-white printing today.

Glazed albumen print
See Albumen print.

Hand-coloured daguerreotype
See Daguerreotype.

Instantaneous photograph
A term that was liberally applied to photographs made with short exposures. There was no universal agreement on its meaning, as technological advances continually reduced

Index

exposure times to new levels all of which were understood to be instantaneous. See page 31 above for a fuller discussion of its meaning during the early decades.

Microphotography (1852 to the present day) An application of the wet collodion process to the specific purpose of reducing an image to microscopic proportions without any significant loss of resolution. Introduced in 1852 by J. B. Dancer of Manchester (1812–87), it remained something of a novelty until the winter of 1870–71, when microphotographed messages were sent by carrier pigeon into the besieged city of Paris.

Platinum print (1873–c. 1920) A process utilizing a complex of platinum and iron in the light-sensitive emulsion of the printing paper. This gives the finished prints an unsurpassed richness of tone that was greatly admired by photographers who sought to achieve excellence at every stage of their work. Following a dramatic rise in price after 1918, the process declined, but in recent years there has been a revival of interest.

Printing out paper (1880–c. 1940) More popularly known as P.O.P., this was the successor to the salted and albumen papers (q.v.) and like them was printed in daylight. As it required virtually no technology for its use within the home, it became a favourite for amateurs printing their own snapshots.

Salted paper print (1839–c. 1855) High-quality writing paper was sensitized by being immersed in a solution of common salt and afterwards floated upon a bath of silver nitrate. The paper would then darken when exposed to light. Talbot used this process to make his 'photogenic drawings' as early as 1834, but he did not publish the details until 1839. Salted paper was most commonly used to print from calotype and waxed paper negatives.

Waxed paper negative (1851–c. 1865) In many respects similar to the calotype process (q.v.), of which it was a variant. The paper to be used for the negative was waxed before being sensitized, which gave it greater translucency for printing. Unlike the collodion negative (q.v.), of which it was a contemporary, the paper could be prepared and sensitized many days before exposure, obviating the need for a portable darkroom.